Lineberger Memorial Library

BEARING THE MYSTERY

TWENTY YEARS OF IMAGE

BEARING THE MYSTERY

TWENTY YEARS OF IMAGE

EDITED BY GREGORY WOLFE

William B. Eerdmans Publishing Company
Grand Rapids, Michigan / Cambridge, U.K.

Bl. Eerd. 8/09 30.00

Published 2009 by
WM. B. EERDMANS PUBLISHING CO.
2140 Oak Industrial Drive N.E., Grand Rapids, Michigan 49505 /
P.O. Box 163, Cambridge CB3 9PU U.K.

Printed in the United States of America

15 14 13 12 11 10 09 7 6 5 4 3 2 1

Library of Congress Cataloging-in-Publication Data

Bearing the mystery : twenty years of Image / edited by Gregory Wolfe.
 p. cm.
 ISBN 978-0-8028-6464-2 (cloth: alk. paper) 1. Christian literature, American.
 I. Wolfe, Gregory.

 PS509.C55B43 2009
 810.8'03823 — dc22

 2009009275

Cover image: Steve Hawley. *Black Glass Still Life with Fish, Pear, and Skeleton*, 1986-88.
Oil and alkyd on paper. 43 x 60 inches. This painting appeared on the cover of the first
issue of *Image* in spring of 1989. © 1990 Steve Hawley.

www.eerdmans.com
www.imagejournal.org

for Luci Shaw and Carol Windham

CONTENTS

CONTENTS

GREGORY WOLFE

Something Understood

ALLEN TATE, the twentieth-century poet and critic, once wrote
that the literary quarterly "increasingly serves the end of
acquainting unpopular writers with one another's writings."
His tongue, of course, was planted firmly inside his cheek, since he
wrote this in the context of a paean to the quarterly's vital contribution
to literary culture as well as to society at large. I find it somewhat
reassuring that the concerns Tate had about the survival of the quarterly
in 1936 are with us still. He worried about the inconsequentiality and
evanescence of weeklies and monthlies like *Time* and *Life* magazines;
today our fretting about shortened attention spans takes the form of
comments about Facebook and text messaging.

As in Tate's day, the quarterly still has to justify itself to those who
consider it too rarefied and obscure, too distant from the so-called
bleeding edge. But if the quarterly continues to have a great deal of
flashier competition, its *raison d'etre* remains intact: there are times
when we need to slow down to something like the quarterly's pace,
to participate in the rich interior event that serious reading generates.
Literary quarterlies are still an essential venue for developing emerging
writers, forging community, making possible the cross-fertilization
that enriches the life of that community, and nurturing the sort of
complex imaginative vision that has a disproportionate influence on
the culture as a whole.

The quarterly may not be dead yet, but the survival of any particular
quarterly for two decades is cause for celebration and reflection, especially
if, as in the case of *Image*, the publication has some claim to a unique
role in the republic of letters.

If I find it difficult to describe that role in the programmatic language
of a mission statement, I hope that will be counted in the journal's
favor. *Image* was founded in 1989, after a decade of raging culture
wars, when the politicization of nearly every aspect of our common

life had advanced to an unprecedented degree, and the arts themselves had become one of the central flashpoints of conflict and pontification. When *Image* announced that it was going to publish original creative work that at some level engaged the Jewish and Christian traditions that have shaped the West, there were undoubtedly some who considered this merely another, more sophisticated way of carrying on the culture war: the "high art" wing of the operation.

But to my mind that would be an intellectually dishonest—or merely lazy—reading of *Image*'s original intent. From the outset the journal has privileged the language of art, which is dramatic and experiential, over the language of proposition and argument. At a time when postmodernists had elevated criticism above the creative act and many religious believers had reduced the engendering experiences of faith to the abstractions of moralism and apologetics, *Image* sought to be a countervailing force. Part of this involved a refusal to align ourselves with particular aesthetic schools, political platforms, or religious subcultures. In short, we chose presence over activism, being over doing.

Certainly a key reason for founding *Image* was to counter the widespread notion that great art could no longer be made by those who wrestle with matters of faith. We found it odd, to say the least, that both secular thinkers and millions of the faithful were in total agreement about this.

The gatekeepers of cultural authority had been making such a claim for decades, even as Stravinsky was composing his Symphony of Psalms, Georges Rouault was painting the passion of Christ in a fresh idiom, and T.S. Eliot and Flannery O'Connor were at the height of their powers.

The myth that there is an absence of religious concerns at the heart of modern literature and art has remained stubbornly persistent. That it remains the conventional wisdom in many circles is not difficult to see. In 2008 a reviewer in the *New Republic* could still write: "the absence of God from our literature feels so normal, so self-evident, that one realizes with a shock how complete it is." Yet when the *New York Times* invited writers to name the top novels of the last quarter of the twentieth century, three intensely Christian writers—Marilynne Robinson, John Updike, and Cormac McCarthy—held commanding positions in the final tally. I would venture to add to that reckoning the ninety writers and artists whose work is reprinted in this volume.

One wonders who benefits from this strange void in our public discourse. Aside from those on the ideological fringe who simply equate religion with fundamentalism—even terrorism—one might hope that secular critics would welcome art that honestly and painstakingly records the varieties of religious experience. After all, art—with all its ambiguities and self-questioning—is a less contentious and more meditative place in which to explore these matters. Narrative and metaphor, rooted in the concrete details of quotidian life, counteract the unreality of politicized abstraction (the building block of extremism, secular or religious).

Two of our most distinguished literary critics, James Wood and William Deresiewicz, have talked around this void without showing any sign of having noticed it. Wood once famously argued that the rise of the novel entailed the eclipse of the Bible as the locus of moral and metaphysical authority. And yet his essays are rife with harsh judgments about the diminished, claustrophobic self depicted in contemporary fiction. Deresiewicz has castigated Wood for espousing a narrow aestheticism. Comparing Wood to the New York Critics (Howe, Kazin, et al.), Deresiewicz argues that a more robust political sensibility will save us from the diminished self. If by politics he means a passion for justice and the common good rather than ideology, he has a compelling point. But if politics provides a larger framework of meaning for the individual, so does the renewed exploration of the questions at the heart of religious experience.

If the novel's authority has also collapsed, it may be that the pendulum needs to swing back a little. In the pages of *Image*, I would argue, ancient scripture and modern literature have been interrogating one another, gingerly perhaps, but with a certain urgency. The result, it seems to me, is a vital process, one that may slowly restore a measure of authority to both literature and religion.

Of course, to lay the blame for this gap in our public discourse solely at the feet of a class of secular critics would be to merely replace one myth with another. As I noted above, many of the faithful share the prejudice that contemporary art can no longer embody the religious questions. Indeed, the roots of what I would call the separationist mentality—the sense that religion ought to exist apart from the cultural mainstream—may more rightly be located in the heritage of North American religious history, with its commitment to forming a purified

community divorced from the ancient institutions of an official culture, than in modern secularist thought. One of the driving ideas behind the founding of *Image* was an implicit critique of the way Christianity has often withdrawn from the public square in an ill-considered and disastrous fit of self-righteousness. Too often believers have circled their wagons, creating subcultures that sacrifice truth for the false allure of safety.

If many religionists have taken a Gnostic attitude toward mainstream institutions—seeing the realm of high culture, for example, as the devil's territory—they have at the same time demonstrated a dangerous infatuation with pop culture. It's not hard to see why. Contemporary pop culture has been annexed by consumerism; songs and movies have become marketing strategies, filled with messages about what to eat, drink, and wear. Why not merely substitute religious messages where appropriate? Product placement for Jesus.

Here, too, *Image* has put up resistance, risking the charge of elitism but steadfastly upholding the disciplines of making and appreciating fine art as a form of spiritual practice. While *Image* has not been alone in challenging the religious community to rise above political and apologetic utilitarianism—the tendency to reduce religion from event and experience to moralism and catechetics—I think it is fair to say that we have played an important role in that endeavor. And the last two decades have seen substantial change in religious engagement with culture.

One sign of such change is Andy Crouch's recent book, *Culture Making*. Its advertising copy—admittedly not the author's own language—says: "It is not enough to condemn culture. Nor is it sufficient merely to critique culture or to copy culture. Most of the time, we just consume culture. But the only way to change culture is to create culture." It is possible to detect here the re-entry of utilitarianism through the back door, but Crouch's thesis represents a real advance in understanding within the Christian community. Because in the end the very process of making culture, so long as it requires a true devotion to the rigors of craft and integrity of vision, calls people of faith to create work that is honest, human—in a word, incarnate. Only then can it become credible.

That is the sort of work we have sought to publish in the pages of *Image* and collect in *Bearing the Mystery*. The astonishing diversity

of styles and approaches that have appeared in the journal over the years amounts to something rich and strange, something that can be experienced in three dimensions, if not from a single perspective. Creed-sayers and grapplers, Catholics, Protestants, Orthodox, and Jews, abstract and representational artists, the whole panoply of human experience is here. James Joyce once said of the Catholic Church: "Here comes everybody." We think everybody has found welcome in *Image.*

As I reread the material collected in this volume, I thought of George Herbert's classic sonnet "Prayer (I)." The poem attempts to define its elusive subject—not only what prayer means but also what it feels like—through a long string of phrases. Some of these phrases are full-blown metaphysical conceits ("reversed thunder") while others are merely oblique ("man well drest...the land of spices"). By amassing these phrases and refusing to make explanatory sentences or arguments, Herbert seems to imply that the only way to ultimately know mystery is through the accretion of experience. Each phrase is simultaneously brilliant but inadequate—language pressed to the breaking point. The sheer accumulation of paradoxical speech threatens to overwhelm the reader.

It may seem a stretch, but the cumulative impact of the paintings, sculptures, stories, poems, and essays gathered in *Bearing the Mystery* struck me as similar to the experience of reading Herbert's poem. These modern works are also delicate pieces of artifice which nonetheless seek to capture a mysterious dimension of reality, to limn the anguished and occasionally ecstatic glimpses human beings have of a presence that is wholly other and yet strangely intimate. The embarrassment of riches awaiting you in this book may also feel overwhelming. But here, too, Herbert's poem provides an analogy. At the end of the poem comes the simplest of phrases—simplicity itself being the greatest of paradoxes. And so my hope is that when you finish reading this collection, whatever your own beliefs may be, you will arrive at the place where Herbert's poem ends—a place beyond artifice or conceit, of "something understood."

DICK ALLEN

The Canonical Hours

Matins

Risen at this most ungodly hour, God,
When stars evaporate, grayness takes the form
Of mountain ridge and forest, small bats swarm
Into the eaves above our empty beds,
We who follow you, who have withstood
The self's preclusion in the reptile's dream,
Seam ourselves to you, seam unto seam,
And praise you and adore you, our wayfaring Lord.

Now as the young lamb knock-knees toward the light,
The infant wakes beneath smudged windowpanes,
When hidden colors of the woods and fields
Call back your strokings, to emerge as bright
Twists of flowers tousling dark lanes,
We hallow and hosanna all your sun anneals.

Prime

We hallow and hosanna all your sun anneals.
Our faces touched, our bodies warmed, we sing
As shepherds to the hills, as fishermen who fling
Their nets upon the oceans when the light reveals
Vast schools beneath small boats that lift and heel
Before the wind. Lord, with your sun you bring
Such grace upon our world, such happenings
Of glory, were minds dancers, minds would reel!

We praise you who have given us this day.
The light itself is beauty, is eternal life.
No matter what shall happen, who shall fail,

Which prayers are answered and which fall away,
The darkness is dispelled, and on the Earth,
Grass, tree and mountain lie within your will.

Terce

Grass, tree and mountain lie within your will,
Lord whom we thank. We thank you for this chance
To once again bear witness, for the dance
Of light on water, for the hawk's high trill,
Roads in yellow woods, breeze or gale
That blows the pine and poplar east or west
Depending on your whim. Praying, we confess
We live within your grace by your avail.

But most we thank you, Lord, for giving us
Ability to love, to love each other, and
By practicing this love, to reach for you.
When lover and beloved reach across
Barbed wire or table and touch hand to hand,
A touch delivers what the heart holds true.

Sext

A touch delivers what the heart holds true
And we are penitent. Forgive us, while the sun
Stands at its highest and no shadows run
Before us or behind. The soldier now renews
His plea that you might blunt the sword he drew
And raised above his land. Forgive each man
Who could not follow what he could not understand
So followed others who professed they knew.

Forgive us, give us solace. We have sinned,
Who have not cared enough, who left
Too many tasks undone, who disobeyed
Your highest biddings, who would win and win
When you would bid us lose. Give us belief.
Escort us, in your kindness, to the weeping glade.

Nones

Escort us, in your kindness, to the weeping glade.
There, let your justice be dispersed as evenly
As we would wish dispersion of your mercy
On those lives brightening and those which fade.
We love and labor for you, Lord, who robed
Our world in light and darkness. Tenderly,
Treat us, Lord, that we may come to be
More than those who spend their lives in trade.

For your purposes, so far beyond our dreams,
We offer you ourselves. The only price
We'd ask you pay is let our teeming world
Continue balancing between the great extremes
Of roar and silence. Curse or bless
You Lord, we still shall call you Lord.

Vespers

You, Lord, we still shall call you Lord
Though this might be the final setting of the sun
Into the hills. The work of daylight done,
Fields deserted and the tools all stored,
We gather now to listen to your word.
For others, for the others whose lives spin
Downwards more than ours, who may have sinned
Yet seek repentance, we would now be heard.

Comfort the old whose bodies are infirm,
Who thought by now that they might understand
More than they do, and yet are left
More puzzled than when crooked in parents' arms.
Help and heal and care. Reach out your hand
For those who can't reach back. Be Thou their gift.

Compline

For those who can't reach back, be Thou their gift.
But for ourselves, Lord, for ourselves we ask
Light mercies, also. Show us truer tasks
Than those yet known to us. Although night drifts
Across our portion of the planet, you will lift
The darkness up again, and we shall bask
In sunlight when it ends—your cold death mask
Broken by re-dawning of belief.

We are as children now, who ask you guide
Us safely into sleep, and lead us through
The valley to still waters, pasture land
Green with the tall grass where brown spiders hide.
When hope seems ended, let us be with you,
Risen at this most ungodly hour, God.

DAN BELLM

Parable

I lit the candles of the Sabbath and covered my eyes,
terrified in the mind as I was and waiting for rest.
And the evening passed. And as they reached their end
the one became turbulent, sputtering, loud,
the left one on the table, the one facing my heart,

the heart of it burning out impure and rough,
a red with tarry shadows, spitting death at me,
the other placid as prayer, clear light and patient
in the copper hourglass bowl, steadfast as the soul
of the one I love, soothing me, being also alive,

and this one I knew would last and burn long tonight,
the other flail down like madness and hard living
of every sort, the darkness that is touched and felt.
And I sighed for the love, and sighed the poor candle out.
Then I could rest, having yielded half the light.

Bereishit, Genesis 1:1–6:8
Bo, Exodus 10:1–13:16

BEN BIRNBAUM

How to Pray: Reverence, [essay]
Stories, and the Rebbe's Dream

ABOUT A THIRD of the Babylonian Talmud is story—or "incidents" in the Talmud's unpretentious phrasing—and the death of Rav Eliezer ben Hyrcamus on folio 28B of the tractate *Berachot* is one of the work's many formula incidents: familiar blossoms that brighten even the most severe juridical terrain. The narrative convention in this instance is this: a teacher is dying, and his students get to ask him one question before the curtain falls.

Rav Eliezer was no common teacher. Likely born early in the second half of the first century, he became one of the men who devised rabbinic Judaism following the destruction of the Jerusalem Temple in 70 C.E., and without whom Israel and its jealous god would long since have joined Egypt, Babylon, Assyria and their jealous gods in the purgatory of museum blockbuster shows. And the men who stood by Eliezer's deathbed were clearly worthy of their master. For notwithstanding his condition, they ran one right up under his chin. "Teach us," they said, "the ways of this life so that we may be worthy of life in the World To Come"—which is to say they asked him how to gain eternal life. And Eliezer joined his final breaths to brace a suitably comprehensive answer: "Care for the honor of your colleagues; teach your children to shun rote memorization, and seat them on the knees of those who have studied with the sages. And when you pray," he concluded, "*da lifne me atem omdim*"—know before Whom you stand.

While it may seem uncharitable to criticize a dying man for not rounding on a tough pitch, respect for the Talmud's own relentless standards of discourse requires us to observe that Rav Eliezer's statement is a wobbly double down the line—prolix and not absolutely coherent (scholars still argue about the translation and import of the phrase here rendered as "rote memorization"). And as any moderately experienced student of Talmud would know, Rav Eliezer's final teaching does seem but a pallid echo of the bracing assertion found in the tractate *Avot*

that the world exists for the sake of three things and three things only: charity, study of Torah, and prayer.

Eliezer's last sentence taken alone, however—his declaration regarding prayer—is another matter, a blast so pure, long and true that it has withstood the caviling of eighteen centuries' worth of rabbinic color commentators and stands today as the definition of a definition of Jewish prayer, linked to the subject the way "All Gaul is divided into three parts" is linked to Latin, or as Atlanta used to be linked to air travel in the South back when Delta was king of the regulated skies: "You can go to heaven or hell, but you gotta go through Atlanta," they said. Likewise, you can go anywhere you like in the consideration of Jewish prayer, but first you need to make your way through "Know before Whom you stand."

Know: prayer is neither delirium nor reflex; it calls for an attentive intellect, what the rabbis called *kavannah*—intentionality. There is no accidental prayer.

Know before Whom: Whom, not what. Prayer is personal. The God of the Habiru is not an abstraction, is not nature, fate or time decked out in a white beard. "An 'I' does not pray to an 'It,'" Abraham Joshua Heschel wrote in a twentieth-century color commentary on Eliezer's final words.

Know before Whom you stand. Prayer does not take you into your self or out of our world. It is not a transcendental meditation. The relaxation response is not its goal. Nor is prayer oratory. Rather, prayer places you in proximal, eyes-front relationship with the Creator. And so the Hebrew word for liturgical prayer is *tefilah*, an invocation of God as judge.

But the Talmud is merely the glorious Talmud. It is not Judaism; it is not the lives of men and women, lived in the valleys and on the flats—holy ground that is nonetheless ground.

One day about sixteen hundred or so years after Rav Eliezer did his best to answer the last question he ever heard, a Russian Chassidic rabbi known as Shneur Zalman of Ladi was praying alongside his son and, turning to the boy, asked what bit of scripture he was using to focus his prayers. The child answered that he was meditating on the phrase "Whatsoever is lofty shall bow down before Thee." Then he

asked his father the same question: "With what are you praying?" The rabbi answered, "With the floor and with the bench."

In Brooklyn, New York, in the early 1950s, I learned to pray as most of us learn to pray: with the floor and with the bench, or in my case with the sheet linoleum and the gunmetal folding chairs in the Young Israel Synagogue of New Lots and East New York, a brick shoebox with painted-glass casement windows that stood at the corner of Hegeman Street and Sheffield Avenue, shouldered by a dry cleaner's and by a long row of squat apartment buildings that we called brownstones when brownstone was not yet an evocation of a lost urban Elysium but simply a word that described a stone so modest and common that it had no real name.

The Young Israel of New Lots and East New York was a devoutly Orthodox congregation, and the world it supported was suffused with prayer: morning, afternoon and evening worship; blessings before drinking Coke or eating cookies (and they were not the same blessing); blessings after each meal and when putting on new clothes and after burying the dead. There were prayers to be said prior to an airplane flight, prayers of thanksgiving to be said upon landing safely, and dense kabbalic prayers on newsprint certificates that had to be taped to the headboards of cribs to ward off the demons and imps who joyed at murdering infants in their sleep.

We recited prayers as we climbed into bed and prayers as we groped for the off switch on the alarm clock; prayers when catching sight of a Jewish sage or a gentile sage (as with Coke and cookies, different blessings). There was even an extraordinary requirement to offer a prayer of thanks for bad fortune as for good. And each Friday evening at the Sabbath eve meal in every house I knew, fathers placed hands upon the bowed heads of their children, and prayed aloud in Hebrew: "The Lord bless you and guard you. The Lord shine His face upon you and be gracious to you. The Lord turn His face toward you and give you peace"—a prayer and a gesture of benediction torn dripping from the pages of the Torah, as old as love and fear.

We families who were attached to the Young Israel of New Lots and East New York lived in a whirlwind of invocation, praise, thanks, blessing, petition, song and Psalm. But we also lived in rows of attached houses in a clotted and crowded place, a place where Rav Eliezer's injunction to "know before Whom you stand" in prayer had to compete

for attention with the injunction of the baby's croup, the injunction of the worn clutch on the DeSoto, the injunction of the willful teenager, the injunction of the twenty sales you needed to make before dusk if you were to earn the commission you were already sorry you'd taken in advance. And so, while prayer was frequent, it was frequently words—words spoken with an eye on the clock, with an ear attuned to the telephone or the cough from the upstairs bedroom or the spear point of anxiety lodged in the heart.

And I was a boy educated to be pious and learned. I knew very early Rav Eliezer's instructions for gaining The World To Come. I knew Maimonides' extraordinary ruling a millennium later that a man who has returned from a journey may abstain from worship for as long as three days, until he regains the degree of concentration that prayer requires. I knew the story of the Chassidic master Levi Yitzchok of Berdichev, who refused to enter a certain synagogue, saying there was no room for him in the building, so cluttered was it with words spoken without love or fear that had not risen to the Upper World but lay strewn in heaps on the floor like trash.

And I, knowing these things, knowing what God expected of us, how could I make sense of the mumbled words, the tossed-off readings, the careless petitions, the hurried mumblings that so often passed for prayer and worship in the Young Israel of New Lots and East New York and on the streets and in the houses nearby? How could I reconcile God's demands and the demands of Brooklyn? Was it possible that The World To Come was a domain set up only for saints or those who lived in Manhattan between 57th and 96th—people who had nothing to worry about and so could pray with proper *kavannah*? Was it possible that just about everyone I knew and even loved would never make it into God's eternal care?

And then I read the story of the Rebbe's dream. This happened when I was eleven or twelve years old, on a Sabbath afternoon in the Young Israel *shul*, in the parched hiatus between the late-afternoon service and the evening service that concluded the Sabbath. Bored, waiting for the Sabbath to bleed away into the week so I could again listen to the radio or spend my allowance, I picked up a children's magazine that was lying on a folding chair in the sanctuary.

I don't remember what the magazine was called, but I remember it as the Orthodox Jewish analog to *My Weekly Reader*. Distributed to

students in yeshiva elementary schools, it offered stories from scripture and Talmud, Torah puzzlers, photos of grinning boys in black yarmulkes who had memorized one hundred or five hundred *mishnas*, and profiles of heroes from Abraham to Hank Greenberg. And the back cover was always a cartoon story, and that's where I turned first and where I found "The Rebbe's Dream." And here it is as I remember it.

Once in a village in eastern Europe, there lived a rebbe known for the quality of his prayer. From every side people would come to hear, to be inspired, to watch this man climb the ladder of prayer from *kavannah*—intentionality—to *d'vekut*—the loving consciousness of God—to *hitpashtut ha-gashmiyut*, the highest rung of prayer, when the soul falls away from the body and enters the Upper World and God's immediate presence.

And one night the rebbe had a dream. In the dream an angel came to him and said, "If you would learn to pray properly, you must go study with Rav Naftali of Berzhitz." The rebbe was a pious and humble man, and so the very next morning he set out for Berzhitz, which turned out to be an isolated hamlet in the Carpathian Mountains in eastern Galicia. After a week of travel he found himself in the village synagogue, and there he waited until the local Jews assembled for evening prayer, and he asked who among them was Rav Naftali. They replied that there was no Rav Naftali in the village. He said that he'd been told on good authority that there was a Rav Naftali in Berzhitz and had in fact traveled a long way to speak with him. "Distinguished sage," one man then said, "someone's played a cruel joke on you for which God will surely take revenge. There is no Rav Naftali here, and the only Naftali at all is Naftali the woodsman who lives up in the hills and is no rav for certain but a *proste Yid*"—a coarse Jew—"not the kind you would care to know." And all the other men nodded.

The rebbe was deeply disappointed, and decided to leave Berzhitz the next morning. But that night, asleep on a bench in the synagogue, he again dreamed that the angel came and said, "If you would learn to pray properly, you must go study with Rav Naftali of Berzhitz." When the rebbe awoke he decided that before he went home he would go to see this Naftali the woodsman. Perhaps the other villagers were mistaken about the man, he thought. Perhaps he was in fact a *lamed-vovnik*, one of the thirty-six hidden saints whose identity is known only

to God, and for whose sake alone the world is each moment spared the destruction it deserves.

And so he walked most of the morning on a rutted road through the forest until he came to a clearing where there stood a log-walled cabin and a horse shed. And he knocked on the door and a woman admitted him. "I'm a traveler seeking a place to rest," the rebbe said. The day happened to be a Friday, and so the woman invited him to stay for the holy Sabbath, and the rebbe sat in a corner of the house and studied from a book of Torah he'd brought with him.

Shortly before sunset, the rebbe heard the sound of a horse and wagon. A few minutes later a short, big-bellied man with a dark tangled beard entered. He stood an ax in a corner of the room, washed his hands and face in a bucket of water and immediately began to mumble the prayers of greeting for the Sabbath. The rebbe was not impressed with the looks of his host or with his hurried prayers, but he joined him in worship, and then the two men sat down at the table to eat the Sabbath eve meal.

Together they said the blessing over the wine, and the rebbe took a few sips from his cup while Naftali drained his cup and immediately filled it again. Then came the blessing over bread. The rebbe ate a slice of challah, and Naftali ate half a loaf. Then Naftali's wife brought out a baked carp and served the rebbe a slice. Naftali ate the rest of the fish to the bones. The woman brought a pot of chicken soup to the table, then a dish of boiled chicken and turnips, then a fruit compote of apples and berries. Naftali ate prodigiously of each course, all the while drinking glasses of wine and hot tea.

And then, after he had quickly recited the blessing after meals, Naftali stood up, wished his guest a good night and went off to sleep. In a minute the small cabin echoed with the sound of his snoring.

The next day, at the Sabbath dinner and then later at the third Sabbath meal, Naftali's wife brought heaps of food to the table, and Naftali ate like a dozen men, devouring every heap that was placed before him.

Saturday night arrived, and the rebbe was ready to leave, to go home, convinced he had misunderstood his dream. And so he said farewell to his hosts and thanked them for their hospitality. "Learned rabbi," Naftali then said, "so you don't go away thinking the worst of me, allow me to tell you a story. All my life I've had a great appetite

for food, and that has been a blessing, giving me the strength to earn
my living. And then one day a few years ago, I was alone in the forest
when bandits attacked me. They were going to take my wagon and
tools and kill me. And so I prayed to our Creator, saying, 'I have no
learning, I have no pious habits—all I have is an appetite. But if You
give me the strength I need today, for the rest of my life when I eat
on Your holy Sabbath, I will eat for You, only for You.'"

The rebbe returned to his own village. He lived many more years. And
when people told him how impressive and uplifting his prayers were, he
was sometimes heard to reply, "Whatever I know about prayer is as dust
compared to the knowledge of my master, Rav Naftali of Berzhitz."

That is the story of the rebbe's dream that I read many years ago
in cartoon form in the dull hour between *minchah* and *maariv* in the
Young Israel of New Lots and East New York. And when I had finished
reading, I knew that what I had read was as true as Rav Eliezer's
deathbed instructions, or Maimonides' ruling, or Levi Yitzchok's
judgment. I knew I had read a story that could change your life if you
weren't careful, or maybe if you were careful.

My guess is that if Rav Eliezer had been hanging around the Young
Israel Synagogue of New Lots and East New York that afternoon,
reading over my shoulder, he would probably have reached a similar
conclusion about the power of the story of the rebbe's dream, and
been none too happy about it.

A member of the most unfortunate generation of Abraham's seed
prior to 1939, Eliezer grew up at the edge of a chasm that split history.
On the far side, the centuries-old order of ritual animal sacrifice by a
caste of priests in a Temple on a particular hill in a particular kingdom
in a particular land promised through God's covenant to the people
of Israel. On the near side, silence and devastation. "From the day the
Temple was destroyed, a wall of iron set itself between Israel and her
father in heaven," Rav Elazar ben Pedat declared in one of the most
frightening sentences in the Talmud.

Attempts to jump the chasm (or break through ben Pedat's iron wall)
were plentiful, dramatic, desperate and, in nearly all instances, doomed:
a series of schisms, asceticisms, revolutions and bloody martyrdoms.
And in the midst of these convulsions came the response formed by Rav
Eliezer and his colleagues (along with Christianity the only response

to the Temple's destruction that has prevailed into our time). It was a response that through Mishnah and Talmud, through custom and law, rebuilt the faith of Judah on this side of the chasm as rabbinic Judaism: a faith made for a people in literal and figurative exile, "a pilgrim tribe," in the words of George Steiner, "housed not in place but in time," and worshiping a God also in exile, whose place was nowhere and everywhere, whose face was invisible and always manifest.

And the core of that rabbinic inspiration was the substitution of word for blood, of poetry for the knife, of The Young Israel Synagogue of New Lots and East New York for Jerusalem—of orderly, communal, regularized prayer for orderly, communal, regularized animal sacrifice. And so, these rabbis declared, just as sacrifice in the Temple had brought forgiveness of sin, so now did prayer. Just as sacrifice in the Temple had been a principal obligation on religious festivals, so now was prayer. As sacrifice had been the means by which one expressed gratitude for a harvest, for a child, for escape from danger, so now was prayer.

Berachot, the tractate of Talmud most concerned with prayer, not only contains hundreds of detailed instructions for liturgy and worship, but is replete with signposts that direct people's attention to the Torah-endorsed link between the lost world of temple and the new world of synagogue. Rav Hiyya bar Abba, for example, speaking on folio 14B-15A in the name of his teacher Rav Yochanan, describes how a man should begin his day: "Scripture," he declares, "considers all who relieve themselves, wash their hands, put on phylacteries and recite the *keryat shema* and pray to be like those who build an altar and sacrifice upon it." Thus did Rav Eliezer and his fellow rabbis try to connect present and past.

But even the noblest bridge admits the chasm below. With all due respect to Rav Yochanan, the Temple priest's ablutions are not Everyman's morning piss. In her erudite history of rabbinic prayer, *To Worship God Properly*, Rabbi Ruth Langer nails the radical implications of Rav Eliezer and company's invention this way: "When prayer became incumbent on all the people, not simply upon the priests in Jerusalem, then all the people became equally responsible for contact with God."

That's not a bridge; it's a new explosion. And like other theological explosions—the Reformation, for one good example—it could well have resulted in a shattered core and a score of diminished and localized

shards, some perhaps dedicated to gluttony, or sexual ritual, or dismaying forms of sacrifice as the way to please or placate God.

Da lifne me atem omdim: "And when you pray, know before Whom you stand." If one listens with a particular kind of care, Rav Eliezer's final words can sound like a desperate cry for order.

By coincidence (a condition that, like tragedy, is ineluctably joined to Jewish history), Chassidism, the eighteenth-century revivalist movement that produced the story of the rebbe's dream, was also a theological explosion, another response to yet another discontinuity in Jewish history. The crack first appeared in 1648, when an unprecedentedly murderous pogrom destroyed 300 Jewish settlements in Poland and the Ukraine. As in the first century, the unimagined tragedy led to eschatological hysteria and a brace of messianic pretenders, two of whom failed dismally, publicly, and shamefully, in the aftermath of which an exhausted Judaism fell into a clinical depression, a stupor of sadness, anxiety, guilt, and obsessive regard for religious regulation.

Led by a set of charismatic rural religious leaders—not all of whom were rabbis—Chassidism took root in the backwater villages of western Galicia. Theologically, it placed heart above mind, man above text, loving-kindness above learning—seeking to reconnect Judaism with a God who had placed His people on earth so they might rejoice in His blessings.

As regards prayer in particular, Chassidim became infamous for flouting rabbinic regulations: for praying too late and too early; for praying too loud and too fondly; for dancing and singing in the midst of liturgy; for concluding the morning prayer with a whiskey toast to the day's remembered martyrs. It was said of Rav Chayim of Tzanz, for example, that he would stand for hours in prayer—not speaking the liturgy, but ecstatically repeating: "I mean nothing but You, nothing but You alone; nothing but You, nothing but You alone."

And there was Rav Moshe of Kobrin, who in reciting the preamble to just about every Jewish blessing—"Blessed art thou, Lord our God"—cried out "blessed" with such fervor that he had to sit and rest before he could continue with "art thou"; and the Koznitzer Maggid, who would dance on a table during worship; and the dark-visioned Kotzker Rebbe who once chastised a man who complained that his heart ached

when work kept him from praying at the prescribed hour: "How do you know that God doesn't prefer your heartache to your prayers?"

How, indeed, does one know what God prefers? Once when I was a boy in the Young Israel Synagogue of New Lots and East New York, late on a Sabbath morning, the men were preparing to return the Torah scroll to the ark after the reading so we could finish the service and go home to eat the Sabbath dinner. A man came forward from his seat and picked up the Torah from the reading table and would not let it go, would not let the service continue. A short, balding man in a navy blue suit, he put his arms around the Torah and his cheek against its silk covering, as one would hug a child in need of comforting. All activity stopped. The white cotton curtains that closed off the women's section of the *shul* parted, and the women and girls stared. Several men—leaders of the shul—went up to the man who had seized the Torah. They whispered to him and he whispered in reply without raising his eyes to look at them. From where I stood I could see sweat on the man's high pale brow. And then the word passed from row to row and chair to chair: the man who held the Torah had that week been diagnosed with terminal cancer. Nothing could be done. But he knew, as we did, that no harm could come to a person who held the Torah. Of course he knew, as did we, of the thousands of martyrs over the years who were killed while embracing the Torah, even, in some cases, while in the Torah's embrace, wrapped in the scroll by the murderers. But that was a mystery and old news. In the Young Israel of New Lots and East New York, Torah was life and this was today. And so the man held the Torah and would not let it go.

No one would take the sacred scroll from him under these circumstances, and besides it was unseemly to wrestle over a Torah. And if it fell to the ground, a general fast would be required.

I don't remember how the episode ended, but I remember it did not last long. I imagine he grew tired: a Torah scroll—roll upon roll of parchment, line upon line of God's word—is heavy in several ways.

At the time, I saw what this man did as an extraordinary act of prayer and supplication—the most extraordinary I'd ever seen. But was it prayer, or was it the reverse of prayer, an act of irreverence, of selfishness?

From the perspective of those who must build and maintain the stage on which prayers of every sort can play themselves out, the question

is not easily answered. As Rav Eliezer knew, and as the rabbis who denounced Chassidism and in some cases excommunicated its leaders knew, if each member of the congregation dances on the table, if each roars the first words of the liturgy and falls to the floor, or kidnaps the sacred scroll, or decides that heartache or a quart of pickled herring with onions will do as a substitute, it won't be long before prayer faces man and not God, before the stage collapses under the weight of self-indulgence. On the other hand, if there can be no daring or originality or creativity in prayer, then no human being will mount that stage except out of a sense of duty—and certainly no imaginative human being will want to see what happens on that stage, which means that prayer and religious observance will attract none but the reverential—which is a very different crowd from the reverent.

I happen to be of that generation of Abraham's seed whose members carry the names of those who died in the Shoah. Binyahmin Rand was my murdered great-grandfather. Likewise, my brother Akiva is named for Binyahmin's son. But Jewish history being the aforementioned tangle of coincidence and tragedy, Akiva also happens to be the name of Rav Eliezer's most eminent student, who, as it happens, is also known for the words he spoke in answer to his own students' final question.

In this case, the teacher was being flayed alive by the Romans, his flesh torn from the bone with metal combs. The students question: How can you stand in silence while undergoing this torture? And like Eliezer, Akiva replied well enough that his words are remembered. "All my life," he said. "I've wondered how I would be able to fulfill the commandment of loving God with all my heart and soul and life." Great-Uncle Akiva's end was not so efficacious. After witnessing the first murderous assault on his village's Jews, Akiva survived the war as a partisan, went to the new state of Israel as a refugee, married, fathered two children, and one day sat in a warm bath and cut open his wrists.

My brother Akiva was born only thirteen months after I came into the world, and as I was from the go raised to be learned and pious, he took the other available option and raised himself to be a lout—quick-tempered, quick-fisted, stubborn, angry, and unlearned. And then, when I was nineteen and he was eighteen, we changed places—or

more accurately, I determined to become a lout, which allowed him to become learned and pious.

Thirty years or so later, Akiva is the dean of a yeshiva in Yiddish Jerusalem, has thirteen children and a dozen grandchildren, and wears a long black beard and a black hat. I am an editor and executive at an American Jesuit university, have three children, no grandchildren, no beard, and own no hat that Akiva would consider worthy of a grown man's head.

For nearly two decades, Akiva and I had almost no contact, but now we meet every year or two when business brings him to the States, and we talk gingerly about the remaining things we have in common: family and Torah.

When Akiva visited Boston two years ago, I had begun to think about prayer and reverence, and so, over a breakfast of lox and eggs at a kosher deli, I asked how he understood Samuel II, chapters five and six, a text obsessed with reverence before God.

It's the story of David, newly made king, and how he goes with his army to bring the ark of the covenant to his new capital of Jerusalem. Relinquished by the Philistines after it caused them plague, the ark had since been stored in the home of Avinadav. And with the help of Uzuh and Achyo, two sons of Avinadav, David begins carting it home. (The English translation I use is from Judaica Press, tin-eared but simply accurate.) "And they came to Goren-Nachon, and Uzuh put forth [his hand] to the ark of God, and grasped hold of it, for the oxen swayed it. And the anger of the Lord was kindled against Uzuh, and God struck him down there" because only a Temple priest may touch his flesh to the ark.

Angry at God and fearful, David abandons the ark on the spot, returning to claim it three months later only after hearing that the man (a Gittite, no less) who had taken the ark into his house at Gonen-Nachom had since been blessed by God. And so David the brilliant opportunist brings the ark to Jerusalem "with joy.... And David danced with all his might before the Lord; and David was girded with a linen ephod"—which is to say, a short shift, which is to say that in the course of dancing with all his might before the Lord and all the people who lived in his city, the king of Israel and Judah exposed himself.

And Michal, David's first and much neglected wife and daughter of his old rival Saul, looks out at the procession and sees "the king David hopping and dancing before the Lord; and she loathed him in her heart." Later, after appropriate pomp and sacrifice, David heads home, where Michal greets him with: "How honored was today the king of Israel, who exposed himself today in the eyes of the handmaids of his servants, as would expose himself one of the idlers." This seems fair and sharp instruction from a born princess to her husband the randy former shepherd, but it is also an act against God's anointed, as David scornfully makes plain. "And David said unto Michal, 'Before the Lord who chose me above your father, and above all his house, to appoint me prince over the people of the Lord, over Israel; therefore I have made merry before the Lord....' And Michal the daughter of Saul had no child until the day of her death." End of chapter and verse.

What makes the text difficult, I told Akiva, is that here we have Uzuh, who lays a hand on the ark so as to keep it from falling to the ground—he gets zapped for all his good intentions. We have Michal, the princess and queen, for pointing out correctly to her husband that leaping up and down in a short *ephod* in a public place was behavior ill-suited to royalty—she is cursed with barrenness. And then we have David, who for exposing himself before the ark and before all the people—no consequences.

The centuries have of course left us with plenty of rabbinic exegesis, most of it over-heated. Some commentators, for example, have tried to sacramentalize David's behavior by saying that his ephod was not really a common *ephod* but the jeweled *ephod* worn by the Temple priest. Others have tried to explain God's extraordinary anger against the well-meaning if dim-witted Uzuh by developing a midrash that discovers four serious sins in Uzuh's one act of touching the ark. The inventive details do not bear repeating. Regarding Michal, another midrash says that she wasn't really cursed but had angered David sufficiently that he never again went to bed with her. But Akiva didn't try to pass off any of this on me. Instead he offered the following.

It's easy, Akiva said (the words he has always used when explaining something he understands and I don't). Uzuh, he said, was struck down not simply because he reached out to steady the ark, but because he did so simply to steady the ark, like a clerk filing a folder—without awe or love. And Michal was punished not because she chastised the king,

but because she did so "loath[ing] him in her heart" and not out of concern for God or the kingdom or the people. And as for David, he was forgiven because what he did—while inappropriate, demeaning, embarrassing, and certainly unsuited to royalty—he did "with all his might before God," which is to say, with selfless devotion. That's what Akiva told me.

And so, while eating lox and eggs, did my learned brother elucidate the difficult text and, though he didn't know it, at the same time provide an answer to the question of how Rav Eliezer and Naftali the woodsman and King David and the men and women of The Young Israel of New Lots and East New York might all be worthy of eternal life. "With all your might before God" will do it every time—will make a prayer of eating, of dancing, of singing, even of kidnapping the Torah.

And here I could stop, standing foursquare on the Torah and my learned brother's midrash. Unlike my brother, however, I'm a modern. I can't feel comfortable except if I rest on vexatious ambiguity, the rough mattress I'm used to. And so a final story that returns me to the Young Israel of New Lots and East New York—the place where I received the chilling intimation, while reading the story of the rebbe's dream, that law and midrash were insufficient, that creation was in final analysis too spirited or opaque or enigmatic or obdurate to submit itself to any study except that conducted by a blind heart.

The story is about prayer and the Chassidic tradition of drinking a post-worship *l'Chayim* each morning in memory of the day's listed martyrs. But more importantly, it is about the handful of men who made up the Young Israel's first minyan of the day, who prayed earliest and fastest and got on with it, and who blessed me for a time by taking me into their odd company, allowing a milky-skinned boy of thirteen to be counted as a man each dawn at the sacred corner of Hegeman and Sheffield.

Tradesmen and shopkeepers, widowers who smelled of the camphor chips in their dresser drawers, men who were too angry or restless to lie next to their wives all night, they rose before dawn and made their way through the darkness to the corner of Hegeman and Sheffield, where they stood beside their gunmetal chairs below the Eternal Fluorescent buzzing behind its shield of painted glass, before the ark decorated


with an emblem of guardian angels yawning like they'd been up all night. And the moment the clock showed sunrise and they could count ten men, they began.

Never since have I heard such fast prayers, like a torrent sweeping the gutters, slaking the wilderness at the corner of Sheffield and Hegeman, the *umens* leaping like startled trout. Maybe it was twenty minutes to the finish—thirty on Monday and Thursday when we had to read Torah—and then we rushed to the long table below the bookshelves at the back of the sanctuary.

And one of the men took the Seagram's from the secret ark behind Maimon's commentary on the *Mishnah*, while another brought a tray of shot glasses, heavy as bad news, from the caterer's kitchen, and together we took into our bellies the first golden happiness of the day, crying out a "L'Chayim"—To life!—in memory of some saint we did not know but whose death on this date was somewhere recorded, we believed. "For," as I wrote in a poem published a few years ago:

> ...the world was old
> and men died each hour,
> some of them saints or martyrs,
> while someone else, whose job it was,
> wrote names and dates
> (and what fuel was used to start the job,
> and the final words, if intelligible).
> And if we didn't have the details
> at Hegeman and Sheffield,
> that couldn't be our fault
> that we should have to suffer.
>
> So *L'Chayim* and again *L'Chayim*.
> The hoax of International Brotherhood. *L'Chayim*.
> The stink in the air shaft. *L'Chayim*.
> The boxcar of broken shoes. *L'Chayim*.
> The traitor baseball team. *L'Chayim*.
> The martyr behind the deli counter. *L'Chayim*.
> The bone in the sea-root's grasp. *L'Chayim*.
> The silent wife at the Sabbath meal. *L'Chayim*.
> The girl in a summer dress
> who passes as you sit in the steamy elevated car
> and makes you remember what you once believed, *L'Chayim*.

And then each man went off to business or breakfast except for old Mr. Auslander, who stayed to wash the shot glasses and hum "Bali Hai" at the hallway sink generally reserved for the priests' Holy Day ablutions. While I, damp-eyed, happy apprentice to the saints, who had to be in eighth grade and cold sober in an hour, hurried home in the new light among gentile dog walkers, beneath muscled London plane trees, in the perfume trail of girls from public high school, home to the dark-eyed mother in a frayed robe, home to the dying sun of butter in the galaxy of the oatmeal bowl.

SCOTT CAIRNS

Adventures in New Testament Greek: *Metanoia*

Repentance, to be sure,
but of a species far
less likely to oblige
sheepish repetition.

Repentance, you'll observe,
glibly bears the bent
of thought revisited,
and mind's familiar stamp

—a quaint, half-hearted
doubleness that couples
all compunction with a pledge
of recurrent screw-up.

The heart's *metanoia*,
on the other hand, turns
without regret, turns not
so much *away*, as *toward*,

as if the slow pilgrim
has been surprised to find
that sin is not so bad
as it is a waste of time.

RICHARD CHESS

Woman Scribe

for Ruth Levi

This morning, before I opened

an eye, I

beheld ׳, *yod*, suspended point of

infinity, and I knew, I knew today

would be the day I would write

nothing but the Name, leaving

my boy to his father, forsaking

husband and child for the Name

of God: this. The Name of

God: morning. The Name of

God: before. The Name of

God: I.

Yesterday, I wrote דם, *blood*,

and I heard earth screaming,

I wrote טל, *dew*, and I tasted

the indescribable, but

as it had every day of my long

apprenticeship, the Name

eluded my quill as I wrote

story and law.

On earth, black Jews

spit when they hear my name, woman

scribe. Your God is

my God, I say and release

the robe and surrender

to purifying water

and emerge, crowned

in black satin, ready

to sharpen a turkey

feather to the exact size

of the Name, prepared

to ink in every gap

of creation, the empty body

of my own created-in-the-image self

fit to be filled with

יהוה, the Name

of God.

MICHAEL CHITWOOD

Dog

I pray that my dog will live.

I ask the Lord, the Almighty,
Yahweh, I Am That I Am
to keep my dog alive
even though he has righteous gas
and a broken tooth,
even though soaking wet
he smells like old shoes soaked in urine,
even though he's going to have to squat, trembling,
and shit out the pair of pantyhose he's eaten,
still I pray for his life.

I pray out loud to the Lawgiver, Nation-smasher,
Deliverer, Kingdom-maker, the Old Pharaoh-thrasher himself
and do not feel ridiculous. Out loud.
Please let this dog live, I say
to the one who laid the foundations of the earth,
who shut in the sea with doors
when it burst forth from the womb,
please let this bad, matted-rug-of-a-dog live.

What else could I do
with a dog possibly foundered on pantyhose,
a dog whose sleeping head warms my lap?
What else
but speak aloud to an empty room,
to address walls and windows
and the air beyond
and the beyond beyond,
the Thunderhead Troubleshooter
we turn to when turning the prayer wheel again?

DAVID CITINO

Sister Mary Appassionata, Loving the Self

This morning, again,
as I wash my face:
those eyes, that mouth.
The courtship begins anew

in the steamy mirror,
a gaze nearly copulatory,
reptilian and limbic brains
whispering *You're living*

forever, Love, despite
what the cortex knows
about space and time. Here
all desire begins; here

will it end. The least
I need, another end to night,
light dilating the pupils.
Researchers know eighteen

different human smiles,
ways of saying to mirror,
lover, other, *I mean you
no harm*. The brain,

three-pound honeydew history
of the world, admiring itself.
There's but one way out
of this mad, passionate affair,

when you think about it.
Whitman's brain splattered
on the floor of the lab
of the American Psychometric Society

when a technician, calculating
the capacity of brute desire—
one brain estimating another—
stumbled. Can the body

allow a mind to conceive
of a thing beyond itself?
The awful fall, a universe
tumbling toward dissolution,

ripe fruit flung by gravity
at dark once again. I smile
to, at, myself. Saved by dawn,
habitual act of love, I'm back.

ROBERT CLARK

Darkroom
[essay]

I WAS BAPTIZED on December 27, 1963. I was eleven years old, a sixth grader attending an Episcopalian boarding school in southern Minnesota. It was two days after Christmas (there was a hard, crunching snow on the ground) and thirty-five days after the assassination of John Kennedy. My mother and maternal grandparents were present. There were three witnesses and godparents and two priests, the rector of my grandparents' parish, Saint John's in Saint Paul, where the ceremony was taking place, and the chaplain of my school.

According to the certificate which I still have, I promised "to renounce the devil and all his works, the pomps and vanity of this wicked world, and all the sinful lusts of the flesh" as well as to believe "all the articles of the Christian faith" and "to keep God's holy will and commandments, and to walk in the same all the days of my life." Then water must have been poured on my head, followed by a prayer, and there would have been congratulations all around. My mother had been in rebellion against her parents' religion when I was born, but now I—unbidden and of my own free will—had entered the fold. It was an unexpected and gratifying event for my grandparents, and, I suspect, a relief to my mother, a vicarious mending of an intrafamilial schism.

But I remember none of that with any clarity. I only remember the angel. She was life-sized, or at least—since I have no idea how large angels actually are—of human scale and proportion. She had waves of hair falling down her neck and a gown belted just below her breasts that pooled in folds and drapes around her sandaled feet. She held an enormous scallop shell, and this held the water with which I was baptized. She seemed to be gazing down into this, pensive but serene in her beauty.

I was most struck, however, by her color and what I can only call the texture of her body. The angel was made of white stone, neither dull nor shiny, but crystalline like salt or sugar or new snow. Whatever the light gave it—and I later realized it was artfully lit by several flood

lamps—it seemed to give back translucently, as though radiated from
within itself. At the time I imagined this was alabaster, which I knew
from singing "America the Beautiful" was an exquisite material, although
I now suspect it was some more modest type of stone.

I think that the quality she held for me had to do with the light,
with what I don't want to call "a trick of the light." The angel was
in any case a being that I wanted to get closer to. I had an irresistible
urge to be with her, but in what way was unclear: as mother, girlfriend,
guardian, or savior, or perhaps some combination of all of them.

I don't know exactly what had taken hold of me, no more than I
know what possessed me in wanting to be baptized. Perhaps it was
simply to get within proximity of the angel. I can't recall asking to be
baptized, but at the same time I'm quite sure it was done at my request
and that it was done in a hurry.

In September of that same year, three months earlier, I'd begun
attending a school affiliated with the Episcopal Church. Chapel
was required twice a week, but beyond that there was little religious
observance and certainly no attempt to proselytize. I know I was
impressed by the liturgy, which, although distinctly "low" church, was
as theatrical as anything I'd seen, and I know I was moved by the sound
of the hymns, plainsong, and organ as well as of the prayer book's Tudor
English. I also suppose that, like any sixth grader, I simply wanted to
belong, and although only half the students were Episcopalian, that
was another means of fitting in at a new school.

What I can't find is any evidence of fervor, of that "change of heart"
Evangelicals speak of, never mind of being "born again." That, of course,
was not the manner of Episcopalianism, which, true to its English roots,
makes an outward show of pomp and ceremony but is inwardly and
psychologically restrained, even reticent. Perhaps, for other reasons,
it went without saying: my parents had separated when I was one year
old, and my father contracted polio shortly thereafter. I saw him only
twice after he became ill, during court-ordered visitations. He lay
on his bed, breathing through a respirator, scarcely able to move his
head from side to side. He had died five years before my baptism and
perhaps, however heavy-handed and obvious the interpretation may
be, I simply wanted to replace him with a stronger, more powerful, or
at least more reliable father.

Still, I have the weekly letters I wrote home all that autumn and

winter, and the baptism is never mentioned, before or after the fact. The closest I came to displaying any newfound religiosity is in wishing my mother "Happy Advent." I do remember being excited to discover the existence of this season before Christmas, and how I liked the purple altar furnishings and vestments and especially the Advent wreath, whose four candles were lighted on successive Sundays, counting down to Christmas Day.

Of course any child anticipates Christmas with an almost erotic longing, and perhaps my observance of Advent made the anticipation that much more delicious. My letters do mention the things I wanted for Christmas: a book of Indian lore, a record store gift certificate, a biology class dissection set, but most of all a used 35-millimeter camera. I'd had a succession of Brownies and then an Instamatic, but the 35-millimeter was a real camera, the kind my grandfather used to take his Kodachrome slides. That the camera I had my eye on was made by an obscure manufacturer and had a cracked viewfinder did nothing to lessen my ardor.

As against the clouded memory of my baptism, I recall precisely what I did with my new camera: I went and photographed my grandparents' church in Ektachrome. I'd heard it was the color film professionals preferred, rather than the Kodachrome my grandfather used for his family line-ups and tedious cloudscapes and sunsets—the kind of things I intended to surpass. I took shots of the sanctuary, its white and gold altar cloths, its garlands of spruce and pine, and the blue winter light bleeding through the stained-glass windows. And of course I shot the angel from several angles. In the slides, however, her immaculate white body came out a discolored ivory, tending to orange. That, too, was a trick of the light.

Early in January I sent some prints of these to the rector, Reverend Mead, who had baptized me. This is the only allusion to that event in my letters home for the rest of the year. On the other hand, the letters are full of talk about photography, of requests for film, prints, and photography magazines. A lot of kids took pictures at my school, and there was even a rudimentary darkroom. They were shutterbugs toting Brownies and Instamatics, but with my 35-millimeter I was already thinking of myself as someone working at a higher, more serious level. I set my mind to photography with the same willful deliberation I had to set it to religion.

My original model of a photographer was my grandfather, the first person I'd ever seen with a camera that had f-stops and shutter speeds and produced slides rather than snapshots. He was, in reality, the very essence of an amateur. There were no imperatives to his photography beyond his own pleasure and a need to reify again and again a repertoire of clichés: the family face-forward, the spectacular sunset, the antic child, the capering or solicitous pet, the adult raising a convivial glass to the lens.

Of course their technical deficiencies were manifold, but my grandfather had no particular expectations. If a shot "turned out" it was a serendipitous stroke of luck, like a run of good cards at the bridge table. In the same spirit, his photographs were barely composed or even framed. He aimed at the center of the cluster of aunts, uncles, and cousins and flung his dart. If it landed within the boundaries of the print or slide frame he was happy enough. He accepted and perhaps even cultivated the givenness of his images, the vagaries of blinking subjects, uncertain focal lengths, unbalanced, excessive, or inadequate light. Whatever came back from the photo lab was gratefully received.

Once I had my own 35-millimeter camera, I imagined I would quickly overtake my grandfather, but there was nothing to bear that pretension out in my photos. In terms of composition and formal interest, they scarcely equaled my grandfather's Kodachromes. I took pictures of boys from school pitching rocks into the river, of baseball plays obscured and blurred by a frieze of chain-link fence, and of a bend in a pair of railroad tracks arcing off to their vanishing point.

I also habitually photographed church interiors: long shots up the aisle toward the altar, stone tablets and memorials, and stained-glass windows. But for all my effort, these were the most disappointing of my photographs: for lack of light, they lacked contrast and detail; or because I was using daylight film under artificial light and knew nothing of tungsten film or filters, the colors were bleached or luridly flared.

Despite that, I kept at it, oblivious to my photos' technical flaws and the sheer dullness of their content and composition. I was devoted to the work, religiously so, and I suppose I believed it constituted something allied to the transcendent and the beautiful, to art.

I was also, in the manner of self-conceived geniuses, ambitious. I persuaded my grandparents to let me set up a darkroom in an abandoned coal cellar in their basement and to outfit it with a twenty-year-old used

enlarger. It was corroded to begin with, and in the damp of the cellar it began to rust. The technical faults in my photographs multiplied: my negatives were fogged by light leaks into my darkroom, stained and marred by tired chemicals, inadequate rinsing, and poor temperature control, and scratched by particles of the omnipresent coal dust. My prints weren't any better: muddy, blanched, or milky in tone and spotted with dust and crud that had lodged inside the enlarger.

But I went on, undeterred. I was brazen. In the seventh grade I took photos of my school's sports teams—the football squad vaguely out of focus, the basketball players eerily lupine on account of red-eye from my flash—and talked the members and their fans into buying them. That spring I learned that perhaps the most eminent photographer in the state lived not a block from my family in a large stone house, and one afternoon during the summer between the seventh and eighth grades, I simply went to his door and knocked. The house was imposing in the manner of most of the houses on that street, our city's premier boulevard, but conspicuous for having a bright red door—crimson in fact. It was opened by a small, hunched old figure with a crabbed and harried expression, the kind of man who spoons out the castor oil in an orphanage. I was afraid, but forced myself to ask if the photographer were in. He was, the old man allowed, and shut the door in my face, presumably to go fetch him.

Some time later, the door opened again and in it stood a younger man, perhaps forty-five or fifty. His hair was combed back over his head and he had a pencil mustache. He wore an ascot and a white shirt that seemed to balloon around his shoulders and arms. A cigarette dangled from his mouth. But it was the crutches that startled me—those and, as he motioned me to come in and turned down the hall, his rolling, corkscrewed walk. He might have been sawed in half at the hips and then put back together again with the halves slightly misaligned. I was not sure it was a good idea to go inside, but I followed.

We entered the kitchen where the old man was preparing lunch. The photographer indicated that this was his father, who looked up, glowered at me, and returned to agitating his pan of tomato soup. The photographer lowered himself into a canvas director's chair, and as he did, he pitched the crutches toward the wall where, miraculously, they settled, leaning upright. Then he drew hard on his cigarette, and asked me what he could do for me.

It had not occurred to me to formulate an answer to this in advance. I wanted to learn about photography, I said. I hoped I could hang around and see what I could learn. It only strikes me now how audacious, not to say presumptuous, this was, as though I were oblivious to the fact that this was a grown-up with a life to lead, with a business to run. And I suppose, in truth, I was oblivious to that and to much more. The old man brought the photographer a bowl of soup and a plate of toast.

He stubbed out his cigarette and began his lunch. At some point, he asked if I wanted something to eat, but I thought it better not to impose nor, more crucially, to chance the old man's cooking. Then it came out that, yes, the photographer might be able to help me out. At a minimum, he'd be happy to show me around his studio.

He hauled himself up and onto his crutches, crutches I saw were fabricated of stainless steel and black rubber, as slender and elegant as crutches might be. As I followed him out of the kitchen and from one room to the next, it seemed that this house was very much like my grandparents' house a few blocks down the same street: constructed on three floors on the same broad and massive lines, with its formal, high-ceilinged downstairs giving onto a central foyer and staircase by means of double doors. There was a dumbwaiter, a backstairs, and an indicator board in the hall for a now moribund system of bells and call buttons. It was a house designed in the 1890s for a prosperous family and its servants, but now it contained only the photographer and his sour old father.

But for their two bedrooms and the kitchen, it was otherwise consecrated entirely to photography. What had once been the living room was an enormous studio cluttered with lights and three cameras—eight-by-ten and five-by-seven Linhof view cameras and a two-and-a-quarter Hasselblad—on tripods. From the ceiling hung long rolls of background paper in four or five colors. Cables ran over the oak floor and the windows were blacked-out. The adjacent dining room was outfitted with a dry-mounting press, board and paper cutters, and racks of boxed prints and illustration board. In what my grandparents would have termed the library or parlor, another studio was set up for seated portraits and groups.

I was impressed by these rooms and a little intimidated by their being sealed off from daylight, lit only by the fill and strobe lights in their standby setting. But I wasn't much interested in studio photography.

I wanted to see the Hasselblad and the 35-millimeter Nikons, if he had any (which of course he did), the tools of photojournalism and art photography. More than these, I wanted to see his darkroom.

In fact, the photographer told me, he had two darkrooms, one in the basement to process film and another upstairs for printing. And with that he seated himself on the stair lift parallel to the balustrade and, with me climbing the stairs alongside him, we ascended.

The darkroom was adjacent to his bedroom at the back of the second floor, and was entered by a sort of light-proof airlock. Inside, the walls, ceiling, and floor were painted black. There was a long bank of sinks along one wall in which trays sat surrounded by a continuous flow of temperature-controlled water. Above it were fixed shelves filled with jars and jugs of chemicals.

An outsized bench against the adjacent wall held two enlargers (one for the sheet film from the view cameras, another for the 35-millimeter and two-and-a-quarter negatives), along with timers, controllers, and switches. Beneath and to one side of it were boxes upon boxes of photographic paper in different sizes, grades, and finishes, and a little further off to one side a phonograph and a stack of jazz and classical record albums. The photographer also had a special chair, a tall stool on wheels upon which he could scoot himself back and forth between the enlargers and the developing trays using one crutch.

After he'd shown me the layout of the darkroom, the photographer threw a switch. For an instant, the room was utterly black, without any light, so dark that the darkness felt almost material, a substance through which you might slowly and laboriously pick your way. But then half a dozen bell-shaped lamps suspended from the ceiling went on. They cast brownish-orange pools of illumination over the sinks and the enlarger bench, a light by which you could see, but which seemed to give no shadows or depth to the objects it fell upon, an airless light by which you could work as though underwater.

I was a little relieved when the photographer put the regular lights back on, but no less thrilled by what I had seen: a darkroom more fabulous than any I could have imagined. It was not only magnificent: it was cool, a quality I had just lately begun to grasp and which was exceedingly rare in Minnesota. In fact the photographer was cool: it was cool that he had a mustache, that he wore outsized shirts, that he had oil paintings on his walls—real ones, abstracts on canvas—and

that the walls and hallways themselves were painted dark olive green and Chinese red and were lit by floods and spots that left vast pools of shadow and dark, not spooky dark but cool dark.

Most adults I knew were authoritarian—the character of their relation with me was explicitly or implicitly about control—and when they relaxed they were earnest or dull: they either kept their true selves hidden, or perhaps they had no selves of any real interest to see. They were, in the argot of the day, uptight, or, as psychologists liked to put it, anal.

But the photographer was offhand; as in the style of his twisted body, he was all akimbo. He didn't care if I was under control. He had time for me, me and his darkroom. What he cared about, it seemed, was his art. I sensed all this as we went back downstairs, as he sidewinded his way down the hall, onto his perch on the chairlift, and returned to the kitchen, where I asked him if I could come back and he said I could. And I knew it, grasped it incontrovertibly, as I walked past his garage and saw his car, a black 1958 Thunderbird.

His polio, his sickness and the handicap it had incised on his body, had of course struck me, but less as a fact than a faint presence, a backlight against which his other qualities—the thing he had made of his life—contrasted and even shone. Nor can I say that I made a conscious connection between my father and him; between the ashes of my father's history and the triumph of the photographer's, who had turned his tragedy into art in even the simplest things, in his insouciant clothes and dark, transgressive automobile.

§

I spent much of that summer at the photographer's. Sometimes he or the old man had to send me away when a subject was being photographed in the studio or there was a backlog of work in the darkroom. But as the weeks passed, he began to allow me to stand around as he worked. I was learning to be quiet and how and when to fetch things he needed, or to run errands, tasks for which I could be his legs. I ate the old man's cooking at lunch, and although I never stopped believing he disliked me, he seemed to scowl at me less.

I also began to learn something of the photographer's history. He had gotten polio during the Depression and had spent several years in a hospital ward recovering and learning to breathe and walk again. It was there that he took up photography, studying by correspondence

course. He had been married once. He was from South Dakota. That
was as much as he told me.

I tried to find out more. I was a snoop, and the fact that the
photographer couldn't move very fast—that in fact you could hear the
squeak and sigh of him approaching on his crutches—allowed me to
enter his private rooms for brief periods without being detected. His
bedroom was just opposite the entrance to the upstairs darkroom.
He kept it dark with the shades pulled down, even in the height of
summer, and it was black and sumptuous. There was a red cover on
the bed and a rank of overstuffed orange and black pillows at its head.
I am sure the night stands and the dresser were Chinese or Japanese,
or at least wrought in a style I was unfamiliar with. The details of the
room are difficult to recall, perhaps because it was hard to see them
in the first place.

I do know there were record albums and art books (some of them
featuring nudes) and copies of *Playboy* (a publication whose images,
tattered and passed around among boys I knew, I had taken consolation
in, but which was never openly displayed in the homes I frequented).
A small stand held liquor, glasses, and an ice bucket. And there were
photographs hanging on the walls and set atop most of the tables and
counter spaces. Most of these were of women and, I realized over time,
of one woman in particular.

I was not much past the age when a boy's benchmark for female
beauty is his mother, or perhaps a favorite aunt, but this woman I quickly
realized was more beautiful than any woman I had known. She was film-
star beautiful, yet more beautiful than a film star for not being one, for
being someone you might know, or at least someone the photographer
had known. I also saw from the signatures in the corners and from what
I was beginning to comprehend as the photographer's style that they
were all his work, that he had photographed her again and again.

The woman's face was serene, dignified yet—I would have said
had I known the word—sensuous. She had high cheekbones, large
eyes (brown, I would have ventured, although all the photos were in
black and white), and her nose was of a piece with her chin, straight
and—again, had I known the word—classical. The photographer's
style was a little in the mode of Hollywood portrait photography of
the 1940s, and his rendering of this woman made her a little sweeter
than Barbara Stanwyck but more severe than Rita Hayworth.

But I am not sure that her hair was not more significant than her face. Again, I had to extrapolate the color from the gray of the print: perhaps medium brown or even auburn. But the color was the least of it, because it wasn't merely hair—a superfluity that might be altered or shortened without changing the person who wore it—but an integral part of her. It was sculptural in the way that Bernini's drapery is no less essential to his figures than are their hands or ecstatic lips. The woman's hair had folds or pleats, but it had mass, and in the way it fell and flowed off and around the head, it had gravity, a kind of downward motion.

But for all that it was a little insubstantial. You might have said that the hair and indeed the whole face were slightly out of focus, but not so much that you might squint to see if you could make it out more clearly. Rather, the forms contained in the photograph were not so much blurred as they were diffuse, or as though being seen through some diffuse material—a veil or lightly frosted glass or a diaphanous mist.

I knew from looking in the studio that the photographer used various filters and that in the dark room he had not only the customary tools for producing dodges, burns, and vignette effects, but also sheets of glass he laid right over the photographic paper on the enlarger easel to produce scarcely perceptible patterns—crystalline, linear, pointillist—in the finished print. Everything that went on in the darkroom was a kind of etching with light, of masking and exposing the coating of silver on the paper so that some places darkened and others did not, an illumination but also corruption since what darkened the paper and thereby threw the images into relief, into visibility, was chemically not much different from the tarnishing of silver.

But the images of the woman were just as much or more a product of lighting in the studio, of calculating not only the shadows and highlights a given arrangement of lamps might make fall on a subject, but of the perceived sense of distance and volume—what became the presence of the person pictured—that the light induced in the eye of the viewer.

In that sense, it was the light that was material and the body and face of the subject that were immaterial, the light that was solid and the flesh that was transparent. It was this that gave the images their air of sharpness within diffusion, of seeming to be renderings of spirit rather than matter, of angels rather than creatures, an impression of a numinous sculpture cast in light and poured in silver.

I could not help but think the photographer must have loved this woman very deeply to have photographed her so many times. Perhaps he felt compelled to, if only on account of her beauty. I suppose he was lucky to have such a fine model, and in that sense he was merely using her, practicing his art upon her. Having never seen her in the flesh, I could not say whether he had succeeded in capturing her beauty completely, or if perhaps he had exceeded it, had made her still more beautiful than she was in reality, in ordinary life. In any case, because of love or obsession or artistic ambition—perhaps all three—he had taken great care, great pains, and immeasurable time and concentration with her.

There was also a photograph of the woman in the hallway, and one afternoon that August I made a pretense of noticing it and asked the photographer who it was. "She was my wife," he said and offered nothing more. I understood it was something he didn't want to go into, not only with me but perhaps with anyone. From then on, I felt that this woman rather than his polio had been the great tragedy of his life. Her leaving him (perhaps because of the polio and what it had done to his body) or their not being able to get along was the great shadow that overlaid the entire house, that adhered to its every corner, that made the darkroom—where the photographer mustered such light as he could through the enlarger's lens—dark.

I can't say I thought of that or of the photographer himself much once I returned to school in the fall. I'd stumbled onto my sexuality—masturbation and sex with other boys—and with it, images of my own to incite, prolong, and deepen it. I did visit the photographer during the Christmas holidays. There was no wreath on the door and no tree inside the house. In the studio and the darkrooms his winter days were identical to the summer. The days were shorter, but the amplitude of light and dark inside the house was the same.

For Christmas that year I got an unusually large check from my grandparents and I used it, together with a vast advance on my allowance, to buy a used two-and-a-quarter reflex camera. I took it back to school in January, ran a dozen rolls of film through it, and submitted my new work—not much less execrable than before—to our school yearbook. Some of them were used on a page of student "candids," and so I was at last in print, reproduced and set before an audience of perhaps hundreds.

The following summer, on the cusp of ninth grade, of high school

and true adolescence, the photographer became a little freer with me. He didn't treat me as an equal or reveal anything more of himself, but he let me do more around the house and included me in his work. We filled the black Thunderbird with cases and light stands and went out. I helped him—if only as a porter and errand boy—photograph new skyscrapers and the gubernatorial candidates of that year's election. He began to let me work on my own projects in his darkroom when he wasn't busy there.

I could have learned a great deal just by watching him pose his subjects, arrange his lights, angle his tripod, filter his lenses, and choose the precise moment to trip the shutter. But I didn't. It wasn't that I was unobservant or didn't listen, and I certainly knew how good he was: I bragged to my friends about knowing him. Rather, his best work seemed beyond anything I might achieve in the near future—it was part of the miraculous world of grown-up competence that had mastered the slide rule and sent astronauts into space—and I was indifferent to the more quotidian kinds of photography that were his bread and butter.

For example, it wasn't until that second summer that I realized he had taken my mother's wedding portrait. I was looking through an album, and there, in the right hand corner, was his signature. At the house of my grandparents, who kept a kind of photographic shrine to their children on a table in the living room, I saw that he had also photographed my aunts as brides. The wedding portraits were all full length, the gown a whorl spreading out from the feet, the head lit from above. Their objects floated like the goddess with her torch in the Columbia Pictures logo.

I'd been looking at these photos since I was four or five, and I could have pictured any one of them accurately in my mind's eye. But I had seen them as one sees an icon, not as a representation *of* someone but almost as the person themselves, a fragment or trace of their actual presence. You would say, "That's Aunt Patsy," not "That's an image of Aunt Patsy," and so it—she—was. How or by whom it was made was beside the point, of no interest. To these family talismans—signs that manifested the bodies of its members—neither the idea of art nor of the artist was applicable.

But now that I was a photographer myself, I looked at these relics and icons in a different light. To discover in them evidence that the

photographer's world—the house and the darkroom and his obscure
existence—had intersected with mine, with its flesh and blood, seemed
stunning and profound.

I mentioned to him one day in June that I had seen these portraits,
complimented him on their quality—although in truth they had none
of the distinction of his images of his ex-wife—and pressed him on
whether he recollected anything about the sessions at which they were
shot. The photographer responded vaguely to my query, but I couldn't
imagine that anyone could photograph my mother and not take away
some impression beyond the negatives that he supposed must be filed
away somewhere. That he had probably shot at least a couple of portraits
a week for the last twenty years did not occur to me.

Nor could I fathom that he wasn't as curious about me and my family
as I was about him. But he disclosed himself in the same manner as he
might have made a print: selectively dodging, manipulating presence
and absence in a dialectic of light and dark which never composed
itself into an image. He was a shadowy figure.

I also couldn't square his offhand reaction to these forgotten
photographs to the ideas his work had engendered in me about art:
the seriousness and passion that drove you to it and to the deep and
consequential truths it manifested. I think I must have imagined that
my mother's beauty should have prompted him to do great things.

I had such notions about my own photography. I was already
becoming a snob about commercial work, but I couldn't grasp that the
photographer's old portraits of my family had been for him nothing
more than that. Even my new reflex camera wasn't serious—I want
to say "grave"—enough for me, and in early July I persuaded the
photographer to loan me a five-by-seven view camera with bellows
and an enormous ground-glass focusing screen you monitored from
under a black cape. I took it, of course, to church.

Not just any church, however. By then I was after some grander,
more serious conception of religion, and the church I was baptized
in seemed, like my smaller cameras, incommensurate with my
yearnings. So I took the view camera to the Catholic Cathedral of
Saint Paul. For all my presumption and general cheekiness, I entered
the building a little fearfully, firstly, because I wasn't sure I had
any business taking photographs there, secondly because I wasn't a
Catholic, which meant that perhaps I shouldn't be in the cathedral

at all. Now I tend to believe that the photography was an excuse to be in the building—to poke around in a place I felt I shouldn't be but wanted to enter into.

It was a daunting church, huge in fact, as big as our state capitol, which sat on an adjacent hill. The Catholic Church itself was a daunting institution, ancient, immense, and, to a Protestant, both mysterious and suspect. In scale and form, it catered to the senses—it traded in superfluities of awe and pity—and that was precisely what drew me to it. It was intense and overwrought, gothic and baroque where Protestantism was lean and neoclassical. Its surfaces—the censers, chant, and plethora of rites, saints, and hierarchies—extended to unimaginable depths and heights. At just that time the erotic had welled up in me like an efflorescence of acne, and I could not have told you where that craving ended and this one—both about beauty and being swept away toward some ultimate kind of being—began.

The first day I made an exterior shot from a little way down the hill. It was hot and humid, and as though from the day itself, a flare of light or fog got in through the negative carrier. It bleached out the image but created a corona over the dome of the cathedral. My second exterior—taken from a closer vantage point—wasn't fogged, but it was slightly out-of-focus and lopped the cupola off the top of the dome.

But it was the interior I was after, and I hauled my gear inside. I didn't ask anyone's permission. I simply set my camera up on its tripod and worked as quickly as I could, hoping I would be viewed as just another tourist taking a snapshot. I managed a straight-on view of the high altar and another from the side before retreating. A service was about to begin, and I had already gotten away with plenty. I wasn't going to intrude on the mass, or, worse, be mistaken for a worshipper.

The next day I processed the film in the photographer's basement darkroom and then, when the negatives were dry, he allowed me to print them on the enlarger upstairs. I sat in the dark on the photographer's tall wheeled stool and watched the images form themselves, pooling into a mosaic of grays in the developing tray under the russet safelight.

I made one print and then another, and when I was done I felt triumphant. These were serious works made with serious equipment for serious reasons. I wanted to dry-mount them on illustration board so I could exhibit them and carry them around in a portfolio. The photographer helped me do this without any comment about the

pictures. It was not his way to comment, to cast light where none was wanted.

Doubtless he saw what I could or would not see: that every one of the photos had some technical fault, not to speak of defects of craft, never mind of art. He did explain the problem of the top of the baldachin being out of focus in my straight-on shot of the high altar. This was an architectural camera I had been using, he emphasized, and both the lens mount and the back that held the film could be tilted so as to allow the correction of foreshortening and to deal with the problem that the base of a building might be in focus while its pinnacle was not. But you had to know what you were doing. You had, for example, to keep those two planes parallel. He did not speak the words, but it went without saying that I did not know what I was doing in this regard, or in many, many others.

I think he was wise not to say so, although I no more knew his reasons than I did the fate of his wife and his marriage. I was eager to learn, of course, but no one could tell me anything I was unprepared to hear once I was set on a course as serious as this one. He might as well have tried to talk me out of pursuing beauty or giving up masturbation or resisting the gravities that were pulling me toward the Catholic Church.

I went back to the cathedral a day later. This time I set up my camera in the apse that formed a half circle behind the high altar. It gave on to the sacristy and, on either side, a succession of small altars dedicated to various saints and martyrs. I photographed several of these and, working my way toward the sacristy door, peeked inside. It was here that all the ceremonial gear—vestments, candlesticks, censers, and liturgical silver—were housed. A young priest saw me and asked me what I was doing. Terrified, I admitted I was "looking around," taking a few photographs.

The priest told me to come in if I wanted. He was preparing for the noon mass, and his vestments were laid on top of an enormous chest into which were set a rank of shallow drawers that might have held maps or blueprints. I shuffled further into the sacristy and saw there was also a boy inside it, a boy about my age dressed in a cassock and surplice. He looked at me sullenly, or so it seemed to me.

I asked the priest what was in the drawers, and he pulled a couple open to reveal further sets of vestments, more or less identical to the

green ones on top of the chest but in other colors, purple, red, and white. Then he began to dress. There was a series of prayers printed on a card that sat on the chest, and as he donned each piece of his ensemble he said one of these under his breath. When he had finished, he and the boy waited for the noon bell to strike. I felt no sense that they were engaged in anything of great importance. They might, except for their clothing, have been about to go fishing or to toss a baseball back and forth.

I excused myself. I wanted to get away before the mass began. But back in the apse, I met another priest, this one smaller but attired in a soutane with red piping, buttons, and a skullcap and sash, a bishop. Having negotiated the sacristy without embarrassment or harm, I was by now less afraid and it didn't seem he was going to confront or even speak to me. But drawing from some reservoir of chutzpah I wasn't conscious of possessing, I spoke to him. I asked him if I could take his picture.

He was on his way somewhere, in a hurry. But he agreed and stood in front of one of the small altars. I took one shot and persuaded him to stand still for another. Then he was gone.

I packed up my gear, exultant. I had made a full-length portrait of a prelate in his habitat, a genuine bishop. It was the apotheosis of my work in the cathedral. I raced back to the photographer's basement darkroom and processed the film. I don't know how long I then had to wait to gain access to the enlarger upstairs. That was the photographer's sanctum sanctorum, the place where he did his alchemy and conjured his tricks of shadow and light. He allowed me to use it only when there was absolutely no likelihood he might want or need to work there.

Perhaps he'd gone out, was working in the studio, or was simply eating soup, smoking cigarettes, and drinking coffee with the old man. Anyway, I had perhaps forty-five minutes to use the enlarger. I put the first negative in the carrier and the image fell onto the easel. It was a little foggy, slightly out of focus. Or the foreground was muddy and the background too bright. I made the best print I could, and put the second negative in the enlarger.

This one was nearly identical to the first. The bishop had maintained exactly the same posture and expression while I changed the film holder and made adjustments to the camera. He looked, depending on your point of view, serious, perhaps even holy, or—as I feared—impatient.

Perhaps he was glowering at the camera, at me. His small hands hung at his sides, looking not so much like they needed something to do as they looked like there was someplace else they wanted to be.

But the point was, you could *see* all this in the second negative, or at least reasonably surmise it. It was in focus, more or less. True, the tripod had been crooked and the picture sloped off to one side and a corner of the altar was hacked off. There was also a vicious, glaring shadow falling off one of candlesticks onto the wall. And I'd positioned the camera too far off to see the bishop in detail—to frame him as the subject of the image, rather than an object within it—yet too close to incorporate the statue of Saint Boniface behind him on the altar. But all in all, it was the best thing I'd ever done, a near-professional quality photograph made with professional equipment and the most serious of intentions.

I had arrived, I felt, at my métier. By the first of August, I had business cards printed announcing myself *Robert H. Clark, Photographer.* I got a student membership in the Professional Photographers of America. And I moved my darkroom out of my grandparents' basement and into a storage room in our apartment building. It was as dirty and inadequate as before, but it was close by, should inspiration strike.

Still, I continued to visit the photographer, to follow him around his studio and his house and, when I could, to use his darkroom. That August, the summer I was turning fourteen, you could also have found me working at his dry-mounting press, putting my cathedral studies onto illustration board, building my portfolio.

I wouldn't have thought I'd become cocky or smug about my abilities or my work, but doubtless I conveyed something like that to the photographer. At that age, I carried my enthusiasms before me with manic surety. I meant well by them, but my intention—the velocity at which I flung myself into the world—was heedless and overbearing. Still, the photographer treated me the same way he always had. He snaked broken-backed on his crutches through the halls in his black slacks and billowing shirts, a cigarette clenched in his mouth. I followed behind, watching his hips twist and roll.

Nothing had changed—a single summer seems a very long time when you are fourteen—and I suppose I should have been happy enough, but in some way I wanted, indeed needed, there to be a change. I wanted, I think, the photographer to see me as a photographer. But

to him I was still just a kid from the neighborhood. I cannot say that he became more remote and distant, although this is how it began to seem to me. Probably I was moving away from him without knowing it. He, after all, could scarcely move at all, and rarely came out into the light of day.

One evening at the end of August, around Labor Day weekend, I was walking by the photographer's house. I'd never been there after five in the afternoon, but the sun was still up and on an impulse I went to the door and rang the bell. The customary interval—enough time to rise and right himself, seize his crutches, and begin his swaying passage to the door—passed, and he appeared. He had his cigarette and was wearing his ascot around his neck. He seemed relaxed, even jaunty. He said, pleasantly enough, "It's not a good time."

A moment later, a woman appeared in the hallway behind him. She was about my mother's age, slim and pretty. She was carrying a drink in one hand and her own cigarette in the other. She smiled at me. She wasn't wearing any shoes.

I think we acknowledged each other—I was taken aback to see anyone outside the studio in the photographer's house other than the old man—and I quickly excused myself. I felt a boundary had been crossed. I wasn't sure if it was by me having turned up unexpectedly at an unaccustomed hour, or, somehow, by him. I didn't return for several days. I'd taken to working in my own darkroom by then despite its obvious crumminess, despite the fact that everything that came out of it was in one way or another defective or spoiled.

I went back a few days later, late on a Saturday afternoon, when surely he wouldn't be working. I rang and waited, waited longer than I ever had before. I was about to leave when I saw—through the window in the door—the photographer making his way down the hall toward me slowly, as though he were moving through a fog. He opened the door unsteadily and the scent of gin eddied from his mouth. His eyes were red, dull and diffuse and unfocused. He might have been crying.

He seemed to be staring at his feet, down the sight lines of his crutches, as he spoke to me. He said, "I can't...today. I need to be alone." And with that he shut the door and turned away. I watched him shuffle and wind back down the hall. His distorted back and all its burden seemed to follow in train behind him like a snail's carapace.

I was stunned. I had never seen him like this, or in any other state

than his customary quietly genial and workmanlike manner. His mood had been as smooth as his body was bent. I knew, although I could not bring the specifics into focus, that it had something to do with the woman I'd seen barefoot in her nylons a few nights before.

The photographer must have aimed to do with her what he'd done with the woman whose image filled his bedroom. He'd pulled his twisted frame together and flung himself at a work, a beautiful and serious thing, of the same or even greater magnitude, and he'd fallen, landed pitifully, tangled in his own limbs. And I'd seen it, that great part of him that had been concealed from me, veiled in darkness until now.

I didn't go back after that. Perhaps I'd been too shocked, or perhaps I had arrived at a point of maturity to understand that some sort of account of that evening would have to be made, and it would be less embarrassing for both of us if that moment were avoided. But in truth, I didn't want to see him again, not the way he'd been that night or even before then. I didn't want to risk seeing what he must have seen, however curious I had been about his life and history.

I began ninth grade the week after. Once, a few months later, I saw the old man out walking. He nodded at me and passed on his way. I thought that he must be pleased that things at the house had returned to the state they were in before I'd come along. I was sure he had smiled.

I didn't give up photography, not right away. I continued to use my darkroom at home, although more and more frequently it functioned as a cover for mutual masturbation with my friends and furtive cigarette smoking. I entered my cathedral photographs in a national competition sponsored by *Scholastic* magazine. The photos were returned the following spring without comment or so much as an honorable mention. But by then, I was past caring. I'd moved on. I'd outgrown tinkering with enlargers and chemicals, with lenses and exposure time and the whole apparatus of darkness and illumination.

By then I'd also drifted away from religion. I scarcely entered my own church except to please my grandparents at Christmas. I returned to the cathedral perhaps once, that same spring, during Lent. I'd gone in for no explicable reason, and I would have been embarrassed if anyone I knew had seen me there. The Roman Catholic Church had not quite fully entered into the Sister-Corita felt-banner and folk-mass aesthetic

of the late sixties, so although the altar had been turned to face the congregation in the post–Vatican II mode, other customs from the church's Gothic and Baroque past still survived.

When I entered the cathedral that day I was struck by some lack, by what I could not see, and at first I couldn't figure out what I was missing, the absence I could not grasp. Then I saw that every image in the building—every statue, painting, even the enormous crucifix over the high altar—was covered in purple cloth. The towering marble saints and apostles—bearded and fierce—that summed up the awe and intimidation I had once felt here were mute and blank, shrouded as though for burial. Their hiddenness was an immense presence.

This veiling, I learned, is imposed during the last fourteen days of Lent, and continues through Holy Week until Easter, when the cloths are removed. It's accompanied by a simplification and stripping down of ceremony, music, and even light during the mass. The services of the last three days of Holy Week are called Tenebrae, the Latin for darkness or shadows. In the final minutes of Holy Saturday, at the beginning of the Easter midnight mass, the entire cathedral would be dark, and then one candle lit and then another until the entire building was alight, until the darkness has been driven away, every corner illuminated and revealed.

I didn't go back to the cathedral that Easter or at any other time for some thirty years. I did sit disconsolately—watching the angel, whose beauty was never ever lost on me—with my grandparents in their Episcopal church that Easter, and at Christmas for several more years until I was old enough to opt out, to say I'd prefer not to go. I did not exactly lose my faith; rather, I put it away as in the back of the closet. I did not deny it, but merely veiled it for a stretch of time.

I suppose it was there all the while. It hadn't been destroyed or abnegated any more than those hulking statues had been during Lent. It was only hidden in the dark: you might have thrust your hand into the shadow and felt it, made out the rough shape of it with your fingers. The philosopher Hans-Georg Gadamer wrote that works of art necessarily always exist as objects but come into fullness as art only when they are being observed. Without going into their merits as sculpture, I suppose that means that during those final weeks of Lent the cathedral's veiled marble saints were still assuredly statues, but they were not quite art.

Gadamer was clarifying a point made by his teacher Heidegger that art as truth is "how self-concealing being is illuminated. Light of this kind joins its shining to and into the work. This shining, joined in the work, is the beautiful." But Gadamer takes the idea further. He wants this illumination to extend to the spectator of the artwork, to have the same self-disclosing, revelatory effect on the viewer as it does on the image he is beholding. He links it to the experience of religious awe, to the sense of the divine being, and to the possibility of redemption: "...the absolute moment in which a spectator stands is at once self-forgetfulness and reconciliation with self. That which detaches him from everything also gives him back the whole of his being."

That is art and that is God, Gadamer appears to be saying. I am as dim as I ever was back when I took up faith and a camera lens and then put them down. But now, trying to make sense of that time, feeling around in the half-light as I once did in the darkroom, it seems germane, not entirely clear but not opaque either. Let us say it is almost translucent, like the angel's stone flesh.

§

Perhaps I'd grown tired of that light or a certain kind of illumination, of seeing things in a particular way, and what had once seemed light had turned to shadow. I had wanted, I thought, to see the unconcealed, hidden life of the photographer, but I ran away when I got a glimpse of it. I had wanted to make the beautiful still more beautiful in my photographs, but I couldn't learn to focus the lens or find the right exposure. And I wanted to be with God, but, except in the form of his angel, I couldn't bear the sight of him.

Faith is supposed to be a consolation, but not a few skeptics—including myself not long after I'd worked in the darkroom for the last time—have called it a crutch. That may be, for me at least, the truth. I never bargained for faith being a burden—the labor of sustaining hope against despair, light against darkness—as it has often proved to be, and so I suppose one needs a crutch to bear it. When I was baptized I imagined it was merely beautiful, as beautiful as the lighted angel, and when it turned out be otherwise, I put it away.

Now I see it as I saw my photography, an admixture of light and dark in an unimaginable number of grays. And perhaps the living of it is a little like the photographer's life. You haul your burdens and

your pain—mostly concealed—on your back and your hips, staggering forward on crutches. Sometimes, once in a long while, you make something beautiful, and it is all unveiled, transmuted into radiance.

The last time I saw the angel was at my mother's funeral, a little more than two years ago. I was looking at her, wondering if I still found her beautiful and if my judgment forty years before had been justified. I decided that I'd been right: it really was one of the few things I'd seen clearly at that time. She was beautiful, or beautiful in a particular late-Victorian way, beautiful the way the Victorians idealized women as "the angel in the house" or, in the earliest photography, the work of, say, Julia Cameron or Lewis Carroll, where girls are ethereal wraiths, pure, lovely spirit, beauty embodied, but just barely. All of it—pre-Raphaelite annunciations, the medievalism of Ruskin, Tennyson, and Morris, and the Anglo-Catholic guardian angel in Newman and Elgar's *Dream of Gerontius*—went toward opposing the emptying out of God from the world that they saw all around them. It was a crutch.

At the funeral, people got up and, in the contemporary custom, spoke little elegies. Had I remembered, I could have recounted how, after my father had gone, my mother used to sing me a lullaby I called "Angels" because of a line in it that mentioned angels keeping watch around my bed. "Sing 'Angels,'" I would plead at bedtime, and I'd keep at it until she did, until she rendered up the beautiful thing.

Now my sister was at the lectern, and I was still looking at the angel, if only for distraction. My sister was speaking about her awkward and often painful relationship with our mother, of how my mother, for all her warmth and charm, was a fearful, manipulative, and sometimes spiteful person. My sister was illuminating what I felt was better concealed. I might have gotten up and talked about "Angels" or offered some other picture of my mother, but I limited my own participation in the service to reading the Bible lesson. It was my role—I am the believer, the churchgoer in my family—but you already see how paltry and crippled is my faith, how limited is my vision.

When I was writing this essay, I went down to the basement where I keep the family scrapbooks and memorabilia in order to find the wedding picture the photographer had taken of my mother. It was there, but so was another photograph I had no recollection of, a portrait of my mother taken, perhaps, for her college graduation or her engagement. The photographer had never alluded to the existence of this other

photograph of my mother—he'd never acknowledged remembering photographing her at all—but there was his unmistakable signature across the bottom corner of the picture.

In this one I am not sure she is as beautiful—as goddess-like—as she is in the wedding portrait. Her nose is a little too broad, her eyes a bit too small, and her expression is stern rather than happy or genial, although these were very real features of her. She looks like someone who was capable of anger and even vengeance. If nothing else, I think she was trying to look serious. This was the time when she came home from college, shorn of her faith or at least of the Episcopal Church, which created the breach—concealed to be sure—that my baptism should have mended. And perhaps it did. We held her funeral in that same church, and although she never expressed a preference about the matter, I doubt she would have objected.

As I spend time looking at it, I'm more and more inclined to think it a better photograph than the wedding portrait. The other is perhaps more beautiful, but the quotient of truth in this one is, for me, higher, and we are meant to insist on the coupling of beauty and truth in art, if only as a clichéd shorthand for what we feel we see, for the presence we confront before which we are revealed and—who can say?—redeemed.

Of course the photographer was not without craft here, not without his gestures and leitmotifs, used often enough that he might have seen them, despairing and drunk, as gimmicks. There is, in any case, the light, and perhaps it is a trick. It falls from above and a little to the side of her head, and her face is numinous, veiled, but in light, a veil you can see through. But it all comes down to the hair: it falls, the hair and the light together, and it's nothing so much as the hair of the stone angel. It frames my mother's face, the radiance that's pouring out of her. I see her clearly. She's just a few years short of bearing me, bringing me into the world, and I'm a few more years short of asking her to sing "Angels," begging her to sing it again and again, because I want God the Father to protect me and because I want to be in the presence of the song, of my mother's beautiful voice. I'm still unbroken and uncrippled. I can walk and I can see.

ROBERT CORDING

Parable of the Moth

Consider this: a moth flies into a man's ear
one ordinary evening of unnoticed pleasures.
When the moth beats its wings, all the winds
of earth gather in his ear, roar like nothing
he has ever heard. He shakes and shakes
his head, has his wife dig deep into his ear
with a Q-tip, but the roar will not cease.

It seems as if all the doors and windows
of his house have blown away at once—
the strange play of circumstances over which
he never had control, but which he could ignore
until the evening disappeared as if he had
never lived it. His body no longer
seems his own; he screams in pain to drown
out the wind inside his ear, and curses God,
who, hours ago, was a benign generalization
in a world going along well enough.

On the way to the hospital, his wife stops
the car, tells her husband to get out,
to sit in the grass. There are no car lights,
no streetlights, no moon. She takes
a flashlight from the glove compartment
and holds it beside his ear and, unbelievably,
the moth flies towards the light. His eyes
are wet. He feels as if he's suddenly a pilgrim
on the shore of an unexpected world.
When he lies back in the grass, he is a boy
again. His wife is shining the flashlight
into the sky and there is only the silence
he has never heard, and the small road
of light going somewhere he has never been.

ROBERT CORDING

Finding the World's Fullness [essay]

I WANT TO ARGUE in this essay why it is so crucial to hold open the possibility that, as Richard Wilbur lovingly puts it, "the world's fullness is not made but found." Postmodernist thought has called into question the dangerous illusions of self-possession and the dogmas surrounding our capacity to know. We have learned, certainly, to see the all-too-human interests that lie behind our words. Yet, if there is a pressing need at this time to deconstruct the old hierarchies, to remind ourselves of the mind's endless impositions of meaning, the process of doing so should still be, as Wallace Stevens writes, to "discover an order as of / A season, to discover summer and know it.... / Not to impose, not to have reasoned at all, / Out of nothing to come on major weather." The role of the arts and poetry in particular is always to bring us back to such primal moments. This task requires what Northrop Frye calls "double vision": the recognition of our own limits of understanding; and, after that, "perhaps the terrifying and welcome voice" that "annihilate[s] everything we thought we knew, and restore[s] everything we never lost."

Some time ago a friend sent me a sequence of poems of the Nobel Prize–winner Czeslaw Milosz called "A Theological Treatise." In the first poem, Milosz says "a farewell to the decadence / Into which the language of poetry in my age has fallen," then asks "Why theology? Because the first must be first. / And first is a notion of truth." Milosz has never been afraid to speak his mind. This poem lays out an intimate connection between theology and poetry. Of course, we live in a time when the language of theological discourse, as Paul Mariani among others has pointed out, has been emptied of much of its former significance. In his essay, "Toward a Sacramental Language," Mariani realizes that to live in a world that denies the possibility of the sacred seems utterly and unnecessarily reductive.

What we writers need, Mariani posits, especially those of us who do not accept the idea of "the totally alienated existentialist self," is

"to shape a language that takes into account a world we did not make and that sees the necessity of making room for the sacred." I want, then, in this essay to use Milosz's clarion call of a poem to elaborate on three ideas: the decadence into which Milosz feels the language of poetry has fallen; the old and new relationship between theology and poetry as I see it; and the relationship between what Milosz later calls "reality" and "an absolute point of reference." My aim is to sketch what it means for our language "to take into account a world we did not make."

Let me begin with decadence. For Milosz, and many others, western literature and art since the Renaissance have gradually become separated from Christianity. With humanism and the advent of the scientific worldview, the laws of instrumental reason were elevated at the expense of empathy and Saint Paul's idea of faith seeking understanding. As Milton foresaw in *Paradise Lost*, humankind would soon become the center of its own world, the measure and maker, whose thinking could make a hell of heaven, and a heaven of hell. From Milton to Derrida, the confidence once enjoyed—that the metaphysical underwrites the physical world—has been called into question; for some today the world has no metaphysical dimension at all. The critique goes something like this: the idea of an unmediated relationship between consciousness and an object, a relationship that is prior and uncontaminated by language, is a fiction because, as Derrida argues, from "the moment there is meaning there are nothing but signs."

The next step that many have taken, which seems like a false step to me, is: if there is no pure presence, there is in effect no presence at all. There is only language, and we are lost in its labyrinths, in its fictions. And because we are enclosed in language, we are closed off from everything else. The poet in this little tale becomes the high priest of language. And poetry, to Milosz's dismay, becomes isolated, too esoteric for ordinary humanity and, perhaps worst of all, nothing but "experiments with form." "Western poetry," Milosz writes, "has recently gone so far down the path of subjectivity that it has stopped acknowledging the laws of the object. It even appears to be proposing that all that exists is perception, and there is no objective world." In short, the language of poetry has become incomprehensible and decadent.

The enemy for Milosz is always "speech entwining upon itself like the ivy when it does not find a support on a tree or wall." Speech that entwines upon itself is speech that has "stopped acknowledging the laws of the object." What are these laws? What does Milosz mean by "the object"? For Milosz, and this will explain why I'm turning to him, the object can still be the site of epiphany. The object is not simply an entity that follows the laws of physics; neither is it something which, because we can only point at in words, cannot be known outside our own fictions of it. Rather, for Milosz, to acknowledge the laws of the object, to contemplate "tree or rock or a man" may bring us "to comprehend that it *is,* even though it might not have been."

Let me take a little detour. In his essay, "Toward a Critical Re-Renewal," Quentin Kraft notes, and I agree, that we too often think there are only two opposing metaphors for our conception of language: for the poststructuralist crowd language is a "web, a labyrinth, a screen, a prison house"; for the traditionalists, language is a "glass, however dark and distorted, a window, a door, and pathway." But there is a third way of thinking about language, Kraft argues: language as mediation. Here's the significant passage:

> [M]ediation is something that goes on in the middle; it is a medium, a means, something that intervenes between consciousness and an object. In that sense it separates.... But it also connects; it is what makes interaction possible; indeed it is an *interaction* and not a thing...more verb than noun, not anything statically situated between a person and the world, not a screen, but instead an activity or interaction going on in the space between.... In short, what is meant here by "mediation" is presence, not the mythical pure presence but the actual adulterated presence, the only kind ever available to us.

Let me put my cards on the table: I believe that words point to and depend on a reality apart from the acts of verbal reference, though poetry and, to my mind, theology, is as, Stevens said, "a revelation in words by means of words."

That is, we live in a world which we did not create. This world of objects should force us out of ourselves, out of our subjectivity, since description, the task of the poet, demands attention, demands an attending to the world of objects. Description involves such intense

observation, Milosz says in "Against Incomprehensible Poetry," that the "veil of everyday habit falls away and what we paid no attention, because it struck us as so ordinary, is revealed as miraculous." Or to say the same thing in the language of Wallace Stevens, poems should "refresh life"; they should help us see the world as if for the first time, free of what he called the "man-locked set" of our preconceptions.

Let me recap for a moment. For Milosz and for me, the decadence of poetry's language occurs when poets write out of the belief that words point only to other words, when we live inside what Milosz calls our own subjective "phantasmagoria." Though some might say the intense observation that Milosz calls for is just another form of self-indulgence or self-delusion, two counterarguments could be offered. First, as Milosz lays out in his Nobel Prize acceptance speech, the poet might be, in a perfect world, a "seeker of reality through contemplation." But, in fact, our world, also the world of Nazi Germany and Soviet Communism that Milosz grew up in, is deeply flawed, and such contemplation is negated by the demonic events of history. Thus the role of the poet for Milosz is one that must be lived in the "contradiction between art and the solidarity with one's fellow men," between contemplation of being and action. Milosz, like Simone Weil, whose philosophy meant so much to him, knows that the "contradictions the mind comes up against—these are the only realities: they are the criterion of the real."

Secondly, and this follows on the point I've just made, Milosz is the first to admit that he is not, nor does he "want to be, a possessor of the truth." The truth he seeks does not find its end in the recitation of a creedal belief; rather it seeks the experience of the world itself. "When a thing is truly seen, seen intensely," Milosz writes, "it remains with us forever and astonishes us, even though it would appear there is nothing astonishing about it."

Thus Milosz wants to hold to something W.H. Auden said about poetry:

> Poetry can do a hundred and one things, delight, sadden, disturb, amuse, instruct—it may express every possible shade of emotion, and describe every conceivable kind of event, but there is only one thing that all poetry must do; it must praise all it can for being and for happening.

As Milosz understands it, Auden's statement expresses a theological belief. Such affirmation of life has a long and distinguished past in western thought, and it is precisely this affirmation that lies behind Milosz's question, "Why theology?" and his answer: "Because the first must be first" in the poem I first quoted. And so we've come to the second point I want to elaborate: the relationship between poetry and theology.

Theology, of course, faces the same dilemma as poetry: its language, too, has been emptied of some of its former significance. And it, too, must take into account a world we did not make. I read a piece in *Tikkun* recently by Marc Gafni, "On the Erotic and the Ethical," about the role of the Goddess, symbol of sacred eros, shared by both the temple and pagan cults in ancient Israel. Gafni writes, "The relationship with the Goddess was not a hobby for the Israelites like modern religious affiliation tends to be. It was an all-consuming desire to be on the inside, to feel the infinite fullness of reality in every moment and in every encounter." That same desire is, I would say, what poetry and theology have always been trying to express. What lies behind the age-old impulse of literature to make itself new is just this sense of the erotic. When literature becomes mannered and parodic, as it has during our own time, what we miss and yearn for is the "fullness of reality." To put it another way, the presence of the infinite fullness of reality is always waiting for us to be present. That is "the notion of truth" I think Milosz refers to in his poem and what he means when he instructs: "Let reality return to our speech."

Since I don't want to pretend that I am a theologian, I want to illustrate the connection I see between poetry and theology by looking at what I do know—a poem by Wallace Stevens called "Not Ideas about the Thing but the Thing Itself." The poem's speaker wakes in early March to a bird's cry, a "scrawny cry from outside" that at first seems "like a sound in his mind." As he wakes he realizes that the sound is real, and that the sunlight in the room is not part of "the vast ventriloquism" of his sleep, but is also coming from outside. He thinks of how the first bird heralds the returning flocks of birds:

> That scrawny cry—It was
> A chorister whose C preceded the choir.
> It was part of the colossal sun,

Surrounded by its choral rings,
Still far away. It was like
A new knowledge of reality.

As the title of the poem announces, the poem wants the thing itself
and not ideas about the thing—on one level, the objective reality of the
bird's cry beyond the mind. And yet, while we can know there is some
"thing" outside our mind, as the speaker knows he heard the bird, as
we move toward that thing in consciousness we lose it. In the end, we
can only know by analogy: "like / a new knowledge of reality."

Does that *like* undercut the revelation? I don't believe so. Working
from the concept of language as mediation, I would argue that the
revelation—the knowledge of the bird's connection and our own to
the choir and to the colossal sun that calls that choir and ourselves
into being—remains intact precisely because of the simile. That last
sentence is one of the most moving and authentic moments in poetry
that I know. In his final years, after a lifetime of seeking for and trying
to write the "poem of pure reality, untouched by trope or deviation,"
Stevens concludes "it was like / a new knowledge of reality." Through
the poem, we encounter the impossible resurgence we call spring in all
its colossal presence. And yet there is a second recognition as well: that
what we encounter is also an experience of what remains hidden. That
colossal presence is experienced from within the finitude and limitations
of the human mind. And so it must be *like* a new knowledge of reality.
And this does not diminish the revelation. The speaker is compelled
to announce that such a cry, such a colossal sun exist. He is compelled
to recognize that our experience tells us there is a reality outside our
mind's construction of it; and he is compelled to acknowledge that
that reality, which lies outside the mind, can only be known inside the
language the mind constructs for the reality. The truth of this poem
and all poems that we value is not a proposition or judgment, not an
insight that can be gained by simple transference, nor a message we
can pass on to others, but rather an enactment of the bird's cry.

Stevens's poem, then, goes on in the middle; it is "a medium, a
means," as Kraft has it, an interaction between consciousness and
a bird early in March. Certainly it is true that Stevens, like many of
the modernist artists, saw the imagination as redemptive. Often, and
wrongly I think, such statements have come to mean that the modernists

saw art as replacing religion, and saw the mind as the single artificer, creating form and meaning out of meaninglessness. But the desire in late Stevens to "live in the world but outside of existing conceptions of it" is not a desire divorced from reality.

"Reality is a vacuum," Stevens declares in the *Adagia*, but in his essay "Imagination as Value," he writes, "The ultimate value is reality." The first statement seems to suggest that without the imagination we live in a world of dead objects, while the second suggests the primacy of the world. But when "reality is a vacuum" in Stevens, it is the reality we have become numb to, the world of objects that we so habitually see, we no longer notice. In a letter to Henry Church, Stevens wrote: "someone...wanted to know what I mean by a thinker of the first idea. If you take the varnish and dirt of generations off a picture, you see it in the first idea. If you think about the world without its varnish and dirt, you are a thinker of the first idea." The "ultimate value," then, *is* reality if we can see it "without its varnish and dirt." What allows us to see reality "in the first idea" is metaphor. The "supreme fiction" that Stevens works toward but knows is impossible is, on the one hand, an acknowledgement that the poetic text is never complete because the metaphors poets employ to approach our intuitions of reality always break down. On the other hand we need a supreme fiction, not because it gives us the truth, but because it gives us a belief we can live by.

That belief, to return to Milosz, is that the world is, even though it might not have been. Such a belief is, indeed, an "absolute point of reference" because it says we did not create the world through our imagination. And yet the "ultimate value of reality" that we seek can only be known in language. The poet's obligation, then, is not to become a priest (as the modernist dictum often had it) but rather to become priestly, to evoke the world in such a way that what "struck us as ordinary, is revealed as miraculous." The human search, then, is always for a language that can help us see the world again as if for the first time. What we listen for in the "sound of words," Stevens tells us in "The Noble Rider and the Sound of Words" is a "finality, a perfection, an unalterable vibration" that bring us closer (since metaphor always seeks to bring the world closer in its act of finding correspondences) to the "muddy center," the first idea, God.

Let me conclude with some notes on the role of poetry. When Keats speaks of the "holiness of the heart's affections" and links those

absolutes of imagination, beauty and truth, he understands that poetry must have some ultimate purpose. So does Milosz. So did Wallace Stevens. So do I. It is true, certainly, that we are alive in a historical moment in which the old truths are experienced as inadequate. But it is not a matter of the old truths being outdated or outstripped by our own age. Rather it is the living essence of our Hebraic and Hellenic roots that seems lost. As Frye has written, our tradition's founding religious language, our sense of its metaphorical integrity, becomes farther and farther removed from the experience that gave rise to its revelations and myths. As Stevens and Milosz well understand, it is necessary to break apart those acculturated values that stand between God and our conceptions of God. As Frye points out, "God may have lost his function as the subject or object of a predicate, but may not be so much dead as entombed in a dead language." Wallace Stevens says we search for the "metaphor that murders metaphor." That is, we search for a language that murders our stale philosophical ideas, our outworn metaphors that entomb God, that keep us at a distance rather than reenact the primordial moment of the transcendent. If we give up that search, we also give up the world's fullness.

DEBORAH JOY COREY

Discovery [fiction]

WHAT'S A GIRL without her dreams? Just a pumpkin head. Some are that. Nothing more than squash inside. Not my sister Sharon and me; we're big dreamers. Those girls downriver in Fredericton maybe have heads full of lace and gossamer like in their pretty windows. No future to them at all. Sharon and me have time on our hands; that makes the future a real concern. No croquet set to make the afternoons go by, just the clouds passing over and us staring up. We've seen those city girls when Mama takes me to the doctor about my headaches. One yard all mowed pretty with a pitcher of lemonade on a little table. Girls standing round in colorful dresses. One girl looked at our old car and pointed. Them Fredericton girls always pointing, look at this, look at that, too busy to dream.

When Sharon and I are famous, we'll come back and be their friends. They could stand us then. We'll be honored guests at their lawn party, magazine sherbet punch sticky on their lips, "I love you so Sharon and Patty; you make a rag look good. You were so pretty on the cover of Chatelaine magazine. Rags to riches," they'll say. "Imagine."

We got us this dream, Sharon and me, lingering like a sad movie in our heads. Fame. Just one minute of it, then we'll be back here. River girls with city girlfriends. It's something we suffer, going off to make ourselves worthy. The river shore is what we like best. Sharon calls it the land of milk and honey. All day, we wander alongside it, picking cattails and marveling at the swirling eddies. Mama taught us about the river and its ways. She's lived here all her life. Never once gone off.

When we get to the big city, Sharon is going to be a fashion designer, and she says I'll make one fine model with my long legs. I can wear her fashions. Sharon gave me the idea. Before, I'd just say these chicken legs, why'd God give me these? Our big sister Ruthie says my nice legs will not save me. I ignore her. She says my ears are too big to make a pretty statement. I cover them up, all kinds of tricks for that. Anne of Green Gables braids are the best. Mama says

I'll grow into my ears. She did. I've never really seen Mama's ears. She's a Pentecostal and wears her long dark braids coiled around them like snakes sleeping. When we're not around, Mama takes her hair down and brushes it out on the porch. I find her broken hairs floating in the sun. Brushing, she tells me, is the secret to a good shine. No easy road.

I don't ignore everything Ruthie says, though. I watch her real close because she has a baby boy, even though she's not married and has had boyfriends galore. All that on one plate. She says with her, love is a fleeting matter. Just the same, Sharon and me take pointers, because that's what we're most interested in, love, even before our careers.

Sharon says she wants most to be knowledgeable without giving anything up. I say that's a tricky road to follow. Right now, Ruthie has a new boyfriend, an explorer. He came here because there have been sightings of a strange long-necked bird flying over the river. So far, this is who has seen the strange bird: two boys, a farmer, a housewife fishing, and a biology professor from UNB. No one paid it any mind until the professor saw it, then it was news. Sharon says the world loves an educated person.

Not long after the bird news, Ruthie found the explorer sitting on the river shore with a set of binoculars and more cameras than a photo shop. Ruthie and him got attached right off. Love, that is. Sharon and me thinks it's Ruthie's best boyfriend so far. Definitely better than the last one who fixed old cars and the one before that who worked at the pulp mill down river and smelled like rotten eggs.

The explorer says before he came here, he was over in Europe studying the bog people. Sharon and I roll down and laugh at that. Bog people, but he wants us to believe him. He says the bog people are perfectly preserved from hundreds of years ago. Even have hair. "What preserved them?" Sharon asks.

"The acid in the peat bog. They're absolutely beautiful," he says. "Shiny as bronze."

"Really," Sharon says, scratching her cheek. "A bird is going to be a letdown after those people."

"Oh no," Leonard smiles, "if the bird's neck is as long as the reports say, it will be a real discovery. A neck that long defies aerodynamics."

Sharon kicks at the dirt, then looks up. "Ever seen the Shroud of Turin? We seen a movie about that at church. It's amazing."

Leonard runs his hand through his moist red hair. "That's a hoax," he says.

Sharon smiles. "You saw it?"

"No and I don't want to. It's just some image burnt into a sheet."

"Oh no," Sharon says, "the movie said it was proof Jesus was resurrected. That's why God left it. He raised him up without anyone seeing, you know. That's why he left that behind. Proof."

Leonard smirks, shaking his head, then looks down and fiddles with a camera.

"Where do you think the bird came from?" Sharon asks.

"Well, it could be something thought to be extinct or it could be a mutation."

"A mutation!" Sharon laughs. "Who cares about them?"

Leonard looks at her seriously, pinching his thin lips together.

Sharon fans herself with her hand. "They're nothing special, every kind has them."

Just then, a red squirrel runs in the tree over us. Sharon and I look up and chit-chit at it. We like to talk to the animals. In the land of milk and honey, everything is ours. Leonard stands up, his cameras rattling around his neck like chains. He grabs some rocks and starts throwing them up at the squirrel.

"Just a squirrel," I say.

"A red squirrel," Leonard says. "Do you know what red male squirrels do to gray male squirrels?"

I shake my head no.

"They bite their balls off."

Sharon and me look down and giggle.

Leonard keeps throwing the stones even though the squirrel is long gone. He's worked up a real sweat. "Someday, gray squirrels are going to be extinct," he huffs, "all because of those little bastards."

We look up at the tree. It's a beautiful maple with sunlight shining through it. "They're special," Sharon says, adjusting her red sarong on her shoulder. "Mama says once those squirrels could go from here to the Mississippi without ever touching the ground. All that way, on the treetops. Thousands of miles."

"Squirrels, they're common," Leonard says.

Then for a bit, he turns quiet and sulks. He sits back down on his spot, squinting at the sky over the river. For the most part, Leonard

is real nice. We tell him our dreams and we value his opinions because he's educated. Leonard loves to tell us about advances in science. Sharon and me eat it up. The topic of *biodeterminism* seems to be his favorite. He taught us that word. *Biodeterminism*. He says not long ago they made a goat from a human egg. I wondered what kind of advancement that would be. It made me think the whole world might be going backward. Sharon smiled, then leaned against the big maple. "Is that goat thing true?"

A shadow came over Leonard's face, like something dark was flying over. "Truer than anything you know about." He said it almost sad, then looked my way. "What do you think, Patty?"

I took a few steps back, watching Leonard. In the shade, his face was gray and still. I thought about the goat and wondered if it might be able to feel things the way we do. Sharon always says there's no heaven for the animals, that's why we have to be good to them. This is it.

"Patty?" Leonard said, "do you believe in the goat?"

"I'm not sure," I said.

"That's just it," he said, "that's the problem with you girls who get into religion. It makes you afraid to see the world."

"That's not so," Sharon said, "everyone's got to look at the world. We could see Jesus anywhere, even in your goat."

Leonard shook his head.

"Would you know Him if you saw him?" Sharon asked, but Leonard wouldn't talk anymore, so we shut up and looked at the river, too.

Sometimes, if Leonard thinks the bird is not going to show up and Ruthie is waitressing, he takes us swimming. He goes naked, so Sharon and I have seen his penis, which is a disappointment to us both. What did we expect? A bouquet of flowers? It just looks like a slug hanging from a burning bush. No passion to it. Sharon says it defies aerodynamics.

After Leonard gets over the red squirrel episode, he takes our picture together, then suggests we all take a dip. Sharon made me a red sarong for the river shore, too. We wear them in the water. Sharon's dark hair is pinned up high and mine is braided down past my tiny bosoms. All we're missing is that red jewel shot between our eyes. The red sarongs bleed and make the water red around us. We watch the red like it is our own blood curling out of us. Leonard says something as simple as dye in

the river could throw off the ecological balance. "You should take those things off. Go naked." We hee-haw at that. He goes under water and skims our legs like a fish. This makes Sharon and me hold still. We sing low, *the river is deep and the river is wide, hallelujah,* then laugh wild.

When Ruthie's done work, she brings the baby down and we all fight to hold him. Mama has had him all day. No one is going near that baby when she's in charge. She loves him so. Leonard usually gets Ray the longest. He looks in his face and touches his chin, even his lips, which isn't really sanitary. You can't blame him though. Ray is roly poly, all doughy and soft to touch. Blue eyes like the sky; the whole world reflecting in them. Leonard gives Ray a jujube. He chews it watching Leonard, sweet pink spit dribbling down his chin. The baby is teething, so he just loves to chew. He'll chew on a stick or rocks if you let him. Leonard studies the baby. He says he's never seen a baby up close before and Ruthie says, I believe you're more interested in him than me. This is when Leonard gives Ray to me to take up the hill. The baby's smell is pure white and powdery.

Mama's always at the door watching for the baby to come back. She comes out on the verandah when she sees us. Mama says you're never alone with a baby. They're the best company. For that reason, we all love him. Mama reaches out and takes Ray. He's asleep and the dye from my wet sarong has soaked into his head. That insults Mama. My care for him, that is. "Our only boy," she says, "stained."

Right away, I get a headache, lights flashing and pain like something driven through my head, right where the red jewel should be. The doctor says go into a dark place with that pain, so I lift the cellar door where the daylilies are growing.

Sharon says she'll wait in the sun for me to come up from the cellar. I say, "Good, but don't sit on the trapdoor. I need to know I can get back up without knocking."

Sharon waves her hand like a fairy. "Free to come and go," she says, "everyone deserves that."

I step down the cellar steps and lower the door over my head. The cellar is practically a dungeon. Dark, cold, and musty. I feel my way along the rock wall and sit near the potato bin where I know old potatoes are sprouting little horns. They smell a thousand years old. I lift my arms up and rest them on the bin. Everything I touch is cold and gritty. I

hang my head down and close my eyes. Sometimes I throw up sour, but today I try to concentrate on things over me. Mama's footsteps echoing on the kitchen floor and Ray making sounds like a mourning dove. After a bit, the flashing lights settle down and the pain is just a jab. Even though I'm cold, I tell myself to stay until nothing's left of my headache. I say, just leave it right here in the dark, Patty.

When Ruthie comes up the hill, orange twilight is behind her. Sharon and I ask what she's been doing all this time. She says, "this and that." The back of her dress is dirty. "Where's Leonard?" we ask.

"Gone back to his motel," she says, waving her hand.

I picture Leonard driving downriver to Fredericton. I wonder if once he leaves the spot where he's been watching for the bird all day, if he stops watching. Maybe he relaxes like he's in a dream. Maybe he stops looking, even if the orange sky is wild and pretty. Sharon twirls around the porch post. "Why doesn't he take you with him, Ruthie?"

Ruthie stops and blows a piece of wet hair from her mouth. "I have Ray," she says half hurt. "Besides, he's busy at night."

Sharon looks off at the sky, her face is peachy in its light. "Maybe you and him could go out driving," she says dreamy, "look at all the pretty houses or get a frosty float from a take out."

The next day is Ruthie's day off, so we take Ray down to the river shore. We pack sandwiches and invite Mama, but she always stays back if there's a stranger around. She tries to convince Ruthie to leave Ray at home, but Ruthie says it's her family day.

The sun is bright and a breeze is blowing with the scent of sulfur from the mill. Ruthie carries Ray on her hip along with a bunch of orange lilies she picked for Leonard. The flowers are wrapped around Ray like he might have grown right out of one. Why not? If a goat can come from a human. I carry the brown bag of deviled ham sandwiches. Sharon is in a long black stretchy dress that she designed. She calls it *Easy-Wear*, because it's easy to get on and off. The armholes haven't been hemmed yet, but the rest is put together good. I'm in a dressy dress with lots of tiny buttons up the front. I was thinking of Fredericton girls when I got dressed. They look so happy in their colorful clothes.

Leonard is all set up when we get there, a big Canon camera on a tripod, and a huge net strung in the tree over him. "What's the net for?" Ruthie asks.

Leonard turns and his eyes are lightning in his head. "I saw it," he says, holding his hands together like he's praying. He rushes towards us. "I saw the bird. Six o'clock this morning. Right up in this tree. It was glorious. Oh," he says, letting a big gush of air out, "a wingspan like you wouldn't believe. I've got to catch it. I've got to catch it and take it to the lab at UNB."

"What about the squirrel?" Sharon asks.

Leonard looks confused. "What about it?"

"That's his tree. What if he gets tangled in the net and strangles himself? That'd be worse then having his balls bit off. No going to the Mississippi, then."

Leonard looks up at the net, then out at the water and back at the net again. "That won't happen," he says as if Sharon is stupid. He acts like that if you get in the way of his curiosity.

"How do you know it won't?" Sharon asks. "A man can't know what a squirrel will do."

Sharon and I already had this discussion after Leonard taught us that word. *Biodeterminism.* Maybe scientists could plan the way something was going to look, but we didn't think they could shape its mind. That part is the wild kingdom. *Free to come and go.*

Leonard turns away and starts rummaging through one of his bags. "I've got your photograph, Sharon and Patty," he says excited. "I developed it last night." He turns holding up a big black and white picture of us. "When you girls get to the big city, you can use this for your portfolio."

Sharon and I step closer and look at the picture. We're intertwined like Siamese twins. Our faces are bleached out white. No expression to them. If it wasn't for the red sarongs, we wouldn't even know it was us. Ruthie steps up and looks at the picture. Ray reaches his sweet hands out and coos. "Pitiful," Ruthie says. She says it in her jealous way, but I have to agree. With those washed out faces, we could be anybody. No looking in our eyes. I can't help but wonder if Leonard made the pictures that way on purpose. Sharon snatches the picture and steps back, then looks up at the net. "That's still no way to catch a bird."

Leonard picks up one of his cameras and begins to polish the lens with his shirt. "What would you suggest?"

Sharon fans her face with the photograph while she thinks. Mama always says a good hunter knows the area, that's the talent to hunting, but Sharon doesn't say that. She says, "You've got to prove yourself to it."

Ruthie laughs out.

Leonard gets a half-sneer on his face, then says in a fakey way, "Now Ruthie, don't laugh at Sharon. Let her explain what she means."

Sharon stops fanning the picture and looks down at it. "If you want to behold something, it's best to tame it."

Leonard starts howling with laughter. He bends over, grabbing his stomach. "Tame a strange bird," he howls. Ruthie laughs with him. She passes him the lilies and he swats them at his knees, laughing.

"You can do it," Sharon says proud. She looks over at me and her eyes are frowning, "it just takes time."

For a long while, we've been bringing leftovers to the river shore. Potato peelings, old apples, peanuts, bread crusts. We never throw anything away. Everything comes to the river shore with us. We reckon that's why there are so many birds and animals here. It's their haven. One little rabbit eats right from our hands and once, a hummingbird lit on Sharon's head and stayed there long enough for me to get a good look at it.

Leonard shakes his head. "Time," he says, "tick, tock, tick, tock," then he stops still and wide-eyed like a dead man. "I don't have time," he says mean. "That's for girls like you."

All day, we play along the river shore. We pick blackberries and dip our feet in the eddies. For the most part, Leonard is in a happy mood. He kisses Ruthie and Ray and he eats all of our sandwiches without asking. Ruthie tells him her dreams of getting married and having a nice house. She says she wants a big picture window in the living room, so the inside will always be bright. It's a dream Sharon and I have heard before. Leonard stares through his binoculars while Ruthie talks. Once in a while, he swats a bug away, but mostly he just watches.

When the sun gets high in the sky, it turns hot. We all start to complain in one way or another. "Hotter than a desert," someone says.

"Why don't you go for a swim," Leonard says, "cool yourselves off." He's got his shirt unbuttoned and is scratching his thin white belly.

"You come, too," Ruthie says, putting one hand in under his shirt and touching him.

"Oh, no. I'm staying right here. I'm waiting on that bird. But I'll watch Ray while you go."

Leonard takes the top off his canteen and guzzles down some water.

Ruthie looks up at Sharon and me. "You girls come, then. I don't want to go alone."

"Go on," Leonard says, smiling up at us and wiping drops of water from his lips. "Go back in the bushes and take your clothes off. The water feels good when you're naked. It's freedom gained."

Sharon looks at me worried.

"Don't worry," Leonard says as if reading our minds, "I'll close my eyes until you're in deep."

Ruthie hands Leonard the baby. He sits Ray beside him and gives him a little treat. Ray chews it and smiles. Even if Leonard doesn't realize it, he's pretty well tamed Ray with those sweets.

We hang our clothes in the branches. It's hotter in the bushes. Almost breathless. Sharon and I stand with our privates covered, but Ruthie is brave. She said once all modesty is gone after you give birth. "Cover your eyes," Ruthie yells out, "these girls are virgins."

That makes me blush, even though Ruthie doesn't say it in a teasing way. She says it more like a mother would.

"Covered," he yells back, a laugh in his voice.

We take off running, dipping to one side when we step on a branch or a sharp rock. We hear the camera snapping and look over at Leonard who has the camera pointed at us. Sharon and I dive under as fast as we can. When we come back up, Ruthie is standing waist deep with her hands on her hips. "That's not respectful," she scolds.

"It's all in fun," Leonard says, snapping her picture.

"Taking pictures of me naked is one thing, but they're girls."

"Yeah," Sharon says. We're neck deep holding hands. The current is strong and pulling us. Leonard opens the camera up and pops the film into his shirt pocket, then reloads. "They'll be proud as punch

when they see their pictures tomorrow." He says this like we have exactly the same feelings, like there's no difference to us.

"Don't you dare develop those pictures," Ruthie says. "My sisters are nobody's business."

Leonard stares out beyond Ruthie. Nothing she says seems to affect him. Ruthie dives under and disappears. Ray picks up one of the lilies and swats it at the ground. The petals snap off and fly up like butterflies. He swats it until his mother comes back up. Sharon and I are still standing neck deep. It doesn't feel good to be naked. It feels like freedom taken away, like something in the current could get us quick. I wish I was at a lawn party drinking lemonade. Things seem simple there.

Leonard goads Sharon and me to race each other to the other side of the river, but we ignore him. Crossing the current is always dangerous and something we've been warned against. *You're better off floating downstream.* Besides, we're not interested in swimming anymore. The picture taking took our desire. Ruthie goes under again, then pops up beside us. Her hair is slicked back and her eyes green as grass. She grabs our hands and lets her legs float out behind her. "Don't listen to him," she says squeezing our hands, her eyes sparkling, "he's being a jerk."

A dark shadow glides over us. We let go of hands, then stand and look up, shading our eyes. The bird's long black neck is like a spear arching over us. Watching it, everything seems to stop and the air turns moist and lush. The back of the bird's body is bulbous like the weight of the world is there, but that doesn't seem to affect its grace. It circles the river over and over, never going near the tree with the net. I imagine telling Mama about the bird later. I'll make it out to be more than it is, even though what it is should be enough. Better than the Shroud of Turin, I'll say. Leonard snaps one picture after another. He doesn't once put the camera down and look at it with his real eyes. Proof is what he's after.

Ruthie gasps, "Leonard."

Without looking her way, Leonard hushes her.

"Leonard," she says louder, moving toward the shore, "where's Ray?"

Ruthie slaps her hands against the water, then starts running. She looks like she's trying to fly. The bird is right over her and it makes a loud scratchy noise, a mutation of a caw. It dips down over her head, then flies low over the reeds. "The baby, Leonard," Ruthie's voice is pleading, "where is the baby?"

Leonard looks at Ruthie confused, then goes back to taking pictures like the baby is a common thing to him now. Sharon and I spread out in the water. A battered lily is floating in the middle of the river, downstream. "He's in the water," I say, picturing Ray as a bog person. Picturing his whole self shiny as bronzed baby shoes. Ruthie dives under water and so does Sharon, but I rush out past Leonard and into the bushes. I grab Sharon's *Easy-Wear* dress and pull it over my head, then run up the hill.

"Mama," I holler. She's bending over on the porch, brushing out her long hair.

When she flips her head up, I see her ears for the first time. They're white and bigger than saucers. The sight of them tells me certain things about a person don't change no matter what they tell you. Mama's eyebrows dip. "Patty, why have you got Sharon's dress on?" She knows I don't like black.

"It's Ray," I say, "we can't find him. We think he's in the water."

Ruthie and Sharon are still searching the river, but Leonard and his cameras and bags are gone. Mama walks into the water without taking her shoes off. She lifts the hem of her dress and looks up and down the river. Ruthie and Sharon are swimming frantically, first diving in one spot, then another. I can't bring myself to step into the water. It's strange to me now. I look up at the sky for the bird, imagining for a moment that maybe it stole our baby, but all I see is the empty net, slung low.

Mama walks down along the shore with the current. She's walking slowly, studying the shore. She looks like she's listening to a far off message, something on the breeze. I want to tell her to jump in and look for Ray, but I don't dare. Who am I to question her faith? Finally, she stops in a shallow eddy and smiles at the shore. I rush over and look. The baby is sitting in an old nest in the reeds, chewing on a cattail. I've never seen the nest before, but it looks like it's been here forever. It looks like a relic from another time. Black feathers float in the water around it. Ray waves the cattail at Mama, then puts it back in his mouth and chews.

"You sweet thing," Mama says. She looks at me. "You girls weren't thinking," she says flatly. It sounds like something Leonard would say, but then I remember the night we watched that movie at the church. Mama was all smiles, thrilled with revelation. Walking home, she said, "You see girls, faith is a fine-tuned science. No hit and miss to it."

When Ruthie hears Mama cooing, she rushes in and grabs Ray from the nest. She's so happy that she starts to cry. She lifts him up and the nest sticks to him, then falls into the water and begins to float down river. The bottom of the nest is missing, which makes it look like a crown of thorns.

Sharon stays neck-deep in the water, watching us. Her lower lip is trembling, but she won't come out.

Mama takes Ray from Ruthie and kisses his cheek. She holds him close, then looks at Ruthie's naked body. "What went on here?"

Ruthie tries to take the baby back, but Mama won't let her.

"I said, what went on here?"

"Leonard was supposed to watch him, Mama. While we went swimming. We were hot. It was awful hot."

Mama shakes her head, then says firmly, "You sacrificed Ray's safety to cool off."

Ruthie looks down crossing her arms over her bosoms. "It wasn't like that."

"Oh?" Mama says.

Ruthie blinks, "I thought he was being watched."

Mama gets a sorry look on her face. A look that says the weight of that message is on her now. For a minute, I picture her big and bulbous like the strange bird. "You better get dressed, Ruthie," she says.

I don't put my colorful dress back on. I leave it for Sharon to wear and follow along after Mama. Her hair is long and black down her back. In the sun, it's like silk. It amazes me that I've never seen it hung out beautiful like that before. That she kept it to herself. Ray is looking at me waving his arms and smiling. He could have floated down river so easily; he could have been lost forever. Lights start to flash in my head, then a sharp pain starts between my eyes.

When we get near the house, the strange bird is sitting on the peak of our roof. It makes a sweet sound as if to say how good our baby is. Mama pays no attention to the bird. She keeps on walking like she's seen it a thousand times before, like maybe she's even chitchatted with it. Ray turns and when he sees the bird, he coos with wonder. I think how silly it is to want to leave this place even for a while, even for a dream. This place is what we know best. Besides, down by the river, things just come our way.

ALFRED CORN

Anthony in the Desert

To be filled with that hallowed emptiness
The hermit sojourns in a desert cave.
Fasting and prayer will make seclusion safe,
His daily bread, each word the Spirit says.

Chimera stirs and rears her dripping head;
A slack-skinned reptile puffs and makes a face;
Vile, harrowing nightmares shimmer through long days;
The sun beats a brass gong and will not set.

Faint shadow on cave walls, you foretell grief
Or joy, not known till whose the profile is:
Love itself may corrupt and then deceive
Its object, hiding venom in a kiss.
Anthony kneels, embraces his fierce lot,
And hears: *Be still, and know that I am God.*

KATE DANIELS

Scar

When the mirror sliced my daughter's thigh,
it slowly flowered open in bloody layers of broken
glass and petalling skin. Now the wound has healed
to a dark, thick worm of keloided flesh
humped up high on top of her leg. Still,
it destroys me, and the way she walks at the pool,
or emerging from the bath—trying to hide
her imperfection with her splayed-out hand—
hurts me the way her puppy's back end wiggle
signifies a fear of men, and ignites a little narrative
in my mind: some creep with a beer in his hand
batting around a five-pound pup, and thinking it's funny.

The fact that I still sneak in like some pervert
to my daughter's bedside and peel back the cover
and lift the gown and hunker down inside a sacred moment
of healed skin and human skill won't be held against me
surely. I pray there, my fingers tracing the raised nub,
the same way they pray the Rosary, the motions
calming, the routine a ritual that conserves my sanity and praises
 her life.

And so my daughter's scar moves me, my stomach bottoming out,
my mind raving with the images of that evening, refusing
to relinquish even one detail of the night my God hung back,
masquerading as a dark deity, a complicated god
who would hold a small child hostage and torture her mother.
Now it will take a long time to fasten Him back where He belongs
—the way we falter screwing in a light bulb in the dark, panicked
and visionless, the glass globe turning uselessly in our hand,
the tin rind of the socket refusing to thread, and wondering
what we will see, and who will be there beside us
in the dark when the light finally returns.

MADELINE DeFREES

The Eye

Lodged in a bony orbit in the skull, the eye
is slower than the hand
and more inclined to doubt in spite of
what the old saw claims: *Seeing is believing.*
This was not the case with skeptic
Thomas, who put his unbelieving hand
into the Master's wounded side

 and only then
declared his faith. I trust the eye: it winnows
wheat from chaff. And in the furnace, separates
true metal from slag. An eye for minimal
upheaval proves a mode of second
sight: the anthill army's small
earth-moving crew. Wrought-iron handrails

filigreed with spider-cloth, sequined with dew.
Half-open clematis against
a chain-link fence, their creamy lemon
shading into white. Blue-black sky
swept clean with brushwork in the evening
light and winter-bare japonica's faint
flush of green before the leaves come out.

Because the eyes are windows on the soul, wise
men close the curtain. Hoard rivers of bright
color. When words arrive with hearts
pinned to their sleeve, the brave will plunge
the writing hand into the right-brain
wound to draw out blood and water
the doubter can believe.

RUBÉN DEGOLLADO

Host

[fiction]

These are the mornings,
Which King David sang of;
To the beautiful girls,
We sing of them here.

—"Las Mañanitas," author unknown

OR THE eve of Mother's Day, Victoria Izquierdo's brothers-in-law had said they would get the fire ready, trim the fajitas, and season the chicken. As they did this, her husband Gonzalo would pick up his mother on his way home from work. Her nephew by marriage, Cirilo, had also offered to help, saying he would bring ice for the cooler. Victoria thought it was because he was such a nice boy and he loved driving and showing off La Bomba, a beat-up Galaxy struggling paycheck by paycheck to become a low-rider.

Cirilo dropped two bags into the ice chest. He passed the aunts and the bar that cut the kitchen in half, to their husbands who were busy preparing the meat. He was a tall, beautiful boy who would be a senior next year. Cirilo would barely get out of the eleventh grade, Victoria thought. His teachers would probably pass him only because he was such an artistic, respectful boy, even though he looked like a gangster. They could see these redeemable qualities in the pictures of the weeping, martyred Jesus he drew day after day in all of their classes. They would look below the portrait and expect to see the *Latin King Love, Trece Killa* graffito. Instead they would see *Puro Jesús* in Old English letters and think that this was one that should be saved, should maybe take intermediate classes at South Texas Community College.

Qué pasa, mijo, all of Cirilo's uncles seemed to say at once, with knives and meat in their hands. One by one, he gave saludos to the Three Amigos Gordos, as Victoria's husband called them. Not being Izquierdo men, Manuel, Eulalio, and Joey had big identical guts that

made them look old standing next to Cirilo. The boy shook Artemio's hand, the little Mexican national who had knocked up and married Suzanna, the last Izquierdo girl. He told them he would be back to help after he said hello to all of his tías. Was Cirilo rushing past them just a little?

Victoria watched him as he said Happy Early Mother's Day to all of his aunts at the table. Had Cirilo looked at her when he said it? He stopped and stooped to kiss each of them on the cheek, even hugging them, which was something not all of the sobrinos did anymore. As Cirilo moved on to the next aunt, the blood was in their faces and they tried to hide the flattery from their viejos, who were too busy cutting and seasoning anyway.

He gave his saludos to Melinda, Suzanna, Ana, and now, next to Victoria, he told Sol, Are you losing weight, Tía?

Ay, I hope so. I been on those ugly shakes for three weeks already.

Pues, I think you have, Tía.

Ay, gracias, mijo. Why don't you tell your tío? she said, pointing her eyebrows at Lalo, who was working the beef, slicing off hunks of pink fat and laughing.

I will. He could use those shakes himself, no?

¿Ay, y tú, mijo? You're so skinny.

I know, Tía. I been trying to gain weight.

Ay mijo, I *wish* I had your problem.

Victoria grinned and turned away from Sol's chins and the makeup that was too caked, too light for her face, making the darkness of her neck stand out. Sol and the boy had this conversation every time Victoria saw them, Sol knowing that she hadn't lost any weight and Cirilo knowing he would never say anything to Uncle Eulalio.

Hola, Tía Victoria. ¿Cómo estás?

Good, Cirilo.

As he leaned forward, Victoria smelled him, clean and young, with a touch of Tres Flores pomade in his hair. Victoria wasn't surprised when he sat down next to her. There had always been something between them, but she was not really sure what it was. Maybe it was because she was only twenty-seven, and not fat and dumpy like his other tías. Her having style and nice legs, not cottage cheesy with shorts, made the boy feel like he wasn't totally wasting his time. Because she had seen the way he looked at her, not sexual really, not all the time. Sometimes

though, when she looked away from him, she caught him darting to skin, then darting back and looking into her eyes as he talked to her. He was such an Izquierdo.

¿Que onda, Ojos Borrados? Victoria said.

Same old. Same old.

¿Y tu dad? She asked.

Nada, just work and church.

Same here, mijo.

He laughed. ¿Y el chiquillo?

In his room with his cousins.

He starting school next year?

First.

¿Ya?

Sí, moving right along, verdad?

Deja tú, I'm going to be a senior next year.

Y summer school?

Como no. Ese pinche….sorry, Tía Victoria. Ese algebra, olvídate.

Ese *pinche* algebra, I know. You'll pass it this summer though.

I just want to graduate. Because I don't want a G.E.D. Qué vergüenza, you know.

Ay, Cirilo, don't worry. You'll make it. Talking about school, you got a girlfriend yet?

She connected his hazel eyes, ojos borrados, so unlike the Izquierdos' so like his divorced cantinera mama—to some girlfriend who would find love and salvation in them.

Pues, you know the girls. Ya cuando te tienen, they don't let you do nothing.

That's not true. I'm sure there's some nice chiquita like you, who'll let you hang with your camaradas.

Yeah, you're right, Tía.

I know I am, Cirilo. I know I am.

¿Y Tío Gonzalo?

He went to go pick up your Abuelita after work.

Que bueno. I feel bad because I haven't seen her in a while.

They should be here already, Victoria said and looked out the window for her husband. The sun had softened and the cicadas were buzzing now. After it cooled off, the others would be coming. It was getting hot outside now that summer was coming, but in her house it

was always cool, because Gonzalo hated the heat after being outside fixing air conditioners all day. He made sure their central air was always working and in the seventies, especially during the summer.

Do you remember how Papa Tavo used to hire mariachis to sing "Las Mañanitas"? I was thinking about that.

Something in the way he said it made Victoria think he wanted her to turn away from the window.

Sí, Cirilo, your abuelita loved that.

She's going to cry tonight when she prays.

Every time all of us get together, she thinks about Papa Tavo and misses him.

Pobre Abuelita. I hate to see that. He meant he hated to see her cry, because Grandma was strong when she took care of him when Big Cirilo and Blanca were drunk in the cantinas. And he hated to see her cry because she had been soft for him the time Big Cirilo kicked him out of the house for getting busted with some roach pills.

No te preocupes. She's strong and she knows it was better that Abuelo went home.

I hope so.

Seeing that the boy was still down, she said, You remember when we prayed with Papa Tavo before he died?

Cirilo nodded and smiled. She meant to bring up the time just before Grandpa died, but didn't like the way Ana and Sol looked at her when she said Papa Tavo's name.

Papa Tavo had had another nervous breakdown, and everyone believed it was because he had been cursed by Brujo Contreras, the witch-man across the street who had always been jealous of the Izquierdos. After the breakdown, Papa Tavo was in and out of nursing homes because he was too difficult, screaming all night and talking gibberish. Everyone felt better when he entered San Juan Nursing Home because the Shrine ran it and it was closer to God.

One Sunday, Cirilo's dad had called them all up and said that he had felt all day that Papa Tavo needed the family to be with him.

When they got to San Juan's that Sunday, Papa Tavo just looked at their faces like he didn't know them anymore. He just moved his lips and lifted his hand and pointed to something like he always did after he got sick. Abuelita, she put her hand on his hair and she said the Our Father and the Hail Mary. Then she tried to make the sign

of the cross with his hands, but he was fighting her and moving her hand away.

Big Cirilo grabbed his hand tight and said, Papá, I know you can hear me. He prayed the prayer to be saved, with Papa Tavo repeating, even though no one could understand him. Abuelita picked up his hand and he let her make the sign of the cross for him and everybody thought this act had freed Abuelo from the curses. Victoria knew that he had accepted Jesús, and that was really why he was free.

She kept this to herself and said, No te aguites, Cirilo. Because she just cries because she wishes he could see how good the family is.

I know. So you think Tío Gonzalo hired some mariachis tonight?

Ese viejo, I *never* know what he's up to. Hablando del diablo.

The truck was hidden by the wall, but she could see Gonzalo's headlights on the pavement outside. Then she heard his engine.

So did Little Gonzalo as he ran into the dining room, saying, Papi's here, Papi's here, with his two little cousins trailing behind.

Cirilo got up and began throwing the bags of ice onto the floor.

¿Qué pasa, mi compadre? Joey said.

Nothing new, cuñado, Gonzalo said, opening the door for his mother and brushing past Little Cirilo without saying anything.

Abuelita walked in and gave her quiet general saludo and everyone stood. They surrounded her and took turns hugging and kissing her.

¿A donde está mi Gansito? She said, exaggerating the search for her Little Goose.

I'm here, Little Gonzalo said behind his father's leg.

She reached for him and he pulled back.

Big Gonzalo said, Don't be that way. Say hi to your abuela.

He let her squeeze his face and kiss him.

Estás creciendo, Gansito.

Little Gonzalo rolled his eyes.

Sí, he's getting big, Victoria said from behind her husband. So near the door, she smelled the burning mesquite from the barbecue pit. Hola, Suegra. ¿Cómo estás?

Bien, bien, hijita.

Sientese, sientese, Suegra, Victoria said, pulled out a chair, and asked her if she wanted something to drink.

Sí, una limonada por favor.

Claro que sí, Suegra. Then to Gonzalo, She said, How was work, baby?

Hard, he said in his way that sometimes made Victoria feel as if it were her fault.

Go take a shower, and when you're done, the others should be here. I left you a clean towel on the seat, and I got some new soap. These things would clean him, but only mask the smell of sweat and sun, which returned so quickly, it always seemed to be there.

¿Okay, viejo?

Gracias, he said, and went down the hall to their bedroom.

The men were leaving the kitchen with trays of raw meat as she went to the refrigerator to get her suegra the lemonade.

Behind her, she knew Little Cirilo was hugging Abuelita. She could not see them, but she knew the way they were, hugging each other in silence, sharing the memory of the months he had stayed with her.

Aquí está, Victoria said and placed the drink in front of her mother-in-law.

When she sat down at the table, Abuelita and Cirilo were catching up, Cirilo saying, I'm going to pass to the twelfth grade, and Grandma saying, Que bueno, que bueno. Gracias a Dios.

As they talked, Victoria got up and went to the stove to make sure that Melinda's rice and her beans were not burning, but only keeping warm. Gonzalo's sisters had helped Victoria make the rice and the potato salad. Victoria always made the pot of charro beans herself, which everyone would ladle into Styrofoam cups, and ladle some more until there was only bacon and cilantro left at the bottom of the pot. Then she went to the refrigerator and got out the bowl of fruit salad she had also made.

She called Little Gonzalo.

Her son came into the kitchen and said, ¿Mande, mama?

¿Quieres fruit salad, mijo?

Please, mama.

Quiero que comas rice y then I'll give you a cup of fruit salad. Lots of grapes? Okay?

Okay, mama.

She wanted him to eat now before all of his cousins got there, because she knew he would be too distracted by them. Then, he would wake her up at seven tomorrow asking for pancakes or French toast.

Victoria told the boy to sit on one of the barstools. She served him the rice, taking out the green peppers that he always made asco faces at. She spooned the fruit salad into a cup, making sure she scooped in many grapes covered with even more whipped cream. She told him it would be waiting for him whenever he finished the rice.

Gonzalo had showered and changed, but that wouldn't matter anyway. Standing out there, like he was now, he would come in smelling of smoke from the pit, and of cigarettes. He did not smoke really, only sometimes when he drank beer with the compadres. But she still did not like it. All of them would come in smelling that way and she would wake up in the morning to get ready for church and that ashen, mesquite smell she hated would still be in the house. Even Cirilo, who would split his time between the women and the men, coffee inside, maybe a beer outside, if Big Cirilo wasn't looking, would smell of smoke.

They were out there laughing at some joke Lalo had told. It was a dirty one because Big Cirilo the Baptist was looking down at the dirt, trying to hide his smile. She liked to watch them this way, like with the sound turned off. She was glad Gonzalo didn't have a big panza hanging over his belt like the others. Even Big Cirilo was starting to get a gut too. Gonzalo had started wearing size thirty-six pants, but he still looked good in his jeans and boots, if only slightly thicker in the face.

Even though he was older and heavier now, women still looked at him. At the Christmas party for Mercy Home Health, all of the other LVNs, and even some of the gringa RNs, had watched him when they walked in. She had seen them, the way some of them who did not even talk to her at work had made sure they were introduced to Gonzalo.

Lily, sounding drunk, had said, And who's *this*?

Gonzalo. My husband.

You didn't tell me he was such a papacito.

No, I didn't. She had said this, killing the urge to ask her where her mujeriego husband Bobby was, who picked up women at the Gaslight without shame or guilt. But she walked away instead. And Gonzalo had not said anything about it in the truck afterward, not rubbing it in like a couple of guys she had dated would have.

Can I go outside now? Little Gonzalo was asking, shoveling the last of the rice into his mouth.

Yes, mijo.

He grabbed the cup of fruit salad and ran outside, where all of his cousins were playing now. Beto and Mac, two of Gonzalo's little brothers, had just arrived with their families. The house and yard were full of family now, which Victoria liked, but wasn't used to. Her family—Mom and Dad, Rolando, his wife Evelyn, Yvette and all the kids—were in San Antonio, and their get-togethers were never like this, like all-out pachangas. She had called her family before the others started arriving so she could use the phone in the kitchen, because she hated the way the cordless made that buzz all the time and made her voice sound funny. They were all at Rolando's apartment, barbecuing by the pool and her father had sounded happy as he created a picture of his nietos splashing in the pool. Her brother was preparing his shish kebabs marinated in beer, which he had learned to make in the army, and she had learned to miss.

Maybe next weekend we'll see you, Mama had said. And then we can celebrate Mother's Day together.

The pan seemed to be the only one coming into the house as everybody sniffed and watched it being set on the bar. Stacked high in the pan were strips of fajita, plump, shiny Polish sausages, and browned chicken-halves.

Each woman was responsible for serving her own family, which took poor Sol the longest because she was the one with the most kids, four boys and two girls so far. Victoria spooned rice and beans onto Gonzalo's plate first, avoiding the potato salad because Suzanna always used too many pickles and Gonzalo hated that. She went over to the tray, lanced some fajitas with her fork and grabbed a chicken-half by the leg.

Gonzalo stood near the sink, grabbed his wife's free hand and squeezed it. Victoria set his heavy plate on the counter and he kissed the top of her head and smoothed it with his dry hands.

She said, You're welcome, and smiled at him with her black eyes.

Then she served the same for herself and her son, in smaller and smaller portions, even though Gansito wouldn't eat any.

Once Sol served her youngest, there was a lull as everyone stared at Abuelita.

Big Cirilo said, Before we eat, I think Abuelita would like to say something. Everyone except Gonzalo got into place, forming a circle

around the kitchen with heads bowed. He was still standing near the sink, drinking a beer, looking for a strip of fajita on his plate small enough to eat in one bite.

Come here, baby, she spoke without sound, smiling, hating it that he could not wait for Big Cirilo to say the grace. He nodded no and smiled, meaning I'm fine here.

Victoria rolled her eyes and grabbed Gansito by the shoulders, trapping him in front of her, so he would not be running around or squirming, distracting everyone.

Gracias, Gracias, Abuelita said. Gracias por mis hijos. Thank you for my children. She was silent for a few seconds and Victoria hoped maybe she was waiting for the Spirit to guide her, and not about to cry.

Abuelita Izquierdo said, Padre nuestro que estás en el cielo.

She paused the Our Father, waiting for the rest of them. Victoria looked at her family as they started saying the words, most of them seeming to be into it, even Gonzalo mouthing them. Of course, you could hold the men *this* long. But when Cirilo would speak after Abuelita, the men's heads would be bowed, yes, but outside by the pit, by the ice chest and away from their wives.

On earth as it is in Heaven, Victoria said in Spanish, and knew her sisters-in-law were staring at her through their half-closed eyes. Through the steel bars of their lashes, they were looking to see if the Protestante, the one who never prayed the Rosary at Christmas or said the Hail Mary, was saying it with them.

For the kingdom and the power and the glory are yours, she said after everyone had stopped at deliver us from evil and amen. Now and forever.

All of them, though they wouldn't admit it, waited for Abuela to begin crying. Padre Nuestro, te doy gracias por mi familia. Our Father, I give you thanks for my family, she said, in her singing whisper. Thank you for all of my beautiful children you gave me. Thank you for all my years you gave me with Octavio. Thank you, Padre, for telling San Pedro to open the gates for my Viejo. Thank you, San Pedro.

Gracias, Gracias, Gracias, she said without crying. And she said this until her whisper shrank into a praying mouth, then into thought.

After he was sure she was finished, Big Cirilo prayed about the food, yes, but he also asked God to help all of the men appreciate their wives as mothers and for God to help the men keep the promises they had

made at the altar. To let this Mother's Day be a new beginning for all the families. And she knew what they were all thinking, because she was even thinking it herself. What about Blanca and the promises *you* made, Cirilo?

She thought maybe he was just practicing for when, or if, Blanca ever came back to him. He kept saying more of the same, and she knew that he had lost them to hunger, and they had closed their ears to his preaching.

God, thank you for my mother and all the mothers. Thank you. Thank you. En el nombre de Jesús. Amén.

Victoria giggled because the family had started moving right after he had said thank you the second time.

They ate and no one spoke and Gonzalo was still by the sink, eating fajitas with his fingers.

Ay, the tortillas, Victoria said, and everybody said, Oh!

Suzanna said, So, *that's* what was missing.

Victoria went to the kitchen and turned on the stove to heat the comál. She got out the buttons of dough that she had made and shaped the day before.

Gonzalo said, No, no, Victoria, tardará mucho, and sat down at the table. Just get the packs I bought at Don Pedro's.

Victoria frowned because she liked for the family to enjoy her homemade tortillas. Of course, no one had seen her make them, so no one knew that her secret was all in the shortening. This made her laugh.

Okay, she said and then she felt like a tortilla factory, because none of the other women were helping, because there was only one comál after all.

Little Cirilo said, Give me some tortillas and I'll put them on the grill outside. Se hacen de voladas, he said and snapped his fingers.

Cirilo and Victoria threw them into the warmer like frisbees as Gonzalo held up the lid and tried to hide his dirty looks from her.

The table had cleared out by the time she and the boy got to eat and Gonzalo had left the table without saying anything. The ladies were cleaning up after their families, wiping up rice and potato salad, poor Sol again taking the longest.

Te aventaste, Cirilo said to Victoria, eating a spoonful of her charro beans.

Thank you. It's the cilantro and the bacon.

Yeah, you're right.

Are there any tortillas left?

He checked and shook his head. It's better. Your tortillas or none at all.

She smiled and tried to hurry eating so she could get away from the table where Cirilo was.

The men had gotten serious about drinking beer, because one of them, Lalo or Manuel, had taken the ice chest outside.

Victoria had made coffee and the women were inside talking about the novelas.

What do you think is going to happen to María La Del Barrio? Suzanna asked everyone.

Victoria did not watch the Spanish soap operas, had never felt the need to. She knew that María was a poor girl who had married rich and was now struggling with life and an ex-wife come back from the dead. She wanted to ask the sisters if they thought poor people in Mexico really wore fancy makeup when they were digging through trash or was María just special?

Victoria said, Ay María's so pretty.

Right? Elvira, Mac's wife said.

Ay, but it looks like she's gaining weight, right? Sol said. *Right?*

Así les pasa. When they get famous. Remember Oprah?

Pero, ahora she looks good. Tiene un personal trainer.

Ay, Sol said, That's what *I* need.

Victoria thought Sol needed to stop talking, because talking was enough for Sol, and action was what she needed.

Saying she took the chromium picolinate Super Fat burner before she ate at El Pato or Whataburger probably made her feel thinner, sexier. As if the little capsule could take Sol back before the kids, before the angry red stretch marks on the insides of her arms. Victoria saw them now as Sol put her hair up in a clip. These stretch marks would go white only with weight loss that would never come, like those that Victoria would probably get after her own tortillas had caught up with her. That is, if Victoria ever let herself go.

Some of them had gone home at midnight. The ones who had come early to help said they would stay late after Gonzalo told them that

he had hired some mariachis. Gonzalo had paged the leader of the group, who had called back from a cell phone, saying they had a few houses to go before they got to his and that they would probably be by at about two or three.

They: Gonzalo, Lalo and Sol, Artemio and Suzy, her Suegra and Little Cirilo, and the kids were outside in the front porch listening to the radio. A Selena song, Victoria could not remember which one, came on.

Bailen, Lalo said, Let me see my girls dance. The way he said it, Victoria realized how drunk he was. Artemio, who was drinking Topo Chico and whiskey, was about the same. Now that Big Cirilo had gone home, Little Cirilo was drinking a beer, and she hoped the boy would not drink another one.

Bailen, Lalo said again, Dance. Show your tíos how you dance Tejano.

Erika and Michely, who had already been standing inside the circle of their family, started to shake their hips without rhythm. The older one, Erika, knew the moves, but could not keep time with the music. To help them it seemed, everyone started to clap in rhythm.

Victoria clapped too and said, Que lindas, thinking maybe she wanted a girl next.

Erika started dancing like Selena, kicking her feet and twirling around, mouthing the words to the song. Artemio got up and moved through the circle where the girls were dancing and Lalo said, ¡Chingado Artemio! ¡Haste! so that everyone could see his daughters.

Now by the cooler, next to Gonzalo, Artemio grabbed ice and dropped it into his glass.

¿Quieres un tragito? he asked Gonzalo and lifted his glass.

No, no. The way he refused the drink, too sure he did not want one, Victoria knew he was looking at her. So she looked back, black eyes cold. And how he got with liquor passed between them.

Last Fourth of July when he was drinking tequila shots, he had yelled, Why did you touch his face?

She had explained he had had a mosquito on his face and she was shooing it away and she had never even touched him.

¡Vieja mentirosa! he had told her after his nephew had left.

There's something going on with you and Junior. And she knew
he had meant there was something going on because they had spent
time earlier talking about Jesús, and he had seen the way Little Cirilo
had paid attention, ignoring the world as he spoke to her. And then
Gonzalo's hand was across her face hard, as she said, No, no, no,
meaning there was nothing going on. Then, No, no, no, this should
not have happened as Gonzalo's brothers jumped on him and held
him down.

Kicking and spitting, writhing to get free, he had said, ¡Dejenme
cabrones! Let me kill her! As she drove away with Little Gonzalo next
to her, she knew he would have done it, crushed her neck with his big
hands, if they had not been there.

But she smiled now, hoping the scene was not being played on her
face for him or anyone to see.

She clapped her hands and said, Dance, dance, chiquitas.

Abuela had gotten tired of waiting, had gone to sleep, and besides,
the mariachis were supposed to be waking her up with their serenata.
Even though Victoria was not sleepy, she kissed her husband, told
everyone she was tired and went to her room. Gonzalo said he would
wake her up when the mariachis got there.

She lit the white candle, the religious type sold in the supermarkets.
She did not like the others, the kind her mother-in-law had, the ones
with pictures pasted or painted on them. Opposite these pictures of
saints, angels and holy children were petitions for help, guidance, and
love. There was even a rainbow one that was supposed to help you
win the lottery. Suegra believed that the candles were symbols that
the Holy Spirit was there in the house, reminding the evil spirits to
keep away. This was better than believing that lighting a candle would
answer her prayers, bring her closer to God's favor. Victoria just liked
the white candles because they lit up the room, not bringing dark,
dancing shadows like the colored ones did. It also reminded her of
Amá Angelina's house when it was so cold outside there would be
condensation on the concrete walls. Sleeping in her grandmother's room
when a cold front came in, she would feel warm and sleepy looking
up at the ball of light the candle made on the ceiling. The same circle
was up there now, shifting as the air blew over it.

Now in bed, she was sleepy all of a sudden. She stared at it some
and it was still there under her lids as she closed them. And before she

dreamed, she pictured her family there in the ball, watching the girls dance without the music. Victoria wanted to think of it some more, but she went to sleep instead.

Baby, wake up. They're here, Gonzalo was saying. She tried to see him, see the red numbers on the clock, but her eyes were too dry, and she was blinking hard and fast, trying to make her way over sleeping Gansito as she followed Gonzalo as he walked out into the hall, then into the front porch.

Her suegra was already there, sitting in a lawn chair. And the mariachis were there, and Victoria laughed. They were bareheaded kids, young men and women, not much older than Cirilo. Beautiful as they were, dressed up in red and black charro suits, with ornate, shiny buttons and clean, unwrinkled faces, she wanted them to look like they always had, like earthen men pulled from yellowed photos of the Revolution, like men who had lived what they sang. The one with the guitarrón, the bass guitar, even had an earring, and hair shaved on the sides, slicked back on top. But they began singing "Las Mananitas" and she stood blinking at them because they did not sound like children.

> Estas son las mañanitas
> que cantaba el Rey Davíd
> a las muchachas bonitas
> se las cantamos aquí

> Despierta mi bien despierta
> mire que ya amaneció
> ya los pajarillos cantan
> la luna ya se metió.

As they sang, Victoria watched the mute faces of her family and her suegra. She was old and hunched sitting in the chair, and the other mother's days were there in the creases of her face, in the dark circles around her eyes. The dark circles that Gonzalo had inherited, making him look sad at times, demonic at others, like when he was under his brothers trying to get her.

Cirilo was out in the darkness of the driveway, the arc of light from the porch just below his neck. He was looking at one of the female singers, the one with the violin. His eyes were soft and kind, and there was something else that she had never seen. The mariacha had

clean, small features and long, brown hair pulled back. And she was thin, almost as tall as Cirilo. Her part came and she extended a long, creamy neck, jerked her bow across the strings and Victoria thought maybe this was why Cirilo had stayed.

> Qué linda está la mañana
> en que vengo a saludarte
> venimos todos con gusto
> y placer a felicitarte.

> El día en que tú naciste
> nacieron todas las flores
> y en la pila del bautizo
> cantaron los ruiscñores.

They were finished with the song now, and they started again with something else. This one was "Gema," about what a gem of God Gonzalo's mother was. And she was still subdued sitting there and Sol was sitting the same way, but behind the singers. Gonzalo came up to Victoria and put his arm around her as she stood, and this was the way he got. Affectionate yes, but a little rough, holding onto her the way he did at the weddings and quinceañeras, challenging the other men to ask Victoria to dance.

This last one, Gonzalo said, is for you.

It was "Despierta," the one Victoria asked the trios to play whenever they went out to eat at La Casa Del Taco. It was about a man coming to a woman's window offering his soul in a song, saying only he loves her and that he is sorry he has interrupted her sleep, her dreams.

Still standing, she sang in Spanish with the young tenor, *Awake sweet love of my life. Awake, if you find yourself sleeping.*

Off tune, a little drunk, Gonzalo started singing too. *Hear my voice rolling beneath your window. I come to surrender my soul. Forgive me for interrupting your dream, but there was nothing more I could do.*

On this night, they sang, *I came to say I love you.* Gonzalo squeezed her waist and brought her in close and she almost liked the way his hands felt.

They were done with the three songs Gonzalo had paid for and they were saying, Muchos thank yous, with everyone clapping, and making jokes about why they were so late and a few of the ones in the back were making to leave.

Otra, otra, Lalo said. One more!

Ay, Lalo, let them go. They got to see other people, Sol said.

¿Qué canción quieres oír? Tell me.

She sat there and stared and then said, "Dios Nunca Muere."

Sing it, he said.

After some of them humming the key, they began the song, the trumpets filling the entire neighborhood. Sol was in her chair now and the mariachis were facing her. Like Abuelita Izquierdo, she would not look up and face the singers and Victoria wanted her to stand or dance, or even look at them. As the mariachi sang, Lalo looked on Sol, and Victoria could barely see Lalo's eyes, hooded and drunk like they were. But they were on Sol, only on Sol, and Victoria thought all that about her stretch marks and the diet shakes that would never help her lose weight wasn't important now. None of it—the girls, the beer—seemed to matter as he leaned over slow and kissed Sol on the lips and she said, Ay gracias, Viejo.

After Lalo paid the mariachis, they left and so did Cirilo, as he had when he had given his saludos, except this time it was in a rush.

Good night. Hasta mañana, he told Victoria. He hugged her and smelled like he did earlier, only the smoke was in his hair and his breath smelled like beer. He pulled away quick without looking at her or Gonzalo and Victoria thought it was good that he went to the violinist and followed her to their van, saying things she could not hear.

Abuelita, who had said maybe she was going to stay the night, decided to leave with Suzy and Artemio. One by one, they all left the porch-light arc for the shade of the street. All that was left were the cans in the bucket outside and the mess and the smell in the porch. Now in the kitchen, Victoria turned on the faucet as hot as she could stand it.

Gonzalo said, Leave it, baby.

I just don't want to wake up to all this. She took off her ring, and set it on the window sill. Her hand dove through the dirty dishes, the slimy food, down to the sink-stopper.

Go to bed, baby.

I'll just clean the table, Victoria said and wrung out the wash-rag and turned off the faucet.

Gonzalo sat on the couch next to the stereo in the living room. He leaned over, plugged in the headphones and turned on the CD player.

¿Te divertiste? he said, too loud.

Sí, I had fun. It's always good to have everyone here.

Right.

Are you going to stay up?

For a little while, he said, pulling one cup off of his ear.

Okay, she said, glad that he was in a good mood. He would probably stay on the couch, his back arched all night and he would wake up sore and crudo from all the beer he should not have drunk.

No te desvelas tanto, she said even though she knew he would sleep in tomorrow because of it.

Okay?

Okay, she said, meaning it was better this way, and walked down the hall to the bedroom.

After her shower, she lay down and looked up at the circle of light from the candle and tried to remember what it was she had been thinking. They were dancing, yes. Erika and Michely were trying to move like Selena in the circle. Victoria pictured herself dancing like she did at the weddings with Gonzalo, but by herself, with everyone watching her and her loving it. She thought about liking them watching her at church when the Spirit was strong in the air and she was up at the altar doing the interpretive dances the traveling negrito preachers had taught her. As this thought came to her, what she saw came from somewhere outside of her. Others were near, pressing in as they danced. Her son, Sol's girls, now Cirilo and Big Cirilo, were up there, in there, in the circle, dancing inside the rim. Little Cirilo danced like he did at Artemio and Suzy's wedding when the DJ played a rap song. He *did* look like a gangster this way, shrugging his shoulders, waving his hands above him and moving his hips like the negritos in the videos. Little Gonzalo, Erika, and Michely waved purple and gold banners that swam through the air like fish. She, Victoria, had her hands up above her, waving them in, like he, the Spirit, was a wonderful aroma in the air that she was bringing in closer to her. As he covered her, Victoria breathed him in and she felt taken care of and warm. Papa Tavo and Abuelita glided past her like they used to in their slow cumbia trot, he with his Stetson tipped to the side and her with her long, india

hair before it turned gray. She knew of, but could not see, Gonzalo out there, outside of the host, flickering for a moment, then fading into shade.

While she was still awake, Gonzalo sat on the edge of the bed, took off his boots and pants, unbuttoned his shirt. He slipped under the covers and she knew she would have to change them tomorrow. He leaned over, kissed her, smelling like an old man this way, beer and cigarettes in his skin. Gonzalo paused over her lips, said that he loved her and she pretended to sleep. The kiss was long enough that if she had woken up, parted her lips at all, he would have been on her, making wordless love in the darkness.

He sucked his teeth in his disappointed way and whispered, Buenas noches baby, in her ear, his lips brushing across her earlobe. Gonzalo rolled over and soon he was breathing beer-heavy, mouth slack, not exactly snoring.

Victoria thought, Good night, viejo, and thought of asking him about church in the morning, but did not say anything, because she did not want him to roll back.

She opened her black eyes wide and the circle like the hostia was up there still, but empty now, no dancers in it. The air conditioner kicked on, whispered over the candle flame, making the circle shift, but not go away.

ANNIE DILLARD

How to Live [essay]

ANY CULTURE tells you how to live your one and only life, to wit, as everyone else does. Probably most cultures prize, as we rightly do, making a contribution by working hard at work you love; being in the know, and intelligent; gathering a surplus; and loving your family above all, and your dog, say, your boat, bird-watching. Beyond those things, ours might specialize in money, and celebrity, and natural beauty. These are not universal. You enjoy work and will love your grandchildren—and somewhere in there you die.

Another contemporary consensus might be: You wear the best shoes you can afford, you seek to know Rome's best restaurants and their staffs, drive the best car, and vacation on Tenerife. And what a cook you are!

Or you take the next tribe's pigs in thrilling raids, you grill yams, you trade for televisions and hunt white-plumed birds. Everyone you know agrees: this is the life. Perhaps you burn captives. You set fire to a drunk. Yours is the human struggle, or the elite one, to achieve... whatever your own culture tells you: to publish the paper that proves the point; to progress in the firm and gain high title and salary, stock options, benefits; to get the loan to store the beans till their price rises; to elude capture, to feed your children or educate them to a feather edge; or to count coup or perfect your calligraphy; to eat the king's deer or catch the poacher; to spear the seal, intimidate the enemy, and be a big man or beloved woman and die respected for the pigs or the title or the shoes. Not a funeral. Forget funeral. A big birthday party. Since everyone around you agrees.

Since everyone around you agrees ever since there were people on earth that land is value, or labor is value, or learning is value, or title, necklaces, degree, murex shells, or ownership of slaves. Everyone knows bees sting and ghosts haunt and giving your robes away humiliates your rivals. That the enemies are barbarians. That wise men swim through the rock of the earth; that houses breed filth, airstrips attract

airplanes, tornadoes punish, ancestors watch, and you can buy a shorter stay in purgatory. The black rock is holy, or the scroll; or the pangolin is holy, the quetzal is holy, this tree, water, rock, stone, cow, cross, or mountain—and it's all true. The Red Sox. Or nothing at all is holy as everyone intelligent knows.

Who is your "everyone"? Chess masters scarcely surround themselves with motocross racers. Do you want aborigines at your birthday party? Are you serving yak-butter tea? Popular culture deals not in its distant past, or any other past, or any other culture. You know no one who longs to buy a cow or be named to court or thrown into a volcano.

So the illusion, like the visual field, is complete. It has no holes except books you read and soon forget. And death takes us by storm. What was that, that life? What else offered? If for him it was contract bridge, if for her it was copyright law, if for everyone it was and is an optimal mix of family and friends, learning, contribution, and joy—of making and ameliorating—what else is there, or was there, or will there ever be?

What else is a vision or fact of time and the peoples it bears issuing from the mouth of the cosmos, from the round mouth of eternity, in wide and parti-colored utterance. In the complex weave of this utterance like fabric, in its infinite domestic interstices, the centuries and continents and classes dwell. Each people knows only its own squares in the weave, its wars and instruments and arts, and also the starry sky.

Okay, and then what? Say you scale your own weft and see time's breadth and the length of space. You see the way the fabric both passes among the stars and encloses them. You see in the weave nearby, and aslant farther off, the peoples variously scandalized or exalted in their squares. They work on their projects. They flake spear points, hoe, plant; they kill aurochs or one another, they prepare sacrifices—as we here and now work on our projects. What, seeing this spread multiply infinitely in every direction, would you do differently? No one could love your children more; would you love them less? Would you change your project? To what? Whatever you do, it has likely brought delight to fewer people than either contract bridge or the Red Sox.

However hypnotized you and your people are, you will be just as dead in their war, our war. However dead you are, more people will come. However many more people come, your time and its passions, and yourself and your passions, weigh equally in the balance with

those of any dead who pulled waterwheel poles by the Nile or Yellow River, or painted their foreheads black or starved in the wilderness or wasted from disease then or now. Our lives and our deaths count equally: or we must abandon one-man-one-vote, dismantle democracy, and assign six billion people an importance-of-life ranking from one to six billion—a ranking whose number decreases, like gravity, with the square of the distance between us and them.

What would you do differently, you up on your beanstalk looking at scenes of all peoples at all times in all places? When you climb down, would you dance any less to the music you love, knowing that music to be as provisional as a bug? Somebody has to make jugs and shoes, to turn the soil, fish. If you descend the long rope-ladders back to your people and time in the fabric, if you tell them what you have seen, and even if someone cares to listen, then what? Everyone knows times and cultures are plural. If you come back a shrugging relativist or tongue-tied absolutist, then what? If you spend hours a day looking around, astraddle high on the warp or woof of your people's wall, then what do you learn to take to your grave for worms to untangle? Well, maybe you will not go into advertising.

Then you would know your own death better but perhaps not dread it less. Try to bring people up the wall, carry children to see it—to what end? Fewer golf courses? What is wrong with golf? Nothing at all. Equality of wealth? Sure; how?

The woman watching sheep over there, the man who carries embers in a pierced clay ball, the engineer, the girl who spins wool into yarn as she climbs, the smelter, the babies learning to recognize speech in their own languages, the man whipping a slave's flayed back, the man digging roots, the woman digging roots, the child digging roots—what would you tell them? The future people—what are they doing? What excitements sweep peoples here and there from time to time? Into the muddy river they go, into the trenches, into the caves, into the mines, into the granary, into the sea in boats. Most humans who were ever alive lived inside one single culture that never changed for hundreds of thousands of years; archeologists scratch their heads at so conservative and static a culture.

Over here, the rains fail; they are starving. There, the caribou fail; they are starving. Corrupt leaders take the wealth. Rust and smut spoil

the rye. When pigs and cattle starve or freeze, people die soon after. Disease empties a sector, a billion sectors.

People look at the sky and at the other animals. They make beautiful objects, beautiful sounds, beautiful motions of their bodies beating drums in lines. They pray; they drop people in peat bogs; they help the sick and injured, they pierce their lips, their noses, ears; they make the same mistakes despite religion, written language, philosophy, and science; they build, they kill, they preserve, they count and figure, they boil the pot, they keep the embers alive; they tell their stories and gird themselves.

Will knowledge you experience directly make you a Buddhist? Must you forfeit excitement per se? To what end?

Say you have seen something. You have seen an ordinary bit of what is real, the infinite fabric of time that eternity shoots through, and time's soft-skinned people working and dying under slowly shifting stars. Then what?

CLYDE EDGERTON

Debra's Flap and Snap [fiction]

LYING HERE NOW, I can look back.
I was always overweight, though not a whole lot, and was never popular with the boys in high school because of my weight. But L. Ray Flowers liked me enough to, you know, do something ugly in front of me in his car one night, the night of the eighth grade dance—after the dance—and I want to go ahead and tell about that night.

It was the only time I went to a school dance. I never was invited to the prom. There were lots of dances after the high school football games, and I went a few times with other girls but didn't dance.

L. Ray was in special education, but he went on to be an evangelist, and had a radio show and for a while, a television show out in the Midwest somewhere. He got to be pretty famous—got a big hair hairdo, the works.

He killed a woman trying to heal her one time. It was a freak accident. You can look it up. It happened out there in the Midwest and the local papers here carried the story. What happened is that they were up on a pretty high stage and she walked backwards in ecstasy off the edge of the stage, hit her head on the base of a flag stand and died on the spot. Honest. Her husband sued L. Ray and lost. Think about the places they put American flags. At restaurants they fly them in the rain and at night. My daddy was always concerned about the flag. He fought in World War II.

L. Ray was seventeen when I was in the eighth grade and he was in shop. They didn't have special ed back then. They just called it shop. I was fourteen. And I don't think the fact that I was overweight made one bit of difference to him. It was not something that mattered to him it seemed like. He didn't feel like he had to be like everybody else in this respect and shun the overweight, or ugly in the face, or anything else. In fact one of the ugliest girls in our school, in the face, had a body I would have killed for and nobody would date her except

L. Ray and L. Ray ended up marrying her. That's the truth. But it didn't last. Another story.

See, I have always hated L. Ray for doing that—masturbating is the word—in front of me the way he did. But the more I've thought about it, and the way he's ended up—his radio show failing and him losing everything to the IRS—there is a way in which I feel sorry for him, too. Although that is not exactly what I mean. I can't quite say it right. He didn't have to take me out is one of the things. He chose me over everybody else. I also can tell about it now because it was long before what all you see on television and especially the movies nowadays.

This happened in 1956 and that's all it was—what he did. Think about what people do in cars and everywhere else nowadays. But even back then my dancing and his dancing were on the same wavelength. Even though I'm feeling a little contradictory I can also say that the experience at the time left me feeling filthy, and thus mad at L. Ray. And I'm sure he forgot me. See how complicated it gets. And he never asked me out again after that night, which I regretted only after I got married. You can see something about my husband from that. My first husband.

As to L. Ray these days, I've seen him up here twice visiting his aunt. She's just been here a few days. I asked Traci, because I thought it was L. Ray. He stood outside my door talking to somebody—looked in here but didn't recognize me. I guess he's over sixty now. Let's see... he should be sixty-one. He looks a lot the same, except for his white hair. He's about six feet two, narrow shoulders, little pot belly, fairly long white hair he combs forward and then sweeps around. He's got a kind of red-head complexion, and those black snake eyes, set back in his head and sometimes looking almost crossed. And real narrow lips. His eyes are quick, quick, quick. I saw him one time maybe a year ago, when I was in the checkout line at Food Lion before I got sick. He was two people in front of me, had done bought his food and had come back to the check-out girl with his long receipt. Wanted to see a coupon he'd just used—or something about a coupon. The coupon was for fifty cents and he hadn't got credit, he said. He showed the receipt to her and she told him the coupon was for something different, slightly different, than what he'd got—like a wrong kind of cereal or something. Would he like to change them, she said, and he said yes

and looking kind of intent, headed back into the store up the checkout line, right by me. Just then he caught the eye of the man standing behind me, somebody who might have been a little perturbed about him holding things up, and he gave him that big, gentle, little boy smile and said, "How do you do?"

It was the eighth grade end of the year dance. And in assemblies and parties and trips and all that, shop was considered eighth grade. Whenever all of us in eighth grade went roller skating, shop went along.

I was a very friendly overweight person, not the depressed, withdrawn type. I was like Miss Piggy in a way, if you can get a picture of Miss Piggy in your head—her sort of like a cheerleader jumping in the air, tossing flowers out behind her. I was this kind of person, always very happy, with lots of girlfriends, always talking, always giggling about the boys and things and always full of curiosity about who liked who and who was going steady with who. And for the entire eighth grade, L. Ray kind of liked me. I could tell it but at the same time I wouldn't admit it to anybody because L. Ray was in shop, and they all met with Mrs. Waltrip down there—where they had electric saws and everything. They didn't do shop—they just met down there. People who went down there for woodwork would just more or less put up with them. On second thought, some of them did do shop.

So, anyway, I had bunches of girlfriends and then too I was a go-between between girlfriends and boyfriends. You know what I mean. I was somebody overweight who would take messages from a girl to a guy and back, giggling when I needed to and looking forward to gossip in general. I made all As, too, and teachers liked me. I was not bad looking at all. I never had the first pimple if you can believe that. And I was class secretary my sophomore and junior year in high school. Not much other than that, though. Not much to write home about.

L. Ray was really dressed up that night. My mama and daddy were okay with him picking me up. Most anything was okay with them. I had five brothers and sisters and a lot going on, and I lied to Mama and told her that L. Ray was in the tenth grade, which of course he would have been if he hadn't been in shop. No, he would have been a junior or senior.

He was intense looking like he is now, but of course he had red hair then, a kind of dark red, and his eyes had that quickness and he had that thin-lipped mouth that would always break into a big smile at nothing, right when he was looking so hard through those eyes. That gives you a picture.

He brought along a present when he came to pick me up, and I knew enough to know that that wasn't required. It was a brown leather billfold—with the flap and snap and a change purse and zip-up paper money holder. It was in a box, wrapped nicely, with a big white bow. It was green paper. When the door bell rang and I opened the door, there he stood with that green present.

As you might can tell, L. Ray was not unpopular, nor was he like other people in shop. It was like he, and therefore everybody else, knew in some kind of way that he didn't belong there. He actually seemed pretty smart, and back then in times when boys combed their hair, he combed his very nicely. Dark red hair.

L. Ray was always talking to people, patting them on the back, laughing out loud at his own jokes, making fun of people in nice, very acceptable ways, and all this. He actually had a kind of adult presence about him. I do admit that I'd always felt something a little bit strange about him, but because he liked me, I overlooked this feeling, and now looking back on everything, I'm convinced that the strangeness which caused him to do that in front of me is the strangeness that I felt.

He was standing there in a light grey suit, white shirt, bow tie, and black shoes—holding that green present with the white ribbon and he gave a little bow with his hands under his chin like a Japanese. Which is something I forgot—that Japanese bow. He stuck the present under his arm just before he made the bow. Just about anytime L. Ray came up to you and spoke, he'd do that—give a little head bow with his hands in prayer-fashion below his chin. But this was before he really got religion and went on the road as an evangelist. That happened mainly when he left the Baptist Church and joined the Pentecostals.

It was to be a big night for me. It was my first date. (And, it turns out, the last to any kind of dance. I only had six real dates as a teenager.) I didn't imagine at the time anything could go wrong. I of course was wondering if he'd try to kiss me goodnight, but in the main I was seeing this as the beginning of a high school career of dates and fun

times. I hadn't for some reason connected being slightly overweight to being unpopular with the boys. All that didn't dawn on me until later. After all, L. Ray was a boy and had been interested in me for a whole school year.

Daddy was a house painter and Mama worked at the laundromat and they both worked unpredictable hours which is why they weren't home. This was not long before they broke up, which was when I was in the tenth grade.

I was wearing my sister Teresa's blue crepe-like dress with the silk top and frilly bottom and fake pearls and earbobs and lots of lipstick and eye makeup. Teresa was seven years older than me and married. She had always been normal sized until after her first child and then during the next year or so she got to be about the size I was at fourteen.

I remember me and L. Ray walking down the walk to his car. We had a rock walkway, flat slate rocks lined up, but they were too close to each other so that if you took regular steps you'd hit in between every other one or two unless you took short steps. I took short steps to hit every one and so did L. Ray—I guess, coming behind me. He let me go first. It had rained and the wet grass hadn't been cut. L. Ray's black shoes were patent leather. He was always saying something funny, always making a joke. When we got to the end of the walkway he showed me the beaded water drops on his shoes and got real serious and said something like, "Looks like little water worlds resting on the hard dark universe, don't it." See. He'd surprise you. He was not a bad evangelist—even that early.

He opened the passenger car door for me. It was his daddy's Oldsmobile or Pontiac, one of those big ones with a lot of chrome, but it was very old and worn-out looking also. L. Ray's daddy sold eggs.

"I think I'll stop and get us a pack of cigarettes," said L. Ray. He pulled the car into the Blue Light, which was a main nightspot back then. "And then how about we stop back in here after the dance for a couple of tall Busches."

Me and Belinda McGregor had drunk beer twice. I was ready to bop. There were lights in my eyes. Blue lights from the Blue Light. Red lights from the cigarette I was about to smoke. White lights from the dance. Green lights from the dashboard of the car when we drove off somewhere later, maybe out to lake Blanca. I knew a lot about life. I had gone to the movies with Diane Coble more than once—us

sitting in the back row when Duane Teal would come in and I would sit quietly and watch them out of the corner of my eye. They would kiss for an hour while his hands wandered ever so gently all over her, all approved, accepted, wanted and needed by her. And by me. Not to speak of what I'd seen my sister and her boyfriends do when they stayed over sometimes and all that when Mama and Daddy were gone.

So we arrived, after smoking a cigarette on the way.

The dance was in the library. We parked by the tennis courts and walked around to the front of the school and up the high outside brick steps and in through the doors, and then down that long, long wooden hall. If floors were still made of wood in America then there would be less horror. Wooden halls meant safety, and God knows plastic and cable TV helped bring a horror to America that in my day and my teenage years was peaked out only by this retarded boy doing something in front of me in his daddy's old Oldsmobile or Pontiac. I know what's going on these days. People are killing each other in schools, but so what—people have always killed each other. But not in schools. The problem is that we used to each have a separate nervous system and now people who are alive all have the same nervous system and everybody feels everything on the surface and there's so much to deal with on the surface nothing ever seeps down to your heart.

I regret I never sat on the ground and stared at a tree for a long time just thinking about all the stuff that was going on inside it—I mean a big tree. You sit there, look at it and think about the water going up inside it just inside the bark and on out a limb to visit the leaves and then getting in the leaves and doing what all it does. Photosynthesis and all that. It is something I never had time for of course. But then you have something like a helicopter sitting on the ground not cranked up, and absolutely nothing is going on inside a helicopter unless somebody cranks it up, and then you've got all that expense of fuel, and little fires going off in the engine. It is so different from a tree. We couldn't be satisfied with a tree, we had to go manufacture a helicopter.

Mr. Albright, my teacher, was standing at the library door greeting students. We got in line behind a few couples. We had to show our tickets that had been handed out in school that day. "Debra, L. Ray," he said. "And how are you all tonight?"

"Just fine, Mr. Albright," said L. Ray, in his very adult way. Did his little Japanese bow.

"Have a good time," said Mr. Albright. "No smoking or profanity."

"I'm here to boogie," said L. Ray.

We made our way in through the door, L. Ray stepping back to let me go first, because one of the double doors was closed.

The library had a book smell that held on above the punch and cookie and balloon and crepe paper smell. There was a record player operated the whole time by Paul Douglass who was also in shop, but Paul was certified retarded. He was a favorite of Mrs. Latta, another chaperone, who got him to participate in all sorts of things, for some reason nobody ever knew. He was just her pet, and not even in her class. She taught sixth grade.

Anyway, I could dance like a fool— Teresa, my older sister, had taught me and Melanie, my younger sister—and so could L. Ray, so that's exactly what we did. We danced just about every dance. We were be-bopping. People would stop dancing to watch me and L. Ray dance and I will tell you this: it turned me on. It really turned me on like nothing else. When I did it real hard, I could pick up a leg and twist and turn and bend in a way that it felt like little lightning bolts of gold. It was delightful, and the way L. Ray moved when he was dancing made me hungry for love even at my age or maybe especially at my age. If L. Ray had just had sense enough, he could have worked wonders. If any boy over a period of four years of high school had had sense, they could have worked wonders.

You get the idea of how it was—people dancing, and us dancing like fools, sweating our heads off, and me having one of the best times of my life. We danced and drank punch and danced and drank punch and ate cookies and potato chips, and more than once people stood and watched me and L. Ray dance all over the place, and all that gold lightning through me, and I was thinking to myself, this is what my life in high school is going to be like. Boys will watch me dance and are going to be asking me to football games and dances all the way through high school, and I'll be a cheerleader and popular and very happy. And three or four times I went to the bathroom with my girlfriends and we freshened our lipstick and makeup and giggled

and talked about each other's dates and what we were wearing. There seemed to be no jealously, no bickering. It was a dream night.

Mostly parents came to pick up their children, sticking their heads in the library for their son or daughter, or stepping inside for a minute or two.

L. Ray and I were among the last to leave. We walked down that long wooden hall, and out the door. I remember that door, the clanky handles, and how heavy it was, though on this night L. Ray held it open for me. Then down the steps and around to his car.

"Boy, that was fun, fun, fun," he said. "Want to go out to the Club Oasis for a little while?"

"Sure." I was game for just about anything.

The Club Oasis advertised on the radio and had live bands and all that. We stopped at the Blue Light and L. Ray went in and got two tall Busches in a paper bag.

"Reach in that glove compartment and get me that church key," he said. He got out the beers and opened them, making the swush sound, and then punched a little hole at the other side of the beer can top.

"Drink up, Debra," he said. "Here's to a long and happy life," and we clunked our beer cans together and I took a swallow. It was cold and it helped me move right on toward the top of the world where I knew I was headed. Then he pushed in the lighter, and, since he was driving, I lit us both a cigarette. I was in the boat of my life heading down the River of Heightened-and-Met-Desires.

Inside the Club Oasis I didn't know too many of the girls, because for one thing they were all older than me. But we danced and danced and danced and sweated and sweated and sweated and went outside and smoked a cigarette and I thought L. Ray might try to kiss me, but he didn't, and then we showed the stamps on our hands and went back inside.

The eighth grade dance had been from seven to nine, and I had to be home I figured no later than about midnight. We left the Club Oasis at about eleven. When I got in the front seat with L. Ray this time, I moved a little ways away from the passenger door toward him. He didn't say anything at all as we left, which seemed a little odd, and he hadn't driven more than I'd say a mile when he simply turned onto a side road, drove maybe a half mile and then pulled over on the shoulder

and cut off the ignition. I thought to myself, this is where we neck. I was nervous and I wondered about cars that might drive by.

No sooner was his hand off the car keys, he said of all things, "Debra, have you ever seen a man's pecker?"

I was surprised to death. I thought about my brothers and daddy when they went swimming in the pond. I wasn't afraid or anything—this was just L. Ray Flowers up to something strange. "Yes," I said.

"Well, let me tell you what I'm going to have to do," he said. "I'm going to have to take mine out and give it a beating. It's been a naughty boy, and what you can do for me is sit right there and I think you'll like what you see."

What could I do? I felt like I was locked in a casket.

He sat right there under the steering wheel, unzipped his pants and pulled out his thing. I slipped over against the passenger door and looked out the window but it was like looking in a mirror—the window reflected everything that was in the green light from the dashboard. "Oh, blessed Jesus," he said, and he started masturbating and I just looked out the window at the night and my mind was blank, everything suspended-like, and suddenly there were headlights coming from behind us, and a car whizzed by, and he kept at it, "Oh, blessed Jesus, would you look at me, Debra? Would you look at me?" I couldn't help but see his reflection. He threw his head back and started his hand going faster and...well, I don't need to go into all that here. I just want to somehow explain two things.

The first is the collapse of my insides, of my heart and my hopes. Everything about this was sad and filthy. But at the same time it was clear to me that I wasn't going to get hurt. I did not feel threatened in a physical way, but what had happened might as well have been physical for the hurt and dirty and completely useless and invisible way it made me feel. I tried to look out the window and he said, "Look, look, look," and I said, "I can see you in the reflection, L. Ray. I don't want to look if you don't mind." And he said, "Arrrrrrrrr. Hallelujah! Praise the Lord. Praise the Lord!" Then he opened his door and the inside light came on and he slung his hand toward the ground. I don't mean to gross you out or anything. I'm trying to describe what happened. Then he says, "This is what God gave me, Debra. I can get it going again right away, if only you'll do it with me, if only you do it while I do it and we watch each other. It can make really fun things happen."

I didn't ask him what he meant or anything. I said, "L. Ray, you have to take me home now, or I'm going to tell Mr. Albright."

"Okay," he said. "Let me clean up a little here." He got out his handkerchief. And in no time we were driving home. Total silence. I could feel my face and neck red as a beet.

He walked me to the door, said goodnight, did his little Japanese bow and was gone. I would not look at him in the face.

On the table beside the couch was the box and green paper and white bow. I had the billfold he'd given me in my pocket book. I sat down on the couch and realized my legs were shaky. And then I started crying.

Mama and Daddy weren't home yet, nor my older brothers and sisters, but my little sister, Melanie, came in and said, "Where have you been?" She was in her pajamas. She was seven then. They were soft pajamas, flannel, white with yellow ducks—they had been mine when I was little. She was wearing her thick glasses and her eyes were looking in different directions.

"Where's Mama and Daddy?" I asked her.

"They went to the drive-in."

"Why didn't they take you?"

"They said it was a dirty movie and I couldn't go. Where have you been?" She was standing there. She was the sister I ended up being closest to.

"To a dance."

"Who did you go with?"

"A boy I know."

"Who?"

"Just a boy."

"Was it fun?"

"Yes. I even went to two dances."

"Then why are you crying?" She jumped up on the couch beside me, crossed her legs, and grabbed her toes.

"I'm crying because I'm happy," I said.

"You can't do that."

"Yes, you can. Sometimes you laugh so hard and so long and you have such a good time that there's nothing left inside except crying. You can be so happy you cry and you can be so sad you laugh. The good thing is that I'm not laughing after all I've been through tonight."

"What have you been through?"

"I told you. A dance. Two dances."

"What did you get for a present?"

"I'll show you." I got my pocketbook from the floor at my feet and pulled out the leather billfold.

"Can I have that bow?"

"Yes."

I still have the billfold. I kept it in my pocketbook all the way through the ninth grade, saying to myself that the next time I had a dance date, I would throw it away and buy myself a new one, and somewhere in there I put the billfold, worn-out, in my top dresser drawer, and then along came this disease with me holding on to that billfold, still. In my life it was L. Ray, my husbands, my children, my grandchildren, then my life with illness.

So is it possible for you to understand that that night was supposed to be the first big dance night of my life? Can you understand if you lived this long without ever having much of a nightlife, when dancing was what you were born for, a gift?

B . H . F A I R C H I L D

Frieda Pushnik

> *"Little Frieda Pushnik, the Armless, Legless Girl Wonder," who*
> *spent years as a touring attraction for Ripley's Believe It or Not*
> *and Ringling Brothers and Barnum and Bailey....*

> —from the *Los Angeles Times* Obituaries

I love their stunned, naked faces. Adrift with wonder,
big-eyed as infants and famished for that *strangeness*
in the world they haven't known since early childhood,
they are monsters of innocence who gladly shoulder
the burden of the blessed, the unbroken, the beautiful,
the lost. They should be walking on their lovely knees
like pilgrims to that shrine in Guadalupe, where
I failed to draw a crowd. I might even be their weird
little saint, though God knows *I've wanted everything*
they've wanted, and more, of course. When we toured Texas,
west from San Antonio, those tiny cow towns flung
like pearls from the broken necklace of the Rio Grande,
I looked out on a near infinity of rangeland
and far blue mountains, avatars of emptiness,
minor gods of that vast and impossibly pure nothing
to whom I spoke my little still-born, ritual prayer.

I'm not on those posters they paste all over town,
those silent orgies of secondary colors—blood red,
burnt orange, purple—each one a shrieking anthem
to the exotic: Bengal tigers, ubiquitous
as alley cats, raw with not inhuman but
superhuman beauty, demonic spider monkeys,
absurdly buxom dancers clad in gossamer,
and spiritual gray elephants, trunks raised like arms
to Allah. Franciscan murals of plenitude,
brute vitality ripe with the fruit of eros,

the faint blush of sin, and I am not there. Rather,
my role is the unadvertised, secret, wholly
unexpected thrill you find within. A discovery.
Irresistible, like sex.
 So here I am. The crowd
leaks in—halting, unsure, a bit like mourners
at a funeral but without the grief. And there is
always something damp, interior, and, well,
sticky about them, cotton-candy souls that smear
the bad air, funky, bleak. All quite forgettable,
except for three. A woman, middle-aged, plain
and unwrinkled as her Salvation Army uniform,
bland as oatmeal but with this heavy, leaden sorrow
pulling at her eyelids and the corners of her mouth.
Front row four times, weeping, weeping constantly,
then looking up, lips moving in a silent prayer,
I think, and blotting tears with a kind of practiced,
automatic movement somehow suggesting that
the sorrow is her own and I'm her mirror now,
the little well of suffering from which she drinks.
A minister once told me to embrace my sorrow.
To hell with that, I said, *embrace your own.* And then
there was that nice young woman, Arbus, who came and talked,
talked brilliantly, took hours setting up the shot,
then said, *I'm very sorry,* and just walked away.
The way the sunlight plunges through the opening
at the top around the center tent pole like a spotlight
cutting through the smutty air, and it fell on him,
the third, a boy of maybe sixteen, hardly grown,
sitting in the fourth row, not too far but not too close,
red hair flaring numinous, ears big as hands,
gray eyes that nailed themselves to mine. My mother,
I remember, looked at me that way. And a smile
not quite a smile. He came twice. And that second time,
just before I thanked the crowd, *I'm so glad you could
drop by, please tell your friends,* his hand rose—floated,
really—to his chest. It was a wave. The slightest,
shyest wave good-bye, hello (and what's the difference,

anyway) as if he knew me, *truly* knew me, as if,
someday, he might return. His eyes. His hair, as vivid
as the howdahs on those elephants. In the posters
where I'm not. That day the crowd seemed to slither out,
to ooze, I thought, like reptiles—sluggish, sleek, gut-hungry
for the pleasures of the world, the prize, the magic number,
the winning shot, the doll from the rifle booth, the girl
he gives it to, the snow cone dripping, the popcorn dyed
with all the colors of the rainbow, the *rainbow,* the sky
it crowns, and whatever lies beyond, the One, perhaps,
we're told, enthroned there who in love or rage or spasm
of inscrutable desire made that teeming, oozing,
devouring throng borne now into the midway's sunlight,
that vanished God of the unborn to whom I say
again my little prayer: *let me be one of them.*

MAKOTO FUJIMURA

Fallen Towers and the Art of Tea [essay]

I F I'D COME out of school five seconds earlier," said my ten-
year-old son C.J. when I finally found him, "I would have been
in trouble." He was covered in white dust, later called "dust of
death," his hair speckled, his black backpack now gray. When the second
Trade Tower collapsed, firemen pushed the children inside and shut the
school doors. The fireball of jet fuel incinerated thousands in a second
and exploded a chain reaction of vehicles. C.J. and his friends ran from
one designated store to another, guided by teachers who told them to
close their eyes. He almost ran into a tree, he said. It was a red maple
that he had helped to plant in front of the school five years before. The
next morning, when we returned to get essential items from our loft
(now at Ground Zero), we walked by the tree, now covered in soot,
each leaf sagging, coated in dust.

I had sat with C.J. on a summer night only a month before in front
of his elementary school, P.S. 234, sharing a verse from Jeremiah 29.
We looked at that red maple tree, the lights of the World Trade Center
windows glowing above us in the evening haze. "Jeremiah told us to
build houses and settle down, and plant trees in Babylon," I said. "Do
you think New York City is like Babylon or Jerusalem?"

It was a lead-in question. The answer is *yes, like both*. The Israelites
were exiled from their identity as God's people, having forsaken God,
and so neither the desolate Jerusalem nor the exilic land of Babylon
would hold any promise for them. The false prophets spoke words of
encouragement, saying it would be a short exile, and God instructed
Jeremiah to buy a field in Jerusalem, as a step of faith and as a seed of
restoration. But God spoke through Jeremiah of a long battle in the
foreign land of Babylon. The battle would be long, even generational, in
New York City as well. "You helping to plant a tree, and being here with
Daddy, living in New York City," I said, " is being faithful in a foreign
land. I suspect we have it better than those Israelites though."

My question to my son has become a lead-in question for me as well. New York City is like Babylon and Jerusalem at the same time, especially now. I survey the damage done to our "backyard." Three blocks away, the stadium lights set up to aid the recovery of bodies cast hallowing white light upon the rubble. Smoke rises like incense from the remains of the towers. Witnessing the devastation day by day, I have crossed the chasm of history, back to the fallen Jerusalem that Jeremiah witnessed. But New York is also the exilic land, and how do I remain faithful here, even among the rubble? Reading the *New York Times*, reading the Bible in the subway, I kept noticing a similar despair in the voices of the prophets of Babylon, then and now.

"Until Tuesday, I was part of a ridiculously lucky generation," wrote a fellow parent at P.S. 234, artist Laurie Fendrich:

> For me, war was what I knew about from movies, reading, and my mother's loss, before my birth, of her brother in World War II. Now, like all Americans, I know something directly about war. I know it as a civilian, having been attacked here, in my own country, my own city, my own neighborhood. After Tuesday, I can no longer speak as a woman, or an artist, or a New Yorker. Speaking in those ways—"speaking personally"—will no longer do. I have to learn how to speak as a citizen.

It has been said that we worship what our tallest buildings represent. Church spires defined city skylines in previous centuries, but have been replaced by those punch-card towers, the pride of our progress. The Twin Towers were the twin visions of technology and commerce flowing right out of modernism. On September 11, out of a cloudless, azure sky, right over the schoolyard, the airplanes cast sinister shadows upon our modern presumption, our trust. The Trade Center used to shade us at hot summer Little League games in Murray Street field nearby. They gave us respite, security. They stood for—and embodied—an economic system that we have come to depend on.

Postmodern art, too, was sustained by capitalism's nurture of modern technology and economy. Postmodernism depended on modern ideals that until September 11 were rarely challenged: build a higher, more impressive building; build a city that will surpass others in economic status and technological vision. The arts require the same presumptuousness, the same innocent belief in our power. Jeff Koons sculptures, Andy

Warhol silkscreens—postmodern art prospers by mocking, like a child, the very hands that feeds it, the hands of modern idols.

How crafty the terrorists who masterminded this catastrophe. Their "art," we must admit, was too powerful, too explosive, and thus all the more sensational. The terrorists accomplished in a single second what no art movement in a century could: their vengeance transcended and shattered the language of ironic distance. Takashi Murakami, darling of 2001 Chelsea and the contemporary art world with his animé-based installations (and his Nihonga—we attended Tokyo National University of Fine Arts Japanese Style Painting Department together), says, "The 'rules' and 'conventions' I learned over the years...have experienced a seismic shift. I must choose now whether to create in the chaos of 'new rules' or not." For many artists I have spoken with, the fires of September 11 exposed the 'rules' of postmodernism as irrelevant and narcissistic. Fendrich even calls for a type of restraint on art making. "Art and images need to be postponed. (I certainly can't think of painting right now.) We need, I think, to achieve intellectual control of our feelings, and direct our actions according to what is right and just, instead of to what pleases us as 'personal expression' or intrigues us as theory."

But the real death-knell for the twin symbols of modernism was not the insipid relativism of the postmodern agendas of our age. It began long ago. The terrorists cleverly turned technology against its makers, injecting poison into the heart of the modern idols, a poison of an ancient flavor, familiar to Adam and Eve. In the garden, the Devil twisted what was given by God to be used for good by injecting our hearts with terror: doubt of God's love and goodness. Terror takes away innocence. Now, having swallowed this poison, we must remember that the flip side of fear is the desire to enslave and control—to be in charge of our destiny.

F. Scott Fitzgerald wrote his lamentation "My Lost City" from the top of the Empire State Building in another dark autumn, 1931:

> From the ruins, lonely and inexplicable as the sphinx, rose the Empire State Building and, just as it had been a tradition of mine to climb to the Plaza Roof to take leave of the beautiful city, extending as far as eyes could reach, so now I went to the roof of the last and most magnificent of towers. Then I understood—everything was explained: I had discovered the crowning error of the city, its Pandora's box. Full of vaunting pride the New Yorker had

climbed here and seen with dismay what he had never suspected, that the city was not the endless succession of canyons that he had supposed, but that it had limits—from the tallest structure he saw for the first time that it faded out into the country on all sides, into an expanse of green and blue that alone was limitless. And with the awful realization that New York was a city after all and not a universe, the whole shining edifice that he had reared in his imagination came crashing to the ground.

The crowning error of the city is in all of us. For the artist, as for Fitzgerald, cities represent both the height of our success and the depth of our failures. Both success and failure expose the error within, showing us that even the greatest city has limits. But the city of man is not limited because of her boundaries. No, the city of man is limited because her foundation is selfish ambition, the desire to control. We are all terrorists in that sense, attempting to twist God-given gifts to serve our greed and leaving Eden poisoned. Fitzgerald imagined falling towers long before the World Trade Centers were built.

Yet it would be a mistake to judge the city, to call it Babylon, to call what happened the judgment of God. Jesus told his disciples to repent when they saw the tower of Siloam collapse, rather than explain it away as God's judgment upon those who died. In our own lives, no matter where we live, we have ground zeros. Babylon and Jerusalem, the exilic and the destroyed, overlap in our cities. Through these ruined cities, the City of God will be built.

Repentance, or the Greek *metanoia*, means turning 180 degrees back to God. Developing a habit, a culture of repentance, will require us to walk straight toward the darkness, including our own imaginative power of vengeance. Our own acts of terrorism toward God drove Jesus to the cross. Jesus's slain body absorbed our anger and defiance, but more importantly, God's just anger toward us. God stands ready to turn our dark imaginations into a vision of the new Jerusalem. Post-September 11 New York is full of fallen idols. But it is not enough to turn from our idols. We must run toward the tower of Jesus.

After the disaster, we drove north. Miraculously, we had been able to get our car out of our garage before it was shut down because of a gas leak. Even at the north end of Manhattan near the George Washington Bridge, we could still smell the acrid smoke. We drove to Oneonta, New York, after dropping off a kind neighbor and her dog

on our way, a complete stranger before September 11. She and her husband had welcomed our family of five into their home that night so that we wouldn't have to sleep in my TriBeCa studio. As I watched the smoke rise from another fallen building, Number Seven, the series of lithographs I had been working on at Corridor Press became a welcome goal. At three A.M. on Interstate 81, thousands of stars lit up the sky, echoed below by the flags.

TriBeCa had been a ghost town that morning. In my head, I still heard sirens shrieking in the bitter night, and my own inept, feeble prayers during my subway ride home as literal hell was breaking forth above us. When I came out on Seventh Avenue at Fourteenth Street, all I could see was the smoke of the fallen towers. I brushed against hundreds of evacuating businessmen and women as I ran toward home. I saw the blood-drained face of my wife who met me at the studio. All three children had been evacuated safely, she told me. Relief.

At Corridor Press, master printer Tim Sheesley and I had been working on a series of lithographs of a medieval pear tree, *Quince,* that I had sketched at The Cloisters. I had exhibited one as part of a triptych at Saint John the Divine's millennium Christmas celebration. On the morning of September 13, as I walked to the printing studio, noting the quiet of the turning leaves, for the first time I saw in my mind the pear tree images printed on thin Japanese paper. I had painted this as a test plate to get used to working on limestone again, and Tim thought the trial piece was successful enough to print [see back cover]. As I pondered this simple image, printed with silver ink, the work began to speak back to me. It was like a small seed bursting into a joyous mess in my mind. I could almost hear it growing.

I told my friends later that I heard the voice of Christ through the image. A voice of Shalom. I had not intended the piece to exist—I meant it for practice only. But sometimes the Lord speaks through our peripheral expressions, like Mary's nard, where expression is allowed to spill out. That voice, like water, spoke out against the voice of fear within, the one that said, *What about the children, now? What about our loft? Do you think it would be left standing? Do we dare move back into New York City?* But as I pondered the print, the whisper of Shalom became more real even than the tree itself.

I wrote in an email to my friends:

Create we must, and respond to this dark hour. The world needs artists who dedicate themselves to communicate the images of Shalom. Jesus is the Shalom. Shalom is not just the absence of war, but wholeness, healing and joy of fullness of Humanity. We need to collaborate within our communities, to respond individually to give to the world our Shalom vision.

Hiroshi Senju, my studio-mate, called from Japan and left a message. He had been traveling, finalizing the plans for a historic commission at Daitoku-ji Temple, the birthplace of the Japanese art of tea. (His was among more than ten messages from Japan. The towers collapsed at ten PM Tokyo time, while many in Japan were watching the news. Many stayed up through the night, concerned about us.) "I realize that everything now has changed," said Hiroshi. "You now have a responsibility to minister and to heal. You have my support in this." In over fifteen years of friendship, it was the first time he had used the word *minister* to describe what I do.

Back in August, the two of us had decided to secure a smaller studio next door, partly to help Hiroshi complete the enormous commission of over eighty screens for the Daitoku-ji Temple, but when he returned, he told me that he wanted to take a break from that project. "I cannot paint in the same way for a while...after looking at Ground Zero," he said. We decided to make the studio a place where local artists could exhibit, dialogue, hopefully find healing. We called it *TriBeCa Temporary,* and dedicated it as an "oasis of collaboration by Ground Zero artists." I was able to secure, almost right away, the help of artists and writers such as James Elaine, curator and artist at the Armand Hammer Museum in Los Angeles, composer William Basinski, critic Tiffany Bell, and Australian-born TriBeCa painter Denise Green, the last student of Mark Rothko. The history of Daitoku-ji, and therefore the history of the Japanese art of tea, will still be woven into our efforts.

Sen-no-Rikyu, the sixteenth-century tea master who is most responsible for the development of the art of tea, lived and died at Daitoku-ji Temple in Kyoto. His teahouse still stands there. In China, tea was a form of celebration during banquets, but in Japan, Sen-no-Rikyu and others refined tea as a form of communication and the teahouse as a minimal conceptual space. In a war-torn period of cultural flux,

Daitoku-ji became the center of activity, and Sen-no-Rikyu became a new culture's main voice.

His teahouse had a distinctive entry called *nijiri-guchi*, built so small that a guest would have to bow and take his sword off. It is no coincidence (but a historic fact ignored by most in Japan) that one of Rikyu's closest confidants, one of his wives, was one of the first Japanese converts to Christianity, the fruit of an influx of missionaries into Japan in the fifteenth and sixteenth centuries. He went with his wife to observe a mass in Kyoto, and there saw the Eucharist celebrated, with a cup—Christ's blood—being passed around. This experience affirmed his vision for tea. His tea would be an art form: a form of communication equalizing any two who took part, shogun or farmer, male or female. As a cup of green tea was passed, the teahouse would become a place of Shalom. Five of his seven closest disciples were Christians, later exiled by Shogun Hideyoshi, who at first gave power and prestige to Sen-no-Rikyu but later hardened his heart against him, realizing, quite correctly, that the egalitarian nature of the art of tea would be dangerous to his power. Shogun Hideyoshi later became one of the greatest enemies of Christianity in history, commanding the execution of thousands of believers, closing Japan for several centuries, and ordering Rikyu to commit Seppuku—the art of suicide—at the very teahouse of Shalom.

For my friend Hiroshi, a practitioner of tea and an artist who stands for today's Japanese aesthetic (he represented Japan at the Venice Biennale), bringing the ancient tradition into the present means finding innovation in today's context. He will exhibit his eighty screens at the Asia Society and the Japan Society before they are installed at Daitoku-ji Temple in an exhibit called *The New Way of Tea.*

TriBeCa Temporary will be a small conceptual space, a Ground Zero teahouse. In such a space, incomplete gestures are acceptable, and even preferred. Perhaps temporary and indefinable statements are the most honest ones we can make. Such gestures must be made; the present darkness beckons us to respond.

"The layers of azurite pigments," I wrote for an exhibit in Santa Fe called *Beauty without Regret,* "spread over paper as I let the granular pigments cascade. My eyes see much more than what my mind can organize. As the light becomes trapped within pigments, a 'grace arena' is created, as the light is broken, and trapped in refraction. Yet my gestures are limited, contained, and gravity pulls the pigments

like a kind friend." The *Gravity and Grace* series that we included in
our first *TriBeCa Temporary* exhibit, exemplifies this "incomplete"
approach. But further, beauty too is defined as a participant in the
suffering of the world.

Art cannot be divorced from faith, for to do so is to close our eyes
to that beauty around us. Every beauty also suffers. Death spreads
all over our lives and therefore faith must be given so that we can
see through the darkness, through the beauty of "the valley of the
shadow of death."

Our prayers are also made of broken, pulverized pigments. Beauty
is in the brokenness, not in so-called perfection, not in "finished"
images, but in incomplete gestures. I wait for my paintings to reveal
themselves. Perhaps I will find myself rising through the ashes.

The Japanese ideogram for beauty is built with two Chinese characters,
sheep and *great*. Evidently, in China, beauty meant a "fat (great) sheep."
In Japan, the word for beauty became more abstract, more refined,
and became associated with death and its sorrow. *Mono-no-aware,* an
expression that captures the sentiment of sorrow (literally "sorrow of
things") points to the notion of beauty as sacrifice. To enjoy the feast at
a banquet, a sheep must be sacrificed. Autumn leaves are most beautiful
and bright as they die. The minerals I use must be pulverized to bring
out their beauty. The great post-war writer Ryunoske Akutagawa
wrote, before committing suicide at the age of thirty-five, "But nature
is beautiful because it comes to my eyes in their last extremity."

I did not realize, when I wrote the above, that my family and I would
witness firsthand, and survive because of, the sacrifice of hundreds of
firefighters. They, along with other heroes of September 11, redefined
life's true expression, something we'd forgotten in recent times, with
our emphasis on theory: their art was in their sacrifice. Their lives
were offered up in response to the terrorist's art of vengeance—their
"last extremity." Theirs was the *metanoia,* turning 180 degrees to face
death head-on rather than fleeing. They are examples of great sheep,
and from their example of sacrificial love, we can begin to know and
experience true beauty.

Our family left Oneonta early on the Sunday morning of September
16, the car full of apples the children had picked from the Sheesleys'
yard, and drove back to New York City. We needed to return for a
time of mourning at our church, The Village Church. We found out

that a few members had escaped from the towers. A few, like us, had been displaced. None was lost.

On that Sunday, C.J. was to be confirmed as a full member and take his first communion, his first public expression of faith. He had been meeting with our pastor throughout the summer in preparation. We wanted to invite family members and friends to join us. We were planning to have a party for him. Now, the best we could hope was to get to the service on time. I asked him, as I negotiated the Catskill Mountains, if he still wanted to go through with it. "Dad, I can't wait. I want to take communion today," he said.

After my fellow elders and our pastor prayed for him, officially recognizing him as a communicating member, he expressed his exuberance with a victory gesture I had seen him give after scoring a goal in soccer. At Communion, he came up to me, his hands cupped as I broke the bread for him, and the voice of Shalom filled my heart again.

"This is Christ's body, bread of heaven," I said to C.J. If God can turn ordinary bread into a sacrament, God can turn anything into a sacrament. There is power of resurrection in this piece of bread going into the hands of a child. These hands, covered in asbestos dust last Tuesday, would be redeemed. God would take the very dust of death and turn it into life, twisted metal into a memorial of hope, and even the broken city of New York into the City of God.

Andras Visky, a Romanian playwright and scholar who was once imprisoned for his faith, told me that "without Communion, there will be no community. Without Communion, there will be no communication at all." Every time we break the Lord's bread and drink the wine, we affirm the foundation of Christ, shaken but not moved, broken but not destroyed. He is the strong tower we run to, and find true refuge in, even as our own towers collapse all around us. This refuge, this communication, this community was what Sen-no-Rikyu desired in his struggle to express humanity in a war-torn time.

With this Eucharistic foundation, we do not need to postpone art, because art flows for us right out of that Table, from the very heart of our universe. If we center ourselves there, then we can go as far as the end of hell and still return home. We can dare to have the innocence of children in a world filled with fear and darkness. Jesus' command not to fear flows from that Table. At the Table, the Great Sheep still resides, inviting us to enter the Beautiful through His suffering.

MARGARET GIBSON

Poetry Is the Spirit of the Dead, Watching

I.

Unpacking books, shelving them
in the library of this old house,
I come across *The Duel,* a chapbook
Louis Rubin made of poems I wrote
before I left school. The book—
barely worn, inscribed
to the boy who would become
my first husband—just to look at it
makes me touch my face
as if touch might summon back
the girl who, like a distant
relative, faintly
resembles me now.
I turn the pages, perusing
a line here, a line there—
stopped finally
by a title so certain, so absolute,
it takes away my breath.

Poetry Is the Spirit of the Dead, Watching

What on earth did I mean by that?
Who was I reading? Coleridge? Yeats?
The Eliot of *Ash Wednesday?*
Listen. *A moss light*
moves the tops of trees,
the hem of a garment walking
in circles, moves patiently and still....
Easter in the poem,
it was April in western Virginia

beneath Tinker Mountain
where I wrote it, the slim trees
puckering with leaves and early
blossoms, shadblow, flowering Judas.

Outside now, a slow rain curtains the house,
sifts through the cedars, beads
on the back of the doe
that crosses the grass in the dark
to eat the day lilies at the garden's
edge. I understand her hunger.
My husband's in bed in another room,
unwell. The fire's made. In Old English
heorth and *heorte*, hearth and heart
are close.
 Ker, ker—
I imagine the crow's chill call.
Let it center me. *Keramos.*
Cremate. Potter's clay.

The roots of words send out their spirits.

We are measured by our light,
said the hermetic and mild
beloved master of this house,
who raised it from collapse
and ruin. He didn't get
his wish to die here,
where the gate to eternity (he felt)
swung on its hinges
open, shut, open—and is swinging
still, he'd say, as the spirits pass by,
watching.
 Alone tonight,
I'll sit with him, with all the spirits
who made this house, hearth, heart.
I would be *with* them.
 Withed.

II.

In the central chimney's great fireplace
the bread oven's set far back—
the woman of the house would have
singed her skirt fetching out the bread,
stirring the kettle of hominy
and winter root crops. In 1680,
a farmer built this house
and scrabbled Connecticut's stones
out of the earth for walls, and a pentway,
for the foundation of a carriage house
said to have been made of bird's-eye maple.
He kept sheep, farmed what he could
in earth studded with glacial rubble.
The house was built by a *poor* farmer
who set gunstock posts,
rough-hewn beams, chestnut
and oak boards for the walls and floors.
The king's wood, seven
of my hands across, meant for
English ships, he cut and nailed
into the wall behind the cellar door,
unseen. The original family
slept in a smoky loft, collected tolls
from anyone who used the road through
their fields to get to North Stonington,
lived poor, died poor, left the cottage
to descendants who, after a few
generations, moved on.

When Hobart Mitchell found the house
in 1950, poison ivy and trumpet vine
furled out the gape in the slumped roof.
It was a critter's den he bought,
with a hundred acres, and for so little
it makes me know what envy is.

Bought it, patched it, fixed it up
between singing tours and
college semesters, lived here with
one wife who died before him,
and with another, dear Jean,
who died after him six months.
Childless, he left us the house
and the road, having put
the wooded ridges, wetland
wolf trees, nurse logs, bobcat,
wild turkey, and deer into a land trust.
We have a few of his books—
We Would Not Kill, which he wrote,
also the chapbook of early love poems
he kept in his desk drawer; and
by Gerald Heard, *Prayers and Meditations*,
which he studied and taught before
First Day's Meeting for Worship.
We have his garden tools,
his manuscripts, and a photograph
of the Himalayas steeply white
above a village in Darjeeling. I wear
his college ring, carnelian and gold.
From Jean we have an earthen vase
from Oaxaca, the blue cloth from
Christmas dinners, the china she
chipped when her hands grew clumsy
with arthritis. Because I wanted
to keep their spirits near me,
I purchased from their small estate
a winged thing, a silver maple seed
that could be fastened by a long
sharp pin.
 In this house,
once the designated poorhouse
in the crossroads town of Preston,
each morning they sat in the silence
of the indwelling Light.

In this room, Hobart used his hands
to heal whoever asked him. At night
for a time they summoned spirits,
moving the planchette across the board,
waiting patiently. They listened to music
before going off to bed and the wild
comfort and wide grace
of their bodies' passion. Outside,
near the well, behind the buckled
old white lilac, Jean
heard a spirit in the wilderness,
so lonely, crying out. She probably
held it in the light—then took it in.

III.

How many years ago, sick at heart and tied to the words of a dying
argument, out of my own darkness I offered the Nameless a sudden,
single-minded plea: *show me the center of the self:* and slept hard,
dreamless, waking in the dark with my whole body full of light. And
what I saw—though I might now say *wheel* or *rose, pulse of fire* or
sunrise—it was not these. I did not feel joy—I was it. I blazed. I did
not think—*There it is* or *Here*. I blazed. Next moment, I was touching
pillow, collarbone, table, wrist, and thinking in metaphor. Flower and
fruit on a single branch broken off the one body of the world of light.

IV.

Tonight, though I would like to ease
the length of my body along the length
of my husband's and enter, breath
by breath, the heat two bodies make,
being *with*—
 tonight I sit by myself
and study the monolith of stone
laid above the fireplace,
imagining the sweat, the struggle,
the sheer will, back-breaking,

and the final pride of heaving
it into place, then the crude clay,
slapped together, to anchor it.
I've seen no lintel stone as great,
but for the one in a crofter's cottage
on Iona—so he was, that Connecticut
farmer, a Scot perhaps, with
bristled eyebrows like my husband's,
like my father's. His, too,
the blue chips of china
I've unearthed in the garden bed
as I shovel down—my muscles sore
with that labor tonight, knees stiff
as I listen to Samuel Barber's
translation of prayer into song—

Thou who art unchangeable,
may we find our rest and remain
in Thee unchanging—
 Kierkegaard's
words, and I see how
one thing builds on another, this room
a poem making room for
Barber, the barred owl's plaintive
hooing in the deep wood,
the far cry of a ferry horn
remembered in the foggy straits
between Mull and Iona—
word on word, stone on
stone, note on note, heaving,
how we rise from the daily midden
of our patch-worked living
and dying.
 What is prayer
if not a marriage
of passion and the opposing need
for quiet loneliness? What is
a poem, if not the death cry

of each moment's hard-won
and abandoned self? What is
the self?

This house, it's a thin place,
I think. The wind outside
might be the wind that summons
the faraway and brings, as near
as breath, the spirit of the dead
watching.
 Who *are* you?
I ask the acres of emptiness
into which everything is gathered
and *is*—
 turning the question
at last toward my own heart,
blind and stupefied—*Who?*

DIANE GLANCY

The Man Who Said Yellow [fiction]

*The camel, I had noticed, was passing, with great
difficulty, through the eye of the needle.*

—Renata Adler, "Brownstone"

WHEN A GREAT RUMBLE of evangelism swept
Brownsville, it left an unswept place around Noe as he
worked in his shed. Noe was the artist, *el artisto*, in his
family. Others looked at him that way. Uncles. Cousins. Neighbors
would come to look in the shed. Strangers who had heard of Noe
would peer in while he worked. Often Noe was unaware of them.
His three sons started going to church with his wife. The house was
abuzz with what was happening. The family had been Catholic since
the Spanish invasion. Now there was an upstart *iglesia*. A church of
their own.

In meetings that lasted into the night, it was said that angels descended
to touch toothaches. Bursitis, arthritis, and cysts were healed. A baby
who had coughed for days was quiet and asleep.

It was the girls who must be at church, Noe thought. Otherwise
his sons would not have been eager to go. His dreams, ah! That was
the origin of art. That was his *iglesia*. That was his Maker, *El Señor*
himself, the road of open dreams. That was where he found his yellow
fever. His yellow works. Canary. Finch. Yellow jacket. Noe also went
to the Laguna Atascosa Wildlife Refuge, the wetlands of Boca Chica,
Los Ebanos Preserve—for images of the wild birds, insects, and small
animals of his carvings, some of them surreal.

Did not the Maker speak of dreams in the book his wife, Hesta,
read to him? *In a dream, in a vision of the night, he opens the ears of
men and seals their instruction.* The Maker was the maker of dreams,
she said, and not the dreams themselves. But Noe did not agree and
brushed her aside.

Sometime later, there were three weddings. Not all at once, but over the year at the church, after the courtings and dinners and parties with the families, Roberto married Inez García. Domingo married Cornelia Gómez. Dagoberto married Elee Padillo.

At least his sons would not marry the daughters of unbelievers, Hesta said. At least they stayed away from the ungodly.

Now that Noe and Hesta were suddenly alone together, they didn't know what to do. Noe kept at work in his shed, carving his wooden pieces, painting them, signing them. The curators fought among themselves for his work. Noe showed his pieces and sold them at the Brownsville Heritage Museum, the Art League Museum, Imagenes Studio, and the Festival Internacional de Otoño in Matamoros across the Mexican border. There had been an article in the Brownsville newspaper about Noe's birds from the center of the earth. Another article followed about Noe's "subterranean cosmos," his ingenious "mythologies of inner aviaries." Hesta sent the articles to their relatives who had gone north to Minnesota for work. She sent them to relatives still in Mexico.

Noe's work shed sat on a hill near his house with its back to the setting sun. Roberto cut a window in the shed for him, to let in the evening light. After dark, Noe could work under a bulb in a metal reflector that caused the light to burn brightly and shine directly on his work. In the day, when the heat came in the window, Roberto installed a canvas awning.

After several years, no children were born and the three wives grieved. "There is a reason," Hesta said.

In Noe's dreams, animals began to appear two by two. When he told his wife, she was beside herself. Maybe God was getting hold of her husband at last. Maybe now he would go to church with her, just as she'd hoped. When Noe's two-by-two dreams continued, Hesta said, "Maybe you'll become a visionary. The end of days must be upon us." She concluded, "There is going to be a flood. Make an ark. Gather animals. That's why there have been no grandchildren."

"This isn't a shipyard," Noe said. "This is the *artisto's* shed with a tin corrugated roof"—where the grackles hopped, making scratching sounds that seemed at times to direct Noe's hands.

"Then make the ark with a tin roof like your shed."

That night Noe heard camels bellow. Muffled but recognizable in the distance. Had he fallen asleep in his shed? Wouldn't his wife be coming to wake him or call him to bed? How could he tell? Male and female. That's what they were supposed to do. Multiply. Replenish.

That's what he did as an artist. Populate the barren world with his art.

"Camels. I see camels coming," Noe said again as Hesta took notes. "A camel train. They are bearing weight. They are with merchants, or the merchants are with them."

Eventually Noe's dreams became darker, murkier. Where did his art come from? Though camels were the central theme of his dreams, he also was flooded with images of Mexican cattle, scrawny goats, lizards, snakes, stray dogs, half-starved horses. In spite of all, he continued work in his shed, three-sided, with the fourth a large door that pushed back so that the front was nearly open to the flat brown hills.

It was as if his dreams, looking into the center of the earth for the birds that flew there, for the animals that burrowed there, had found hell instead. What was hell? What was his definition? His understanding? The absence of dreams and visions? Surely such an important place should have a concept in his mind.

"Hell is when you don't know God," Hesta, his wife, said.

But Noe's theology *was* a man's belief in God. He just wasn't enthusiastic or evangelistic. Noe knew that the Maker, *El Señor* himself, as himself, was there to be reckoned with at the end. Noe would live his life, do good where he could find it to do, be faithful to his work, his art. He would love his wife and family, even when he heard Inez, Cornelia, and Elee scrapping.

What else could Hesta's God, her Maker, her *Señor* himself, want?

Then why these dreams of animals? What was shaping his visions? What journey was ahead? He penciled the shapes from his dreams on a roll of brown paper. He unrolled more of the paper as he drew. He had dreamed more than he realized. What were these shapes? Camels, strange and exotic, he had never seen except in the Gladys Porter Zoo.

He felt something was pulling out his eye.

His sons came of an evening with their plates of flautas and refried beans. Roberto and Inez. Domingo and Cornelia. Dagoberto and Elee, who was never ready, always late. Once Dagoberto arrived without

her. She came ambling in later, quiet and subdued, feeling shame. She
had to make certain of everything. Nothing stayed the same for her.
It moved. Her shoes. Her little anklets edged with tatting. Whatever
she needed, she had to look for. Find. Her world was watery as the gulf
and ever moving. Her dark sullen eyes moped about the room. What
disarray the lives of Dagoberto and Elee would be when the children
came. How loose. Unwired.

Noe continued work on his figures, painting them the yellow of a
papier-mâché dog he had seen in Mexico, trying to find the essence
at the core of yellow. The yellow that turned the eye into it and
would not let it go. If he could look straight at the sun, he would
know it. He would have it. An electrified yellow. The electrification
of yellow. Even the sun could not fade it for years. The sun was what
they had in Brownsville. Licking everything dry. Dulling it. The
brown hills, the brown land, the bottom of the page, the dropping
off into Mexico.

Long ago, he visited his grandparents in a barrio south of Matamoros
in the Republic of Mexico. Inside his grandparents' house, where the
adobe walls were a foot thick, it was cool. The house was built for the
heat. Why didn't Noe have an adobe shed for his workplace? Why was
it a shed made of wood with a tin roof that sat out in the middle of
the sun? The heat waves sometimes rose in his eyes. The whole earth
wavered with Elee's indecision. What had been there in the relationship
with his grandparents—those brilliant days? The irretrievable past was
the ache at the core of yellow.

Noe's grandfather's name had been Lamech. His great-grandfather
had lived long enough that Noe remembered him, whittling on wood
with his bent and swollen fingers, his aching hands. His language the
waltz of the gulf waves. Those days crushed in the past—those words
bled yellow in Noe's memory.

The heat of Brownsville. Despite the large ceiling fans in his shed.
The canvas awning. Despite the spray of water he hosed over the tin
roof in the early evening so he could work after supper when his family
had left for the ongoing revival at the growing new *iglesia*. Where had
it come from? Why had it started? Why did it continue?

Noe thought of an ark with rooms for the animals in his visions.
A narrow window running the length of the ark, just under the tin

roof. One door. A retractable ramp. How would the rain sound when it pecked on the roof? Maybe like a thousand grackles walking there.

Sometimes Noe was still at work in his shed before dawn under the bulb in its metal reflector that accentuated the light. Sometimes at noonday, after lunch, he slept in a hammock in the shade of his yard until the heat subsided a degree or two and he could return to his shed as the sun began to dive into the darkness that waited for it. The sun was the originator of light. The clouds were a garment over it. Garments it seldom wore. Usually it was heat and light and more heat and more light in Brownsville.

Besides camels, Noe's dreams continued with coyotes, foxes, wildcats, the fowl, the creeping things. Snakes in abundance. Scorpions. Fire ants. Termites. Brown spiders with the deadly mark of a violin on their back. How slowly he must pass over words, over visions, over those dreams to see what they were about. They were dangerous. Quick.

When sleep falls upon men, in the slumberings upon their beds— He also had a troubling dream of a black angel, a *Being*, that roamed the hills, that had come out of the earth, that had escaped from hell, that lay in the sun all day because of the coolness compared to hell, the place that drove everyone mad with thirst. When Noe told his wife, she said it was a black angel, already seen by many in Brownsville. It is what had sent everyone running to church. They were nearly on top of one another there, so many people were crowded together in the small building, and the revival kept growing. What were they going to do? Hesta said the angel was a fugitive from the wars in heaven, who now lived in the center of the earth and would have to go back, who had somehow escaped to terrify everyone as long as it was able and to take back as many with it as it could. Just because someone didn't say Jesus Christ was Lord, hell was laid out for them, Noe asked? Unbelievable. Unacceptable. Just Jesus without saints and priests and confession booths and candles? But *Jesus alone* was the message his wife, Hesta, brought back from church. Yes. In a dream, Noe saw someone chasing the Virgin Mary off with a broom.

His night visions continued. Bright yellow camels, not the fulvous ones in the Brownsville zoo. What was up? He had camelitis, someone said.

What if Noe had to build an ark not for the flood but the heat? "What if I dig a cellar? Submerge the ark?" Noe asked his wife one

evening, wet with sweat, as they ate burritos in the yard. What if they had to flee from the heat that would flourish, that would rift, that would bake and transform the ingredients of the world? What if he was called to build a submarine? That's what they needed. The subterranean places were cooler. Just step into the earth, not deep, but just beneath the surface. Weren't Domingo and Cornelia sleeping in their basement that was always cooler? Didn't Roberto and Inez join them on the hottest nights?

In the meantime, Noe wore his carpenter pouch with his hammer in its cloth notch. He was surrounded in his work shed with metal files, clamps, drills, sandpaper, turpentine, rags, small brushes with bristles hardened with dried paint, chisels, augers, little saws with metal piranha teeth. Whatever it took to file, to whack, to form. Tubes of yellow paint, some of the letters covered with paint, which made the tubes read, *low, el,* and others simply, *yel.*

Noe also built insect cages, aviaries for an imaginary ark. He drew plans for stalls for other animals, glass cages for the creeping snakes. What was this dry flood?

El Señor had given exact measurements, and Noe had not written them down. Then Noe was sombrero dancing in his dreams. He was at the 1840s Palo Alto Battlefield National Historical Site near Brownsville. Noe was at war. He was brushed by the history of the Mexican American War that changed the shape of both countries.

The earth was filled with violence, hunger, and need. That was a clue. It was a game of Clue he had played as a boy. In the dream, the game had been in Spanish. When he was a boy, his grandfather, Lamech, had given him the game in English, so he could learn the language he needed. What Clue was *El Señor* giving?

God was giving hints in Noe's dreams, and Noe was losing them. His wife put paper and a pencil beside his bed. "Wake me," she said. "I'll take notes. I will do the writing. But I need measurements. Instructions. Why would they be given to you who work in your shed instead of coming to church with us? Tell me what you see." But Noe's dreams were like someone talking from under water.

One door. Windows at the top. A tin, corrugated roof. Grackles scratching there.

Word got out. Somehow Hesta let it slip. Noe was having visions of camels and other animals, two by two. The church went wild. Cornelia

said it was an aviary itself. Inez said they would all want in. How could he build an ark big enough?

His shed was an ark, wasn't it? A place of refuge in the flood of family and world events. He had sanctuary. He had been replenished. But once the flood started—if there was going to be a flood—would they all try to crowd into his work shed as Inez said? Was it the black angel playing tricks? Was it a ghost whose purpose was to confuse?

What was he supposed to do? Noe built birds, not arks. He sat by his light bulb in its metal reflector. The insects swarmed. Did they know they would die unless they could keep flapping their wings for as long as the flood remained? No, the rain on their wings would bring them down.

"Doors tall enough for the camels," Cornelia said.

"And the giraffes," Elee said.

Noe hadn't thought of them. And of course doors wide enough for the elephants.

What would they do as they sat in the ark surrounded by the beasts, the fowl, the creeping things? Was that what *El Señor* wanted? In Noe's night visions, the whole town sat crowded together in the ark as they waited for the rising waters. Weren't the icebergs melting? Wouldn't they raise the sea level? Wasn't the sea coming up to claim the land? Yes, the gulf would rise. It would cover the Rio Grande. It already was rising, and no one knew what to do. Nightmares and hell were giving evidence of themselves. Was the overpopulation of grackles everyone noticed like the gathering of bad spirits ready for an impending decimation? How long would they float in a flood? And what if Noe built an ark and there was no flood? What if, after Noe's death, his sons used the ark as a bait shop for fishermen on the gulf shore? What if his dreams were a deluge he couldn't stop?

But there was not supposed to be another flood. He remembered a promise of some sort. Hesta seemed unconcerned.

In the night, Noe could hear the black angel rip the hills with its teeth, the mad Being that escaped from hell in the center of the earth. In the afternoons, Noe walked the brown hills. Would he be the last to catch on, like Elee, his daughter-in-law? As he walked the hills in despair, he was stopped as an illegal, but the border patrol brought him home, and Hesta testified that he was a citizen and her husband. Despite his family's fear of the black angel, Noe continued to walk the

hills, following the quavering heat waves, this time with identification. He roamed for weeks. His feet swelled. Bushes scratched his arms. His face sunburned. His children pleaded with him. When would God let her husband go, Hesta thought?

Then the Maker, *El Señor* himself, appeared, wearing a yellow poncho. For a while he watched the hawks. The falcons. The predators. The helicopters from the border patrol. He listened to the upset world with its waters rising. Once in a while, Noe looked at *El Señor,* waiting for the Maker to speak. Soon *El Señor* announced that hell was dreams and visions without *El Señor* attached. The Maker said he had waited for Noe to speak to him. He wanted to tell Noe that he had confused his own dreams with the Maker's, the giver of dreams, just like his wife had said. What would float then was a work shed, an ark of clear vision. Noe's art was still his oar, his only hope, but if Noe would listen to the Maker's dreams, he would understand that it was not an ark that *El Señor* wanted. He wanted Noe to build a church. "I want you to paint it the yellow of your birds and animals," God said, rubbing his fingers together. "I saw your work at Imagenes and the Heritage Museum. I knew I wanted it for one of my churches." It was Noe's yellow that had drawn the Maker like flypaper.

Was it all a fluke? Or had the Creator spoken to Noe on the anklebone of America? Yes, that was Brownsville. No, the foot bone, the toe bone just across the North American border. God had the gumption to come, then leave as quickly as he had appeared—with a trail of burros in his wake. For a moment the sky seemed to open to let *El Señor* and his burros back into heaven, and Noe saw a light that sliced his eyes like a carving knife until he closed them.

Noe had misplaced *El Señor* in his own head, where the Maker was supposed to swim on the floodwater of Noe's thoughts. Yes, Noe had seen himself as Creator. The Great and Old One. Noe fell down on his knees in the floodwaters of regret. When Noe returned to work in a heated fervor, the canvas awning blew up in a sudden storm-wind, and the work shed looked like it had a sail. The townsfolk came to watch. They knew Noe had a vision. What was he building? No, he was drawing—he was drawing plans for their church. In the end, *El Señor* was going to enlarge the *iglesia.* It's what they had prayed for, Hesta reminded them. Noe saw the dimensions in his dream. This time he wrote them down. Noe, the repentant *artisto,* would be used to build

a church, or draw it and show others how to build, or help build. The animals in his dreams had been the people, burden bearers, workers, men and women who carried the weight of their families—also the hungry, the sick, those who needed sanctuary, those who had been scorpions, who had wounded others and now sought redemption.

The ark was *El Señor* himself, Noe's wife said as the family gathered with their chile rellenos and refried beans. Sometimes mystery turned up like a canvas awning. The ark was a type, a metaphor for safety on the floodwaters of the world. Once in an everlasting while, some dust blew up in the heat, stirred by the winds from heaven, and left a puddle of revelation—a downpour of sorts on a level Noe had not expected, nor even desired.

PATRICIA HAMPL

A Week in the Word [essay]

IF I NEGLECT to take my flashlight up to the monastery chapel
for Vespers, I will regret it later when, sloshing blindly through
puddles left in the rutted dirt road by the recent downpours, I
stumble back in the dark to my—hermitage. The word interrupts with
a medieval hiccup this—how do we describe this culture of ours?—this
postmodern world, this banquet of possibilities. Just as this week-long
retreat interrupts my own life "down there," as I already think of
home. I'm on a mountain, praying, thinking my thoughts—or rather,
trying not to think them for once. I am living not simply "away," in a
geographic sense, but out of time, out of modernity, in this California
monastery.

Meanwhile, our postmodern culture still revs along, inside me
too—so many choices all jumbled together, and just one stomach.
We have chosen the name for ourselves: we are no longer souls as
we once were, not even citizens; we are consumers, grasping at the
disorder of life, all the *stuff.* Order is not our thing. *Only connect,* great
grandfather (who was a modernist) instructed. A few generations of
only connecting, and here we are.

And what a strange *fin de siecle* it is. Not exuberant and brainy like
the eighteenth century's mind bounding out of the Enlightenment
looking for trouble, looking for progress, and not swooning like the
nineteenth century, the Romantic heart sopping up sensibility with
its Swinbirne. We're not sad like that; we're sated.

Maybe we don't need memory here either. Like order, memory is
selective, too constrained. Besides, it is parochial and specific, terribly
local. We don't want memories. We'd rather have theories, constructs,
opinions *about* memory. The littleness of real memories is a burden,
also an annoyance. No things but in ideas—that's how it is with us.
Memories (as distinct from "memory") are the sorry consolation of
those who finger their cache of lavender scented old stuff, fuddling
over the past which, if *not* fuddled over, would leave the poor souls
scorched with the truth: they're toast.

We—Americans—hate to be lassoed to the particular like that, like Europeans stuck with their dripping medieval real estate, the grimy pastel villas set prettily on sienna hills, the cobbled corners where their inflamed youth hurtle back and forth on unmuffled motorcycles, rattling the stained glass in the badly caulked basilica embrasures. The kids are trying to get out of there. We understand. Our tradition is to mistrust tradition.

The grotesqueries of leftover cathedrals, the doughty stone enclaves of ancient universities, armless statues, and Della Robbia wreaths—this isn't our kind of Disneyland either. There is no abstraction to it, no illusion of possibility. Especially, there is no freedom *from* it. It is beautiful, beautiful! But where is the trapdoor to the future? That is, to abstraction, to imagining oneself, rather than knowing oneself. For knowing oneself, we seem to know, implies acquiescence to limitations. We aren't ready, not quite, to give in to that—why should we? We're in charge, aren't we? "The only superpower left," we say, claiming our tough guy trophy with meaty hands. The vanity of the imperial glitter rubs off on us, a gold dust all the world longs for and fears. We can't help preening: we've created ourselves. We're nobody's memory.

Strangely, after all this time of being a country—a "great" country— Americans still prefer the idea of the future to the idea of history. In a way, the idea of the future is our history, or at least a version of our cultural history. The filmy future is a can-do place, our natural habitat. But the past is distressingly complete, full of our absence. We seem to know if you take history too seriously, you'll never get out. In the place of national memory we have substituted the only other possible story form: the dream. And the essential thing required of the American Dream has always been that it remain a dream, vivid, tantalizing, barely beyond reach. Just the dreaming of it—which costs nothing, absolutely nothing except every cent of our imaginative attention—inflates the soul. Fills it, rather than fulfill it.

The specificity of memory, on the other hand, is humiliating: You can buck that motorcycle up and down those *rues,* those *strassen* and *borgos,* and still you're caught in your cul de sac, the stained glass Madonna gazing down from her shuddering window with maddening calm. We bolt from the iron apron strings of history. We wish to be free—whatever that means—and we know that memory, personal or civic, does not promote freedom. Memory tethers.

But I am living—one week, maybe two, tourist time—in a niche of memory. Cultural, not personal, memory. It is Lent, and I am on retreat. This is my hermitage. It is a small trailer. Pre-fab, wood paneled, snug. A cell, as the monks still call their own hexagonal hermitages which surround the chapel farther up the steep hill. The idea is not prison cell, but honey-bee cell. The hive busy with the *opus Dei,* the life of prayer.

I am following a way of life, balanced on a pattern of worship trailing back to Saint Benedict and his sixth-century Rule for monasteries. And still farther back, into the Syrian desert where the solitary weirdoes starved and prayed themselves out of history their own mystic way. Benedict's Rule drew all that eccentric urgency into the social embrace. Into history. He took the savage hermitage of the Levant, and gentled it into the European monastery. Made a center out of the raw margin the early desert recluses clawed toward. The convent, after all, says frankly what it is: a convention, part of the social compact which claims order as a minion of tradition.

The monastic day here in California at the end of the twentieth century, like the monastic day at Monte Casino early in the sixth century, is poised on a formal cycle of prayers that revolves with the seasons. It is called the Office of Hours or the Divine Office. It divides (or connects) the day (and night) by a series of communal prayer liturgies. This day, like all days, is a memory of the day that preceded. The day is a habit, the hours reinscribed as ritual. Memory, habit, ritual—those qualities which do not perhaps sustain *life* (which is elemental, fiercely chaotic), but *a life.* A way of life, specific, bound to time with the silken ties of—what else?—words. The West murmurs, trying to locate itself; the East breathes, trying to lose itself.

A simplistic distinction, not entirely accurate. After all, the heart of western contemplative life is silence, and the East, in at least one central practice, chews the word, the mantra. Still, Christianity is undeniably a wordy religion. *Lectio divino,* sacred reading, the ancient practice laid down by the early patristic writers, is alive still today; it is part of the daily routine here.

Augustine, whose *Confessions* I've brought along on this retreat, is the most passionate exemplar of this practice, not simply one of the West's greatest writers, but its greatest reader. The year is 397, and he is composing the West's first autobiography, creating the genre

which lies at the core of western consciousness, substituting in place of the ancient idea of the *story*, the modern literary idea of *a life*. The omniscient authority of the tale told around the campfire turns to ash in the burning voice of the first person singular.

Augustine is, appropriately, hot with his subject, inflamed with the account of his fascinatingly bad life turned mysteriously good. But he only gives this story the first nine of the thirteen books of his *Confessions*. Then, without explanation or apology, as if it were the most natural thing in the world, the work elides smoothly into an extended meditation on the Book of Genesis as if this, too, were "his life."

In fact, the movement from his life to his reading is not smooth—it is ablaze. The narrative becomes more, not less, urgent. *His* story, for Augustine, is only part of the story. There is a clear logic dictating the form of the *Confessions* which unites the account of his life with his reading of Genesis, though this is not a logic we in the late twentieth century see as readily as Augustine's late fourth-century readers would have.

Having constructed himself in the first nine books of the *Confessions*, Augustine rushes on to investigate how God created the universe—how God, that is, created him. And all of us, all of *this*. Reading, therefore, is concentrated life, not a pastiche of life or an alternative to life. The soul, pondering, *is* experience. *Lectio is* not "reading" as we might think of it. It is for Augustine, as it was for Ambrose his teacher, and for these California monks in their late-twentieth-century cells, an acute form of *listening*. The method is reading—words on paper. But the endeavor is undertaken as a relationship, one filled with the pathos of the West: the individual, alone in a room, puts finger to page, following the Word, and attempts to touch the elusive Lord last seen scurrying down the rabbit hole of creation. *In the beginning God created....*

The voice of God is speaking on that page. Augustine, grappling with Genesis in his study, is no less heated—much more so—than Augustine struggling famously with "the flesh." He invents autobiography not to reveal his memory of his life, but to plumb the memory of God's creative act.

"My mind burns to solve this complicated enigma," he says with an anguish more intense than anything that accompanies his revelations about his own life. He understands his life as a model of the very creation that is beyond him—and of course in him. He writes and writes, he

reads and reads his way through this double conundrum, the mystery of his own biography and the mystery of creation.

He makes the central, paradoxical, discovery of autobiography: Memory is not in the service of the past; it is the future which commands its presence. It is not a reminiscence, but a quest.

Yet how bizarre the truncated modern notion of "seeking a self" would seem to Augustine. Autobiography, for him, does not seek a self, not even for its own "salvation." For Augustine, the memory work of autobiography creates a self as the right instrument to seek meaning. That is, to seek God. For what purpose? For praise, of course. For if God, the source, the creator, is found, what else is there to do but praise?

Augustine takes this a step further. On the first page of the *Confessions* he poses a problem that has a familiar modern ring: "...it would seem clear that no one can call upon Thee without knowing Thee." There is, in other words, the problem of God's notorious absence. Augustine takes the next step West; he seeks his faith *with* his doubt: "...may it be that a man must implore Thee before he can know Thee?" The assumption here is that faith is not to be confused with certainty; the only thing people can really count on is longing and the occult directives of desire. So, Augustine wonders, does that mean prayer must come *before* faith? Illogical as it is, perhaps not-knowing is the first condition of prayer, rather than its negation. Can that be?

He finds his working answer in Scripture: *"How shall they call on Him in Whom they have not believed?....they shall praise the Lord that seek Him."* Praise, he decides, antedates certainty. Or rather, certainty resides in longing, that core of self from which praise unfurls its song. This is the same core from which streams the narrative impulse of memory: the wonder of a life lived. In the face (or rather, in the embrace) of creation, there is no way to escape the instinct to cry out.

This is where the Psalms come in. They are praise. More: they are relation, full of the intensity of intimacy, the rage, petulance and exaltation, the sheer delight and exasperation of intimate encounter. This is the spectrum of all emotion, all life. The Psalmist reaches with his lyric claw to fetch it all in words.

Words, words, words. They circle and spin around western spiritual practice. They abide. They even sustain a way of life—this monastic one—which has careened down the centuries, creating families (the Benedictines, the Franciscans, the Carmelites, and others) with lineages

longer and more unbroken than any royal house in Europe. The pattern
of prayer, handed down generation to generation, has sustained this
extraordinary life-line.

Words have proven to be more protean than blood.

The monastic life of the West cleaves to the Psalms, claiming the
ancient Jewish poetry as its real heart, more central to its day than
the New Testament or even the sacraments. The Psalms keep this life
going—the verbal engine running into the deepest recess of Christian
social life, and beyond that back into the source of silence, the desert
of the early hermits.

The idea here in this American monastery, based on a tenth-century
reformation of the earlier Benedictine model, is to wed both traditions—
the social monastery and the solitary hermitage, desert and city, public
and private. It is a way of life based on a historical pattern.

Therefore, this life might be understood as a living memory. It is
also a life lived, literally, within poetry. And as it happens, the name
of this hermitage is Logos. The Word. The word made home. A week
in the word.

Against one wall, the bed. I make it quickly like a good novice first
thing every morning, pulling the dorm-room spread square. Suitcase
stowed beneath—I'm here long enough to want to obscure the truth:
I'm a visitor, passing through. I've never liked being a traveler: I take
up residence. "I'm going home," I say instinctively, returning to my
hotel the first day in a foreign city. So, here: Logos is my house.

Also here, a round table (eat, read, write, prop elbows on, sling
leg over occasionally). Shelves niched in next to the tiny open closet
space where I've installed my books, what I could lug on the plane:
short stories by Harold Brodkey, a writer whose fiction I've sought
out solely because of his searing AIDS memoir, drawn to the art by
the life-as-art. Also a new novel by someone someone else said was
good (not opened), poems I already love, and one new book by Mark
Doty, Augustine with his bookmark, Dawson's *Religion and the Rise
of Western Culture*, plus a dictionary that didn't have the only word
I've looked up so far, and Thich Nhat Hanh with yet another volume
attempting to calm us westerners down, out of ourselves: breathe, feel,
exhale—there. And like everybody on a desert island, the Bible (the
New Jerusalem version).

A rudimentary kitchen runs along another wall; bathroom beyond that, the only other room. And two windows, one to nowhere, hugged by two crowded eucalyptus trees and the vinca-covered curve of the steep eroded dirt road I alone seem to climb to the chapel. The other window, the window that counts, gives onto—paradise. The western rind of America peels off far below into the extravagant white curl of Big Sur. Where the slant of the Santa Lucia range, where we are perched, cuts off the view of the coastline, the Pacific, blue as steel (it is overcast) or ultramarine (on sunny days), appears to be cantilevered below us, a blue platform leading to the end of the world. Sometimes, roughed up by wind and whitecaps, the ocean loses this quality of being architecture; it becomes expensive fabric, shimmering silver. Then, simply, what it is: the vast pool, brimming to the horizon.

This is where I have come. There was no crisis. No, at the moment, heartache or career impasse. No dark night except the usual ones. Doesn't everyone wake up maybe two nights a week, mind gunning, palms sweating? In the eyes-open misery of night, sensation gets mashed to a paste of meaninglessness—life's or one's own. No anguish beyond that to report. Every so often I just do this: go on retreat.

It is not uncommon in this supposedly secular age. Meditation, massage, monasteries and spas—the postmodern stomach, if not its soul, knows it needs purging. Such places are even popular, booked months in advance. Down the coast the Buddhists are meditating, eating very intelligently. Esalen is nearby too, and the place where Henry Miller discovered the hot tub. I could go to the Buddhists, cleanse in the silence, approach the big Empty which is the great source: I believe that.

But I come here, and follow the Christian monastic day laid out like a garden plot by Benedict at the close of the Roman era. I am western; I like my silence sung.

In any case, the day itself is silent. The only words are the chanted ones in the chapel, unless I call home. My thin voice sounds odd, insubstantial. My husband carefully recites all the messages from my office answering machine. I ask if he's okay. He is. You okay? I tell him I am. I love you. Me too—I love *you*. Touching base. The telephone receiver clicks back into its cradle, and the mirage of news and endearments melts. It doesn't disappear exactly—I leave the telephone room, a little booth by the monastery bookstore, smiling,

his voice still in my ear. It's just that conversation has become a bare tissue of meaning, a funny human foible, but not something to take seriously for once. The mid-day bell is ringing, and there is something I'm trying to remember.

That's wrong. I am not trying "to remember" something. I want to get this right, this odd experience of praying all day. More like this: I am being remembered. Being remembered into a memory—beyond historic to the inchoate, still intense trace of feeling that first laid down this pattern. It is a memory which puts all personal memory in the shade, and with it, all other language. In my experience, it is unique, this sensation of being drawn out of language by language which the Divine Office occasions. Praying, chanting the Psalms, draws me out of whatever I might be thinking or remembering (for so much thinking *is* remembering, revisiting, rehearsing). I am launched by the Psalms into a memory to which I belong but which is not mine. I don't possess it; it possesses me. Possession understood not as ownership, but as embrace. The embrace of habitation. Hermitage of the word.

In recent years, I have gone on several Vipassana Buddhist retreats, also silent, where the practice has been sitting and walking meditation. I will do that again because it was what it promised: cleansing, insightful. It felt like the rarest air it is possible to breathe. And its substance was exactly that: breath and its entrance, its exit. Though it was difficult, it was gentle. More: it was a relief. Perhaps especially so for a contemporary western mind, wracked with busyness. It was not a hive, the cells humming.

But here in this Benedictine monastery, even though the day is silent (conversation has been abducted somewhere), the hours murmur. The first morning bell rings at five-thirty. I walk up to the chapel in the dead-of-night dark for Vigils, the first round of daily prayers. The chapel is stark, perhaps to some eyes severe. Not to me: the calm of the place is an invitation. I bow, as each of the monks does when he enters, toward the dark sanctuary. A candle burns there. The honey colored wood chairs and benches, ranked on two sides, face each other. They form two barely curved lines, two choirs deftly passing the ball of chant back and forth across the arched room as, somewhere beyond us, the sun rises and the world begins to exist again.

It is important that this not sound ecstatic. I must leech the exaltation out of the description. Here is what happens: old news is revisited, peeves and praise ritualized (the Psalms don't just exult; they grunt and groan). The call to the elusive one, polished with plainchant, is handed back and forth across the ranks of the honey-colored chairs like an imaginary globe of blown glass passed by men wearing cream-colored habits over their jeans and work shirts, scuffed Reeboks visible below their chapel robe hems. It sometimes seems improbable, ridiculous.

And my mind wanders. There are the monks, looking very much alike in their cream-colored robes, and yet I manage to wonder—is that one gay? The one with the clipped accent—from Boston maybe? The one on the left looks like a banker, could have been a CEO, why not? The guy over here looks like a truck driver. On and on it goes, my skittery mind. Meanwhile, the Psalms keep rolling. A line snags—*More than the watchman for daybreak, my whole being hopes in the Lord*—and I am pulled along.

It can also be boring. What happens in the chapel partakes of tedium. It must. The patterns repeat and return. Every four weeks the entire Book of Psalms, all 150 poems, is chanted. And then begun again, and again, and again. *Sing to the Lord a new song,* we have been saying since David was king. This new song rolls from the rise of monotheism, unbroken, across the first millennium, through the second, soon to enter the third, the lapidary waves of chant polishing the shore of history. There are men here—there are men and women in monasteries all over the world—repeating this pattern faithfully in antiphonal choirs, softly lobbing this same language back and forth to each other. What *is* this invisible globe they are passing across the space?

Worship, of course. But what is worship? It is the practice of the fiercest possible attention. And here, end of the millennium, the ancient globe of polished words, rubbed by a million anxious hands down the centuries, is also the filmy glass of memory. We touch it. But this is memory understood not as individual story, not as private fragment clutched to the heart, trusted only to the secret page. Even in the midst of high emotion, the rants and effusions that characterize the Psalmist's wild compass, there is a curious non-psychological quality to the voice. This is the voice of the intense anonymous self. It has no mother, no father. Or it borrows, finally, the human family as its one true relation. This is the memory of the world's longing. Desire

so elemental that its shape can only be glimpsed in the incorruptible storehouse of poetic image—*he sends ice crystals like bread crumbs, and who can withstand that cold? Our days pass by like grass, our prime like a flower in bloom. A wind comes, the power goes....*

Paging through a picture book of Christian and Buddhist monasteries in the bookstore, stopped by this cutline accompanying a photograph of a beautiful Buddhist monastery, a remark by a dogen: "The only truth is we are here now." The humility of living in the present moment. The physical beauty of the place is eloquent, revealing the formal attentiveness of a supreme aesthetic: mindfulness. The human at its best. And the food is famous there. They are living their profound injunction, honoring the fleet moment, and the smallest life: Buddhist retreatants are asked not to kill the black flies that torment them. Here, when I told the monk at the bookstore that ants were streaming all over the kitchen counter of Logos, he handed me an aerosol canister, and I was glad. I sprayed, mopped, discarded the little poppy seeds of ant carcasses. Sat back satisfied, turning again to Augustine and the mind of the West, figuring, figuring. The sweetish spume of bug spray hung in the air for a day.

Lord, do we need the East. The bug spray has to stop, we know that. Contemplative nuns have told me that without the introduction of Buddhist meditation practice, they wouldn't be in the monastery anymore. "It's thanks to Buddhism that I'm a Catholic," one of them said. I have never been to an American Christian monastery that did not have Buddhist meditation mats and pillows somewhere in the chapel. The gentle missionary work of the East, its light, blessedly unecclesiastical heart, the absence of cultural imperialism, the poetry of its gestures: the bell is never "struck," never "hit." In the Buddhist monastery, it is invited to sound.

But still this handing down of words, still this western practice I cannot abandon, would not wish myself out of. *The only truth is we are here now.* I don't believe we are *only* here. How could I, transfixed by memory as I am, believing in the surge of these particular words down the channel of the centuries? We are here—for now. My conception of this is not of a heaven (and hell) in the future, but rather of an understanding of existence which encompasses history as well as being.

I will ponder the story of your wonders. Imagine that. Imagine living one's life entirely around, within, through, over and under the chanting of poetry. Maybe it is another way, the West's way, of saying *we are here now.* Out of this recitation of the ancient words to reach the stillness of the present moment. The Psalms are an intricate web of human experience, reminding us that we live in history, and that history is the story of longing. Its pulse races.

We enter the dark sanctuary, bow to the flame, assemble in the honey-colored chairs again, two halves of the human choir. Some mornings at Vigils, before first light, it feels strangely as if our little band—fifteen monks, a handful of retreatants—are legion. The two facing choir lines curve slightly, two horizon lines, an embryonic globe forming anew.

We are greeting first light; we are entering dark night. It is all very old, a memory of a memory. And it is new as only the day can be new, over and over. The day is a paradox, and we enter it possessed by time's tricksy spirit, history and the present instant sublimely transposed.

We are here now, the East is chanting from its side of the monastery.

Oh yes, the West chants in response, the antiphon rising as it has all these short centuries, out of the endless memory we inhabit together, *Sing a new song, sing a new song to the Lord.*

RON HANSEN

Writing as Sacrament [essay]

WHEN SAINT JEROME translated the Bible into the Latin Vulgate, he chose the Latin *sacramentum,* sacrament, for the Greek *mysterion,* mystery. We understand these words to be highly different, but their difference is an efficient way of getting at my argument that good writing can be a religious act.

In the synoptic Gospels *mysterion* generally referred to the secrets of the kingdom of heaven, and, in Saint Paul's Epistles, to Christ himself as the perfect revelation of God's will. Tertullian introduced the term *sacramentum* as we know it when he talked about the rite of Christian initiation, understanding the word to mean a sacred action, object or means. And Saint Augustine further clarified the term by defining sacraments as "signs pertaining to things divine, or visible forms of an invisible grace." Eventually more and more things were seen as sacraments until the sixteenth century, when the Reformation confined the term to baptism and eucharist, the two Gospel sacraments, and the Roman Catholic Council of Trent decreed that signs become sacraments only if they become channels for grace. Twentieth century theology has used the term in a far more inclusive way, however, describing sacraments "as occasions of encounter between God and the believer, where the reality of God's gracious actions needs to be accepted in faith" (according to *The Oxford Companion to the Bible*).

Writing, then, is a sacrament insofar as it provides graced occasions of encounter between humanity and God. As Flannery O'Connor noted in *Mystery and Manners,* "the real novelist, the one with an instinct for what he is about, knows that he cannot approach the infinite directly, that he must penetrate the natural human world as it is. The more sacramental his theology, the more encouragement he will get from it to do just that."

Even secular interpretations point to the fiction writer's duty to express the Mystery at the heart of metaphysics. In the famous preface

to his novel *The Nigger of the "Narcissus,"* Joseph Conrad defined a fictional work of art as:

> A single-minded attempt to render the highest kind of justice to the visible universe, by bringing to light the truth, manifold and one, underlying its every aspect. It is an attempt to find in its forms, in its colours, in its light, in its shadows, in the aspects of matter, and in the facts of life what of each is fundamental, what is enduring and essential—their one illuminating and convincing quality—the very truth of their existence.

The highest kind of justice to the visible universe often leads to the highest kind of humility about ourselves. Writing about craft in *The Art of Fiction,* John Gardner held that "the value of great fiction...is not just that it entertains us or distracts us from our troubles, not just that it broadens our knowledge of people and places, but also that it helps us to know what we believe, reinforces those qualities that are noblest in us, leads us to feel uneasy about our faults and limitations."

Writers seeking to express a religious vision often help their readers by simply providing, as Gardner puts it:

> Trustworthy but inexpressible models. We ingest metaphors of good, wordlessly learning to behave more like Levin than like Anna (in *Anna Karenina),* more like the transformed Emma (in Jane Austen's novel) than like the Emma we first meet in the book. This subtle, for the most part wordless knowledge is the "truth" great fiction seeks out.

But I have identified in my own experience and that of many other Christian writers that there comes a time when we find the need and the confidence to face the great issues of God and faith and right conduct more directly.

My first published book was *Desperadoes,* a historical novel about the Dalton gang from their hard-scrabble beginnings, through their horse rustling and outlawry in Oklahoma, to the fatal day in 1892 when all but one of the gang were killed in bank robberies in their hometown of Coffeyville, Kansas. "Crime does not pay" is a Christian theme, as is the book's focus on honor, loyalty, integrity, selfishness, and reckless ambition—the highest calling Bob Dalton seems to have felt was to be as important as Jesse James. But my own religious experience does not figure greatly in *Desperadoes;* most people read the book as a high

falutin' Western, a boys-will-be-boys adventure full of hijinks and humor and bloodshed.

I fell into my second book because of the first. *The Assassination of Jesse James by the Coward Robert Ford* is another historical novel, but is far darker than *Desperadoes* because I was far more insistent on a Christian perspective on sin and redemption and forgiveness. These were bad guys I was writing about, guys who were sons of preachers but did the wrong thing so blithely and persistently it was like they'd got their instructions all bollixed up. If Jesse James was a false messiah for those Southerners still in civil war with the finance companies and the railroads, then Bob Ford was both his Judas and his Barabbas, a self-important quisling who hoped to be famous and who got off scot-free for the killing of his famous friend, but who was hounded out of more than one town afterwards until he ended up as a saloonkeeper in Creede, Colorado. There he himself was killed at the hands of a man who claimed he was evening the score.

It's a form of bad sportsmanship for fiction writers to complain that too few reviewers pick up their hidden agendas, but in fact I was disappointed that the general reading of the book on Jesse James was pretty much as it was for *Desperadoes*. Hidden beneath the praise were the questions: Why is this guy writing *Westerns*? When oh when is he going to give his talent to a subject that matters?

In his essay "Tradition and the Individual Talent," T. S. Eliot asserted that great writing requires a perpetual surrender of the writer as he or she is in the present in order to pay homage and service to a tradition of literature in the past. "The progress of an artist," he wrote, "is continual self-sacrifice, a continual extinction of personality." I was following Eliot's precepts in the wholesale subtraction of my own personality and the submersion of my familial and religious experiences in my retelling of history in my first two novels, and yet I was frustrated that my fiction did not more fully communicate a belief in Jesus as Lord that was so important, indeed central, to my life.

The English novelist and critic G.K. Chesterton wrote in his conclusion to *Heretics:* "A [writer] cannot be wise enough to be a great artist without being wise enough to be a philosopher. A [writer] cannot have the energy to produce good art without having the energy to wish to pass beyond it. A small artist is content with art; a great artist is content with nothing except everything." Everything for me, and

for Chesterton, was the mystery of the Holy Being as it was, and is, incarnated in human life. Everything for me, to go even further, was the feeling that Christianity is difficult, but that Christianity is worth it. I finally got around to a fuller expression of that in my third novel.

Mariette in Ecstasy concerns a seventeen-year-old woman, Mariette Baptiste, who joins the Convent of Our Lady of Sorrows in upstate New York as a postulant in 1906. Her older sister, Annie, or Mother Celine, is the prioress there and on Christmas Eve, 1906, Mother Celine dies of cancer and is buried. On the next day, Christmas, Mariette is given the stigmata—those wounds in the hands, feet, and side resembling those that Christ suffered on the cross. Whether Mariette is a sexual hysteric full of religious wishful thinking or whether her physical wounds are indeed supernaturally caused is the subject of the novel.

I first thought about writing *Mariette in Ecstasy* after finishing Saint Thérèse of Lisieux's *Story of a Soul.* She was the third of her sisters to enter the Carmelite convent of Lisieux where her oldest sister was prioress and, like Mariette, she soon became a favorite there. You may know that Thérèse was just fifteen at the time she entered religious life and she did so little that was outwardly wonderful during her nine years as a nun that when she died of tuberculosis at twenty-four one of the sisters in the convent feared there would be nothing to say about Thérèse at the funeral. She did perform the ordinary duties of religious life extraordinarily well, emphasizing simplicity, obedience, and self-forgetfulness over the harsh physical mortifications that were common then, and she impressed some with her childlike faith in God the father and with her passionate love of Jesus. She *can* seem sentimental at times; there are those who would call Thérèse a religious fanatic and there are certainly psychologists who would diagnose her as neurotic. And then there are people like me who have a profound respect for her in spite of her perceived excessiveness. When you have a tension like that you're halfway to having a plot.

About then, too, I happened upon *Lettres Portugaises,* a collection of letters falsely presumed to have been written by Sister Mariana Alcoforado about her frantic love affair with a French courtier in the eighteenth century. At one point she supposedly wrote the Chevalier de C—, "I thank you from the bottom of my heart for the desperation you cause me, and I detest the tranquillity in which I lived before I knew you."

I was stunned and excited by that line. Emotions like that, I knew, would be at the heart of the novel. I hatched a tale influenced by both those books in which I pretended that the nun I'd modeled on Saint Thérèse of Lisieux would have a kind of love affair with Jesus, with all of a romance's grand exaltations and disappointments, and its physical manifestation would be Christ's wounds from the crucifixion. Further reading about religious women and the phenomenon of the stigmata acquainted me with Anne Catharine Emmerich, Louise Lateau, Theresa Neumann, and, in particular, Gemma Galgani—all of them stigmatics in the late nineteenth and early twentieth centuries.

Some parts of the letters that Mariette writes in the novel are paraphrased from confessions written by Saint Gemma Galgani in 1900 and included in a hard-to-find book called *Letters and Ecstasies*. Quotidian life in my fictional religious order, the Sisters of the Crucifixion, is based on Thomas Merton's account of the Cistercian life in *The Waters of Siloe*. The mass hysteria hinted at in my book was a product of my looking into Aldous Huxley's fascinating history, *The Devils of Loudun*. Simple scenes of the sisters at work and recreation were inspired by a book of photographs taken at the Carmelite convent in Lisieux by Thérèse's sister Céline. The first investigation of Mariette's stigmata is taken from the medical diagnosis of Padre Pio's stigmata in the 1920s. Cribbing and stealing from hundreds of sources, I finally allowed my factual sources to be distorted and transmuted by figurative language, forgetfulness, or the personalities of the fictional characters.

I hoped to present in Mariette's life a faith that gives an intellectual assent to Catholic orthodoxy, but doesn't forget that the origin of religious feeling is the graced revelation of the Holy Being to us in nature, in the flesh, and in all our faculties. If I may be permitted the immodesty of quoting a review, I was trying to stake claim, as Pico Iyer put it, to "a world as close and equivocal as Emily Dickinson's, alive with the age-old American concerns of community and wildness, of sexual and spiritual immensities, of transcendence and its discontents."

Saying the unsayable it possibly was—I felt free to try it because I knew the book would get published somewhere, even if it were a small press, and I knew the books I liked best were not those that seemed tailored to contemporary tastes but those that are unfashionable, refractory,

insubordinate, that seem the products not of a market analysis but of a writer's private obsession.

But in my rebellion against what Yale law professor Stephen L. Carter has termed "the culture of disbelief," I did not feel obligated, as Catholic fiction writers in the forties and fifties often did, to be conformist, high-minded, and pure, as if I were seeking a *nihil obstat* from the chancery. As Robert Stone pointed out in "The Reason for Stories," his essay on moral fiction:

> It must be emphasized that the moral imperative of fiction provides no excuse for smug moralizing, religiosity, or propaganda. On the contrary, it forbids them. Nor does it require that every writer equip his work with some edifying message advertising progress, brotherhood, and light. It does not require a writer to be a good man, only a good wizard.

In fact there may be no obligation for a Christian writer or artist to overtly treat Christian themes. Writing about "Catholic Novelists and Their Readers," Flannery O'Connor affirmed fiction writers whose only objective was being "hotly in pursuit of the real."

Saint Thomas Aquinas says that art does not require rectitude of the appetite, that it is wholly concerned with the good of that which is made. He says that a work of art is good in itself, and this is a truth that the modern world has largely forgotten. We are not content to stay within our limitations and make something that is simply a good in and of itself. Now we want to make something that will have some utilitarian value. Yet what is good in itself glorifies God because it reflects God. The artist has his hands full and does his duty if he attends to his art. He can safely leave evangelizing to the evangelists.

Evangelization for Jesus was generally by means of parables that were often so bewilderingly allusive that his disciples would ask for further explanations of his meaning. Mark has it that "he did not speak to [the crowds] without a parable, but privately to his own disciples he explained everything." Christ's parables are metaphors that do not contract into simple denotation but broaden continually to take on fresh nuances and connotations. Parables invite the hearer's interest with familiar settings and situations but finally veer off into the unfamiliar, shattering their homey realism and insisting on further reflection and inquiry. We have the uneasy feeling that we are being interpreted even as we interpret

them. Early pre-Gospel versions seem to have resembled Zen koans in which hearers are left hanging until they find illumination through profound meditation. A kind of koan is Jesus' aphorism in the Gospel of Luke: "Everyone who exalts himself will be humbled, and he who humbles himself will be exalted."

We are challenged, in Jesus's parables, to figure out how we are like wheat sown in a field, or lost sheep, or mustard seed, or the evil tenants of a householder's vineyard, and in the hard exercise of interpretation we imitate and make present again the graced interaction between the human and the divine.

To fully understand a symbol is to kill it. So the Holy Being continually finds new ways to proclaim itself to us, first and best of all in the symbols of Christ's life, then in Scripture, and finally in created things, whether they be the glories of nature or art or other human beings. And those symbols will not be objects but actions. As theologian Nathan Mitchell puts it, "Symbols are not things people invent and interpret, but realities that 'make' and interpret a people.... Symbols are places to live, breathing spaces that help us discover what possibilities life offers."

The job of fiction writers is to fashion those symbols and give their readers the feeling that life has great significance, that something is going on here that matters. Writing will be a sacrament when it offers in its own way the formula for happiness of Pierre Tielhard de Chardin. Which is: First be. Second, love. Finally, worship. We may find that if we do just one of those things completely we may have done all three.

JEANINE HATHAWAY

Walking My Baby Back Home

Good Friday the church has to get rid of Jesus.
The world is bereft. We consume all our hosts.
The priest gives me two; I pocket one, a dying
god's last wish. Or an ex-nun's chance
to show him around. On the walk home, I frame him
loosely in my palm, flash him at things any one
of my friends might enjoy after long convalescence or
a sudden release from a job.

Here's a familiar sycamore tree. This is called a bike.
Three families live in that house; they are not related at all.
One family lives in this one. Yes, I know they could
shelter some homeless. (If you prick my conscience,
I'll eat you.) The driveway ahead is ours.
Come in. Do you recognize yourself here?
Three glow-in-the-dark Baby
You's afloat in holy water. The desk where I think
about nothing or us will be where you stay
propped against an amethyst—purple, liturgically apt.

I'm sure he's glad to be with me,
so I doze on the sheepskin floor.
When I awake around suppertime
and he's still helpless there,
I come to consider the scandal,
prolonging this last afternoon of his life.
We both know I can't keep him here,
can't save him from dislocation.
Though my ceiling is cracked,
no voice edges through with new rubrics.
I am left with God- or mother-wit
and take him as I would a friend
to rest beyond my lips in a dark place
where death is another word for union.

MARK HEARD

A Musician's Diary [essay]

I MUCH PREFER making music to talking about it. There's something visceral about instruments and voices that transcends words. Louis Armstrong once told somebody, "If you have to ask what jazz is, you'll never know," or something like that.

I'm drawn to producing because it is intuitive. I try to figure out who the artist really and truly is musically, and then capture that on a tape recorder. In this day and age, it is becoming increasingly difficult to concentrate on this, because of the nature of the multitrack recording process itself, and because of the double-duty a producer must do, assisting the artist and answering to the record company for the commercial values of creative choices.

I have had some production contracts with clauses that stipulate the final product must be both technically and commercially acceptable, with the producer held liable should it fail to do so. Of course, luckily, the persons to whom I was contracted happened to be human beings and to love music, and we talked on the phone a lot, and Fedexed rough mixes back and forth so this was not really a problem, but I can imagine that out there in the big-time world it might not be nice to have to be a producer sometimes.

Technology has made it possible for recordings to be as near perfect as possible. You can have an artist spend hours or days on one vocal, filling up countless tracks with alternate takes and assembling the best of all the syllables together, or "punching in" a line until it is perfect.

This is such a common practice that our ears have become accustomed to it, and to be competitive, one must always bear in mind those who spend many hours and many dollars to get the perfect take. It's common for records to cost hundreds of thousands of dollars to make, and for hundreds of hours of studio time to be expended.

I find myself increasingly drawn to the older spontaneous approach. In the early days, things were taken down live, as they happened, in their entirety. Of course, there could be more than one take to choose

from, but when music was mixed directly or mono, there was an energy that is difficult to capture today. I've seen films of Tony Bennett singing live with an orchestra from sheet music and emoting like crazy, and getting it in one take.

George Harrison said of the early Beatles' recordings, "The first album took eight hours to record—the second one even longer."

I like to get an artist ready to do his vocals, get him to remember why he wrote the song, and then get him to sing it without pretension and without melodrama. I always keep the first take, even if there are flat notes, and I generally will not let an artist keep singing past four or five takes. I like to use one take all the way through the song, if possible.

Competitively speaking, there will always be many subtle sharps, flats and rough edges, and by market standards the records I make won't sound as commercial because of this, but I have come to believe that it is these flaws that make a track believable. Luckily, I have worked with some gifted artists, who are accustomed to performing their material solo. The hardest thing is figuring out what else to add once the basic instruments and vocal are on tape. Each song dictates a mood of sorts, sometimes from the outset, and sometimes as it grows, and I try to follow intuition and look for sounds and instruments that reinforce that mood. That is the part I love the most.

If it means in a quiet song turning up a Vox amplifier to full volume and playing a distorted harmonic, I can put several different echoes on it and pull the fader way back in the mix, and it will just be a color. Sounds are indeed like colors, and my hunger for a truer palette of colors grows day to day.

In one song, nothing but a Digeridoo would do. It took me several days to track down somebody who could play one, and he said the only note it played was a G sharp, and the song was in G. Luckily, we could varispeed the tape recorder and have his texture.

Making an album should be fun and not clinical, I think. I am apt to hire musicians sometimes because I know they will have some good jokes to tell. There is nothing like a good joke, usually in the company of musicians I know, the dirtier, the better, to take an artist's mind off: Oh-my-God, this-is-going-on-tape-and-I'm-going-to-have-to-live-with-it-forever-and-ever. It is usually the human things I remember from my sessions rather than the technicalities.

I rarely use charts, indeed, I don't read music, and some of my favorite

players are the ones who see the session as a jam. I'll never forget Byron Berline coming over to play fiddle on Garth Hewitt's record the day after Scuds began landing in Israel. Garth's song was a waltz and began, "Ten measures of sorrow God gave to the world, nine to Jerusalem, one to the rest." It was inspired by Garth's visit with some Melchite friends in East Jerusalem, and had given him a real feeling for the sadness of the situation of the Palestinians living there.

I was setting up a headphone mix for Byron as I played the tape, and he didn't even ask the key or anything, but began playing from the top, without a complete cue mix. Of course, I had hit the record button just in case, and he nailed the whole song first take without ever having heard it before. He was playing his heart out.

I told him it was a keeper, and he, much impressed with the timeliness of the song, asked Garth, "Did you write that song last night?" His emotion about the war was part and parcel of his performance, as it was a jam to him. That's what music is about, and those are the types of experiences I value most in looking for the visceral and unidentifiable thing it is that makes music music, and not something else.

The Radio—April 1990

For the past month I have been producing a Christian artist. The record company is concerned about his sales figures, and would like to boost them by having some songs which would be considered as singles for Christian radio.

I have to keep reminding myself that this is normal in an economy such as ours.

The big rock stations have to be careful in selecting their playlists to get the maximum number of listeners, in order to be able to charge the maximum amount for advertising time on their stations. There are even organizations that test market songs long before they ever get to the airplay stage so that the choices from which playlists are made are as riskless as possible.

The Christian stations operate under similar principles. Every station manager must worry that if enough people call to complain about a song and nothing is done, Joe's Tire Store down the street might pull its advertising. That's a fact of life. You have to play it safe

if your livelihood depends on not offending anyone to this extent.

Obviously, this stifles the creative output of aspiring artists—this imperative to fit the mold. Those who refuse suffer financially—which is also the kiss of death in a capitalist society that knows the price of everything and the value of so little.

The radio guy at the Christian record company called the artist and me to a meeting, where he discussed his strategy for breaking this artist on Christian radio.

First, he suggested some things we not do. On the artist's previous album, which I had produced, we had used some standup bass, fiddle and pedal steel. Our radio man explained to us that these were no-no's this time around. He said the radio stations were scared to play anything with those instruments in them, that it sounded too ethnic. I replied that we had already planned to use standup bass on the new album, and he said, "Well, if you must, but just have the guy play the roots—none of those high-slidey types of notes—nothing too 'ethnic.'"

He proceeded to play us a few songs that were making it on Christian radio. Surprisingly, they were not necessarily heavy in theology—in fact quite the contrary. The lyrics were safe and warm and positive with a bit of mild social concern thrown in now and then. The instrumentation was primarily synthesizer oriented. Very shimmery sounds. Very cut upbeat tempos. Reminded me of the Osmonds.

I got angry. I'm not sure at whom. We began the sessions for the basic tracks of drums and the artist's acoustic guitar. We worked for several days on this, getting a number of songs done, but something in me wanted to play devil's advocate and make a really big hit for Christian radio. I asked the artist if he didn't have some other songs he'd never played me, perhaps something he considered really stupid and inane. It turned out he had just such a chorus.

While the drummer had coffee, the artist and I quickly wrote a couple of verses and a bridge, and the song was ready to record. The drummer was playing too good, I felt. I told him to play stupider fills, like "the people" want to hear. It was a really sappy track.

Next day I called in a keyboardist and asked him to play me his three most "Christian" patches. One of them was bell-piano-shimmery-ish, and I said, "Perfect." Although he is an accomplished player, I had him lay down a simple track full of sweet major thirds. Next came the percussionist. I asked him to not bring his great collection of Latin and

African fare, but the cutest instruments he had, like bell trees, sleigh bells, claves, little bongos, shakers and the like. I had him play warm and fuzzy little counter-hooks through the song—things that might seem like real production value to people who might not know better.

The background vocalists, who normally do more rock stuff, got into the silly mood with me and came up with some really sappy parts, like something out of a bad lounge act in the Seventies. The bass player did big, solid roots, with the occasional pickup as stylized by LA session bassists in the early Seventies.

Everything was finally on the tape. The dictum of, "No—play something even stupider" had paid off. I made a mix with the drums way back (loud drums are a no-no on Christian radio unless you are a very big star—so I put all the drums on one sub-fader for the record company guy to handle himself—where they ended up was 15dB down [I measured it with an oscillator] from where I had them.)

I turned my mix of this new song from the "No, Play Stupider" sessions in. The next day I got a phone call from the radio guy who was very excited. His actual words were, "Mark, we had no idea you were capable of such brilliant production work." I wished I had videotaped the sessions. When the song was released, it went to number two on nationwide Christian radio, and stayed on the chart a good while. Everybody at the record company was excited. After all, these are the sorts of things that assure they'll be able to keep making their car payments and buying shoes for their kids.

I understand that—it's just a job. But I'm not sure how I'm supposed to feel. The whole process had nothing to do with Christianity or excellence; only with making something that sounds like something else you've heard a million times before, and will hear a million times again.

We were recording a song called "I Don't Ever Want to Be without You." The same Christian record company radio guy called me and asked me if we could change the song's title and lyrics. When I asked why, he said, "Because there are two negative words in the title—don't and without ... I'd like some positive ones; can you call the song, 'I Always Want To Be With You?'"

I have had similar experiences on several occasions with my own songs. It's terribly demeaning to write something that tells its story in its own way and be told it fails because it might scare somebody. My God, must we speak with all the candor of a wax Elvis?

Fergus Marsh, a stick player from Canada, and I were working together recently and talking about my experiences with Christian radio, and he mentioned that his brother, Hugh, had recorded an album with a song called, "Rules Were Made To Be Broken," which was constructed of excerpts from a book called *The Bass Saxophone* by a fellow named Joseph Skvorecky.

I got a copy and couldn't believe how frighteningly similar to my experience were some of the rules binding dance orchestras in Nazi Germany—for violation of which a number of musicians were imprisoned in death camps. I quote:

> In this so-called jazz type repertoire, preference is to be given to compositions in a major key and to lyrics expressing joy in life rather than Jewishly gloomy lyrics; as to tempo, preference is also to be given to brisk compositions over slow ones; however, the pace must not exceed a certain degree of allegro commensurate with the Aryan sense of discipline and moderation. On no account will Negroid excesses in tempo be tolerated.
>
> So-called jazz compositions may contain at most ten percent syncopation; the remainder must consist of a natural legato movement devoid of the hysterical rhythmic reverses characteristic of the music of the barbarian races and conducive to dark instincts alien to the German people.
>
> Strictly prohibited is the use of instruments alien to the German spirit, as well as all mutes which turn the noble sound of wind and brass instruments into a Jewish-Free-Masonic yowl.
>
> Also prohibited are so-called drum breaks longer than half a bar in four-quarter beat (except in stylized military marches); the double bass must be played solely with the bow in so-called jazz compositions; if a pizzicato effect if absolutely desirable for the character of the composition, strict care must be taken lest the string be allowed to patter on the fingerboard which is henceforth strictly forbidden.
>
> All light orchestras and dance bands are advised to restrict the use of saxophones and substitute for them a suitable folk instrument.

Nothing too ethnic y'all, none of them slidey-type notes. Heil, baby. Yessir, boss.

Politics

Today I had an interview with an executive from a Christian record company who was interested in signing me to a recording contract. We met for lunch in North Hollywood in one of those trendy Italian vegetarian places where there are six or seven different types of mineral water on the menu.

Allowances were made for each party to give his life story in five minutes or less, between bites of garlic bread and shallots, despite interruptions from the waitress who would be leaving for her break soon, and hoped we wouldn't end up staying all afternoon.

I had my own hopes as the conversation began, as the executive was intelligent and well-read. He was flattering in his remarks about my music and actually quoted my lyrics. He was sure he was going to sign me.

He had a few questions first, however. I don't remember how he worded the questions, or their order, but they concerned, in a pointed and shocking way, my spiritual well-being, and had little or nothing to do with my music.

He said, "These songs seem like they were written by a person who is ... faithful to his wife!" Then he stared straight into my eyes as if to detect some guilty dilation of my pupils.

I asked him what he meant by that.

He said, "Well, these songs seem like they come from the heart of someone who is ... intimately involved with his local church, and is probably an elder!"

I started to figure out that he was prompting me or coaxing me into a ritual confession. I disappointed him, I'm afraid, with the way I shrugged off the question. Why was he asking?

"I'd like to just hear you say, 'God has called me into the ministry of music.'"

I told him that that would probably not be my choice of words, and I would feel presumptuous saying something that implies I'm on a first name basis with the Almighty. I told him that I'm not sure what ministry really is, and that whatever it is, God seems to be kind enough to wrap it into our efforts and sometimes wise enough to bestow it in spite of them.

All he wanted was to hear me use the lingo, recite the mantras of evangelical musicians, kids who have been made to feel guilty using

their musical abilities, and who, as a result, must justify their talents with post-Jesus movement creeds—formula statements that are as culturally nebulous and stale as the Victorian ones against which that movement originally cried out.

He tried several more times to get me to just say the words.

I said that I would make it a point not to say those particular words, if for no other reason than to get him to think about what they meant.

Being a smart person, he knows I would have to do interviews to sell records for him, and that in those interviews, I would be asked the same types of questions, and I would be expected to toe the party line and echo the same litanies—make the "comforting noise," as McLuhan put it.

I told him I just want to write some more songs and put them on tape. I figure the content of the songs and how I choose to answer for myself is my business.

He says he is sorry, even cut to the heart, but he cannot and will not sign me, as, alas, I cannot say the things he wanted to hear.

I say I am sorry he cannot hear the things I'm trying to say.

On Tour, January 1979

Tonight I played at a coffeehouse/club. It was in an old building, and there were what I must assume were paintings of the Holy Spirit or something on the wall, done quickly in bad tempera. The dressing room was an office of some sort, I think. There was no place to sit. I tuned my guitar and was looking through a possible set list when the man in charge walked in. He said it was time to pray, as the concert was to start in five minutes.

After a ten-minute prayer, the gist of which was, "Oh Lord, just sing through Mark tonight and keep him out of the picture altogether," I considered the prospect of lining up a great number of such concerts, then staying at home and sending a cardboard likeness of myself for God to sing through.

I felt like, "Why even bother writing songs?" Why consult your heart and soul in order to expose it, why subject yourself to the gristmill of life and then try to bleed through a pen when it is all so easily reduced?

Why pray to a god who would rather speak through say, a stone? Too bad that God made so many people who are interested in music and so few stones who are.

Needless to say, when I arrived on stage, I was not in the best of all possible moods. I went through twenty-two songs, opting between each not to say anything. I just sang. Having spent over an hour in this manner, and having for the moment quieted the rage inside myself through the therapy of re-living my life on six steel strings, I exited the stage back to the dressing room/office.

Here I was met by the red-faced man in charge who didn't say much, although I heard him clearly. He proceeded onto the stage where he intimated to those present that the man who had just performed could not possibly be a Christian because of the questioning nature of some of the songs and because of the obvious fact that he had not SAID anything, and after all, what is any musician worth who doesn't talk between his songs.

After this information, he proceeded to make up for all I had not said by a gospel presentation seeming to last half a lifetime. He returned red-faced to the dressing room/office, where I still stood, and uttered words to match the color of his face.

Since I had another 13 gigs to play on the tour, he had decided to take it upon himself to call each of the promoters for those gigs personally and inform them of my infidel status. I knew it would be useless to argue. I know I can be stubborn, but I kept asking myself, as we walked through the cold to his dented yellow Pinto, "What good is music if you have to talk about it?"

Ten years later, I was playing guitar on tour for another artist, staying in a hospitality house in Washington, DC. A young girl was serving us a lunch of chicken and rice with fruit and herbs, and handed me a note at the end of the meal. It turns out she had been present at the concert at that coffeehouse/club and had listened to the songs and remembered them, and had forgotten what the red-faced man had said altogether.

Switzerland

We were driven to a house atop a hill overlooking the lake of Neuchâtel. The autumn light and the thin wind made for a striking

light blue color on the surface of the lake, which was further accented by the yellowing leaves in the gardens on the hillsides and the brown-reds of the tile rooftops. We had to climb a couple hundred yards of steps to reach our chalet. It is small with two beds in a loft. There is a nice piano downstairs, but the ground-level floor is a bit chilly for loitering on the ivories.

After resting from the drive and lack of sleep from the long concert the night before, we went to the concert hall for soundcheck. There seemed to be electrical problems—which would persist throughout that night's performance.

After the soundcheck, we talked with members of the local youth-group for about an hour. The church was an old Romanesque structure, and I kept drinking the hot tea we were served to ward off the chill. The walls were damp with condensation. I discovered that the church was adjacent to an excavated Roman-era burial site. We had an hour or two to look around in the musty interior and cold stucco exterior, and the concert began.

There were lyrics projected in German onto the half-rotunda above the stage, onto frescoes so faded they served nicely as a projection screen. Some of the lyrics were out of order, I was told later, and this added a bit of humor for those fluent enough in English to listen and read simultaneously. We talked to a number of people after the concert, most of whom seemed genuinely interested in discussing lyrics, and in discussion itself. A bit different from America.

Afterwards, there was more hot tea and sandwiches. Andrew dropped us off at the chalet in his Citroën, saying, "Tomorrow, I cames to pick you up, then we go eat somebody." I'm sure my German is much worse.

After a number of concerts and meetings, and after talking to quite a number of people to whom we are foreigners, my mind is divided on the way the situation here is as regards the mixture of music with Christianity. Alfredo sometimes seems a typical Christian concert promoter, seeing the concerts as an outreach. Others are simply enamored by American singers who make records in a way that I find rather distasteful. I'm getting a sinking feeling that they are going to make the same mistakes here we have made in America. They want a "Jesus Movement." They want a "Sixties." They see churches, state-run, as cold and heartless places, and the grass to them is greener on the other side of the Atlantic.

They want to be like Americans, and I'm afraid they are looking at the culture that has surrounded American fundamentalist Christianity rather than its tenets, and swallowing it whole.

It is a shame, for the national sense of aesthetic here is remarkably higher than back home. As we were in Lucerne, walking across the old wooden bridge in the center of town, I noticed the oil paintings on the apex of each rafter set in the bridge—quite a lot of them. I asked the promoter if they were re-painted or cleaned periodically. He replied that they were painted in the 1400s and were cleaned once in the 1700s. I asked him if there were ever any problem with graffiti, and he asked me what that was. "You know, where somebody defaces public property with spray paint, or carves their initials into it," I said.

"Why would somebody want to do something like that?" was his reply.

They don't realize what they have, and what they will give up to emulate America.

But a few of the people I've talked to don't really like Americans. They see us as a bunch of people with John Wayne masks on. This, oddly, gives me hope that they won't make all our mistakes here. There are as yet no Christian record labels—everyone has to compete in the same marketplace, and I envy the healthiness of that. We lost it long ago back home, when the Great Religious Segregation occurred. But I think the strength of the American market will eventually burgeon in here with all its ugliness and affect the way they see things.

I just wish the beautiful Swiss could remain isolationists a bit longer and maintain their own style.

Reading Between the Questions

I had sworn I would never do another interview in a Christian publication. I reneged on my promise today. Now, since I am my own record company, I have to take whatever opportunities present themselves in order to promote my music to people who might buy it, so I can keep on doing it. If I had my choice....

The interview went fairly well, as such interviews go. At least I didn't feel attacked. There are two attitudes prevalent in the Christian press as it relates to the music business. Conservatives tend to take one's

spiritual temperature, and I must admit that procedure often feels like it is done with a thermometer of the non-oral sort.

The second attitude is one of "We can be as cool as those secular publications," in which the interviewer wants to feel like an outsider in order to be as cool as he considers the interviewee to be. Both attitudes are, it seems to me, useless, but these folks make their livings that way, and their magazines might help me sell a few records.

Life is much more of a compromise than I ever imagined. In printed media, there is always the angle to consider. No matter what you say, words can be put in your mouth, and usually are, by those of the conservative persuasion. The particulars of what you say are not important.

It's the smell of the interview that seems to matter to them, and if you read between the questions, the primary question seems to be: "But are you really a Christian?" The interview becomes a litmus test. It strikes me as people greeting like dogs. It is a waste of time if you can't move on from that point.

It is especially difficult if a song you have written is hard for them to understand. The unfamiliar causes them to panic, and they want to see the results of your saliva test before they will allow for the possibility that what you have written might be valid.

Funny, if you go through the litmus test for a while, then they will start to listen to you sometimes. But only so far as the next thing you say that sounds unfamiliar to them. I believe this attitude is fostered by fear, and condemns anyone who dares to be a bit different to be assumed guilty until he can prove himself innocent.

I can't count the number of times I have felt hurt inside—that it couldn't just be accepted that I was a Christian—that I had to prove it on their terms and with their words. They can slant the interview any way they wish in their magazine, and make you look like an infidel or a hero.

Dealing with "cool" interviewers can be just as frustrating. People can be so taken with music that they ascribe to it more importance than it has. They find more than is actually there sometimes. With all the new "Christian alternative" labels springing up everywhere, the attitude seems to be: "Hey, we can be just as cool as those bands in the secular world."

It's sad that the Christian music environment has not given these

musicians enough of a feeling of self-worth to the point that they feel they must hide their identity on the fringes and emulate some other pop phenomenon in order to justify their musicianship.

Some try to make the jump to a major label deal. But the music business is no more about truth on the outside of the Christian ghetto than it is on the inside.

Music is a product and a product only in this economic structure. If you find something else in it, then all the better—they'll use that as the angle and sell it to you in larger quantities. But it is nice to see real musical art exist in spite of all these things. The joke is on the business somehow, by God's grace, if you look real hard. It is the people who understand these things, Christian or no, to whom I am grateful after an interview, because usually we are still finding things to talk about after the interview is over.

On a tour a few years ago, I played in a lot of bars. Most people think that bar owners only use music as a come-on in order to sell drinks. But by the end of the tour, I had met a lot of owners of bars and clubs that I really respected—there were so many lovely individual stories.

One couple's lifelong dream had been to open a bar where there could be music they liked and people to hear it. They were not Christians, but they did not mind that I was. They showed us a bit of the town and told us a bit about their lives, and were quite endearing.

Why is it that I felt closer to them than I have with most promoters at Christian colleges I've played? Perhaps we have more in common by virtue of our common humanity than we have differences by virtue of our religions. Maybe the problem in Christian media stems from being taught a reversal of these things, so that a "them and us" mentality takes hold of us, and we have to go on greeting like dogs to make sure that we are on the "us" side of the fence.

Confessional

Music is a solace for me now. As I age, contrary to common sense, I am more and more drawn into it and apt to spend more of my waking and some of my sleeping hours thinking about it, or just feeling about it. It is my escape. What with earthquakes, medical insurance, taxes, correspondence, fatherhood, traffic, lack of job security, I am

increasingly irresponsible, it seems, in that I take on the mantle of Peter Pan and follow the second star to the right directly between a pair of speakers, or to the case that holds my mandolin. To feel the wood in my hands makes up for a variety of stress and pressures that I probably should spend more time worrying about, things which never go away regardless of how caught-up you feel. They do go away for chunks of time, though, when I am making music of some sort.

I don't know why the attraction is so strong. I am surprised haphazardly by the same deep resonances inside when I find myself thumbing through a magazine and come upon a particularly striking photograph, or see a painting hanging in an out-of-the-way place. I'm drawn into the mood of those photographs or paintings—I think of feelings I have had when stopping my car on a cross country drive in the desert and standing there in the windy loneliness for a while, hearing nothing, seeing shadows, the subtle color differences in different heights and textures of blowing grasses, feeling the extreme largeness of the outdoor room and its horizonless walls; or I think of the feeling of waking up in the musty woods with daylight barely filtering through motionless leaves overhead, the dampness on the ground felt as an unheard thud; or the smell of piñon wood burning, and the cold air carrying it into my nostrils, as the sun drapes red dirt and rocks with the crimson curtain of a melancholy sunset; or the feeling of standing helplessly in a fluorescent hospital corridor, watching the minute hand of a cheap wall clock stand still while my Daddy dies a grueling death and steps into eternity.

The primacy of these feelings impels me to capture them, and preserve them in my memory forever; to conjure the magic of something good waiting around the corner, over the hill, tomorrow, on the morning of the resurrection.

Music is my job, so it does not always fulfill this purpose, but usually, at the least, it sets me on the path to it. It is difficult at best to reveal one's true self to those who are closest, much less to friends and acquaintances and audiences. But when you are able to catch a glimpse of your true self, of the beauty you have felt and the despair you have been burdened with, that is something that transcends the antiseptic responsibility of making the daily ends meet.

I wish sometimes that I just didn't have to think about any of this, and could drone away my life. It would be easier. I have worked in a factory, and one becomes a bit hypnotized after some time to the

point where all one can think about is going home, watching TV, having a beer and going to bed—so the cycle may be repeated. The music business can be like this, but I find myself ever thankful that I have not lost the resonances inside when the music is right. I have no idea how we have made ends meet thus far, as I am rather useless in other areas. But increasingly, writing brings about a catharsis of my own terror and pity. It is something I have to do. Dare I say that it becomes an experience of worship for me at times?

When you can see through the fog for an instant, and you understand haltingly and briefly what good is, and how God is connected with that, it cannot help but put a hell of a perspective on things you perceive as problems, and help you discover multiple ways in which you have been numb. For that brief moment you feel that God's in His heaven and all's right with the world.

I've tried to explain this to those family members who are not of the artistic persuasion, and they find it difficult to understand. I find it difficult to understand myself, and sometimes wonder if normal people can feel these strong pluckings of the celestial strings.

Maybe those inclined towards the arts are so spiritually retarded to a degree that we must go through the whole process of cathartic expression just to discover how we really feel. Artistic expression might be seen as a Darwinian protection device for the psyche of fragile individuals, for whom sensuous contact with the outside world is too much to bear, and is repressed, and must be brought up and thrust out into the open from time to time at great effort in order for them to simply survive emotionally.

I only know that I am cursed with doing it.

I must at least tell somebody, even only God and myself, what I have seen and felt. As soon as I think of how I have felt, the words to describe it come, and only need to be written down; the melody is there, and it works its way out of my larynx onto a cheap dictation recorder, to be forgotten or to be listened to later and fleshed out as part of the job. Maybe I'm just a selfish maniac who is wasting his time trying to transfer feelings which perhaps no one cares about onto a fretboard and a piece of magnetic tape. Maybe it's the modern petroglyph, or the modern way to write on the wall of your cave: "I was here." Maybe it is a cry to God about how much I hate the bad things and how much I love the good things.

INGRID HILL

The Ballad of Rappy Valcour [fiction]

THE NEIGHBORS were watching the new couple moving in, some of them peering out from behind ancient shutters, some others boldfaced on their porches or standing right smack in the sidewalk, a few little barefoot wild children—two black, two white, one café au lait—circling in and out of the new couple's moving, like leaves in a muddy stream's eddy. The shotgun doubles that lined Saint Pé street, a hundred years old if they were a day, seemed ready to crumble to powder and blow away not too long off in the future.

There was none of this gentrifying business that was happening other places in New Orleans: people with new money buying up houses they loved for their high ceilings, putting in central air, then silly elaborate ceiling fans—just pretty much for show—fresh Gothic gingerbread scroll-sawed out of pinewood by college-boy carpenters, skylights, stained glass, old brick patios out back, and all of it new. Saint Pé Street was still as it always had been, ever since decades and decades ago the families of okra and mirliton vendors, masons, and sheet-music salesmen had first moved into these houses, back when the air on Saint Pé Street was thick with guttural German, spicy Sicilian, and even occasional French flying this way and that.

But times had altered regardless, around that. The first and the second wars came and went, then that Korean mess; now the Vietnam War had been done for near a decade, and down on the Gulf, the Vietnamese fishermen who had survived had come over and done very well with their nets, making a whole lot of the Cajun shrimpers damn mad, if you got right down to it. This new couple carried that war with them: the husband had lost his legs, both of them, nearabout all the way up to the sockets, and the wife was hauling him up the stairs backwards in his silver wheelchair, him holding on tight to the chair-arms, and her huffing a little bit, trying not to jog him too much.

His name was Rapides Valcour, and his wife's name was Lilah. The neighbors knew this because already the mailman had told them. He

had waved the first pieces of mail in the air like a herald two days before, then stuck them theatrically into the mailbox, with a flourish, as if to say *y'all take a look.*

They were nothing important or interesting: a bill for a sofa from Rosenberg's Furniture on Tulane Avenue—one of the neighbors had held it up to the light (they had not moved in yet, after all, so this was not like snooping on people you knew); a letter from some older relative who lived in Jeanerette, Louisiana—spidery, shivery handwriting—who they assumed was the wife's kin, since the surname in the upper left corner was not Valcour; then, finally, a notice about a rate change from the New Orleans Public Service, the power and light, addressed only to Occupant.

Nobody offered to come out and help Lilah Valcour, in her sweat-sticky rose-patterned dress, to hoist her husband up. She was not a big woman, just average height, with a generous bosom and lively dark hair that tended to escape from the rubber band gathering it. Such an offer, they adjudged, would have seemed impolite, suggesting that she was a weakling, or that they'd been watching nosily from behind shutters, and thus knew that her husband was legless and hopeless and pitied him.

Finally she got him up the last step and onto the porch. He cried out, "Wahoo! You done it, my Lilah Bean!" She opened the door, propped it carefully with the brick doorstop, and pulled him through, into the house's cool darkness.

Catercorner across Saint Pé Street, in a duplex whose paint had long ago disappeared, leaving the wood exposed and hence somehow invisible, a short but enormous black woman in a caftan scolded her six little grandchildren. "Y'all get down from that sofa," she said majestically, and, like little automatons, they jumped down. "Y'all don't be staring at that poor white man." The fabric of her caftan was from Ghana and had gold-ink highlights. She was thinking of jokes about quadruple amputees she had heard white boys make to each other in the grocery line. *What do you call a quadruple amputee who lies down in front of the door? Mat. What do you call a quadruple amputee who hangs on the wall? Art.*

"He got no legs, Gramma," said little DeQuan.

"I *said*," the woman reiterated.

"Yes, ma'am," said little DeQuan, like a perfect Marine. *What do you call a quadruple amputee who's dropped from a plane in the middle of the ocean? Bob.*

But then she thought: that man got arms, so he only a double.

"How come God give that man no legs, Gramma?" said DeQuan's little sister Sh'Vaunne.

"God done give 'em," said Mother "Peaches" Aloysius. "Man done take 'em away. I 'spect that man went to the Nam."

Under her breath she began humming a song that averred *she* wasn't going to study war no more.

"Y'all go eat y'all grill cheese," she said.

The children ran out to the kitchen, where the Reverend Gonzales Brown, one of Mother Peaches' assistant pastors at the Church of the Spirit's Delight, was laying grilled-cheese triangles on melamine plates on a pearly-topped table. The cheese oozed out joyous, lethargic. The children squealed. It was their third-favorite lunch, next to alphabet soup or grits.

Reverend Gonzales Brown mopped the floors at Popeye's Fried Chicken most evenings, and got to practice his preaching sometimes if Mother Peaches had what she called "a little guitar" in her throat, an annoying catarrhal drip that made her have to stop and drink ice water, which then derailed her train of thought.

The last time the little guitar came up, she had mixed up in her sermon the names Obed and Obadiah. Any fool with half a grain of sense knew that Obed was Ruth's boy, the son of that wonderful selfless foreigner Ruth who took care of her mother-in-law, and that Obadiah was the minor prophet who waggled his finger incessantly at all those bad guys in Edom, the offspring of that spineless Esau. Easy distinction. Still, nobody in the congregation even noticed, and that piqued her a tad.

Lilah Valcour had been raised in Jeanerette by her father, "Red" Tramontana, whose flaming bright hair came from his maternal ancestors, the Irish side, and her mother, Alsace Jelineau. Red and Alsace Tramontana loved each other deeply. They had moved out to the country because the city was getting "too ruckus," as her mother put it, and they wanted to raise little Lilah in pastoral splendor.

Jeanerette did not turn out to be pastoral splendor, but Red was away from the Sicilian pinball-machine mobsters in Jefferson Parish who were rumored to have done in his two uncles who went to the Hibernia Bank one day but never came back.

In Jeanerette they were happy as clams. Lilah's mother called her husband "Red Bean," with seventeen spoonfuls of affection, even in front of the neighbors, and he in return called her "Jelly Bean." Alsace told her little girl bedtime stories each night when she got in her covers, stories from books, as well as stories out of her head.

One night little Lilah asked about Daddy's grandfather, who he was and did she know him and could we go see him sometime? Alsace knew that Daddy's grandfather had been a bootlegger, in tight with the Mafia, but she didn't want to say that, so she did the oblique thing.

"Honey, I think that the name Tramontana means 'across the-mountains' and that must mean that way back Daddy's people were very brave travelers, don't you think?"

"Yes, ma'am," said little Lilah, and made beautiful pictures inside her head of those brave travelers.

Even though they were Catholics, no little brother or sister came for Lilah, after two years, after three, after four, and then ever. So the two lavished all of the love they had on this one little girl-child.

When Rapides Valcour met Lilah, when he was twenty-eight and she was twenty-four, after the Vietnam terribleness, Lilah was waiting tables in her little checked apron and nursey cap at the Porky Pig Diner, near the foot of Canal Street. Rapides Valcour was astonished that Lilah was not married. His friend Mac who had brought him there told him that, and it was true.

He noted the glow of love that radiated from her. He later attributed that to the surplus of love, a continuous infusion, pressed down, running over, that she'd gotten at home as a little girl: a whole lot of hugging, and reading, and rum cake at bedtime (he thought that exotic) with hot milk in a cut-glass cup whose handle looked like a clear-glass tree branch.

They still had the cup in the glass-fronted cabinet in the front room, along with some tiny blown-glass figurines, a couple of scenic plates with painted views of Luray Caverns and Mount Rushmore that Lilah's parents had brought home from trips, and a tiny wire replica of the

Eiffel Tower that Rappy had given his wife on their first anniversary with a note that said, *Honey one day I will take you here.*

The third time Rappy Valcour ever set eyes on Lilah, which was the second time she waited on him, he proposed to her right there on his stool. This was before she had even served him his dry toast and his three eggs, sunny-side-up. She blinked in surprise at what he said. She did not even notice his wheelchair folded into the niche beside the jukebox, or the fact that he had no legs: she just noticed his lovely eyes, which were a gold Cajun brown and as warm as she'd ever seen.

She replied that, well, for right now he had just better eat his breakfast and they could talk about that some other time, because there were three people waiting for French toast and two people needing a refill on coffee, and the man from the linen supply would be there in a minute with dishtowels and probably new coffee filters, which she had to check because he sometimes brought a different size in a box that was labeled wrong. She sighed and turned her hands palm-up, as if to suggest that the world was a silly and difficult place. Would that be okay?

"Yes, ma'am," said Rapides Valcour, "That would be perfect." He shook his head, amazed.

"I hope your eggs are the way you enjoy them," she said. "If those yolks are too solid, you just wave me down." Because she was gripping the glass coffee-pot handle in her right hand, she made a tiny quick movement of fingers-as-fluttering-flags-in-the-wind with her left. Then she moved off to replenish the coffee in a tubby truck driver's cup.

Rapides Valcour turned his head slowly, as if he had whiplash, to look at his friend Mac. His look said, *Hey, do you believe it?*

Mac raised his eyebrows and lifted his coffee and smiled in wide, pleased disbelief. Mac had two legs and could not get a girlfriend to save his life.

It was the second week of March now, and the Valcours had moved in the summer before. No one much in the neighborhood knew them, and so one day Mother Peaches decided that it was time to call on them. She rarely crossed the street. Usually she just came out to the curb and got into a car that pulled up and Gonzales Brown or one of her grown children drove her wherever she needed to go. She felt strange as she crossed the street.

She had had a prophetic dream that morning which woke her up just before dawn. Mother Peaches was God's woman, that was for sure, but she still found these dreams and these words from God—directions to do this or that thing that in her flesh she would never drum up—a little unsettling. She hated that resistance in herself, because she wanted to be in God's will, so she just grumbled, "Lord, let this cup *pass*," just like Jesus, then went on and did the damned thing, whatever it was, that God told her to do.

The dream was quite simple: she saw the Valcours' grayed-white housefront, with its two feet of shriveled petunias between the porch and the sidewalk, as if she were peering out from her own shutters, like those little grandchildren the very first afternoon. In the dream the house began to change, seeming to take on a pale yellow color, then brightening until it was like the yolk of a raw egg, bright gold, so gold that it seemed—like organza—to overlay rosy pink, and almost pulsing with life. She knew what it meant: something good was in the offing, and she, as the instrument of God's grace, was called to go check things out at the Valcours'.

She rapped on the door with the silver wolf-head of the cane that she used most of the time now, since she had grown stiff and then, slowing down, had gotten heavier. The sound of her knock was amazingly loud. She frightened herself, just a little. But no one would ever know she was frightened: the wide pale-brown freckled face of Mother Peaches glowed as impassive and calm as the harvest moon.

The door opened, and Lilah invited her in. She had seen Mother Peaches in her comings and goings, though they had never met. Mother Peaches brought a welcome present, a Mason jar of fig preserves she had put up the summer before, grown on the fig bush behind her house.

She brought also a little plastic-framed picture of Jesus with a carmine-red drape hanging over his tunic. He was knocking on the door of a house. Mother Peaches held the picture out to Lilah and waggled it from side to side. Jesus seemed to knock, then rear back, knock and rear.

Mother Peaches said solemnly, in a theatrical monotone, "Lo, I stand at the door and I knock. Revelations 3:20." Then she looked right into Lilah's eyes, which were clear and good. "Thass *weird*, that picture," she said as if half apologizing. She cocked her head and noted to herself that it looked a lot like the Three Bears' house in little DeQuan's big

old book. She wondered how the bears would deal with Jesus, or he with them. "I likes it anyways." She set it down on the table with its little prop-leg poking out back as if it had always belonged there.

She went to the Rosenberg's sofa for which all the neighbors had heard the price, visible through the thin envelope, and sat her bulk down carefully, as if she might break something deep in herself. "Okay. Now, tell me all about y'all," she said, and she turned her full harvest-moon glow on her hostess, who sat entranced, holding upright in her lap the Mason jar filled with its globy squashed fruit hanging as if in amber.

When Mother Aloysius left, closing the door very slowly behind her, Lilah Valcour remained very still, listening to her new neighbor's cane-tip stumping down the stairs and then across the sidewalk to the street.

Lilah sat remembering all of the things she had told the old woman, things she hadn't quite even said to herself yet. That Rappy had moments of panic that frightened the bejeebers out of her: that at Mardi Gras, even in all that crowd, when a child nearby popped a balloon, Rappy almost pitched out of his chair, and then couldn't be calmed down until Lilah wheeled him back past the tamale stand where there were no people and said again and again, "Rappy. It's okay. Hon. Rappy. You're home. At the Mardi Gras. No grenades. Rappy. You hear me?" That once, before dawn, a police helicopter had flown over the house and Rappy threw himself off the bed, onto the floor, and spent almost an hour sobbing and shaking.

She hadn't told anyone these sorts of things, then the first time she met Mother Peaches she told her the whole thing. Well, not the whole thing, but a pretty good chunk. She had not told her the thing Rappy said the day after their wedding: "Honey, you going to have to raise me. Ain't nobody raised me. I do not know how to be regular."

Lilah sat thinking, remembering that. She remembered the way she had stared at him then, wondering what had changed. The day before, she had a bridegroom in a striped cravat, handsome if legless, and now here the next morning she had a person who claimed he was not even human, did not know how to be regular.

She remembered saying, "Rappy, what *do* you mean?" She wondered if everyone changed into someone else once they were married, if this was a secret of marriage that no one had told her. She remembered

the very sad look in his eyes. She still had no idea. She loved Rappy even more.

Each day she went out to the Porky Pig Diner on the bus. Gonzales Brown and his brother Ricardo built a ramp for Rappy's wheelchair out the back door into the alleyway, and Rappy went to the Veterans' Hospital once a week, in his wheelchair, and somewhere else every day, to keep busy: the library, often, a movie, wherever. And then he came back to the house on Saint Pé Street and was there, lit up with joy, when she came home from work, and he loved her as much as a man could possibly love a woman.

Each Friday he brought home a rose, which he put in a vase on the end table next to the picture of Jesus knocking. Each night he held her close. Each morning he kissed her goodbye as if it were the last morning of the world. But the look in his eyes, those beautiful eyes, was of such devastation.

When Mother Peaches shut the door behind her, coming into her living room after having crossed the street from the Valcours', she said aloud to the empty room, "Lord, we got our work cut out for us."

From the kitchen, her daughter Tyeesha called in, "What, Mama?"

Mother Peaches said dismissively, "Not you, T. I was talking to the Lord."

Tyeesha, mother to Bree and Xavier, two of the other small ones who were everywhere here, was chopping up fat yellow onions for barbecue, wiping her cleaver on a damp dishtowel and moaning with onion pain. Her eyes ran with tears. "My land, Mama, when are you not talking to the Lord!" In the next room there was shrieking and bouncing.

"That Rappy man, we got to get the Lord working on him, T."

"Yes, ma'am," she said.

In the back door, through the shortcut from the avenue, came her son Leander, the oldest, born before she was saved, from a father she didn't remember. He was dusty from work and he set his hard hat in the sink and ran water on it. "Leander," she said, in her most imperious tones, "That man across the street in that wheelchair?"

"Yes, Mama," Leander said.

"We going to pray him healed."

"Hah!" said Leander, who was in general fine with this churchiness as long as it held its place but got salty when his mother started this kind of stuff. "Grow back that man legs, right?"

Mother Peaches looked straight in his eyes. "And everything else, and you look at me one more time that way, Leander, and you can forget about barbecue. Not just tonight. Ever."

"Yes, ma'am," said Leander. He meant it.

The next week was the Feast of Saint Joseph. Out in California, where no one on this block but Rappy had ever been (on the way to Vietnam twelve years before), the swallows were flocking back mystically, predictable as sunrise, to the old Spanish mission at San Juan Capistrano. In other parts of New Orleans, the Italians and the Sicilans were making their altars to Saint Joseph.

Mother Peaches, before she was saved, when she was just a teenaged girl, had ironed for some Catholics who did this. They had a plaster statue of Saint Joseph, the foster father of Jesus, with painted golden-brown hair and neat plaster feet poking out from under his skirt, wearing golden-brown sandals. Mother Peaches, who was still a girl then, had observed this with interest.

She had asked her employer, Mrs. DiLisio, what this was for. Mrs. DiLisio seemed taken aback for a minute. "It's for Saint Joseph," she answered, clearly hoping the girl would not want to know more.

"I mean what do it do," the girl asked. "And why do you all do this?"

Her hand swept the air, indicating the terraced, ad hoc altar built out of tables and odd shelving, covered with linen and then crocheted doilies, filling the room with plate after plate of food.

Candles stood flickering between the plates, casting strange shadows that danced like Balinese ladies. Holy pictures—of the Sacred Heart; of various pious and anemic-looking girl saints in white dresses and stockings and wreaths of pale flowers; pictures of Our Lady of Lourdes and Our Lady of Fatima and finally Saint Joseph himself, with his carpenter's tools—had been taken down from every other room in the house and brought into this one.

On the terraced tables at the DiLisios were frosted biscotti on cake plates, and buckets of meatballs in gravy, and deviled eggs fluted with creamy yolk filling and topped with pimentos. There were glass dishes of watermelon pickle. There were three beef roulades that Italians

called bracciolone: the rolled steak, the stuffing, and at the roll's center, a boiled egg, so that when the bracciolone was sliced it presented a bull's-eye.

There were anise cakes and jars of peach butter and jellied-veal mold. There were bottles of homemade wine. There was a pea salad with peanuts in it, and something red-jewely nestled there too. There were at least a dozen varieties of pasta, in white sauce and red. There were musical instruments—saxophones, xylophones, drums—made of marzipan, yellow and pink and green. There were round little balls of white cookies with nuts in them, that they called Mexican wedding cakes.

The teenaged maid waited to hear: did they think Saint Joseph ate this, like Santa Claus, or like the elves in the shoemaker story?

Mrs. DiLisio said again, "Well, it's all for Saint Joseph, and this is, um, what we do." The girl shook her head and went back to her ironing. She did not come back until Tuesday and everything was back to normal, and all the stuff gone.

A dozen and more years later, she took over the Church of the Spirit's Delight the day after old Reverend Cornelius B. Jackson got taken home by the Lord right in the middle of a sermon about the Rapture, his hand laid flat across his heart, his eyes rolled to heaven, and he breathed out then never breathed in.

They just needed someone to hold things together a while, but it went on and on and they started calling her Mother and paying her upkeep, and that was it. That next spring Mother Peaches remembered Saint Joseph's Day, and decided that the Church of the Spirit's Delight could use something like that. Kind of a party, for its own sake.

The Spirit's Delight altar to Saint Joseph had cabbage rolls, after-dinner mints, chocolate doughnuts, and chitlins; it had deep-fried shrimp, black-eyed peas, pots full of creamy and buttery white mashed potatoes. Because a Chinese man named Lee Ling Ho who lived next door to the church heard about the celebration and brought over a dish of thousand-year-old eggs, it had green unshelled duck eggs, jade-slick and gorgeously veined, which really were not that old but looked mysterious, like eggs made of marble and dug from an emperor's tomb. Lee Ling Ho sometimes came to their services and clapped slightly off the beat, singing along in a kind of sincere nonsense language.

Because nobody knew what Italians did with the food afterward, Mother Peaches decided to give some of it to the orphanage, say, the doughnuts and mashed potatoes and black-eyed peas, because children would eat those things, and to bring some of the fancier stuff to a convent of cloistered Catholic nuns off Magazine Street, who could not come outside the gates and so had their extern take in the food on a revolving tray through the wall. Mother Peaches was put in mind of the modesty turntable in the ladies' room for passing urine to invisible lab folk the last time she'd gone to the hospital.

Her younger son, Leftenant, from the husband who died in a gas station robbery in Gulfport, had looked at the thousand-year-old eggs that morning and said, "Mama, don't you go bring them damn eggs to the nuns. They gone think you crazy."

She raised an eyebrow at him. She was about to tell him not to take the Lord's name in vain but then she realized he hadn't. "I believe they the best thing we got," she said. "That Mr. Ho say it took him since last summer to make them."

"Suit yourself, then," said Leftenant, after his wife Cheryl shushed him in mime from across the room. As she walked away he saluted his mother behind her back with his eyes wide in mock something-or-other, and Cheryl looked daggers.

So Mother Peaches, who had been thinking about the new neighbors a lot since she had had that dream the week previous, and then visited the next day with Mrs. Lilah Valcour, thought that she would bring the best thing they had over to the Valcours. And in case they didn't like thousand-year-old duck eggs, she brought a banana cream pie for good measure.

Lilah Valcour was surprised to see Mother Peaches at her door again. "Come in, come in!" she said. Mother Peaches had not told Lilah about her dream, in which the Valcours' house turned yellow, then seemed to be full of rosy life, like the sun rising. You couldn't tell people those things until you knew what you had there. "Set yourself down, Mother Peaches," she said. "What is all this?" She was looking at the pie and the platter of duck eggs. Mother Peaches had left her cane home and navigated across the street carrying all of it balanced precariously.

"This ain't nothing," said Mother Peaches. "This just an excuse," she said, and then was silent.

Lilah Valcour didn't know what to say, so she said nothing. The clock in the next room ticked loudly. The two women sat not speaking for several minutes. From the back of the house came the sound of a television. Crowds were cheering.

Mother Peaches pursed her lips. "Spo'ts," she conjectured. Lilah nodded. "You husband, he like to watch spo'ts?" Mother Peaches ventured.

Tears welled up in Lilah's eyes. "No," she said. "He doesn't. He just can't do anything else, much. And he isn't very happy, and I cannot make him happy, and, oh, Mother Peaches, I just want to die." Lilah Valcour fell onto her knees and put her head, plop, into Mother Peaches' capacious lap.

"Jesus say he have come that we may have *life,*" said Mother Peaches, "and that more abundantly."

Lilah lifted her head and tossed back her hair. "Then why did he take Rappy's legs?" Her face was wet and messy.

Mother Peaches was taken aback for a moment. The image was startling: Jesus taking Rappy Valcour's legs? "No, no," she said. "That ain't the thing." She was trying to remember what the Bible said about this, or what Reverend Cornelius B. Jackson had said in some sermon, but none of it made much sense.

"And there's something else I haven't told you," said Lilah Valcour, with a kind of guilt, as if they had been talking their whole lives and she had withheld this. Mother Peaches sat at attention, her shoulders pulled up as if lifting her heart off her diaphragm to give it more room to beat. Her ears seemed to shift and change shape slightly, almost to take on elfin points.

"The day after our wedding my Rappy said...." She paused. "He said...I would have to raise him, that nobody had raised him." Mother Peaches' mouth was gathered like the mouth of a drawstring purse. Her ears shifted again. Something drew Lilah Valcour's eyes downward. Mother Peaches' toes in the open slippers she wore, made of fake mink, crossed and uncrossed, seemed to have a life of their own, like happy puppies deep in a fur basket.

Mother Peaches intoned it, an echo. "Ain't nobody raised him. What, he a orphan?" She was thinking about the orphans' home where Leftenant and Cheryl were taking the black-eyed peas, as they spoke. She thought, Lord, we all orphans.

"No," said Lilah. "His mama's just mean. She did terrible things to him when he was little. You don't want to know."

Mother Peaches groaned soundlessly deep down inside herself. The pulsing yellow house in the dream-vision, with all of its pink life inside it, came up in her mind's eye. She knew what it meant now. She hated these times, when she had to be channeling miracles. It just took everything out of her, but it was what she was called to do.

She remembered the pipe underneath her kitchen sink when Leftenant had replaced it, after the water stopped running except for a trickle. Leftenant was swearing and bumping his head, and Cheryl was raising her eyebrow and running out over and over to the TruValue Hardware to pick up the stuff that Leftenant wrote down on the back of the last Sunday's church bulletin, and then to the drug store for something to fix his forehead.

Mother Peaches remembered the pipe when he'd finally gotten it free. "Feast you eyes," said Leftenant, accusingly, as if Mother Peaches had done something terrible. Inside the narrow pipe, thick as that, was crusty mineral buildup from years of hard water coursing through. Her last husband had died of the artery clog, from a life of fat building up inside him like that. She had never thought what that might look like. There was hardly enough room for a trickle to get through.

Mother Peaches made a sermon around that the following Sunday, the way that an oyster would build a pearl. She told the congregation that if we would have God use us, we must keep our pipes free of that buildup. She said God could send his grace through like a blowtorch, if that's what we wanted, in an instant. But we had to give him permission. She said it might hurt.

She knew she would have to do that after dinner, go into her prayer closet on the back porch that Leander had built her and hung with dark red velvet curtains and talk to the Lord about Rappy Valcour. And she knew the first step was that she herself had to repent of her sins, any sins she might have missed along the way, any new ones she'd committed today, so that God's grace could blowtorch through.

All this went through Mother Peaches' head in a split second. Lilah saw none of it. Mother Peaches said, "You man ever cry, honey? About he legs? About he mama?"

"No," Lilah said. "Not outside. But one time I heard him say out loud in the bathtub, as if he was talking to somebody, only nobody was there, 'This here is why people kill themself.'"

"You want me to say that again about Jesus?" asked Mother Peaches a little sternly. "I came that you might have life, and that more abundantly?"

"I heard you the first time," said Lilah, sounding slightly sullen, as if that were just a tease she would rather not hear at all. "But Jesus can't bring Rappy's legs back. Or make all that terrible childhood stuff go away."

"You telling me he *can't?*" said Mother Peaches. She seemed to be rising in her seat, inflating, as if like a dirigible she would lift off and bounce slow and soft off the light fixture overhead.

Lilah's face looked almost bruised with sadness. From the back of the house came the roar of a crowd at a game. A sport. Fun!

"No," she replied. She was thinking about all of those Bible stories, and whether she was supposed really to think that was possible. She decided to say she believed.

"Then you eat you damn pie," Mother Peaches said, actually rising now, and simultaneously asking God's forgiveness for talking like Leftenant under the sink. "And don't ever say nothing like that about Jesus again."

She inspected the pictures arranged on the wall. There was one of a baby, white-haired and dark-eyed. The picture was black and white, tinted a sepia brown. The baby sat on a blanket with fringe and reached with a chubby white hand toward something just out of sight. The soft bottoms of his feet made Mother Peaches want to touch them. They looked like a bear's. She said, "Thass you husband. Am I right?" Lilah nodded. There was another baby picture beside it, a little girl with brown curls, also sepia-tinted. Mother Peaches walked slowly over to the glass-fronted cabinet and squinted to read the lettering on the Luray Caverns plate, and then the Mount Rushmore. "Y'all done been these places?" she said. Lilah shook her head no. "If you *was* to go somewhere, a trip, honey, where would y'all go?"

Lilah frowned slightly. "A trip?"

"You know," Mother Peaches said. "Like, on a Greyhound bus. Like you sends in a box top from...." She tried to pull a brand name out

of the air and failed. "From something, and you wins a trip anyplace you wants to go."

Lilah rolled her eyes, thinking. "Wyoming?" she asked. She was picturing wide open spaces, and mountains, and velvet-grassed pastures, and cattle all russet and white, and perhaps—was that what that was?—tumbleweed, rolling and tumbling and rolling, and nice ponies watching it.

Mother Peaches said nothing, just walked to the door and went out. Lilah wondered about the cane, whether she only needed it some days. Apparently so.

That night in the kitchen Leftenant and Cheryl and Tyeesha and her boyfriend Raoul, whom Leftenant called Raoul the Fool, because he thought that Tyeesha had him wrapped around her little finger, played cards on the pearly-topped table. Mother Peaches believed that the Bible said nothing at all about card-playing, just as it said nothing about penicillin or dentists or television, so God let us figure things out for ourselves. "What y'all think he done give y'all y'all's brains for?" she said.

In the prayer closet on the other side of the thin wall, while the card game went on, Mother Peaches groaned loudly, and sang in her oddly weak tremolo, and thumped her head against the backboard of the prayer closet. Leftenant just shook his head and rolled his eyes.

Two of the children, LaJuana and Roosevelt, Raoul's children that his ex-girlfriend had left on his porch, came in from the TV room and begged for money to go buy some ice cream.

Leander came in then and they climbed on him. "Money, money, money," he chanted. "Y'all think I made out of money?" Yes, actually they did, because Leander never had married and so had a pretty big bank account.

On the other side of the wall, Mother Peaches called out to Jesus and banged her head on the backboard. The thick velvet curtains muffled the sound somewhat, but it was still quite impressive.

"What Gramma doing?" said little Sh'Vaunne.

Leftenant tossed his head. "Y'all done saw that movie, *King Kong*?" he said to Sh'Vaunne. She nodded yes. All of the little barrettes that held her braids—fuchsia, turquoise, and taxicab-yellow—danced merrily.

Leftenant said, "That ape done escape. Gramma fighting with him in the prayer closet." Cheryl slapped him on the back of his head with her long, brightly manicured fingertips, and Sh'Vaunne looked up at the door to the back porch in mixed horror and glee, expecting to see the great monkey.

Just then Mother Peaches lurched into the doorway. Her hair was awry and her prayer stole was askew. "Leander!" she said. "You go see if that Rappy Valcour okay."

Leander looked at her dumbly. He looked at the card players to see what they knew about this. They knew nothing either and gave him only wordless looks in reply.

Leander took his jacket, which he had just hung up, down from its hook. He put it on again. He left, and Mother Peaches stood in the doorway holding onto the doorjamb on both sides as she heard people did in an earthquake. The card players resumed their game.

In a few minutes Leander returned. "He fine, Mamma."

"What you see?" she demanded.

"He just sit in that wheelchair," Leander said. "Looking right flat out in front of him."

"What else?" she said.

"Nothing else," he said. "They done eat four of Mr. Ho eggs. She say they taste all right."

Mother Peaches went back to her prayer closet. The card game resumed. Leander was persuaded to leave his jacket on this time and go for the ice cream. The back wall of the kitchen seemed to bulge and retract with the old woman's groanings and intercedings.

Sh'Vaunne and DeQuan and Xavier and Bree and LaJuana and Roosevelt ran around in a loopy circle through the house until they all crashed in a pile in the front room and fell asleep.

Leander returned with the ice cream. "I knew it," he said, rolling his eyes at the sight of the piled children braided together and breathing damply in sleep like a giant dog.

Across the street, at the Valcours', Lilah was helping her husband into bed. His absent toes—on the ends of his absent feet, on the ends of his absent legs—were hurting him again tonight. "Ghost piggies," he called them. The doctors called this phantom pain, but he told Lilah, the toes might be phantom, the pain was not.

He had lost his legs throwing himself on a grenade, he told her. "Throwing yourself?" she echoed. He could not mean that. She'd misunderstood. Yes, he'd said, all the stuff from his childhood just made him want to die—he said the word with a quick exhalation of air—and at that instant he had seen a three-way chance to protect his buddy Hamlin Dennis, who was in front of him, to be remembered as a good person, and to die quickly and leave no remains to speak of. He did not want a funeral. He wanted obliteration.

The plan misfired, of course, and while Hamlin was saved from the grenade, he drowned swimming in a river in the Mekong Delta two months later, while Rappy lay in the Japanese hospital where the army had flown him.

Lilah Valcour, having tucked Rappy in, went to check the doors. When she looked out the front window, just at nothing in particular, she squinted. Something just seemed odd. There was a sort of a glow at the back of Mother Peaches' house: the only way she could describe it to herself was that it was as if someone were having a midsummer party and Japanese lanterns were strung around, loopy and jewel-like. There was also a hum in the air, like electrical wires on Saint Charles Avenue when a trolley was coming but you couldn't see it yet.

She turned out the living room lights and locked both of the latches, then went to bed. She climbed into the sheets beside Rappy and looked over at him. A tense whiteness came into his face when he hurt like this, like the look of a foot that has been far too long in its shoe, but of course that was a terrible way to put it, because Rappy had no feet at all. So she just thought, he looks very pale tonight. She said, "Rappy, did you like those thousand-year-old eggs?"

"They was okay," he said. "But you know what I like, Lilah Bean?"

She said, "What, Rappy?" She could tell something good was coming.

"You," he said simply, and fell asleep, tunneling his hand beneath hers, which was under her pillow, and holding on nicely.

The next morning was Lilah's day off at the Porky Pig, so she had not set the clock. She woke up with the sun lying like a hot towel across her face, and she turned away from the light. She reached over to put her hand on her husband's back but he was not in his usual spot. The covers were kicked askew. Her heart caught in her: she loved him so

much she feared sometimes he would be stolen away. The one thing she wished in her life was that she could have saved him from all of the badness that came before.

She sat up with a start. The pillows were pushed around. Something was funny here. The smallest snuffling sound in the world rose from behind Rappy's pillow. She pulled the pillow aside.

A squeaky small gasp came forth from Lilah Valcour's throat. It was a baby there behind the pillow, a newborn, as silky and powdery-innocent as could be. She thought it, then said it out loud: "Rappy!"

She picked up the amazing creature. She held the child up in the light. Its hair was like corn silk, and white-blond. It was too new to smile, but it clearly had not had time to be hurt, and so was perfect and pure. Every finger and toe was there, chubby and pink and intact.

Lilah remembered her husband's words: "Lilah Bean, you'll have to raise me. Nobody raised me."

She said it out loud then: "No!" meaning not, *I won't,* but rather, *This cannot be.*

She wrapped the child up in a blanket and laid him down on the bed between two of the pillows for safety. She washed her face, gargled with Dr. Tichenor's, and dressed in a hurry. She looked in the mirror to see if she recognized herself. She did.

She picked up the baby and went across the street to Mother Peaches' house. It was quiet. She knocked and Tyeesha answered.

"Shh," Tyeesha said. "Mother Peaches not so well this morning. When she do intercession, it take everything she got out of her. Leftenant done took the children to visit they cousins live out in Chalmette." She motioned Lilah into the house.

Then she noticed the baby. "Hunh?" said Tyeesha, her eyes wide.

She folded aside the top flap of the blanket. The little pink innocent stared back at her like a star, like a flower, like the gorgeous little incongruous white-child doll that they used for the Baby Jesus in the Christmas pageant at Spirit's Delight.

Lilah just shook her head and smiled a bit off-centeredly. She had no way to explain this. "I want to see Mother Peaches," she said firmly to Tyeesha.

Mother Peaches was propped in her bed in a darkened room. She stirred up off her pillows when Lilah came in.

"Holy...." Mother Peaches began, and stopped short. "Did I do...?"

"Yes," said Lilah Valcour. She handed the baby to the old woman. The room smelled like violets, and barbecue, and the lingering after-scent of Leander's hair pomade.

Intercession just did take it out of a person, Mother Peaches said, then she smiled a big smile which showed her gold front tooth that had a star cutout. She called it her "burying tooth" and she said the mortician could take it and sell it to pay his fees, because her mouth would finally be shut, in the coffin, but Cheryl and Tyeesha said would she please stop saying that, in Jesus's name, and they would take care of that stuff when the time came.

The next morning Lilah Valcour and the baby got on a Greyhound bus. Leftenant and Cheryl had driven her to the bus station, with DeQuan and Sh'Vaunne and the others strapped into the seats of the church van behind them. The children alternated singing "Trust and Obey" with another song that they had learned from Kermit the Frog on *Sesame Street* called "It's Not Easy Being Green."

Leander staked her the ticket, and Tyeesha and Raoul the Fool promised to take care of all the loose ends. Mother Peaches was still in her bed, and might never get up, for all it looked like. Tyeesha was getting the sofa and some of the other stuff. Lilah had packed up some Huggies, a week's worth of clothes for herself, and the small Eiffel Tower, along with the cut-glass cup with the tree-branch handle, for when the baby got bigger.

The bus ticket was to Cheyenne, and she knew she could figure it out when she got there. There seemed to be nice places all around: Mountain View, Paradise Valley, and Medicine Bow were the three that first struck her when she looked at the map.

The little legend on the map said that the state flower was called the Indian paintbrush, and the state bird was the meadowlark. Surely there would be someplace nice out there, with all those wide-field expanses of Indian paintbrush and those scattered copses of trees filled with meadowlarks, to raise a baby right.

EDWARD HIRSCH

Simone Weil: Lecture on Love

I would speak to you about supernatural love,
which touches creatures and comes only from God,
though I am unworthy to speak of divine love.
God's pity for us is not a reason to adore God
but to know ourselves, for how else *could* we love
ourselves without the motive—the reason—of God?
I am a stranger to myself, whom I cannot love,
when I have fallen away from knowledge of God.
Is my wretchedness a sign of His eternal love?
I believe not, though I am understood by God
who recognizes the porousness of human love:
the divine Word descends and returns to God.

I speak to you from a chastening solitude.
You must never allow yourself to be soiled
by human affection. Preserve your solitude,
though everything vile, everything soiled
and second-rate, revolts against this solitude:
the naked fantasy of those who are soiled
wishes to dirty the abundance of solitude.
To touch is to be sullied, revulsed, soiled,
to relinquish power over your own solitude.
Possessing another—to be possessed—is soiled,
since only purity can restore our solitude.
Sentiment offers fertile ground to be soiled.

Not by accident you have never been loved,
for love no longer knows how to contemplate,
only to possess (disappointment of Platonic love).
Carnal love, which Plato would not contemplate,
is a degraded image—a parody—of divine love:
to love gloriously, to adore and contemplate
the distance between ourselves and what we love,

the void between what we love and contemplate,
the Lord Himself. But how can we possibly love
ourselves with the Word of God to contemplate?
Agape: to be delivered into a divine love—
what He divines in us is strange to contemplate.

I will know that my adoration of God is truth
when joy and suffering inspire equal gratitude;
affliction is our warrant, the deepest truth
of human existence, which fills me with gratitude.
Belief in the existence of others is a truth
to be acknowledged—like faith, like gratitude—
and may even demonstrate a desire for truth
beyond the confines of self. We show gratitude
when we acknowledge our vulnerability as truth,
the mark of existence that marks our gratitude.
We have touched the flames of supernatural truth,
and now can burn with the fires of gratitude.

It is always a fault to wish to be understood
before we have made ourselves clear to God
or to ourselves, who can never be understood
unless we offer our contradictions to God.
We must relinquish the desire to be understood,
annihilating our need to want anything from God.
Our affliction can be realized and understood
as a form of opportunity proffered us by God
who knows us as creatures He has understood;
we must sacrifice ourselves to this inhuman God.
George Herbert called prayer "something understood":
I would have us shattered by understanding God.

LINDA HOGAN

The Hidden

There are the far universes, the undiscovered
ocean depths, the hidden magma,
as if every morning you've been forsaken
and given smallness which you must accept as truth.

And some earthly paradise,
how reverent and radiant
the first fronds of green beginnings,
the shine of moonlight behind a cloud,
or the pearl in an ordinary shell.

There are the often described blue sheep
of the Himalayas,
the grain of gold beneath the earth.

Oh traveler, what if the far river had not been created.
Where then would you dream of going?
What if you hadn't believed the story
or trusted directions through the desert
all those dry miles

I don't care what you call it,
the human other portion, trust, belief.
What if you looked at it all aslant
What if you hadn't believed the story,
then you would never have arrived
in the good red land, the heat,
suddenly finding the spring
and the wild horses.

Paradise has always been just out of sight.

JOHN HOLMAN

Wave [fiction]

SOMETIMES BECAUSE of traffic Ray cut through a neighborhood that emptied out behind the hotel where he worked. He operated a wait-staff service that was contracted to a small hotel in Research Triangle Park. It was a quiet street, twenty miles per hour, though fairly busy just before school in the mornings and in the afternoons when school got out. At one house about half-way in, there was a man who sat on his porch and waved. The man waved no matter who was passing by. He waved every time, at every car, at everybody. He was always on the porch, unless the weather was bad, and then he sat on a tall stool inside the glass storm door and waved.

Ray had recently discovered this alternate route, finally found a way around the clogged stretch of expressway. Lately the usual wrecks and congestion were caused by sandbags in the lanes, and chickens, lumber, or wet paint. The oddities seemed to compete, to Ray's amusement and frustration. There had been roofing shingles, cats, loaves of bread, golf balls, and a washing machine blocking the way. The hazards of the thriving economy. So Ray needed the shortcut. After the first two greetings from the man, when Ray realized the man was not simply friendly but somehow stunned into a compulsion to wave, his dilemma was whether or not to wave back. If he was in a rush, Ray sometimes noticed too late and threw up his hand at the neighbor's porch, as if his wave might trail backward like a ribbon and flutter at the man before snapping forward to catch up. He felt silly waving to a possible idiot. It made Ray feel like an idiot, making an empty gesture at an empty-headed old white man who waved because he couldn't help it. It was like talking to a doll. He couldn't fully pretend it was meaningful. Yet, if he did not wave, he felt guilty. Sometimes, traffic or no, he stayed on the main road to the front of the hotel, only to chastise himself for preferring the stress of traffic to the stress of simply waving.

Occasionally, policemen pulled over cars for exceeding the street's speed limit, drivers late for school or work, or maybe rushing because

of fear of the waving man. The man's house was small and blue, with a neat little yard. Azalea bushes trimmed the border along the porch. A clean concrete walkway led to three porch steps. The porch was fenced by a painted wooden rail, and the man sat on a rocking chair and waved. He was a big man, as chubby as an infant, with an infant's bald head and an infant's dimpled smile. He had gleaming small teeth and silver-rimmed glasses. In cool weather he wore a dove gray cardigan, and when the temperature was warm he wore pressed, pale-colored sport shirts. He was neat, clean, with plump soft-looking hands. Sometimes he leaned forward from his chair and waved. When he was behind the glass door, as he was this morning, and Ray had to make an effort to find him, the man would also be ducking and leaning in an effort to be seen.

Desperate optimism, Ray thought. This on a bleak, wet, early March morning when, the rainy night before, Ray had discovered someone lying drunk and crying in his backyard, trapped in the narrow space between his back hedges and rusting chain-link fence. Hearing the cry, Ray had gone out in the downpour and aimed a flashlight on him, a ruddy-looking man with soaked dark hair streaking his face—some kind of Indian maybe, in sopping denim shirt and pants and wearing the weight of wet black cowboy boots. Ray asked if he was all right, what's wrong, tried and failed to pull him up by his limp heavy arm. Shivering, Ray held the umbrella over the man for a while. This man was inordinately sad, eyes closed, speaking no language but despair. Sobbing and moaning. Rhythm and lilt.

So Ray covered him with a blanket and a bunched sheet of blue plastic tarpaulin. Ray's friend Alma was visiting, standing at the opened back door and looking out. She wanted to call the police, or an ambulance. "He'll freeze, catch pneumonia and die," she pleaded when Ray came inside.

"Catch pneumonia, maybe. He can't freeze out there tonight." He talked Alma into waiting. The police would be more trouble for the man, and an ambulance didn't seem warranted; he was just depressed, breathing well, not hemorrhaging. But they watched the Weather Channel to check the forecast for the night. The temperature would stay in the forties and rain would persist. Then they turned off the kitchen light and stared out the back window, but they couldn't see

the man where he lay. He still sobbed loudly now and then, and his intermittent wails reassured them.

Standing there in the dark, sharing a bottle of red wine, was awkward. Alma was not exactly Ray's girlfriend although he had thought she was, or could be. When she first moved to town, months ago, he was all for some romance, and she had a flirty way of being friendly that sustained anticipation. And that night he still hoped for her affection, except the presence of the sad man was an impediment. No way to talk of love, and no sign from her other than her being there. She had come with a betting sheet for the NCAA basketball tournament, wanting Ray's help choosing winners for her office pool. The paper with the names of the hopeful teams in their starting brackets was held by a magnet to his refrigerator, where it semi-glowed in the weak tree-filtered light from a neighbor's back porch. Ray went over and pretended to study it in the near-dark.

"Maybe we should take him something to eat, or some coffee," Alma said.

So Ray opened the refrigerator and realized the uselessness of taking food out there. "He's not going to eat anything. He's too... disconsolate." He pulled out lunch meat anyway. And mustard and mayo and lettuce. "Are you hungry?" he asked Alma.

The man outside moaned. "A sandwich would disintegrate in this rain," Ray said.

"Oh I can't bear this," Alma said. "Either that guy goes, or I do. I mean, get him inside or something, which is not really what I want while I'm here."

"Well, you're not going anywhere just yet."

"But he's out there like a wounded dog, or deer, or bear. What moans like that? There's nothing human about any of this."

Ray turned to look at her. She was making gestures of frustration and impatience, flexing her fingers and pivoting in her hiking boots, performing in the fan of refrigerator light, her short braids lifting slightly, like tentacles.

"I can't put him out of his misery. Besides, a wounded animal is the most dangerous kind, they say."

She stopped pivoting. "You're not making jokes about this, are you? You're using that poor person to make fun of me?"

Ray closed the refrigerator. But Alma was still dimly visible in front of him. "Sorry. It's just a way of being patient, of passing time here. No offense to you or him. I mean, if I were heartbroken and lost, drunk on the ground in the dark rain of somebody's raggedy back yard, I'd want to be left alone. I wouldn't want anybody to know I was even there. I'd want to suffer until I was through without some do-gooder guy and his happy young friend meddling with delusions of rescue."

"Then you ought to shut the hell up instead of moaning and crying to high heaven. And who the hell you calling happy?"

Ray laughed at that. "All right. Damn. Sorry about that, too. I thought you were happy. Why aren't you happy?"

"None of your business." She turned away, and when she turned back, in the semi-darkness, he thought she held her wineglass. There was a glint of light at the position of her heart.

"Aw, you're happy. You're just ashamed to say it."

"If I were happy, you'd know it."

"How?"

She didn't say anything. She raised her glint of light and drank from it. She'd had some troubles he knew about, the job for one—struggling a little bit when she first came to town to be Assistant Director of Special Programs at the college library; she was young, just out of grad school. And housing for another—such as having to move suddenly when her apartment building caught fire, and then moving in with a co-worker and another roommate who was either on crack or struggling with some other alternate reality. That roommate had taken to wearing Alma's clothes and claiming they were hers, that she and Alma had clothes just alike. But all Alma needed to solve the problem was to move again. In with him, would be nice. She could wear *his* clothes. And they could be amused together at what the roommate's disturbance would cause next.

"What would make you happy?"

"I don't have a clue," she said, cheerlessly. "Maybe the end of all wars, and all people experiencing personal adoration with humility." She looked down at her wine.

"Of course. Well, that's a clue." Ray stepped over beside her and poured more wine into his glass, and then hers, wishing she would ask him that question. Then he could say that she would make him happy, that he was happy with her just being there, but that holding

her would work the magic, having her hold him back. Something real rather than pretend or cursory like their cheek-to-cheek kisses when they said hello or goodbye.

The man outside was quiet now. Ray flicked on the flashlight and shined it through the window but it was hard to see through the yellow glare on the glass to the spot of ground the light shined on. He raised the window a little, to the splatter of rain on the soggy earth.

"Well, it's not good for him to spend the night out there," he said finally, because he imagined water rising up around the man, head in a pool, nostrils filling with puddle and silt.

"Maybe he'll just leave," Alma said. She put her glass down and left the kitchen, went to the bathroom Ray thought.

"There's pretty good drainage out there," he called out to her. There had never been any real flooding that he knew about.

Ray took the tournament diagram into the living where he sat on the blue sofa and lay the sheet of paper on the glass-topped coffee table. There was light from a chrome floor lamp and the TV was still on, *Animal Planet*—leopards lounging in tall dry grass. He watched that a few seconds, the image of the man out back swelling onto it. Dry leopard, wet man; if it was meaningful he didn't know how.

For the first round, he picked the teams he knew about but soon understood that filling all the brackets would take some time, some very considered guesses. Everybody picked Duke to win the whole thing, be the team of the decade—the nineties—but the teams Duke would beat were harder to choose. Among them, somewhere, was the team of the '00s. The zeros. Was anybody even hopeful for that distinction, Ray wondered.

Alma came and sat beside him. She turned up the volume and changed the channel to ESPN in case they were analyzing the teams. But it was hockey night, so she muted the sound.

Ray watched her as she went into the kitchen to bring the wine bottle. He said, "Are you hopeful, then?"

"About what?"

"Hopeful. If not happy?"

"Sure." She slid the betting sheet in front of her and took the pencil from Ray's hand.

While she scanned his guesses, Ray thought to tell her about the man who waved, but his mind skipped over to the subject of his boss,

the hotel manager who seemed hopeful *and* happy, but was also mean. He was burly, with a British accent and tight suits. He treated Ray like a servant. Ordered him recently in a room full of his staff to raise their wages (necessitating some struggle not to offend either his staff or the manager, while trying to disguise his anger and humiliation), threatened to hire another serving group within earshot of customers and staff alike, but then pretended to be friendly, as if he'd been only teasing—such an arrogant, meaty thug, in Ray's opinion. So that was a problem, since Ray's contract was up for renewal. His regular staff depended on him, he thought, and he kept a pool of extras active. This contract kept him steady at the one hotel with pretty good money. He was developing a hate for the manager, but he didn't want to quit.

He wasn't ambitious, he chided himself. At thirty-one, he should have already accomplished more than becoming a glorified waiter. This week he was to meet with the manager to discuss contract renewal, terms thereof. Still, he wasn't sure he wanted it—another year of that bull. Except the manager might be leaving, he'd heard from Jamal, the assistant manager, who might take over—a better man altogether. So maybe stick it out—maybe something good could happen—a nice long-term contract eventually, and an employer who treated him like an equal, like another boss.

He knew better than to get into all that with Alma. Those thoughts colliding in his head sounded like complaint, like whining, even more so with a broken-hearted man watering the backyard with tears.

So, "Did I tell you about this guy on my way to work who waves at everybody?" he asked. The way it came out, like mockery, even that sounded like complaint.

"No. Something wrong with that?"

"I don't know."

"People wave, don't they? It's a common, person-like gesture." She tucked her braids behind her ears. She had funny ears. They stuck out, even more with the braids pushing behind them. She didn't seem self-conscious in the least. He found that utterly charming, such a pretty, comical face.

"People don't do it like he does. Not like that," Ray said of the waving. "He's automatic, compelled, troubling."

"You don't like him?"

"Yeah, I like him all right. He makes me feel funny, though. It's like he went crazy and his mind stuck on friendly, which is better than taking the serial killer turn. Still, while you want to feel good about chronic cheerfulness, it doesn't look any more sane than chronic moping, hatred, and murder."

"Ray," she said, leaning to stare facetiously into his eyes. "What's wrong with you?" She held up her hand and wiggled her fingers in his face.

"What's wrong with *you*?"

"Nothing." She leaned away.

"I want it normal. I want that waving son-of-a-bitch to be sane. He's got somebody inside the house to put a sweater on him when it's cold and to sit him inside when it's freezing and wet, to buy his shirts and shave him, maybe."

"The Luckiest Man, you mean."

"You got it. One time I was going by and he was helping some lady bring a couple of small suitcases from a car in his driveway—the first time I'd seen him on his feet—and you should have seen the panic on his smiling face. He couldn't wave 'cause of the suitcases, so he just stood there looking at me passing as if I was an ice cream truck coming to flatten him. You know, something both welcome and troubling. So I waved, and felt perfectly evil, then. It was like he was drowning and those suitcases were concrete blocks tied to his wrists."

"Not waving but drowning."

"Well, I guess."

"It's a poem."

"What is?"

"That line. It's from a poem about somebody seeming to wave when actually he's drowning, and somebody else misreading the gesture. I think that's the reading."

"Oh. Maybe I remember that poem, then. But this guy is just waving. It was like drowning when he couldn't wave."

"You're not evil, Ray," she said, patting his knee. She handed him his wine glass and clinked hers to his. "But speaking of drowning, do you think your boy out back is dead yet?"

"Aw, that guy." Ray glanced back at the dark kitchen window. "What's the matter with him, anyway? How come he gets to do that?"

"He's a drunk man. Desperate. Down on his luck and on the margins of society, lying up against your fence."

"Now you get to make the joke," he said.

He took the flashlight back outside. The rain had eased to a hard drizzle. In the beam of light, rain flashed. The grass was spongy, and Ray stepped over illuminated bare spots of glistening mud. The sound of rain in the trees was enthralling and Ray didn't want to go over to the man. Didn't care to see him lying there passed out or dead, or to hear the sobbing, and the thick splat of blunted rain hitting the slick face and wet clothes.

When Ray walked to the hedges by the fence, the man was gone. The light revealed matted grass, flattened tufts of daffodil stems. He pointed the light through the fence in case the man had climbed over and collapsed there. Nothing. Not even a liquor bottle left behind. Alien abduction, perhaps. Alma, he thought, would be relieved.

She left soon after, the betting sheet thoroughly guessed at. Ray put away the sandwich makings, finished the bottle of wine, and fell asleep on the sofa to the hockey game. The next morning going to work he was waving at the man sitting on the stool in the doorway.

It wasn't until after work that he felt bad about the man in his yard again. He had two lunch meetings to serve and one of his waiters got sick during the shift while another just didn't show up, and still another came in late during the serving with hair limp from rain, her white shirt wet and sticking to her shoulders, which showed pink through the thin fabric. Meanwhile, Ray tried to fill in, going from room to room to keep plates moving, but the hotel manager kept popping in, stupidly commenting on contract points while Ray was hoisting trays of *cordon-bleu*, hustling with pots of coffee and pitchers of tea. Then, still short-handed, he had to break down both rooms and set up a larger one for a breakfast meeting tomorrow, check with the kitchen to synchronize the head-count because the manager told him late that the number had been increased, and often the kitchen never learned of such changes. While he was there, he had a talk with the dishwasher staff about sending out racks of glasses and cutlery covered with spots that his crew was obliged to wipe away. Then he got on the phone to some of his staff, to leave messages, persuade others to come in very early tomorrow morning to cover the crowd.

Raining all day, a steady, sharp drizzle. Ray had sneaked a couple of
moments to stand on the kitchen's loading platform and sip a glass of
tea. Then at five-thirty, before leaving for the day, he stood there again
and looked out on the lushly wet cedar trees that buffered the hotel
from the expressway, and at the stretch of green yard through which
the jogging trail coursed. He was tired; yet he imagined the insistent
rain excited the earth. Flowers were already springing up, opening.
Azalea buds dotted the bushes. Daffodils were already everywhere.
He was thinking of Alma of course, thinking of how romantic the
rain could be—the way it encouraged huddling under umbrellas, as
it had when he walked her to her car the night before, and the way
it sent people indoors with the options of what to do there; he often
imagined the intimacy of the hotel guests in their rented rooms, and
envied them. And then the rain became sad again, gray and relentless,
falling all night and all day and probably all night again. He and Alma
had done nothing much indoors last night. And the image of the man
in his backyard returned. "Forlorn," he said aloud, tasting the sour
age of the word. Another little something from a poem. Keats. Alma
wasn't the only one with an education.

It was time to go home, the deflated mood of low expectation upon
him. Alma wouldn't come by again tonight, two nights in a row, and
there was no excuse to go see her, and her strange roommate. Surely
Alma knew he longed for her, and obviously it didn't matter.

He sat in his car awhile and listened for the traffic report. Incredibly,
cattle were loose on the expressway, their transporting truck overturned.
The rain slowed a little. Ray circled out of the parking lot and steered
onto his alternate route. At a traffic light, he noticed a line of cars
behind him, and much of it followed as he turned onto the street
through the neighborhood where the waving man lived. He wanted
to be alone, not leading a procession through his secret. But maybe it
was everybody's secret, and he wondered whether the others imagined
a relationship with the waving man, too.

It was then, thinking of the waving man, and the sad man still on
his mind, that he felt himself held in a balance, sustained between his
own hope and despair, caught between the waving man and the wailing
man. He realized that he was afraid to move, to risk sinking under
the weight of his pessimism, or rising up too happy and untethered
by solemnity, of being lost in space like the waving man. It was why

he wouldn't drive over to Alma's and climb through her window and wait for her in her bed—that and her roommate—and why he wouldn't simply leave her alone. To contemplate either one wobbled him, because for her to accept him would mean his giving up his hold on his reality, his suffering, and for her to reject him would send him crashing. It was not a stasis that cheered him.

Maybe, he thought, a similar stasis, a similar fear, kept Alma from being happy. Maybe all it would take was for him to upset the balance, push her off her anchor. And maybe they could soar into a new life, a new decade and new century together. And maybe not.

At the blue house, the man was on his stool behind the storm door and waving. Ray waved back. He looked in his rearview mirror and saw that driver also wave. The driver was wearing a suit and tie, in a soft-gold Lincoln with green tinted windows. A wealthy man, it seemed, the car old and well-kept, water beading on the polished gold surface like wet jewels. Behind the Lincoln, the wet headlights of the other cars filtered through those green windows, creating a gliding capsule of soft-green glimmer, the color of water in an ocean. Ray slowed and kept glancing back to hold the slow float of green headlights, the glimmering green rain on the Lincoln's windows, to ride it around the curves and out beyond the neighborhood to the unobstructed expressway, the wealthy man's car creating a green lens of comfort in the gray day.

On the expressway, the Lincoln pulled around to pass, and Ray waved, thankful for that sustained moment. The man waved back and sped by. Other cars sped by, too, spraying thick rain onto Ray's windshield. Ray quickened his wipers and soon could see well enough to drive safely home.

ANDREW HUDGINS

Botticelli: The Lamentation over the Dead Christ

Dismiss the body bent so awkwardly
across his mother's lap: there's no god in it.
Dismiss the saint holding the nails, the thorns.
Remember only the Marys: Salome,
Cleophas, Magdalen—
and Mary, fainting virgin, her body
distended, bulging, because she suffers more
than anyone can grieve unless she loosen
her human shape and become impossible.
And Saint John's arm grows long, too long, because
he cannot comfort her or ease
her body back to what it was before.
Impossible, too, are the other Marys, one
at either end of Christ. Their hands contort,
necks twist strangely, and bodies bend
until they're radiant with suffering.

And though she's standing back, hiding in plain sight,
remember Magdalen. She's hunchbacked, wrenched
by dark, misshaping sorrow.
The first time, Botticelli gave her eyes.
They glittered, ugly with her hatred, rage
at those who killed her savior.
But in her grief, she called out to the artist,
Take them! Erase my eyes! Instead,
he's hidden them behind her hands, two hands
where there had been a face
until she asked that cup be taken from her,
and Botticelli, unlike God, could nod,
could say yes, and he does.

MARK JARMAN

Psalm: First Forgive the Silence

First forgive the silence
 That answers prayer,
Then forgive the prayer
 That stains the silence.

Excuse the absence
 That feels like presence,
Then excuse the feeling
 That insists on presence.

Pardon the delay
 Of revelation,
Then ask pardon for revealing
 Your impatience.

Forgive God
 For being only a word,
Then ask God to forgive
 The betrayal of language.

RICHARD JONES

The Face

*Emmett Till's mother
speaking over the radio*

She tells in a comforting voice
what it was like to touch her dead boy's face,

how she'd lingered and traced
the broken jaw, the crushed eyes—

the face *that* badly beaten, disfigured—
before confirming his identity.

And then she compares his face to
the face of Jesus, dying on the cross.

This mother says no, she'd not recognize
her Lord, for he was beaten far, far worse

than the son she loved with all her heart.
For, she said, she could still discern her son's curved earlobe,

but the face of Christ
was beaten to death by the whole world.

RODGER KAMENETZ

My Holocaust

Don't remember talking about it much as a child.

Faces of men in striped pajamas
behind barbed wire, blinking at the light.
Their flesh soapy, unnatural. Their time
on earth slowed down to forever,
their waiting a new unit of time:

My eyes, their eyes. My flesh, their flesh.
My bones, their bones. My Holocaust—
is a museum, a movie, a TV show.
A few old folks with tattoos who can say
I was there, and soon enough
they will step out of the light.

My Holocaust is a book of fine print.
The names of dead relatives
I never knew recited in a small synagogue,
a chamber of memory where the chazzan
is fat and seedy in the shadows.

In a museum in Washington a tourist
holding an ID card shuffles past cases
though no ID card will link me
to bits of crunched bone, crushed into flesh.

What can I take home as a souvenir?
Pity is too cheap and the history
of the Jews is not their deaths.

And I have no idea, dear chazzan,
how to join you in your reedy prayer and chant,
like a saxophone of spittle in your throat,

how to lift the obscure Aramaic of mourning
through seven heavens of praise
dragging the roll call of the dead
behind us like boxcars
through a Poland of smoke.

My Holocaust is a dozen wooden synagogues
dollhouses on a table—for hundreds burned—
all of them, in Russia and Ukraine.
The host of slaughtered towns
covers a wall that can't be read,
thick and obscure as dried blood.

My Holocaust is Europe without her Jews
a pleasant Europe of shops,
prosperous boulevards,
fine art, and few Jews.

Judenstrassen where there are no *Juden*
Jewless Jew towns, and in small shtetls,
the broken walls of a synagogue
pen pigs while an old man
who witnessed the slaughter
tends a cemetery of weeds.

Will my people reduced to a loud fraction
join their old friends the Hittites,
Jebusites, Moabites?
Lost tribes, lost language, ruined temples,
gods and goddesses suspended
in a Lucite case.

When a people disappears, they leave
opaque, inexplicable names,
Ouachita,
Tallahassee, Mississippi—

Death is a solvent breaking the bonds

of word and object, fist and song,
marching orders and boots
that crushed small hands, the whips and dogs
whose teeth sank into particular flesh
and routed from an attic a trembling boy
whose name is lost. The cry of a child
and then the night was still
and the full moon continued its passage,
a great white boat carrying nothing.

The smoke left the chimneys rising
according to physical laws, and bodies in motion
remain in motion, and bodies at rest
disintegrate, their names break down
into letters and hollow breaths
of lost vowels. And bodies burned remain
ashes buried or scattered. So why should
memory be more permanent,
more sacred than flesh?

In my Holocaust Theme Park you will see
a river of blood, a mountain of gold crowns.
Here in the Fun House
it's a scary ride down into the tunnel
of broken teeth and children's shoes.

And what do I teach my children?
To be angry, not to be angry,
to hate the haters, to love them,
to love everyone, to hate everyone,
to remember, to be a little afraid,
to learn how to forget,
to be a Jew out of pure revenge,
to teach Hitler a lesson?
Who should I forgive and who
is now to be forgiven?
Naked bodies in piles that
cannot be untangled or unremembered....

The sparks in our souls are tired of leaping,
tired of bearing all these names
in Hebrew, Yiddish, Polish and pure will.

When you leave the Fun House
you will get a blue tattoo,
souvenir of all lost memory,
to burn a day or two on your arm
and whatever you feel will be adequate,
for you bought your ticket for mercy
and had it stamped in sympathy,
though I wouldn't invest too many tears:
the Holocaust doesn't have a future.
Another fifty years and it's history.

Death is a great equalizer
and it is up to us to live against that fact
for the men in stripes have given me
their Holocaust to keep
and I don't know yet what to do with it,
The bodies with arms stamped with numbers
will be numbers again
unless an angel chazzan with a giant mouth of prayer
recites all their names, slowly one by one.
Or we will mourn with popcorn in a theater.

And someone is saying, how many tickets were sold?
And someone is asking, were there really six million?
And someone is saying, are there really enough prayers?

1990-2001

JULIA SPICHER KASDORF

Across from Jay's Book Stall in Pittsburgh

Sun glitters on bronze legs like thorns, arms thrust forward
as if that enormous torso has always longed to tear free
of brick and walk up Fifth Avenue clanking like the Tin Man

in search of a heart. Girl in a flood of golden lamplight,
in an olive green chair, leafing through *Highlights* magazine,
looks for a teapot hidden in a tree, or a hammer, all alone

except for the lady behind a desk who smiles when she looks up
until the mother backs out of a door, bent and weeping. What kind
of doctor makes even grown-ups cry worse than getting shots?

The mother grabs the girl's hand, dabs her own eyes, blows her nose,
sobs on the elevator, pressing buttons, sobs on the sidewalk beneath
the façade of the school of public health: great legs like thorns,

arms thrust forward as if that body has always longed to tear free.
They walk forever as people part discreetly on the sidewalk;
if there are looks of sympathy, the girl does not see. She wears

buckle shoes and pans the scene from afar: silk lampshade,
sculpture's hard glitter, stack of thin books under one arm.
The girl is serene, knows pain makes people weep, and silence

makes the best hiding place. Later she will admit: people weep
to get well, sometimes. The sad will always seem blameless.
The depressed will always be with us. She will remember it all

from the limbs of a sycamore tree, like Zacchaeus, tax man who
climbed up there to catch a glimpse: *Zacchaeus, come down. I am
going to your house for tea.* Even those broad, leathery leaves

couldn't hide him from a Savior's invitation. In a child's soup,
limp noodle letters float among points of glowing vermilion
grease and spell nothing. We swallow them whole without chewing.

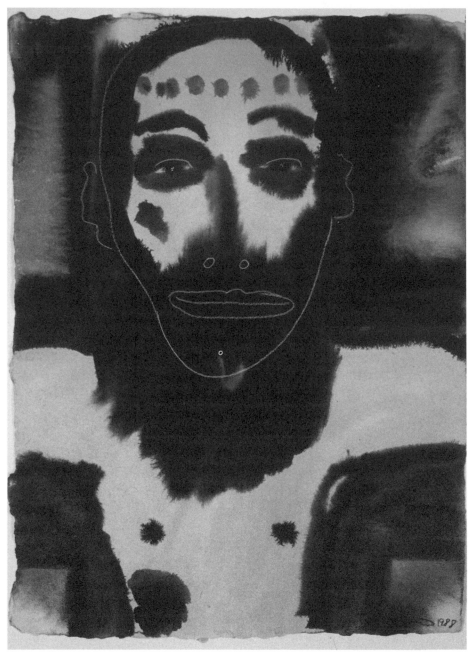

Frederick Brown. *Christ's Last Breath,* 1988. Mixed media on paper. 24 x 18 inches. Collection: Sebastienne Brown. Issue 9, Spring 1995.

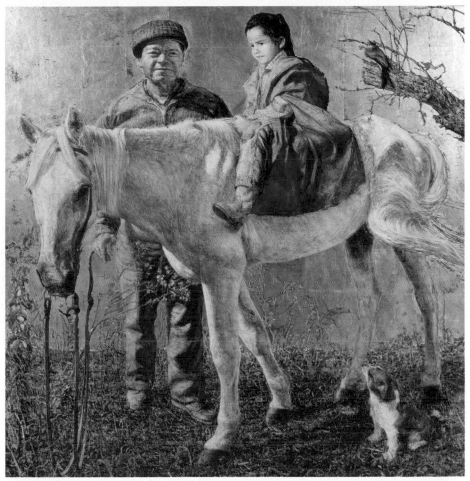

John P. Cobb. *Mary (the Mother of Jesus) as a Child, Her Grandfather Joaquim Guiding*, 1988. Egg tempera on Masonite board. 34 ½ x 34 ½ inches. Issue 47, Fall 2005.

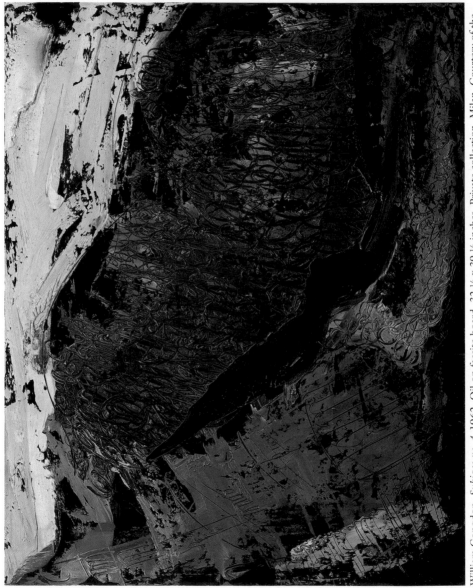

William Congdon. *Subiaco no. 4*, 1962. Oil on faesite board. 32 ½ x 39 ½ inches. Private collection, Milan. Courtesy of the William G. Congdon Foundation. Issue 14, Summer 1996.

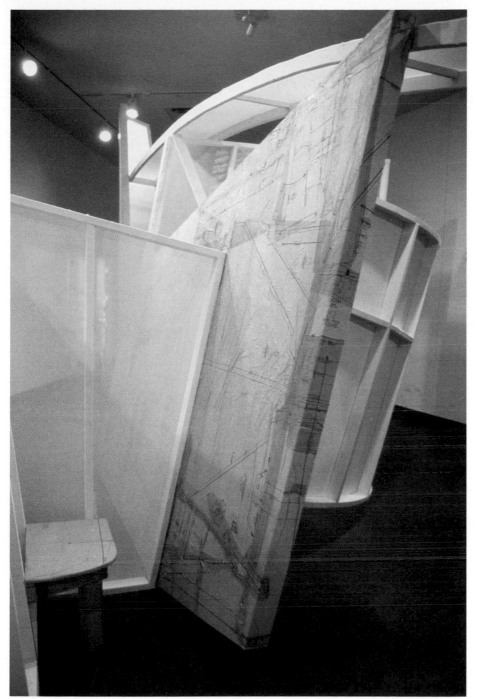

Roger Feldman. *Inside Outsiders* (interior view), 2000. Wood, polyurethane, fabric, vellum. 14 x 30 x 14 feet. Copyright of the artist. Issue 30, Spring 2001.

Ginger Henry Geyer. *The Gift to the Elder Son*, 2000. Glazed porcelain with gold. 10 ¼ x 9 ¼ x 9 ¼ inches. Adaptation of Rembrandt's *Return of the Prodigal Son*. Issue 33, Winter 2001-02.

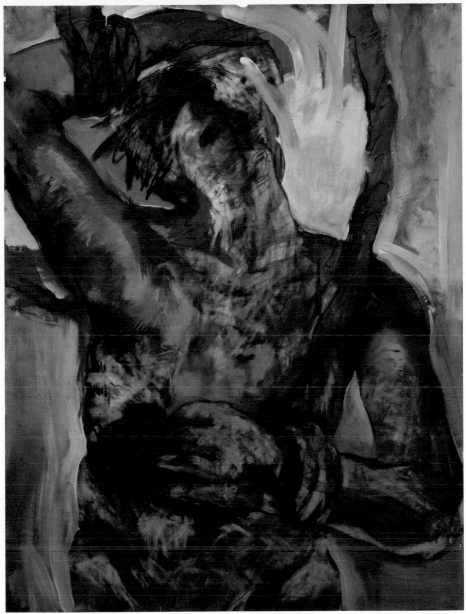

Bruce Herman. *Descent*, 1992. Pastel. 50 x 38 inches. Issue 7, Fall 1994.

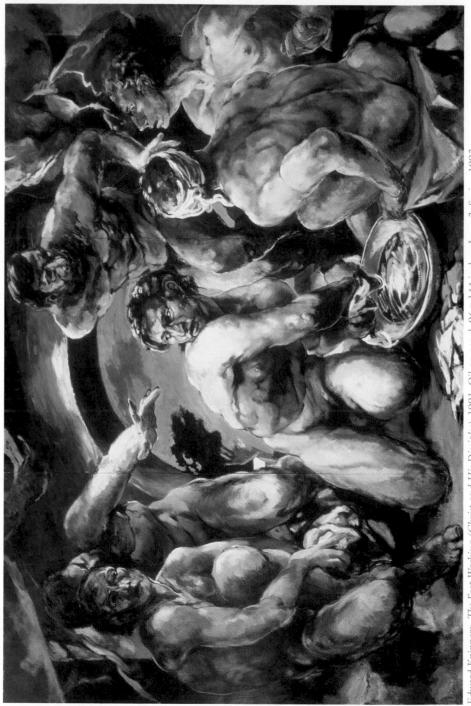

Edward Knippers. *The Foot Washing (Christ and His Disciples)*, 1991. Oil on panel. 96 x 144 inches. Issue 3, Spring 1993.

Barry Krammes. *Of Longing,* 2006. 60 x 32 x 18 inches. Mixed media. Photo: Kurt Simonson.
Issue 55, Fall 2007.

Laura Lasworth. *Saint Thomas and Mr. Eco*, 1994. Oil on panels. 78 x 33 inches (each panel).
Collection of Ronald E. Steen. Issue 17, Fall 1997.

Zhi Lin. *Five Capital Punishments in China: Drawing and Quartering*, 2007. Mixed-media painting and screen print on canvas. 106 x 74 inches. Courtesy of Howard House Contemporary Art. Issue 56, Winter 2007-08.

Tim Lowly. *Beacon (Kite)*, 1991. Tempera on panel. 7 x 7 inches. Collection: Anne and Warren Weisberg. Courtesy of Gwenda Jay Gallery, Chicago, Illinois. Issue 7, Fall 1994.

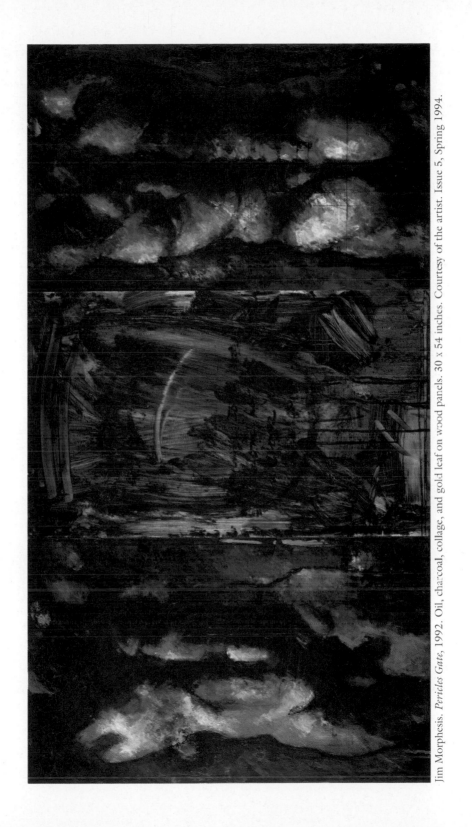

Jim Morphesis. *Pericles Gate*, 1992. Oil, charcoal, collage, and gold leaf on wood panels. 30 x 54 inches. Courtesy of the artist. Issue 5, Spring 1994.

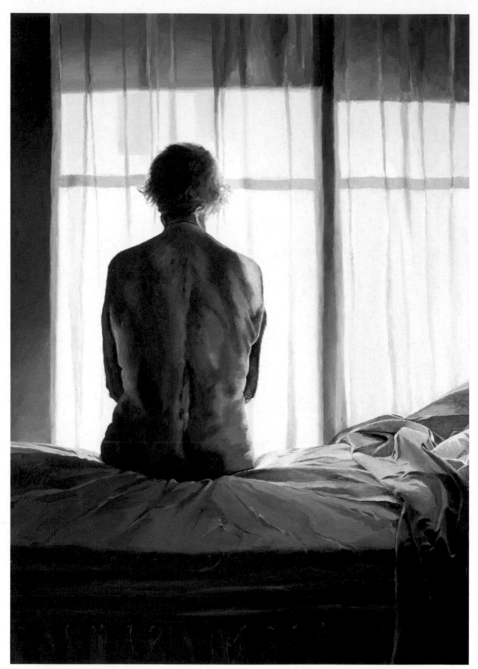

Catherine Prescott. *Her Back to Me*, 1996. Oil on canvas. 66 x 48 inches. Issue 36, Fall 2002.

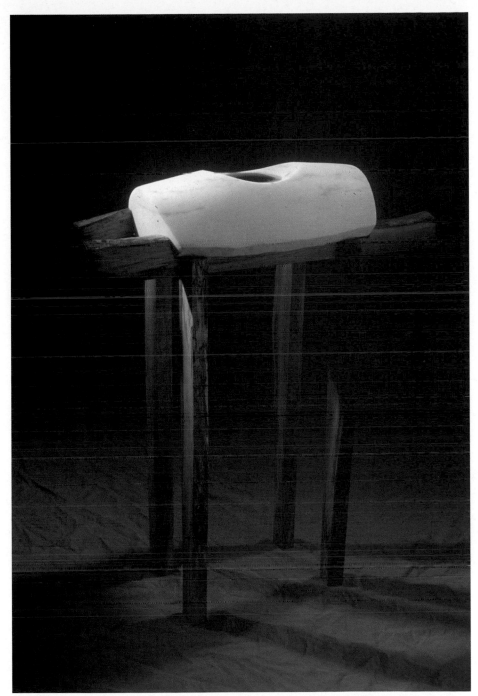

Theodore L. Prescott. *Taste and See*, 1996-97. Butternut, Colorado Yule marble, hand-blown glass, Tupelo honey. 34 ¾ x 28 x 11 ½ inches. Issue 40, Fall 2003.

I See the ▲▲▲▲ed Land

This was Dr. King's last, a ▲▲▲▲▲▲▲n. He delivered it, on the eve of his assassination, a ▲▲▲▲▲▲on Temple in Memphis, Tennessee, on 3 April 196 ▲▲▲▲uarters of the Church of God in Christ, the larg ▲▲▲▲l denomination in the United States.

Thank you very ki ▲▲▲ph Abernathy in his eloquent and ▲▲▲ht about myself, I wondered who ▲▲▲have your closest friend and a ▲▲▲d Ralph is the best friend tha ▲▲▲

I'm delighte ▲▲▲storm warning. You reve ▲▲▲omething is happening i ▲▲▲d.

As you k ▲▲▲with the possibility ▲▲▲n history up to now ▲▲▲, which age woul ▲▲▲y Egypt through ▲▲▲on toward t ▲▲▲ldn't stop t ▲▲▲ount Olym ▲▲▲Aristop ▲▲▲eat and ▲▲▲

▲▲▲of th ▲▲▲ t ▲▲▲

Tim Rollins and K.O.S. *I See the Promised Land—Daniel Boccato (after the Reverend Dr. Martin Luther King Junior)*, 2008. Watercolor and pencil on book page. 9 x 6 ½ inches. Courtesy of the artist and Lehmann Maupin Gallery, New York. Related to a work from Issue 45, Spring 2005.

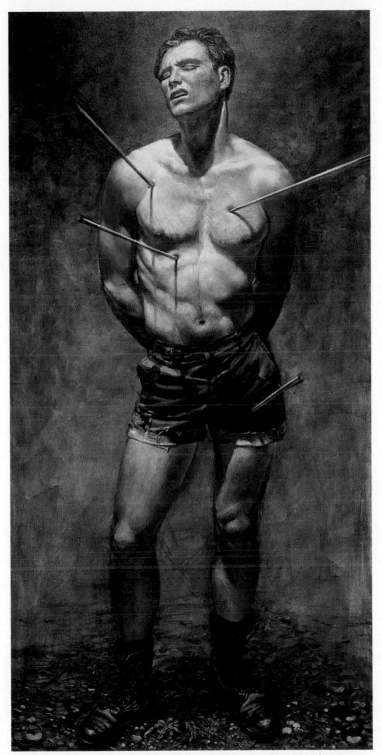

Melissa Weinman. *Saint Sebastian*, 1996. Oil on canvas. 72 x 36 inches.
Collection of the artist. Photo by Susan Dirk. Issue 30, Spring 2001.

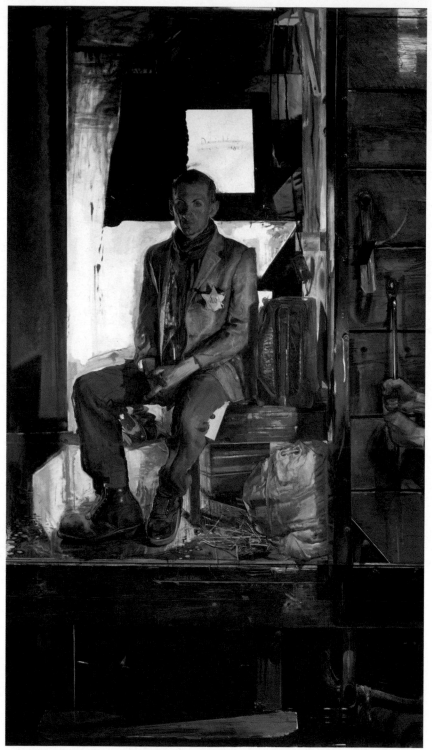

Jerome Witkin. *Terminal,* 1987. Oil on linen. 123 x 71 inches. Collection of Mary and Vaughn Lang, Cazenovia, New York. Courtesy of Jack Rutberg Fine Arts, Los Angeles. Issue 11, Fall 1995.

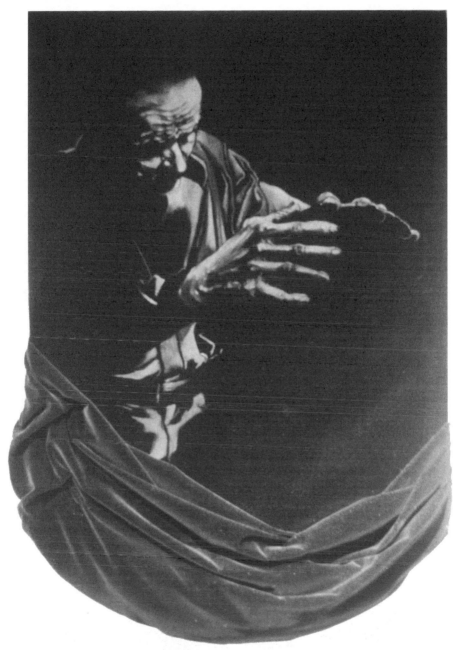

Eleanor Dickinson. *Lord, Send that Old Time Pow'r*, 1979. From the series *Revival!* Oil on velvet. 48 x 36 inches. Copyright of the artist. Issue 48, Winter 2005-06.

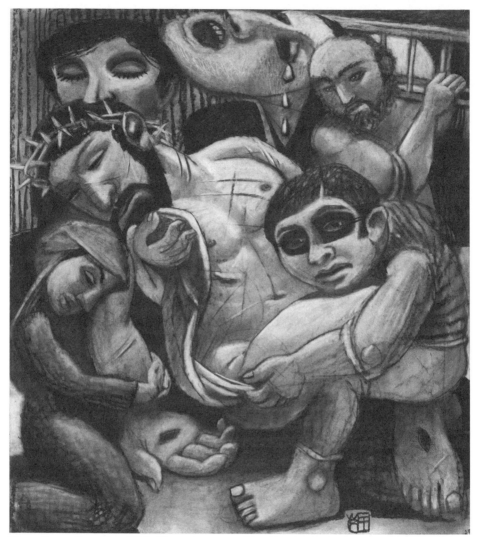

Wayne Forte. *Deposition*, 1990. Charcoal on paper. 50 x 40 inches. Related to a work from Issue 13, Spring 1996.

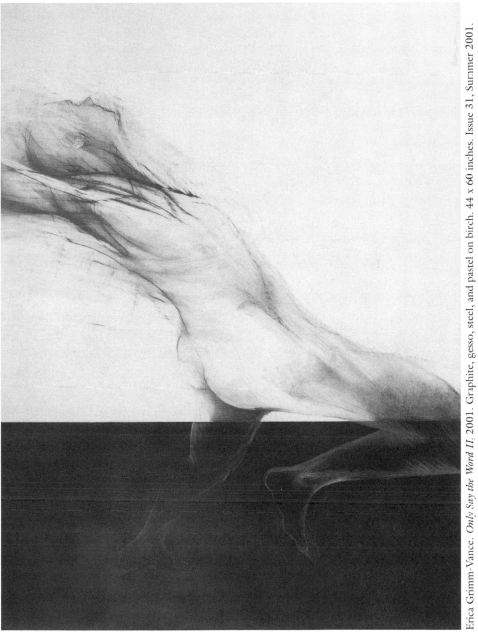

Erica Grimm-Vance. *Only Say the Word II*. 2001. Graphite, gesso, steel, and pastel on birch. 44 x 60 inches. Issue 31, Summer 2001.

David Herwaldt. *Baxter Peak / Hikers / Fog*, 1995. From the ongoing series Highpoints. Black and white gelatin silver print. Issue 40, Fall 2003.

Barry Moser. *The Nativity,* 1996. Wood engraving. 10 ¾ x 7 ¼ inches. Issue 21, Fall 1998.

SYDNEY LEA

The Host in My Dentures

It struck me first much more as sound than pain:
still timpani-loud, the puck that found my mouth
and—*plock!*—four decades later, has me wearing

this partial bridge. My mother wouldn't let me
see the dentist, imagined me tough as she was.
I'm not, I wasn't. *Things pass,* she said. They didn't.

Of course the fault lay partly with me: sixteen,
you didn't wear helmet or mask, because you thought
—using the verb *to think* somewhat too loosely—

you'd skate right over a wounding, even a dying.
I should've been hit in a game at least, not practice!
The shot burst off Bill Chapman's stick and caught me

there where I'd knelt to block it. Kneeling this morning,
I took the cup and the bread, and continue to bear
scraps of the Host in my dentures, so I've been thinking:

not sacrilege, this, and yet it's dreary enough.
In mind my girlfriend Constance still sits in the bleachers—
watching mere *practice*—probably bored stiff.

I've been glancing her way and grinning since taking the ice.
Her waspish features, her even smile, the frost
that powders the neck of the letter sweater I gave her.

In less than a month, I'll have the sweater back.
She's too close to flawless to keep. I'll keep the teeth,
but only till age catches up and ancient defects

bloom in my roots. That dreariness I felt
in the pew this morning goes back perhaps to a girl,
to how she quit me: who'll love a dark-mouthed geezer?

God. I know that's what I should give for my answer,
but it sticks a bit in the maw, though it ought to come easy
after taking communion, which is meant after all to change

our view of the world, ourselves, our fellow humans.
I hear that *plock,* and something like thought supervenes:
These are the teeth of my body, broken for thee,

and not for Constance or Peg or Ruth or Jeanne,
nor any other heartbreak crush of my boyhood.
These orts that lodge in the wire and plastic contraption:

having no choice, I'll choose a satisfaction
(I wasn't worthy, I was, I'm not, I am)
in bearing them through a day. O saving remnants.

DENISE LEVERTOV

Dom Helder Camara at the Nuclear Test Site

Dom Helder, octagenarian wisp
of human substance arrived from Brazil,
raises his arms and gazes toward
a sky pallid with heat, to implore
"Peace!"
—then waves a "goodbye for now"
to God, as to a *compadre*.
The Mass is over, go in peace
to love and serve the Lord: he walks
down with the rest of us to cross
the cattle-grid, entering forbidden ground
where marshals wait with their handcuffs.

After hours of waiting,
penned into two wire-fenced enclosures, sun
climbing to cloudless zenith, till everyone
has been processed, booked, released to trudge
one by one up the slope to the boundary line
back to a freedom that's not so free,
we are all reassembled. We form
two circles, one contained in the other, to dance
clockwise and counterclockwise
like children in Duncan's vision.
But not to the song of ashes, of falling:
we dance in the unity that brought us here,
instinct pulls us into the ancient
rotation, symbol of continuance.
Light and persistent as tumbleweed,
but not adrift, Dom Helder, too,
faithful pilgrim, dances,
dances at the turning core.

PHILIP LEVINE

When the Shift Was Over

When the shift was over he went out
and stood under the night sky a mile
from the darkened baseball stadium
and waited for the bus. He could taste
nickel under his tongue, and when he swiped
the back of his hand across his nose
he caught the smell of hydrochloric acid.
There were clouds between him and the stars,
not ordinary ones but dark and looming,
and if rain had begun to fall, he thought,
could it be black? Could a halo form
on those fine curls his Polish grandma
loved to brush when he was a boy, cupping
a hand under his chin? How silent
and still the world was after so much
slamming of metal on metal and the groans
of the earth giving way to the wakened fury
of the earth and the separate cries of people
together for these nights. How odd that he,
born of convicts and soldiers, of men
and women who crossed and recrossed the earth
carrying only the flag of their hopes,
should stand numbed by the weight
of a Thursday shift and raise his head
to a heaven he had never seen and sing
in a hoarse voice older than his years,
"Oh, Lordy Lord, I am, I'm coming home!"
He, who had no home and no hope, alone
on a certain night in a year of disbelief,
could sing to the ranks of closed houses
and cars, could sing as clear rain fell.

PAUL MARIANI

There Was a Boy Once

There was a boy once went out
to find the world. And the world,
it seems, found him in return.
From what his parents saw, nothing
ever seemed to satisfy the boy.
And as he worked his way toward
manhood, he tried on everything—
knowledge, sports, a two-piece
business suit, a navy uniform.
He tried on causes, and rode a bike once
all the way from Boston west to Santa Barbara
in the high sirocco winds to feed the hungry.
Likewise he tried on languages:
Spanish first, then Chinese. Even Arabic
with a French accent, and read *The Economist*
and *The New York Times,* and in one long
summer combed all the classics from Gilgamesh
to what he dubbed "those awful Modernists."
Sci-fi by the box, and Merton, and three volumes
on the English language. Likewise the Bible,
cover to cover, I would add, and once—in Morocco—
The Qur'an too.
 Somewhere in all of this
he heard God whisper. Perhaps it came when he
was twelve, and asked his parents for Chinese
lessons, the only Caucasian in the class. Perhaps
when—at his confirmation—he took the name Ignatius.
"Ignatius?" the bishop quipped. "There's trouble."
Still, how to explain why he followed where he did?
The answer's plain. The answer's complex,
subtle, contradictory, yet finally very plain.
After two years in Taiwan, he landed on the Chinese
coast. Heading north—so the story goes—

and traveling third class with dogs and roosters,
as he neared Beijing, there was the Voice.
"Well, what are you waiting for?" it said,
and may even have called him by his name,
though he surely knew to whom the Voice
was talking. The rest is history. The rest is joining
the Company of Jesus out in California.
The rest is L.A., Fordham, Seattle, Mexico,
and Berkeley. Ditto Hollywood and Chicago, and
wherever else he's called. "I did a practice mass,"
he wrote just before his ordination after eleven years
of study. "And I am happy to say I was as stiff
as the tin man and as adept with the Sacramentary
as with a Sanskrit grammar. I guess I need
a little more practice before they unleash me
on God's people." Once his father also heard
a voice (the family always was a little strange).
"Don't worry about your son," is what he heard.
"You and his mother have taken him this far.
The rest is between him and me." With that, peace
settled on the anxious father. A strange place,
this world of Mystery, where things never
seem to add up the way you think they should.
Where for every gift you give, the Lord
increases that a hundred. The proof, they say,
is in the breaking of one self to feed the hungry.
And who among us has not been hungry?
Has not wished for the gnawing void
to be filled with light? A boy went out to
meet the world, and the world met a man,
who understood that for every *no*
there is a *yes* if only, like his Master,
he could just say *yes* and *yes* and yet again a *yes*.
And so he took a cup that he would
come to share with others, and on the bottom
wrote: "Ordained to serve." And thus it was
the boy I speak of finally found himself.

ERIN McGRAW

The History of the Miracle [fiction]

W HEN THE PEBBLE flew out from the gravel truck in front of them and cracked the windshield, Iris wasn't even looking; she had leaned over to tighten her daughter's seat belt. She jerked her head up at the sharp pop and looked into a lattice of hard lines. Lisa, of course, started to cry. "Hush," Iris said, fighting unsuccessfully to keep the snap out of her voice. "It's just an accident."

Lisa wailed.

They were on their way to Lisa's third day at school, and the girl had been crying for a week, threading herself around Iris's legs, refusing in the mornings to pull on her own socks. "This happens all the time," the kindergarten teacher had assured Iris, but Iris, drained of patience, knew better—she remembered how Lisa's brothers had whooped and torn into the classroom. Now the girl was thrashing under the seat belt as if it were a harness, screaming "I hate it! I hate it!" Iris pulled over by yanking on the steering wheel, and the car bumped hard against the curb, sending the girl's screams up half an octave.

"You're too old for this," Iris said, trying to still the quiver in her voice. "You're a big girl."

"No!" Lisa squalled, pointing to the explosion of lines. Iris couldn't begin to guess the replacement cost. She sighed, shifted the car into park and smoothed her daughter's hair. "All right," she said. "Let's calm down now."

"No." Lisa subsided, but Iris could see her calculating a victory; the car had stopped. "It's broken," she said, nodding at the windshield.

"It sure is," Iris said. "But isn't it pretty? Look," she said, running her finger along a line that caught the morning sun in a bright channel.

"Pink," Lisa said, pointing her own small finger at another line.

"You wouldn't have seen this if it didn't get broken."

"I hate it," Lisa said.

"Me too. But at least it's pretty." Iris shifted the car back into drive before Lisa could cloud up again, and they made it to school only five minutes late. Lisa dragged morosely into the classroom. "See?" the teacher said, smiling. "They always come around." Iris smiled back, too depleted to think of a snappy answer.

She felt tired all the time lately. She had hoped for wide drifts of time now that all three of the children were in school, but her energy dribbled away into PTA and Cub Scouts. If she hadn't known better, she might have thought she was pregnant again; her own body seemed mysterious and alien and exhausting. She stooped for a drink at the water fountain outside Lisa's classroom door, then went down to the teachers' lounge for a cup of coffee. She might as well stay; she was scheduled for ten AM playground duty.

By the time she made it out to lean against the fence and watch the fourth graders play kickball, Iris's mood was perfectly sour. The preliminary telephone bids for the windshield were each enough to break the bank; Jack would be furious. By the third call she simply hung up and went out to the playground. The children played ferociously; games ended when some bruised child sat sniffling and shrugging her away, and Iris wondered what her presence there was supposed to do. She had never once prevented an accident.

She listened, keeping a distracted eye on the game, while Frances Holmes fretted about next week's parish-wide crab supper. Frances was hoping the event would bring in at least five hundred dollars. Plans for the outdoor chapel were way behind schedule, but Frances didn't know what people expected her to do without any budget.

Iris sighed and stared unhappily at her feet. Sheer guilt would force Jack and her to go, although seafood made her queasy. Why couldn't the committee have set up a steak dinner? She was about to ask, and nastily, when she glanced to her right, toward the boys, to see the red kickball shooting at Tommy Pointer and catching him on the throat; the boy dropped as if he'd been shot.

Iris took off. Tommy had fallen hard, straight back, and on the asphalt beneath his head there was a tiny seepage that Iris looked away from the moment she saw it; she could only stand so much.

Tommy was silent, and his face had already turned a rubbery gray. Iris, wincing as sharp pebbles cut into her knees, took his hand.

"Tommy? You're all right, aren't you?" A moment passed, and Iris was aware of the boys jostling behind her to catch a glimpse, though none of them made a sound. Then Tommy opened his eyes and pulled his hand away from hers.

"Sure," he said, scooting onto his feet. He wiped his nose with a gritty hand and ran toward the water fountain while his friends jeered. Iris felt a rush of relief, and for a moment she stayed on the ground, too soft with gratitude to stand. When she glanced at the spot where Tommy's head had lain, there was no moisture at all, and she thought it was amazing what a panicky mind could invent.

"They're indestructible," said Frances when Iris rejoined her at the fence. "Did you hear about Pat Kenny's boy?" Iris nodded. Pat's four-year-old, left for a moment in the car, had slipped off the emergency brake. The car had rolled across an embankment and four lanes of traffic before settling underneath a speed limit sign.

"God keeps an eye out," Iris said, surprising herself, and then let Frances go back to costs and logistics. Iris's head pounded with children's laughter and shrieks; she felt like an overfull cup. Five minutes later, when the recess bell sounded and the children formed wavering lines, she had to look away, weak at the thought of looking after so much sweet, unscarred skin.

The night of the crab dinner, Jack and Iris entered the church auditorium warily. Iris's sourness had lingered and spread to Jack, so that they had spent all weekend sniping at each other. On the drive over, ducking and craning to see through the windshield, Jack said, "We'll get stuck with the Logans. Bill will talk all night about his important work for TRW and his important work on the steering committee and his important work with the Boy Scouts. And then we'll come home and you'll throw up all night."

"We don't have to sit with them. We can't not show up. People expect us." Iris was trying to get the clasp on her necklace to catch, taking deep breaths—her stomach already felt wobbly.

"We certainly wouldn't want to let *people* down," Jack said, pulling into a space by the rectory and jerking up the parking brake. "My head feels like it's breaking in half."

"What do you expect? You diddle around in the basement until it gets so late you don't even have time to take an aspirin. Ben wanted to talk to you, you know. He wanted to show you his project."

"I thought you wanted the water heater fixed. I thought you'd asked me to look at it."

"For God's sake," Iris snapped. "Here. Let me rub your head for a minute. We can't go in there looking like murder."

"Ah hell, nobody notices anyway," he said, settling his head into her lap. She could feel the tightness quivering around his eyes, how hot he was, and she brushed his temples with the tips of her fingers, unable to keep herself from slumping. Her weariness seemed able to deepen infinitely.

"That's better," he said.

"Relax."

"I mean it. It's better." He held her fingers still against his head for a moment, then straightened up.

"It can't be. I hardly touched you."

"Well, it's gone, Magic Fingers. Let's go in. Maybe we can still get home before the news."

But Iris was exhausted; Jack had to help her to the door, where Frances met them and said, "We almost started without you. Thought maybe you'd decided not to come."

"Who, us?" Iris said faintly. "Bells on."

The auditorium seemed to rattle with laughter and the banging of steam tables. Above the racket, Iris heard the buzz of Kay Wendell's wheelchair and winced—Kay had been diagnosed with MS ten years before, only a month after her husband was killed by a hit-and-run driver. She persisted in attending church functions, Iris was convinced, because she could trap people into listening to her pathetic litany. Iris turned, but Kay was already on her.

"Well, you finally made it. I guess I shouldn't expect people with children to be on time."

Iris felt Jack stiffen beside her, and she put her hand on his arm to keep him from bolting. "Nice to see you, Kay."

"How many wee ones are there?" Kay cackled. "Six?"

"Please. Only three. That's plenty."

Kay looked down and fiddled with the controls on her wheelchair. "When you live alone, everyone else's house seems so full of life."

"I see plenty of life in you yet, girl," Jack said, and took Iris by the wrist. "Look, dear. There's Bill Logan. We'll be seeing you, Kay." He steered Iris to a table already heaped with red and white crabs while Iris ducked her eyes and glanced back at the other woman, who at least wasn't following them; she had caught Betty and Frank Marsh at the coat rack.

Iris survived the meal by industriously separating meat from shell and then eating the hard French rolls—first her own, then Jack's. Jack and Bill Logan carried the conversation, Jack laughing forcefully at all of Bill's jokes. Jack wiped his eyes. Iris wished he wouldn't try so hard. By the end of the meal, her plate and lap were covered with crumbs, and she thought of her house and robe with a yearning that bordered on the erotic.

As Jack was encouraging Bill to tell him more about the Scout trip, a cry rang out directly behind Iris. She turned to see Meg Price choking and flailing at her husband, who shrank away from her. Meg's shoulders jerked and her face turned the color of iron. Iris scrambled up before she had a chance to think and started pounding Meg on the back, while the woman grabbed her and whined desperately. Iris turned Meg around, clutched her under the ribs, and pulled up so hard she felt something in her own back give. She had no idea what she was doing. Meg was still choking, so Iris tried it again, half hanging onto the other woman for support. After the third try Meg barked and spat out a piece of shell an inch across that gleamed as it hit the plate. She fell forward, hanging onto the table, and Iris reached for a chair. Her lower back seemed to have separated into distinct, fiery pieces.

The auditorium clamored. People rushed in on Iris and Meg, exclaiming over what they'd seen, congratulating, marveling. Iris's knees quivered, and the damp shadows of nausea swept across her stomach. "Lucky for Meg you knew how to do the Heimlich," Jo Salton was saying. "I keep meaning to learn."

"Instinct, I guess," Iris said. "I just found myself doing it." She saw Jack studying her from across their table, looking startled and uneasy. "If it wasn't me, somebody else would have helped," she said loudly, looking straight at him.

"That's right," Kay called out, whirring over from two tables away, her mouth bunched up like a paper bag. "Anybody would have done as much."

"Not that I wasn't glad to help," Iris said.

"Purely human nature," Kay said. "Reflex."

"You know, it's harder than you think. Next time...," Iris began.

"Somebody else will get to do the saving," Kay said, grinning at the speechless Iris until Jack picked up his coat and said that they'd better get back, before someone needed saving at home. He had to let Iris lean on him all the way out to the car; her ankles kept buckling as if she'd been drinking.

Jack stalled a week before he asked, diffidently, how Iris had known what to do for Meg, and Iris looked out the window and told him the truth: "I don't know. I found myself grabbing her." He didn't ask any more, but she felt him tracking her as she made her way around the house.

She wished he would stop it. He snuck looks from around the newspaper, watched her dry dishes as if she might reach into her pocket at any moment and produce a hissing fuse. "Here," she said, setting a cup of coffee in front of him. "Please just drink this."

"I don't know if I want it that bad."

"What does that mean?"

"You're acting like Joan of Arc at the stake because you fixed a cup of coffee. I didn't even ask for it. What is going on with you?"

"I'm trying to be a good wife. I'm trying to do my job around here."

"Well, quit trying. It didn't used to take you all this effort."

That night, while she was brushing her hair, Jack came and laid his hands on her shoulders with a gesture so proprietary she jerked away despite her best intentions. "I'm *tired*," she said, which was the level truth.

In the morning she apologized, but Jack grunted; mornings were not his best time. And still she felt nervy, full of prickles; she swore at the agave by the door when she stepped too close and snagged her stockings. Later, she drove to the guild meeting snags and all, barely avoiding a dog who got lost in the fractured windshield, and when she was nominated to head the outreach committee, she said with embarrassing passion, "Please! Anybody else." At the break Mary Lou Betts asked compassionately whether everything was all right at home, and Iris smiled, shrugged, and nodded, afraid of what might fly out of her mouth.

At home the kids' noise filled the house, and Iris found she could get by on nods and shrugs, which at least kept her from picking more fights with Jack. He didn't understand; she was scrabbling to keep solid ground under her feet. When Ben came down with the flu, she made Jack take the boy's temperature and dole out antibiotics. "I can't afford to be exposed," she murmured as an excuse. "We go to the clinic next week."

In fact, she was in charge of the guild's annual visit to the free clinic downtown, the one committee duty she didn't mind. Iris enjoyed watching the young doctors and nurses who volunteered there. The clinic patients were mostly immigrants—entire enormous families—and Iris listened happily while the doctors prescribed blood-pressure medication and iron supplements for the grandmothers, dark green vegetables for the children. Here was real help; she was glad to be a part of it.

For weeks the women in the guild had been collecting medical supplies from their own family doctors—drug samples, tongue depressors, disposable gloves and basins. The bags of supplies always seemed impressive to Iris until she got to the clinic, where the stack of tongue depressors rattled into an empty drawer. A nurse smiled at Iris. "There's never enough," she said.

As always, the women stayed to serve lunch to the doctors and nurses. Iris took on sandwich duty in the clinic's tiny kitchen, where she methodically sliced the ham they had brought and slapped it onto slices of bread. She was good at this; the line of sandwiches was scarcely different from mornings at home.

A woman, one of the patients, slipped into the kitchen with Iris. She was thin, and had a lump the size of a tangerine under her jaw. She wasn't supposed to be in the kitchen. The guild couldn't bring enough food for patients, so they tried to be discreet about lunch. Iris wondered whether she should say something, or simply escort the woman back out to the waiting area. She stared at the woman's lump; the skin over it was stretched so taut it was lustrous. "Would you like a sandwich?" Iris asked.

"Yes."

Iris handed it to her, watching while she took her first bite. The lump didn't prevent her from swallowing, and so Iris smiled and went back to the ham. "Thank you," the woman said, and then the door clicked softly after her. Thank *you*, Iris thought, pleased with herself.

She made three more sandwiches before she heard the door open again and looked around to see the woman standing with a crowd of children—seven? ten? The woman looked at her calmly.

Iris felt the small of her back sag. She gestured at her meager provisions—two loaves of white bread, a small ham and the mustard Renee Cox had remembered to bring. "There isn't enough." She looked at the woman with the lump. "I'm sorry."

The woman said nothing, and played with the hair of the boy standing before her, who was looking at Iris with eyes so soulful they seemed impertinent. "Oh, for heaven's sake," Iris said, and began to hand sandwiches around. She would go out to a grocery store. Lunch would just have to be late. The children chewed their dry sandwiches, and she returned to the counter, hacking at the ham. She felt a tug on her skirt. A little boy pointed to the oranges, and she handed him one. "Thank you," he said.

Then Iris heard the door open again, and Renee saying, "What are you *doing*?"

"Things got out of control."

"There are medical professionals out there, volunteering their time for these people."

"Give them these." Iris filled her hands with sandwiches and a few oranges.

"Now everybody wants to eat. Iris, we never feed the patients."

"They never asked before," she said, reaching into the bag for more bread.

Before long, the guild members began coming into the kitchen in shifts to collect sandwiches and oranges. In a minute, Iris told herself, I'll have to go out and get some more. But her hands, greasy with fat, kept slicing and stacking, and she stood at the narrow counter and made sandwiches even after Renee told her that she had made enough, that everyone had eaten. There was still the butt end of the ham, half a bag of oranges. Renee had to take her by the elbow and force her to sit down, when finally Iris felt blind with fatigue. Renee pressed a sandwich into her hand, but Iris couldn't lift it to her mouth.

"We didn't have that much food," Renee was saying. "You know we didn't."

"Hush," Iris said.

Monsignor Laoghrie was calling when Iris walked in her front door, and after him neighbors, half-strangers. People had heard reports that Iris had been bathed in light, had talked in languages no one had ever heard. Suzanne Muller asked if it was true that the oranges tasted like sacramental wine. "Mine didn't," Iris said, talking with her head propped against the wall.

It was after four, and none of the children was home. Iris shivered. She felt naked in the house without their comforting uproar. She tried to remember—was this the afternoon of Jim's rehearsal, Lisa's soccer practice? She was hanging up the phone for the seventh time when she finally heard a shuffling at the door. "Hey," Iris called. "There are cookies in here."

She heard them file back to their rooms. Fear rose in Iris like a quick flood; she set the phone off the hook and went to the boys' room. Jim, face down on the bed, didn't move, and Ben sat with his back to her, his jaw hard and quivering. Sometimes he looked so much like Jack that Iris caught her breath. "Don't you want anything to eat?"

"No," Ben said.

"What's up? How come you were late home?"

He shrugged. "Leave me alone."

She went to Lisa's room, her mouth dry. Like Jim, Lisa was stretched out on the bed, but Iris heard her sniff and she crouched by the bed, laying her head beside her daughter's on the pillow. "What is it, honey? What happened?"

Lisa edged away from her, and at first Iris thought she wouldn't talk at all. "Sister made us stay. The whole school. She made us all stay after school and said you'd performed a miracle." Her shoulders were rigid. "She said you were holy."

"Oh, honey," Iris said. "Honey. I'm just your mom." She put her hand on Lisa's steely shoulder. "Everything is just the same."

"It is not. Everything's wrecked."

Iris looked at her daughter, who lay with her head twisted away from her. Wildly, she wanted to laugh. "If I'm holy, maybe I'll be a better cook. What do you want for dinner? Do you want spaghetti? I'll make you anything you want."

"Leave me alone."

"You'll see," Iris said. "It will go away in a few days, and you'll see that nothing has changed." She reached out to stroke her hair, but then let her hand drop in the air between them.

Jack came in an hour later, and they looked at each other warily across the width of the living room. "Well," he said. "I hear I'm married to Our Lady of Sandwiches."

"Is that supposed to be a joke?"

"You are some kind of famous," he said, his tone so noncommittal that Iris felt like slapping him. "I've been getting phone calls telling me the history of the miracle all afternoon."

"What do they say?"

"It's the loaves and the fishes, right here in River City."

"The food went further than we thought. Nobody thought we had enough, but we did. That's all." She stood blinking at him, her hands clenching and unclenching.

"A committee will be over later to take the measurements for your shrine."

"Listen to me, dammit. I sliced the ham thin, and it went around. Who are you going to believe here?"

"A hundred people say it was a miracle. You say it wasn't. How do I know who to believe? Hell, Iris. How do you know?" He shrugged.

"You never believed in miracles before."

"You never performed any before."

Iris shook her head; frustrated tears were crowding her throat and eyes. "Wait till you hear what Sister did," she whispered, fighting for control.

"I heard."

"The kids won't speak to me."

"They'll get over it. They're scared."

"So am I. Aren't you?"

"Terrified," Jack said flatly.

That night, after Iris had burned the potatoes and broken two dinner plates while loading the dishwasher, the doorbell rang. It was Sandra, the little girl who lived next door. Her parents didn't belong to the parish, so Iris only saw the girl when she happened to be outside playing, a tiny, weedy thing, smaller than Lisa. "It's late, honey," Iris said. "Do your parents know that you're out so late?"

Sandra nodded. "I hurt my elbow."

"Where?"

"Right here," the girl said, jutting her knobby elbow at Iris, who couldn't see any scratch or bruise. "It hurts," Sandra said. "I hurt it."

"Do you want me to kiss it for you?"

Sandra nodded again, and Iris bent swiftly. When she straightened again, the girl's expression was rapturous. "I knew it would feel better if you kissed it. I'll bet it will never hurt again."

"Kisses don't last that long," Iris said, but Sandra was already backing away, her hand cradling her healed elbow, her face radiant. "Shit," Iris muttered.

"Suffer the little children," said Jack, coming in from the living room.

"Very funny."

"Come on, honey. Kids love saints." He skimmed his fingers lightly up her sides, and she jerked away. "Stop twiddling at me. I am not a saint. I don't do miracle cures."

"Not on the home front, that's for sure."

"Then quit looking at me like you're expecting something."

"Lately I don't expect one thing from you. Some miracles are just too much to hope for."

Iris nearly collided with Ben as she stormed to the bedroom. He was still sniffling, and she rested her hands on his head as they passed. She listened after he went into the bathroom, but he wasn't crying any more. God *damn* it, she thought.

The next morning the phone was still off the hook and notes were stuck under the welcome mat; Iris had refused to answer the door again after Sandra's visit. Jack left early for work and the kids shuffled and muttered, refusing to look at their mother. When Ruth Dowers, who was driving carpool that week, swung into the driveway, Jim and Ben and Lisa raced out the door like escapees.

Iris trudged into the kitchen. Sugar was scattered across the table and floor, milk was already hardening at the bottom of glasses. The frying pan Jack had used was jammed into the sink, dried egg crusted around its sides. Iris stiffened her arms in front of her. "Shazam," she said. Nothing moved.

There were beds to be made, laundry. But she walked through her house with her hands stuffed deep in the pockets of her robe. She wanted to sit down, but there wasn't one chair in the whole damn house that didn't have ripped upholstery or jabbing springs. She and Jack had said for so long they would get around to new chairs. How many nights had she watched him squirming in the recliner by the door, trying to find a smooth space? She felt her heart open to him as if it took a physical fall, even though she had meant to stay angry.

She wandered into their bedroom, vaguely planning to make the bed, but she stopped at the doorway, looking at the one crucifix in the house. It hung next to the window. Iris hated religious art, and had agreed to put up the crucifix only because it had been a wedding present—she couldn't remember now from whom. Someone who didn't know her very well. She took it off the wall and turned it around in her hand, surprised at its lightness. Cheap construction. Sitting on the bed to relieve her back, supposing she ought to pray, she let her thoughts race away from her. She remembered how, when Jim had been a toddler, he'd sat for hours turning his toy car in tight circles over and over the same patch of floor. It had worried Iris that he'd been so content with the car tracing its own tracks. What had happened to that car? She couldn't remember.

She looked at the crucifix in her hand. The figure of Jesus didn't seem to be in pain. If anything, he looked a little buoyant. She closed her eyes, trying to stop these thoughts, which were probably blasphemous and would bring on swift retribution. She remembered a holy card she had gotten in second grade, showing the Good Shepherd surrounded by dozens of children. His face had been beardless and full of light. Her friend Susan's showed him walking on water, which Iris would have preferred.

"I guess this is your idea of a joke," she said to the crucifix. Two months before, she had been closing in on happiness like safe harbor. But now she was right back out in the deep water, and the lights on land were winking out. She got up, hung the crucifix back on the wall and turned away, fighting the habit to touch her lips and murmur "Ad majorem dei gloriam." Old habits, she thought as she left the bedroom.

The local RiteBuy served as the neighborhood town square, and
Iris could usually count on running into three neighbors in the cereal
section alone. But remarkably, as she hurried through the aisles, she
didn't see any familiar faces. Sister must have called the whole town
in, she thought. She picked up treats for the kids—cookies that were
out of the budget, ice cream. She fingered the oranges, then let them
drop back in the bin. She moved past the fish section briskly, but she
couldn't help glancing at the glazed eyes of trout, horrible, and beside
them neat sets of shad roe.

Jack adored it. On their first anniversary he'd taken her to a restaurant
that featured seafood as well as beef; Iris was sure she could stand to
look at roe, as long as she wasn't expected to eat it. But when the waiter
brought their meals the sight of it, reddish and coiled like intestines,
was too much for her, and she'd spent the rest of the night retching,
first in the restaurant and then back at home.

Now she stepped back when the butcher told her how much the sets
cost. She gazed at them, rich and heart colored. Peerless as a peace
offering. After a moment she told the butcher she'd take a single set.
She would present it to Jack that night for dinner, and tell him it was
a miracle.

In high spirits Iris sped through the store, escaping unnoticed until she
made it to the parking lot, where she was unloading groceries—gently,
trying to spare her back. The sound of a wheelchair motor burred in
her ear; "If it isn't the talk of the town," Kay Wendell said.

Iris let the groceries in her hands drop. "Kay. What a surprise."

"Do you know what people are saying?"

"I feel like I have to go out with a bag over my head." She smiled,
but Kay refused to be drawn in.

"The parish is half lunatic about this. Six people have told me that
you're performing miracles."

"Well, Kay, you know—people." Kay was squinting, her face twisted
and wild, and Iris edged back.

"What really happened?"

"There was more food than we thought. We wound up being able
to feed the patients. We were all glad." Iris squeezed her mouth into
a smile.

"People are acting like it's the second coming."

"That's not my doing. But it's surprising that one little ham could go so far."

"So you're calling this divine intervention." Kay snickered.

"I'm not calling it anything." Iris stretched out her hand to brush back hair from Kay's eyes, but the other woman turned and began chugging away.

"Don't try to touch me." Kay called over her shoulder. "Do you think I'm waiting for a miracle? I know what to expect from the world."

It occurred to Iris that this was Kay's whole problem, and she was irritated enough to catch up and tell her so. As Iris hurried behind the chair, Kay snapped at her. "Get away from me. I'm not looking for your grubby cures. Get away!" She flapped her hands at Iris, who stopped the chair, caught Kay's frail wrists in one hand, the top of her skull with the other, and bore down.

"I've never known anyone who deserved curing more," Iris said, twisting Kay's wrists a little.

Kay stopped struggling, and in its sudden collapse her body seemed even tinier. "Go on, then," she said. "Make me dance."

"It's not so easy...," Iris began.

"I know, walk a mile in your shoes. Well, Mrs. Miracle Worker, I wouldn't mind trading in my shoes for yours."

"Fine," Iris said, and picked Kay up out of her chair before she had any idea what to do with her. The woman was heavier than she looked, and Iris staggered, shoving Kay onto the hood of a sedan before her own legs folded and she dropped into Kay's chair.

"Am I supposed to walk to you? You must have gotten some of the mumbo wrong." Kay pointed to her flaccid legs. "They still don't work."

"Fine," said Iris again, examining the switches on the arm of the chair. "You stay put. I'm just going to put on your shoes here."

"You idiot," Kay snarled. "It's not a Disneyland ride."

But it might as well have been; Iris found the lever to lift the brake, then turned and whirred up the slight incline of the parking lot, away from Kay.

"You'll burn the motor out!" Kay yelled. "Are you planning to take care of me when it's broken?" Iris leaned forward in the chair to urge it along. She felt pleasantly mischievous. When she came to a speed bump she had to take two runs before the chair cleared it, making a harsh,

mechanical cough. It stopped on the other side. Kay was squalling from the sedan, attracting attention. To get away, Iris nudged the lever; the engine coughed again but the chair only slid back an inch, settling at the speed bump.

"See?" Kay was shrieking. "*See?*"

Iris jabbed at the switches, but the little motor whined, the sound all wrong. "Please," Iris muttered, knowing already she was done for. "Damn."

Exhaling unevenly, she tried to stand, to wheel the chair back to Kay and face the music. It was then that her back, dazzling with pain, seized Iris so that she gasped, unable to move. She looked up to see Kay crying and waving her arms. Iris was crying herself; hot blades seemed to be carving channels on either side of her spine. She knew she needed to reach Kay, who would get help for her. But she couldn't move, and had to watch Kay screaming and pointing at her before people finally came out from the store to save them.

MARY KENAGY MITCHELL

Loud Lake [fiction]

I T WAS AGAINST camp rules to be out on the water before
breakfast, but Pete guessed that his father would be secretly
proud of him, and probably relieved too. In the east the sky was
turning white, and the last stars were disappearing over the opposite
shore. The sun would rise in half an hour, and a breeze had begun to
wrinkle the surface of the lake. It blew Pete's hair back from his face
and made him draw his hands into the frayed sleeves of his sweater as
he walked out onto the dock. He wore shorts and soggy tennis shoes,
and he carried a dingy sailbag. He was small for his age, twelve, but
big enough to lift the removable mast of a Laser. He laid the mast on
the dock, unpacked the sail and shook it out. It was patched with tape
and stained with lakewater, like the boats. In two minutes he had the
Laser rigged and running before the wind toward the fading stars. He
let the boom out and leaned to counterbalance its weight. Each wave
reflected the white, pre-dawn sky.

Pete squinted back toward the camp. He had gray eyes like his
mother's, and his skin was tanned from summers on the water. His
knees were scabbed and scarred, and also blotched with curious white
patches, a harmless sort of cancer, the doctor had told his parents.
He was supposed to watch the patches to make sure they didn't get
bigger. Around his neck he wore a wooden cross on a leather thong,
given to him by his father.

His father, Don Bonds, was the director of the summer camp, a
barrel-chested man in his late forties who still wore nylon sandals
and printed T-shirts and had an unhittable jump serve. He'd walk
out past the back line of the volleyball court, pretending to hobble
like an old man, then turn, make the high toss, take a slow two-step
approach, fling himself into the air, and release all the force of his
body into the ball. Then he'd laugh in the bewildered faces of the
other team. "God breaks the rules all the time, just to get people's
attention," he was fond of saying. "That's what miracles are." Loud

Lake was a non-denominational Christian camp, and Pete's dad was a sort of stationary missionary. Kids came to him, or were sent. He was an impressive person, deep and gregarious at the same time. He was a great and competitive talker. "You can't force people to accept Christ," he said. "You can only show them that they don't have any other logical choice." He would sit for a long time after dinner and "argue philosophy" with the older kids, who loved him most of all, the boys especially. He was generous with his time and affection. If he had a fault it was that his love of surprising people was mixed with a love for attention of any kind. He got up every morning at five to sit on the end of the dock and pray for an hour before calling the camp to breakfast over the public address system, using different comic voices. In the dining hall, everyone would beg to hear the voices again. Pete loved and respected his father, and assumed that he himself would eventually get on track and grow up to be just like him.

Pete didn't befriend kids at camp the way his father did, not even the ones who came back summer after summer. He tended to hang back and observe during capture the flag and bucket ball, and the counselor hunt. He spent a lot of time sailing the old Lasers, cruising the edges of the afternoon sailing lessons. He'd show off a little now and then. "Watch Salt!" the instructors would shout at their students. "There's a real rolling tack." Praise shamed Pete, because he knew he wasn't a great sailor, and he also figured the campers thought he was arrogant. In fact, he was shy. His father's charisma made his shyness more painful.

His father took the older boys on grueling, perilous hikes and did special Bible studies with them, for which he owned large dictionaries in unfamiliar alphabets and a six-volume concordance. Every summer the older boys were a little gang, and he was their godfather. This year's group wanted matching tattoos. At meals, girls and younger boys would gather around their table, and they'd tell how one of them had almost died rock climbing, and how another had saved his life. The one called Mike told Pete in a serious voice after dinner that his dad was the greatest human he'd ever met. They had just come back from a three-night survival trip. Pete said okay, thanks, and couldn't think of anything else to say. He wasn't sure he liked Mike.

That summer, Mike was legend. When he was six, his father had been killed on a fishing boat in Alaska. His mom had forbidden him

to see the grave, and Mike would sneak out and go anyway, all the time, even though it made her scream. His friends spread the story around. "His dad left them right before he was killed," explained Brian, the friend who had brought Mike to camp, "and his mom still hates his dad, but Mike's not bitter like her." Brian's family had paid Mike's way to camp.

On the back of Mike's wrist was a bird-shaped scar. He told his table about it one night at dinner, and the story was all over camp before fireside. Pete heard it first-hand, since he sat at Mike's table whenever he could. "I was playing with a knife my dad left me," Mike said, "and just before Mom went to bed she said, 'Mike, don't do anything stupid with that,' so I did it, over the kitchen sink." The other kids leaned close, one forgetting the fork that hung in his mouth, and Mike told about carving the wings. It was a good bird, realistic-looking, a hawk or an eagle in flight. The healed skin was white and shiny as teeth.

"How come a stupid bird?" said Meg Holloway, the new girl. Everyone ignored her, as usual, and Mike described the blood going down the drain. Meg had come late to camp, and she made her cabin-mates uneasy from day one. At her first breakfast she refused the greasy camp food and instead drank coffee from the counselors' table. Her cabin-mates, seventh graders, were worldly enough to be put off their waffles. They hesitated, making chicken scratches in their syrupy plates with the tines of their forks, until their beautifully sunburned, athletic counselor Gravity helped herself to bacon and assured them that girls had to eat too. They finished their meal, glancing at Meg, some with worry, some with disdain. At the far end of the table, Pete didn't eat a thing. He was sure that if he had, Meg would have thought less of him. He felt solidarity with her in fasting, and he wondered whether she had noticed.

Nobody but Pete seemed to like Meg, while everyone admired Mike. His father's death made him magical and tragic. Pete liked the story about the grave, though to him, defying parents only for the sake of defying them seemed mean. He felt sorry for Mike's mom, coming downstairs in the morning to find a ring of her son's blood around the garbage disposal. Mike was the first person Pete could ever remember disliking, and since Pete had no one to talk to, he disliked Mike in a secret and festering way.

One evening after dinner he overheard his dad telling his mom what a blessing Mike was. Pete was upstairs trying to get a radio station to come in, a hobby of his. His radio was large as a piece of furniture, made of fake wood, with an upholstered front and two aluminum dials like bottle caps. It had been left in the attic by previous tenants. The camp was distant from any town, and the radio received only garbled spurts of noise, but the idea of a world of continuous, unheard voices and music always existing in the air around him tantalized Pete, and he spent hours trying to get the antennae in the right places, inching the needle across the dial, trolling for a signal.

When he heard Mike's name, he turned the sound down. "The one with the cheeks," his mom said. It was true that Mike had big cheeks, and Pete liked his mom saying it. Popular opinion held that Mike was very good-looking, if tough. Meg's cabin-mates all said so.

"That kid is something," his dad said.

"He'd have to be, vicar," his mom said. Her voice was warm and whispery, and the room went quiet. Pete turned the radio back up and wondered why Mike had to be something. Because he came from a tough home, maybe. Or maybe he was sick.

When Pete's mom married Don Bonds, her family was confused. They were cultivated people, faintly Anglican, and Don didn't seem like Joan's type at all. They were made restless by the long, heartfelt prayer he gave when he first came to dinner. After that, Grandpa Gayle started calling him vicar, as a joke. "Well vicar, did you win your softball game last weekend?" he'd ask. Behind his back he was *the* vicar. Pete's mom would call him that too, affectionately, when she disagreed with him. "Have it your way, vicar," she'd say, closing her eyes.

Pete had once heard her tell him he should be careful how much he made the campers like him. "They're like Konrad Lorenz' baby ducks, some of them. They imprint on the first thing that catches their attention, and then they're yours for life," she said. "It can't do them any good. You'll be gone." Last fall, she had fielded the angry, embarrassed, and confused telephone calls from parents whose children had come home from camp and given all their possessions to the Goodwill, and in some cases some of their parents' possessions as well. Her husband had stood behind her chair, listening in and laughing. It took her the entire school year to convince him to be less exacting the following

summer. "God gave me my wife to understand the world for me," he told people, and she sometimes joked that without her to weigh him down he'd rise straight up to heaven without even waiting to die. Then he'd correct her theology, and she'd pinch his ear. Pete respected his mom instinctively, but he didn't work at pleasing her like he did with his dad. She was always in the background. During the summer, she rarely left the house. She ate few meals in the dining hall and did not go to the bonfires.

On the fourth night of every week, Pete's dad gave an important talk in front of a bonfire in the amphitheater, and afterward lots of campers always accepted Christ. He would come home blustering and radiating, and talk with his wife for a long time. Though she never attended, she had never gone to sleep after a bonfire without hearing about it. They would sit in chairs side by side on the back porch, and he'd tell her how many, who, and what they were like. Pete would fall asleep with their murmuring voices drifting through his window.

Fourth nights spooked Pete a little. His father would stand in front of the fire, his long, flickering shadow falling across the benches and onto the pines. Behind him, a column of swirling ash rose from the blaze, the flakes floating upward into the dark. He would call kids forward by name, ask them questions, stare into their eyes, and pray with them. Kids cried, and other kids came forward to lay hands on them. Kids were filled with the Spirit, which made them stare and quiver and confront their friends with divine messages. Giving or receiving a message like that made a person act funny all week. That summer, Mike was first. Pete's dad put his hands on Mike's shoulders, and they looked into each other's faces for a while and spoke in low voices until they were both nodding and smiling together. Pete guessed it was a good thing. He had watched from the woodpile, picking at the ashy scars on his knees. The first time he saw a fourth-night bonfire, he wondered whether he was really saved, because no such thing had ever happened to him, and later he asked Jesus into his heart again just to make sure. After a while he decided that things were different for him because of his dad. Maybe his revelation was spread out over his whole life, a little at a time, so that it never seemed like a big deal.

He did feel, when he was alone, that God was there with him, interested in him, and this was an idea that gave him some peace and

also some fear. On one particular day the summer before, he had been sitting by himself above the rock climbing face, near the place where the lines were anchored to three wizened, stunted old trees that grew out of cracks in the rock slope. Below, he could hear climbers calling out to their belayers, and the belayers shouting encouragement up to the climbers, but he couldn't see anyone; the slope plunged into a face ten feet away, and all he saw were the tops of the trees, and farther away the roof of the cookhouse, and beyond that the other side of the lake. He'd been minding his own business, thinking about going back to school in a week or two, when it occurred to him as it did from time to time that God, who heard all his thoughts, was hearing his thoughts at that very moment, but instead of seeming fearsome and mysterious as it usually did, the idea seemed perfectly ordinary and natural. Pete felt as if he'd finally given up on trying to pull off a fantastic and increasingly complicated fib, and some deep, rustling movement began far away inside himself, but soon he felt afraid, and the movement subsided. His father had probably been praying for him again.

Lately he had tried to make the feeling come back. He would sit still in remote spots and wait, but nothing happened. Once, as he stood in the cedar grove at the far end of the farthest trail, Meg Holloway walked by. She came out of a part of the forest where there wasn't a path, and she said, "Hey," as if they were on a sidewalk and not at the loneliest spot in the wilderness. Pete couldn't think how to answer, and Meg shrugged and kept walking.

Meg Holloway made that summer different from any summer before, to Pete. He tried to sit at her table whenever he could, and since she wouldn't eat he didn't like to eat in front of her. He became thinner. Even his hands and feet got thinner, and he could see his own tendons and bones. Because she'd come one week late to camp, Meg was the new girl all summer. Word was that her parents were atheist psychology professors who had sent her to Loud Lake to observe Christianity in the field. She had a lot of curly hair and wore silver rings on all her fingers and some of her toes. She looked permanently bored, and her dense, baggy clothing concealed her shape. The other campers regarded her as a spy. Her counselor Gravity was forever hunting her down during activity periods, finding her in the empty kitchen with

a paperback, or lying on a boulder by the lake. Pete's father had tried several times to talk to her.

One day she had turned up missing from leather bracelet-making, and Gravity was just going off to search, when Pete saw his father motion to her to stay put, and go himself instead. On the back porch after dinner that night, Pete's father asked his mother if she knew who Meg was. Pete was upstairs in his room, almost getting a station on the ancient radio. He'd made extensions of aluminum foil for the antennae. The reception was best when he held one antenna, touched the wall with his other hand, and stood absolutely still. There were voices, a man's and a woman's, impossibly muffled by static. He let go and adjusted the dial. He heard abrupt fractions of words, a blare of music, then a white hiss.

When he heard his dad say Meg's name below on the deck, he turned off the radio and the light. The back deck was built on stilts over the water, directly below his window. "The one with the army boots," his mom said.

"The faculty kid," said his dad.

"They do mean well."

They were both quiet for a moment. "She seems special," his dad said. "Important to reach. There's something about the way she looks at you that's— Does she seem special to you?"

Pete went to the window. His parents stood close together in the half-dark below. "I don't know, honey. She seems like a normal kid, an outsider, but there's nothing odd about that. She's one of those people who need space." His mom's voice was whispery again. "You know people like that."

"I've been trying to get her to talk to me, but she's not having it," he said.

"Really?" She set her coffee cup on the rail and put her arm around him. Above, Pete drew back from the window.

"I've practically been stalking her."

"If you're starting to make her uncomfortable you'd better leave her alone. I know you, but she doesn't know you. There's no telling what she thinks you want."

"Geez, I wasn't—" Something small and wooden clattered on the deck and rolled away. His father had dropped a napkin ring. "I hate it when you say stuff like that." Pete laid his folded arms on the sill.

His arms had turned harder since he'd quit eating. Skipping meals made his whole body feel sharper and more adult. Meg still wasn't eating either.

"I'm just pointing out how it might look," his mom said.

"I don't like that you can even think that way."

"It's how most people think, vicar," she said softly. Waves gently lapped the wooden pilings below the deck. "You should be glad you don't," she said. They were both upset. When his dad said Meg was important to reach, Pete knew he meant saving her.

A day or two later, coming back from the boat shed in the afternoon, he met Meg walking toward the south trail with Mike. Since they were two and he was one, Pete stepped off of the path to make way and stood under some low fir branches. Though they passed only five feet from him, they never looked his way. Mike never took his eyes from Meg, who looked straight ahead, unsmiling. This was the first time Pete had seen her alone with anyone, and he remembered that she'd called Mike's scar stupid on her first day at camp. He hoped she still thought so. As the pair stepped into the thicker trees, Meg tucked an invisible strand of hair behind her ear and glanced at Mike, and Pete saw the quarter part of her face. Her smile was nervous, and he'd thought she breathed in excitedly.

That evening Pete made his plan to go out on the lake. He would go to the other side to sit and think and pray and watch the sun come up over the camp, and then come back while his dad was still on the dock. He knew that his dad would have to punish him for breaking the rule about being on the water before breakfast, and he knew that the punishment would probably be helping wash up. He liked working in the steaming industrial kitchen, slamming racks of dishes around, splashing water and listening to the cook's R & B. And his dad would not actually be angry. His dad said often that when you broke men's rules you had to take men's consequences, but better men's consequences than God's. Pete imagined what his dad might say at breakfast. He would boast by pretending to complain about how stubborn Pete was, and how committed, and he would think, *just like me at his age.* Pete wanted people to say that he was a spiritual boy, just like his father was a spiritual man.

Pete also imagined he'd have to hear his dad's praise and look stupidly into his oatmeal. He wasn't good with come-backs. At times

like that, he knew he was letting his dad down. If only he could make a good story of his trip, the way Mike had with the bird scar on his wrist, everybody would like him. Pete's own scars, his congenital knee patches, seemed bland and incoherent by comparison. They weren't even scars really, just flat, blotchy discolorations. They had no story and no meaning, but there they shone on his brown legs, a stupefying pair of peeling white spots.

Pete was at the middle of the lake when the wind became stronger and the boat began to lift. He started scanning the opposite shore for a place to land. The sun wasn't up yet. He wanted to stay clear of the spot where a stretch of road was visible, where there was a restaurant, the only other building on the lake. He saw another boat ahead and glanced automatically at his watch, disappointed that anyone else was awake. It was quarter to five, still long before breakfast. He gained on the boat, which was also heading away from camp. It was a camp canoe paddled by one person, a girl. She had seen him and kept glancing back, but didn't call out or wave. She was paddling too fast, not taking the glide, and the waves rocked her. She seemed not to want anything to do with him, but the lake was big and empty, and it would be civil to see how she was getting along. Civil was his mom's word. Maybe the girl hadn't expected the wind. Rescuing someone when he had gone out to pray could be better than going out to pray by itself.

As he approached, he pulled in the sail. The girl's hair was tucked inside the hood of her sweatshirt, and he could see flashing silver rings on the back of her hand. Meg Holloway. She held the paddle too close to the blade, and half her sleeve was black with wet. She must have known he was alongside, but she didn't look. "Coming alongside," he said.

She turned. "He speaks." She'd been crying, and her face was wind-chapped. He pulled the sail in and coasted. In the bottom of the canoe were a large army duffelbag and a small backpack covered in black beads. He tried to think of something to say. "You're Bonds' kid," she said. He nodded. "You're out awfully early."

"Are you doing okay?"

She shrugged. "You have a camp name, don't you? Salt."

He picked at some splinters in the tiller. "My real name is Pete."

"You don't like your camp name?"

This was going all wrong. They were supposed to be talking about her.

"You should tell people if you want to be called Pete."

"That's the point of camp names though," he said lamely. He felt ashamed for letting people call him by the wrong name all those summers. "Where are you going?"

She began to paddle halfheartedly, and the wind pushed her off course. Pete offered to show her how to adjust her stroke, and when he reached for her paddle, she looked at him suspiciously and tightened her grip, and it occurred to him that she shouldn't have been running away from camp, and that if he took her paddle away he could grab her painter and tow her home. His dad wouldn't do it that way. His dad would convince her.

"I hate camp," she said.

Pete did not love his father's camp. He liked school better than summer vacation. His mom seemed more alive at the house in town. She talked more at dinner and smiled at his father more often. But Pete had spent every summer he could remember at camp. It wasn't something he hated or liked. It was home.

Meg went on. "I hate the singing, the praying, people going batty and crying all over the place, the skits. I'm not staying two more weeks. And my cabin. Nice of them to pray for me, but it's not like I need extra cosmic forces in my life."

Pete could see that Meg had Issues of Faith. His dad talked about how to help people with this. He would practice on his wife, and upstairs Pete would listen, with the radio off. His dad would prove loudly and articulately that there was a God whose very existence demanded praise, and then Pete's mom would cross-examine him. All Pete could ever hear of his mother's argument was a low murmur. He looked back toward camp and thought he saw his father on the end of the dock, starting his morning prayer. He tried to think of what his dad would say to help someone like Meg. He remembered something he'd once overheard. "How could the world be so beautiful if there's no God?" he said.

Meg looked at him as if he'd just appeared. "I never said I don't believe in God. And do you really think this world is beautiful?" She didn't miss a stroke.

His ears got hot, and they were both quiet. They had passed the center of the lake by now, and were nearing the other shore. Pete looked at Meg's left shoulder and inhaled deeply. "Still, Jesus Christ died for you on the cross, and you need to—"

"—accept him as my personal Lord and Savior." She paddled faster, tearing the water. "Listen, you're a very nice kid, and I appreciate your concern, but I know about it already. I've taken it under advisory." Pete felt crushed, and he must have looked it, because when she spoke next her voice was kinder. "But you're much nicer than some people. Nicer than everyone, actually, and if I were in the mood to listen I'd much rather listen to you than any of them. But do me a favor and go home now, and when you get there keep your mouth shut."

He continued to scull the Laser alongside the canoe. "Sorry," he said.

She pushed out her lower lip and blew her bangs out of her eyes. "I'm sorry, too. It's becoming a sore spot. I know you're just doing your job." She paddled in silence for nearly a minute. Then she said, "Do you actually like living here?"

"We live in town during school. Mom likes that better." He wanted her to know all about his mom. They would have liked each other. "She's a teacher. Seventh grade."

"I've met her."

Pete wondered how Meg had met his mom, but this seemed private. His mom was a private person. "What are you going to do when you get across?" he asked.

"Going to stash the canoe at the restaurant, hitch to town, then back to the city."

Pete was impressed. "Are your parents there?"

"Yes."

Dark lines swept across the surface of the water ahead. The wind was beginning to dance and shift. Pete tried to imagine what atheists were like. "Won't they be mad you left?"

"They'll probably ground me, but my dad will brag about me to his friends."

Pete nodded. "My dad would do that, too."

"He'd like it if you ran away?" Her voice was dull, unbelieving.

"He likes me to break rules. I know it's weird." She studied him more closely than before. "I'll have to do punishment for being out

here, but I won't really be in trouble," he said. He cinched the boom
down a little farther and tried to think of what his dad would say to
Meg next. Probably he'd keep asking questions.

"Your dad will be impressed," Meg said. "He'll be glad you had
this experience."

"I guess so. Are your parents really psychology professors?"

"My dad is. My mom teaches at the same school as yours." She was
short of breath, and her teeth chattered. She must have been on the
water much longer than he had. "They both wanted me to have this
experience."

"Like an experiment?"

"No, not so perverse. They just wanted me to see it, in case I might
like it." She let the canoe coast. "Except if I did like it, I think they'd
be embarrassed." Pete didn't see why, but he wished he could help her
feel better. She looked cold and miserable in the canoe.

"My dad gets embarrassed when I'm too quiet," he said.

She smiled a shivery, white-lipped smile. "Mine too. And my mom.
They want me to be more of a tomboy. You know, no Barbies." She laid
her oar across the gunnels. "I'll tell you something. I'm not leaving
because of your dad. He's okay. I don't really hate camp. I'm leaving
because of this guy Mike."

"I don't like him either," said Pete.

She smiled her shivery smile again. "I thought I was the only
one."

"Mike is how my dad wants me to be."

"Mike's a fake." She looked as if she were weighing whether to say
more. The canoe had stopped. He watched the water. She pushed her
sleeve back and began to paddle again, slowly now. "I got tricked," she
said, and that was all. Pete thought of his parents' talk on the deck,
the vague, unmentioned things that upset them both. "That's all you
need to know," she added. He realized he'd been staring.

The distant figure on the camp dock behind them seemed to be
standing now, hands on hips, scanning the water. Pete wanted to stay
out on the lake a little longer just talking with Meg, but he knew he
wouldn't be able to say the right things before they got to the other
shore. Only his dad could say the right things to her. "Just let me show
you something before you go," he said.

She rolled her eyes and handed him the paddle. He'd known she would. She trusted him. Sadly, he released the sheet and shoved the boom leeward. The sail snapped full, and he began to overtake the canoe. "What are you doing?" she said. The Laser swept forward. As he passed her he leaned out, and without meeting her eye, picked up the canoe's painter. "You absolute rat," Meg said. She looked up at the sky. "I am so flawlessly naïve that there is no hope for me." Pete cleated the painter to the Laser, watching the wind patterns on the lake's surface. When the line was taut, he came about hard toward camp and yanked in the sail. The canoe followed the turn and almost capsized. Meg clenched the gunnels. She didn't shout, but he could hear every word across the span of water. "I thought you were like your mom. Did you know she let me hide in your kitchen during bonfire? I bet your dad didn't know that either." But she was wrong. Pete was not surprised at his mom. She was that way.

Air roared across the side of the boat, cutting through his wet clothes. Meg crouched in the canoe's bow, trying to untie the painter's weathered knot. He could just hear her voice. "I should have known he sent you. You're just like him. You and Mike both." Pete felt like nothing, like a dry twist of lakeweed on a docked hull, light enough for the wind to blow away. Towing the canoe, the Laser moved sluggishly. He wanted to tell her all the ways he wasn't like his dad, how hard he had to work to be even a little bit like him, that the difference between him and his dad was way, down deep inside, that really he was like her. He couldn't drag her back. He didn't care whether it was right or wrong.

He released the sheet and let the air spill from the sail. Both boats glided to a stop. They rocked and drifted, bumping against each other gently, blown backward by the wind. Their hulls made a deep thudding sound. Pete looked at his ash-colored knees, and at Meg, who tore at the painter knot with white-cold fingers, her face hidden by her hood. He watched until she looked up. "I'm not like anyone," he said. The fierceness went out of her face. She let go of the knot and sat back down in the canoe. Her shivering had stopped, and she breathed hard, her mouth open. They were exactly in the middle of the lake.

Crows flew overhead in a long, noisy line, wheeling and rising on the wind, falling out and reforming, flying east toward the day. There were so many that their procession began and ended beyond the horizons, spanning the whole sky like radio waves. They kept coming

and coming out of the West. Pete tilted his head back until he saw only sky and crows. Something was moving over the water around them, like the wind but not wind, and not crows, something he could nearly feel. It was right alongside their boats, some shape or shadow beyond the periphery of his senses. He wanted to look, and he felt sure that if he tried, whatever it was would disappear like a faraway radio station when he let go of the antenna. He kept looking up, hearing the crows and the hollow tapping of the boats. The cold air went right through his sweater. Meg was quiet, her breath calm. He remembered his dad saying that God is relentless, that he is always with us.

He looked. Nothing was there except boats and air. "It's a strange lake," Meg said. She put her hood back. Whatever it was had already begun to seep away. God would always be shy with him, forcing nothing. He uncleated her painter and threw it back into the canoe.

"It's real," he said. The thing was gone.

"A really strange place. Beautiful, though," Meg whispered, hugging herself and looking at the sky around them. She took the paddle and began to push the canoe away. Pete drifted, watching. She moved awkwardly, still not taking the glide, but the wind had shifted and was no longer interfering. The line of crows ended. The last of them crossed the sky and disappeared over the dawn horizon, circling and dodging each other in flight, rising on an updraft like bits of ash. At breakfast, he'd eat. He felt hungrier than he'd been in his life.

The wind came from the east, from camp, and the Laser keeled hard as Pete cut his oblique path home, heading first to the right of it, then to the left. He braced his feet under the strap and hiked his weight far outside. Without the canoe, the Laser rode high. As he neared the dock, he saw the outlines of three people hugging themselves in the cold morning. Mike and his father stood side by side, dressed and ready, as if they'd known this would happen. His mom was in her bathrobe. He cleated off the main sheet and leaned back, feeling the spray soak his clothes. He had nothing to tell any of them.

A.G. MOJTABAI

Signs and Wonders [fiction]

I DON'T KNOW how it was in other towns but here in Lifton the placards surfaced like mushrooms overnight, an eruption of truth-telling after a deluge of scandal and lies. Imagine the shock—the embarrassment—finding MISERY in the middle of your picture-perfect lawn, or ENVY casting its shadow over a garden filled with flowers, or MONKEY IN A SILK SUIT in big block letters, angled at a neighbor's living-room window, when you'd only thought such a thing to yourself before. It was no laughing matter: DESPERATELY SEEKING brought on such a rush of suitors and scammers that the woman who owned the property had to move out of state. Surely, you'd think, there were easier ways of tackling the problem—but, if you tried to remove one of these signs (at your own expense), a replacement was bound to surface within the week. Only the shape—octagon, diamond, or pentacle—was apt to change. The things were cunningly crafted, as tall and solidly rooted as most official road signs.

Strange energies afoot!

Part of the mystery was that no one had ever been caught, let alone *glimpsed*, installing these signs. The things seemed to materialize out of thin air, appearing after a wild night, or a quiet night, during which (the recipients recalled only later) they'd heard a clangor of bells, far off. For what it's worth, it's usual enough on any night to hear dumpster lids clanging.

Useless to petition city hall, itself a target: the grounds there had become a permanent excavation site. Unless the perpetrators were found, the signs could not be proven libelous. Complaints to the traffic department and a flurry of letters to the editor of our local rag were unavailing. In the absence of a clear case of conflict with existing road signs or encroachment on the public right-of-way, no law on the books seemed to apply.

People took sides: It was serious business, or it wasn't. It could be simply a prank, a publicity stunt—but, if meant as a joke, it wasn't

funny. Some saw the whole business as another one of those so-called art projects and worried that taxpayer dollars were involved.

For certain preachers in town, these signs were a summons no one could miss. Hunger for proclamation was rampant in the land—hadn't they said so, time and again? These signs were a foretaste, crumbs before the feast. Soon we'd be called, each by name, and our soulless insect-lives would cease.

I had no theory of my own. Once or twice, I wondered what message might be directed at me had I a lawn. I could think of half a dozen apropos, hurtful but safely hypothetical, nothing to nail me, no actual skin off my actual back. As a renter, not a homeowner, I remained unmarked, untouched, and felt no cause for alarm as I strolled past lawn after lawn, reading as I went, amused, or bored, or interested, as the case might be, a spectator merely, a tourist on the scene. I took pride in my exemption. Personally, I'd never even be caught wearing one of those T-shirts with writing plastered across my chest telling the world my business, or allow a brand name on my pocket, or sleeve, or anywhere on the outside where others could see. Even if you paid me for it, I wouldn't.

So I told myself.

We'd been having a spell of Indian summer, leaves humming, the air full of languishing golden motes, a whole week of brimming, balmy days, and I wanted to savor every minute of every day, knowing that it wouldn't—couldn't—last. So I was walking home. I knew I had to hurry, though; there was much yet to do: intercepting Marge, my fiancée (the delicate part), then making it to Sue's on time—a date, you might call it, had it been licit. It was nothing of the kind, of course. Why do I do this? I asked myself, not for the first time. To prove that flight is still possible, the will unfettered, the mind of man unknowable? (All too knowable, I fear. I wanted to have my cake, eaten and uneaten—plus an edible plate and fork, while I was at it.) I never learn! I'd done this before, been engaged before—to Loris, and my dalliance with Loretta (mere friskiness) had shattered it. Now here was Marge, a perfectly wonderful woman. I was well aware of how lucky I was in that respect. True, Marge was a bit older than Sue, and—how should I put it?—of a more muted plumage. But I'm getting ahead of myself here.

It didn't help that it was so lovely out. You know that special time, that magic liminal hour, not day, not yet dusk?

My first mistake was deciding to walk home. My car was at the garage, but if I'd wanted what I thought I wanted, I should have shared a ride with Ed, who'd offered. Or taken a cab—I could have afforded that if I didn't make a habit of it.

If only I had!

Sue had laid down the ultimatum last week: she'd wait for me, allowing for traffic, ten minutes past the agreed-upon time, but not a minute more. So I had it all plotted down to the minute. If everything went according to plan, I'd be home to receive my fiancée's what-are-you-doing-for-dinner call at precisely a quarter to six. I had to be at home to receive it. I'd considered buying a cell phone but decided against it; with a cell phone, my call could be coming from anywhere; it wouldn't have given Marge the reassurance she needed.

Once home, I'd plead an overload of student essays. That wasn't entirely a lie. The students still had a few days until deadline, but a surprising number of them had handed in their papers in advance. We'd had our last session on Yeats and, after struggling through "Leda and the Swan" with them in class, I knew what I'd be getting—the extremes, anyway. I can't say which I looked forward to least: the feminists, aggrieved and not for an instant fooled by Zeus in his swan suit, his borrowed plumes; or the devotees of beautiful words, lofting high and gracefully over the brute fact of rape.

But about the call to Marge...I thought I'd throw in a headache for good measure, and promise a rain check for tomorrow. A five-minute conversation would release me from the obligatory, and I'd slip out the back door to freedom—my six o'clock rendezvous with Sue.

My sweet Sue...mine, I fear, no longer. My second mistake was stopping to read another sign on my way home for that phone call. So close to freedom, the seconds ticking away—how could I waste a one? All I can say is that curiosity is a chronic condition with me. And I happen to be addicted to the written word; it's a lifelong thing. So it wasn't an impulse out of the blue, although, given my tight schedule, it's something I should have squelched at the outset.

Should have! The fact was, though, I was mightily distracted: the estimable Marge, on the one hand, silky, sultry, light-fingered Sue on the other, plus the superlatively fine weather, the world smiling all

around me. And then there were all those signs—proclamations, left and right—every spirit waving flags!

I discounted a couple of endorsements for roofers, cardboard stapled to plywood, set in shallow earth. There were a few election notices of the same construction with the same temporary look. Passing a huge house with three fireplace chimneys, captain's walk, and gazebo, I spied, half-obscured by a realtor's placard—CAN WE LIVE THIS WAY? I passed BEWARE—BAD DOG, the warning tacked to a gate, but I seemed to recall it being there a year ago when I moved into the neighborhood, long before the arrival of the mystery signs.

I passed LET 'EM EAT GRASS and HUMBLE GRUMBLE and the mystifying MISTER WHIRLICAT, skimming along, enjoying them all. I wasn't at risk, as I said, wasn't personally involved—I remained a spectator. I wasn't the only one. Weekends, lately, you'd see people strolling or driving slowly through the streets, touring and taking in the signs, same way they took in the festive lights and house decorations during the Christmas season.

So I was sightseeing and enjoying the splendid weather, no crime in that. Yet that was my undoing. I paused—just for a second—to check out a notice on a utility pole. Why it caught my eye right then, I'll never know. The sign was weathered and fraying; it wasn't new. I wondered how I'd missed it before. It was far too wordy—I could see that at a glance—but, once I'd taken in the first two lines, I couldn't resist at least scanning one or two more.

<div align="center">

PLEASE HELP US!!!

LOST COCKATOO

REWARD

</div>

ON OCT. 15, OUR COCKATOO CHRISTINA DISAPPEARED. SHE WAS SPOTTED ON OCT. 19 AT THE CORNER OF DEAL AND DUNCAN WHERE SHE LANDED ON A MAN'S SHOULDER BUT WAS SCARED AWAY BY A DOG.

There followed a photograph of Christina—a photocopy of a photograph, to be exact—in shades of gray and white. I assumed she was mostly white; it was impossible to make out the intermediate colors, which were not described. Even without color, Christina was stunning, a queen, with her regal, back-sweeping crest. Only a bird, I know, but unmistakably a *she*—all sweet, sweet curves, from her

mantle—the plump of her shoulders—to the tips of her folded wings. Whether her tail tapered or bunched or broadened out, I couldn't tell: the picture was cut off above the tail. It didn't matter. I'm not a bird fancier, but a bird with a torso like hers, shaped like a valentine, was clearly a heartbreaker. I had to read on.

IMPORTANT

IF SHE LANDS ON YOUR SHOULDER DON'T BE AFRAID! SHE IS VERY TAME, LOVES A CUDDLE, AND WILL NOT HURT OR BITE YOU <u>UNLESS PROVOKED</u>!

Here, I paused to take in the double underlining. Unless provoked. I gave the phrase due pause before continuing:

PLEASE TRY TO WALK SLOWLY BACKWARDS INTO YOUR HOUSE WITH HER ON YOUR SHOULDER. TO CATCH HER IN FLIGHT PLEASE OFFER HER A SLICE OF BREAD OR SHOW HER A SMALL BOX AND SHAKE IT IN FRONT OF HER AND YELL, "CHRISTINA, CHARCOAL." SHE IS CRAZY ABOUT BIRD CHARCOAL.

WE ARE DESPERATE TO GET OUR BELOVED CHRISTINA BACK! PLEASE HELP US! CALL ANY TIME DAY OR NIGHT.

It occurred to me only after I'd crossed the street that the Christina notice had been neither tacked nor taped to the post, but must have been clinging to it somehow, perhaps plastered there by the wind. There wasn't a breath of wind stirring, though.

I didn't dwell on this because I was speeding then, my mind roving along, keeping pace with my feet. I thought of the lawn signs again, passing another new one with I'M STILL HERE in silver, reflector-paint letters against a black background, rising from a mangy patch of buffalo grass. The words must float eerily at night, I thought. I passed UNSUNG HERO—posted, no doubt, by the owner himself. So much desperate seeking—for attention, fame, validation, Christina. I thought of my romp to come in Sue's waterbed, our intimate dinner (Chinese-Cuban takeout by candlelight), then back to the lurching bed, our revels mercifully private, and wondered why others lusted so for publicity.

By now I was getting hot, and really hustling, as I should have been all along, minding my own increasingly urgent business. As I checked

my watch I thought I heard someone chuckling. I glanced over my shoulder, but there was no one behind me. A car passed, drawing to a stop before turning the corner; its windows were closed. The sound I heard wasn't coming from there.

Again! More chuckling, three syllables repeated, clearly inflected. I was being shadowed, yet—I made a sharp about-face to make sure—no one was following. No wandering dogs or cats in sight. No squirrels.

But there *was* something—a soft shuffling in the air, a shimmer. Something loitering, loitering with intent, moving slowly in a holding pattern, overhead. I was being shadowed from above. I glanced skyward, warily, making a visor of my hand. There it was: a local—all too local—cloud, silvery, then white, a dazzle of white tinged with gold. A small, circling cloud. And I was inside the circle, inscribed.

I knew at once who it was, even before I could hear the clapping of wings or catch the single word of her summons: "Chill!" Then I felt the great webs of her wings stretch over me. It was Christina, without question Christina, and I—all I could think of was to cover my eyes. *Why me?* What to do? What did I know about birds, actual birds? Not a thing, not a thing. There was Prometheus, of course—but those were vultures, weren't they?—and there was something I'd read who-knew-where about an ordinary midsized pet bird who'd demolished a chain-link fence with a few chops of his tiny beak. The only other thing I knew was that birds ate incessantly, ravenously. Christina would surely be hungry after a week of foraging on her own. I feared for the soft pendants of my ears, the glossy grapes of my eyes; I could not turn my face to meet hers. All I heard was her insistent "Chill! Chill!" Indeed, I did chill. I stood stock still, I chilled, I froze in place—

—as she alighted on my shoulder, my left shoulder. Heart side. The gentlest of touchdowns, but I must have recoiled without thinking. With a flutter and puffing of feathers, she rose and hovered again.

Then she resettled on the top of my head.

My hair, though I cover it carefully, is thinning, and I felt, keenly, the precise, four-pointed imprinting, the distinct hieroglyph of each splayed foot on the tender parchment of my scalp. She did not scratch—for the moment, she chose not to do so. I remained motionless, a pedestal, as she settled on her high perch. Would no one rescue me? But there was no one about, except for the body beautiful jogging, already

vanishing, through the intersection ahead. I had to remain calm; I could not call out.

Slowly, ever so gingerly testing, placing each foot unsurely, I turned, facing the way I'd come, and started to step backward. Christina held.

And now here I am, plumed—ridiculously, ferociously, gloriously crested. It is not yet too late. If I were brave enough.... Why, oh why, did I ever stop to read that sign? What if I hadn't stopped? I know I am losing seconds at every step. My game is almost up. Almost, not quite—I could still cut and run. I am only a few blocks from home. If I dare—

But, no, it's all up with me! She is so close that her wings ruffle the short hairs around my ears; in a minute my phone will ring, no one will answer it; my feet, baffled, will not be hurried; never could I explain this and be believed, my head wrapped in feathers, my house at my back ever before me, my heart racing, racing—

LES MURRAY

Corniche

I work all day and hardly drink at all.
I can reach down and feel if I'm depressed.
I adore the Creator because I made myself
and a few times a week a wire jags in my chest.

The first time, I'd been coming apart all year,
weeping, incoherent; cigars had given me up;
any road round a cliff edge I'd whimper along in low gear
then: cardiac horror. Masking my pulse's calm lub-dup.

It was the victim-sickness. Adrenaline howling in my head,
the black dog was my brain. Come to drown me in my breath
was energy's black hole, depression, compere of the predawn show
when, returned from a pee, you stew and welter in your death.

The rogue space rock is on course to snuff your world,
sure. But go acute, and its oncoming fills your day.
The brave die but once? I could go a hundred times a week,
clinging to my pulse with the world's edge inches away.

Laugh, who never shrank around wizened genitals there
or killed themselves to stop dying. The blow that never falls
batters you stupid. Only gradually do
you notice a slight scorn in you for what appalls.

A self inside self, cool as conscience, one to be erased
in your final night, or faxed, still knows beneath
all the mute grand opera and uncaused effect—
that death which can be imagined is not true death.

The crunch is illusion. There's still no outside world
but you start to see. You're like one enthralled by bad art—

yet for a real attack, what cover! You gibber to Casualty,
are checked, scorned, calmed. There's nothing wrong with your heart.

The terror of death is not afraid of death.
Fear, pure, is intransitive. A Hindenburg of vast rage
rots, though, above your life. See it, and you feel flogged
but like an addict you sniffle aboard, to your cage,

because you will cling to this beast as it gnaws you,
for the crystal in its kidneys, the elixir in its wings,
till your darlings are the police of an immense fatigue.
I came to the world unrehearsed but I've learned some things.

When you curl, stuffed, in the pot at rainbow's end
it is life roaring and racing and nothing you can do.
Were you really God you could have lived all the lives
that now decay into misery and cripple you.

A for adrenaline, the original A-bomb, fuel
and punishment of aspiration, the Enlightenment's air-burst.
Back when God made me, I had no script. It was better.
For all the death, we also die unrehearsed.

MARILYN NELSON

The Contemplative Life

Abba Jacob said:
Contemplation is both the highest act
of being human, and humanity's highest language.
If the language of things reaches beyond things
to designate the Absolute,
the silent interior mantra
bespeaks a profound communion
with that Someone further than ourselves—
and communion within
ourselves, for the two go together.
When we meditate, we enter
paschal mystery, the frontier between death and life.
Egyptian mythology has a wonderful image
of the pass from life to death: a great ship
which bears us to eternity. Charon
is the great passer of Greek mythology,
helping souls cross the River Styx from life to death.
Christianity turns it around: Christ
is the greatest passer, helping us pass
from death to life.
Contemplative life is always making the passage
from death to life, from humanity to divinity.
It is always taking the risk of being human.

There is an extraordinary message from the grave
as to what it takes to be human: a letter
from a Cistercian monk, one of seven
who had their throats cut
by Muslim fundamentalist terrorists
in their monastery in the mountains of Algeria
about ten years ago. Their prior
left a letter, just in case:
they knew it was probably coming,

they knew they were at great risk.
The letter was found and published.
Here is how it ends:

To the one who will have killed me:

and also you, Friend of my final moment,
who would not be aware
of what you are doing,
yet, this: Thank you.
And adieu to you.
For in you, too,
I see the face of God.

Abba Jacob wiped his eyes.
Interval of birdsong from the veranda.

He's seeing not an abstract God,
but a God who has assumed a face,
a God who shows him this face
in every one of those Muslim brothers and sisters,
including the one who kills him.

Contemplative life has no frontiers.
And it is the heritage of all humanity.
Through contemplation we enter
into communion with everybody.
And this leads to service.
But that's a subject
for another day.

KATHLEEN NORRIS

La Vierge Romane

...love is strong as death, passion fierce as the grave...
—Song of Songs 8:6

Her face long
and plain, impossibly
serene, has prayed
through blood
and water,
childbirth, death,
these eight centuries past.
She lets her hands fall
open, the child secure
on her lap, old
beyond his years.

"There is your son," Jesus says
from the cross—his stretched hands
powerless—"there, your mother."
And at mass, during Easter,
the two-months infant
nurses beside me, in the monk's choir,
knowing only mother, milk
of all promise,
hands kneading greedily
at the breast.
And the man
in the choir stall before me,
whose mother has died,
holds his hands
behind his back, as if a prisoner
being led to a fearful place.

I think I will go
where words are neither hard
nor loving,
but blaze unseen in bones
that grieve, in bones that thrive
and grow. And all that binds
the child to mother will be
sweet food, like sun on stone,
on the wood of the Virgin's face.

She prays for us,
but silently. Her hands hold on
by letting go. From her
the child learns
to give us to each other.

GINA OCHSNER

The Tower
<div></div>
[fiction]

Now the whole world had one language and a common speech. As men moved eastward, they found a plain in Shinar and settled there. They said to each other, "Come, let's make bricks and bake them thoroughly." They used brick instead of stone, and tar for mortar. Then they said, "Come, let us build ourselves a city, with a tower that reaches to the heavens, so that we may make a name for ourselves and not be scattered over the face of the whole earth."

—Genesis 11:1-4

MID-JULY. The heat beats down like hammer on tin, driving wrinkles into the hard headache blue that stretches the x and y-axes for as far as anyone cares to look. The only break in the sky's sweep is the stinging orange sand beneath our feet, a few scrubby acacias rooted at the base of some low-lying dunes, and this tower.

The tower, which is really more like a pyramid or ziggurat, we are building by hand, brick by brick. Each brick is imprinted with a sentence of great import. This explains why after four weeks with four crews working double shifts the tower is only seven stories tall. Add to this the bricks are mighty heavy. But I shouldn't complain. The brick I'm carrying is fairly light by relative standards. AIM HIGH! it reads, a pretty straightforward sentence. And as there is nothing dodgy about an imperative, I hoist my brick onto my shoulder and lengthen my stride.

"It's Leland, by the way," I say to the man in front of me. Why not? I've been looking at the back of his head for three hours now.

"What?" He stops and glances over his shoulder.

"Leland," I say. "That's my name."

With a grunt he stops, hefts his brick a little higher onto his shoulder. "Dwayne, with a *w*," he says and starts walking again. I can tell by the way he grimaces that his load must be quite a bit heavier than mine.

It reads: SUCCESSFUL INTERRELATION OF THE PARTS IS THE RESULT OF COMPATIBLE COMMUNICATION BETWEEN THE PARTS.

Up ahead two men carry between them a brick of massive density. They work with the silence of men who've known each other for a long time. And it's a good thing, too, because their brick, a compound complex sentence, of which the relative clauses—loose constructions of camel dung and straw—leave a long trail of droppings we take great care not to step in: *who, where, which, when.*

"Remember, men, there's no *I* in *team,*" Mortensen calls from his perch in the boom lift. With some artfully placed cardboard, he's transformed the basket of the lift into a shaded minaret. We nod to the lift, then tuck our chins to our chests and keep moving. Before all this tower business, Mortensen was a motivational speaker employed by the biggest and best, flown to shipyards and hangars to say the words, the right ones, that would inspire workers to reach their potential, which is a concept of mathematics I have never quite understood. Which is why we need Mortensen, who understands such things, to motivate from beneath the shade of the cardboard minaret. The other reason is because Mortensen has the lovely canting voice of a true tenor. And he's not afraid to inspire in unconventional ways: bagpipes, bullhorns, cat-o'-nine-tails.

We wear coveralls, orange. Hardhats, orange. Bug-eyed safety goggles, orange. Super-strength gloves, orange. The bricks are also orange, though some carry a slight cast of umber or rust. In front of the north face of the tower the night crew mixes sand, camel dung, and clay while another crew bakes the brick in the kiln, which is really a long, covered trench dug deep in the sand. The scholars stamp in the sentences, and to watch them work brings a sting of salt to the eyes.

But it's the hod carriers, the hoddies, and the grunts who do the real work. The hoddies mix and carry in their wheelbarrows the mortar, which is, in accordance to specs, a bituminous sludge. Grunts like me follow, humping the bricks as fast as our stocky legs can manage to the masons who rest on bended knee and slap the bricks into their places. There's a covert ops contingent of engineers who disappear at dawn into the hidden heart of the tower. To ponder the blueprints? To test the staying power of their cell phones? I can't quite figure, but

such musings are a distraction, and thus, not at the heart of successful interrelation, and if there's one thing we agree we must do well, it's interrelate. Which explains why we have these bricks stacked upon bricks, these sentences side-winding into the sky, our switch-back ramps, our ropes, our wheelbarrows, our camels that crap with a high degree of regularity, and, of course, Mortensen.

At shift's end, Mortensen trades the bullhorn for his bagpipes and his fluty cries turn to twangy skirling. The noise scatters the birds and breaks the resolve of the unending blue, leveling dusk to grainy lavender. Later, after the buzz and hum has died down, we gather in the shadow of the tower and Mortensen marks the day's progress by the length of the shadow fall. If we're ahead of schedule, we get double rations at the canteen. Then off we go to the tents huddled at the south side where ambition is a blanket we tuck tight around ourselves to stay warm. From beyond the dunes drift the songs of the scrub sparrows and babblers. We listen and watch the changing shapes of the dunes. They are camels slumbering. They are women lying side by side, their smooth hips dark and rolling. When the sun goes down, the dunes, the sand that composes the dunes, are anything you want them to be.

Overhead the stars snap on, one by one, and we close our eyes. We dream of a sky that weeps in the subdued shades of gray and slate. Some of us harbor visions of the women we wish we'd known. Some of us consider the tower that reminds us that we are men with a mission. I think of the girl who wipes down the metallic counter at the canteen. Her noble and aloof bearing reminds me of the camels who sit kiln-side, impervious to our human presence. The older woman who works the grill calls her Zamira, but her nametag reads "June," and I like the sound of her name, both of them, even though June in the desert is a crushing heat wave. Her eyes are dark as the water at the bottom of a long long well, her skin shade beneath a tree. She wears a yellow Yukos T-shirt, which is just tight enough to give me some hope: only Coptic girls wear clothes that conjure a shape, and this is good news because I'm Christian, too—a Methodist of a very broad stripe. And I think if I don't screw things up, I might have half a chance with her.

At daybreak Mortensen takes a ceremonial pee from the boom lift.
Then up goes the signal orange bullhorn and the call to work sallies
forth in pure notes that warm the wax in my ears:

> *Language is the means of becoming human, the record of wit at
> play. The right hand of thought, language is the evidence of life, the
> substantiation of meaning.*

Pretty heady stuff and sometimes, like right now, even Mortensen
has to stop and ponder the substantial meanings. But only for a minute
and then it's time for boot-up, for the Q-and-A portion of the morning
sound-off.

"What are we making of our words?" Mortensen calls out. The boom
lift ticks up up up, forcing cricks in our necks as our gaze follows it
up up up.

"More words!" we cry, tugging with a last savage pull on our boot
tongues.

"And what are words?" he shouts.

"Markers!" we shout back, taking to our stations.

"And what are we marking?" Mortensen's cadence is so even and
sure-footed that I suddenly feel as if I have inherited his certainty that
some things we can count on, were meant to be counted.

"That we were, that we are, that we will be!" we bellow, even as our
joints buckle down in their sockets and our vertebrae crack on cue.

The weight of the bricks we are assigned to carry depends on our
relative strength, a value determined by the width of a man's shoulders
or his IQ. For example, when I consider myself the numbers break
down neat and tidy:

> Leland
> Shoulder width: 24
> IQ (estimated): 95

As a quarter grunt with a double-digit IQ, I am good for fragments
(intended or accidental), simple declaratives, and imperatives such
as WORKERS OF THE WORLD UNITE! Zamira-June, I bet, could carry a
bigger brick, but thank heavens for the small mercies: she works the
east-side canteen and can't see me here, struggling up the west side,
which is, in accordance to ziggurat specs, a level 45 degrees. It's a

burden, this climb, and frankly, it's Zamira-June and her coffee that's helping me gut it through.

August. Even though the tower is twenty stories tall, Mortensen's in a sweat. We're on a tit-tight schedule. Dwayne's words, not mine. Point being, we have to really haul some brick if we're going to finish this build on schedule. We shave our heads high and tight so as to reduce friction. The average temp hovers at 121 degrees. The scratchy smell of sand scorches the air. The leaves on the tamarisk bake to paper and the seeds inside the pods of the acacia rattle at any suggestion of a breeze. We hallucinate. Our words, these messages on these bricks, are like the long-legged birds that peck the dumpster behind the canteen. Awkward on ground, the birds are graceful once they reach their intended height. I say this to Zamira-June during a water break and she smiles. A first, this smile. She tells me a man invented an alphabet and a whole dictionary of words after watching cranes wing their flight patterns through the sky. Is this man's name Mortensen? I ask her, and she laughs—also a first.

> *With enough cooperation anything in this unruly world is tractable, within our grasp. We can conquer the sky, subdue the clouds.*

As if summoned by us, Mortensen calls through the bullhorn and back to work we go. By late afternoon the sun is a slow-moving blister. The songs of the birds have dried up in their throats and three men at the kiln pass out. The scholars are calling for salt tablets. But we press on. Electrolyte imbalances and dehydration give us our dreams. I remind myself that it takes a desert to produce any mirage, this kind of unrelenting heat to convince the eyes to see with an alternate, I think, better vision. To see not as things are, but how you wish them to be. In a thousand years, I tell myself, the sand under our feet will be a sea of glass. And when considered this way, the tower assumes even grander proportions. People like us built something mighty, something wonderful, and we did it together. Giddy with this potential accomplishment, my feet falter and I stumble. "Stupid ass!" the guy behind me calls out, and I blink in surprise. Clearly the heat is getting to us: name-calling is not at the heart of cooperation, and is expressly forbidden in our standard-issue book of rules and regulations.

Heavier than any brick I've ever carried is the book of rules and regulations. Wedged between the slurry-sludge indices and the special note about emulsifiers is a hazardous material advisory regarding certain forms of thought, speech, and conduct. Because we lack the proper certification, three things, maybe four, quarter grunts like me are instructed to avoid.

Metaphors. Similes. The frisky forms of figurative language that vex even the scholars as the bricks, high in fibrous content, exit the kiln woefully under baked. More than once I've witnessed such bricks slide out of the grip to land on the feet. In general I've discovered that the more figurative the brick, the bigger the bruise, and lately we've been shoving these types near the base entrance where the engineers stand around smoking, looking drafty and superior.

Whether on shift or off, and regardless of rank, jokes are to be avoided by all workers at all costs. As with fig-lang, jokes afford a wide latitude of interpretation, which Mortensen says increases the likelihood of confusion by at least 63 percent, and confusion is certainly not at the heart of cooperation. Also we have been advised not to date the help, specifically mess hall and canteen workers, many of whom are displaced persons and therefore forbidden to us. Asking why is unacceptable, as questions are the last item on the list of things we are absolutely to avoid.

Questions we are not to touch, Mortensen cautions, as they so often illuminate just how much one doesn't understand. But what's been bothering me for days now: won't it get awfully confusing—all these bricks with different messages piled one on top of the other? If there's a pattern to them, I haven't seen it yet. And should we read the bricks right to left, left to right, or start at the sand line and work skyward? And why shouldn't I ask the beautiful Zamira-June out if I want? It's a mystery all right, and at the risk of sounding like a naysayer, I bring it up with Mortensen on our break.

"What color is your hardhat?" Mortensen asks in return.

"Orange," I say.

"And what color is my hardhat?"

"You're not wearing a hardhat, sir."

"Pre-cisely." Mortensen stretches a munificent smile across his face. Then Mortensen blows his whistle, the signal to double-time it.

It's late by the time the last wheelbarrows and trowels are stowed away. The sun is a leak of blood smearing the dunes. Down I go for the last call for coffee. There's June polishing the metal counter to a shine so high I tell myself I can read her thoughts. I tell myself she's thinking about me. She's thinking about her being with a guy like me.

Though there's sand stuck between my teeth, I smile anyway. "I'm not good with women," I blurt. If I had a brick to carry the rest of my life, that's what mine would say.

"Most men aren't," June says. And then, the heavens open and stars tip on edge. June leans and puts extra sugar in my coffee.

"Let's you and me go out some time," I say. Risky, sure, but as I've kept it simple and Mortensen is at the far end of the canteen, I'm feeling relatively safe.

June bites her lip. "How much taller is this tower going to get?"

I want to laugh, to say: "Oh, June. Such questions!" It's what Mortensen would say.

"I don't know," I say at last. The tower is twenty-two stories tall now. There's talk that they will dispense oxygen masks soon, and the bricklayers have been claiming that the Dallas Cowboys cheerleaders are to deploy sometime next week and provide ground support in the form of morale boosting.

"What's this tower all about, anyway?" June asks.

Another question, and it's one I've asked myself—silently of course. And the answers have taken their time arriving. It's hard to explain the meaning of the tower. Hard to explain the need for a reminder that you were, that for a time you lived and spoke. That you had a name. That this means something to a guy like me, unimportant, completely forgettable in every way. I try all this out on Zamira-June but my words are awkward, long-legged and short-winged. Though my tongue flaps and flaps, my sentences achieve negative gain, zero lift. We are standing so close that our shoulders almost touch, and yet June is far away from me, her eyes impenetrable and as shiny as that counter she has been cleaning this whole time.

"Don't you know who you are?" June asks. It's a long and thick silence between us. June points her nose eastward and inhales. "I think this tower is bad news. I think you have no idea what you have gotten yourself into." She sighs, throws the cloth onto the counter and

pushes past me. Well, it has been my secret belief all along that June is in possession of a sturdy reservoir of negativity that some people get from living in places like these. I also think that behind her words is a secret message she wants me to decode. And I think, time, that's all we need. Me to understand her, her to understand me, and I drift to sleep lulled by the rhythmic pound and slide of bricks being kilned and offloaded.

The next day the wind is up. In this desert nothing is more terrifying than what wind can do. Not even this tower can defeat it, and even a small gust drives Mortensen to his knees. We've all witnessed how a true gale can lift a brick right out of our hands, send it sailing into a dune, which is why we all harness up now that the tower is twenty-five stories tall.

"Success is just another name for ordinary people working together to achieve the extraordinary. Think: *my yoke is easy, my burden light.* Whistle happy tunes!" Mortensen calls. His toupee flaps wildly. But his words are so soothing, rooflessly soaring, that we keep on. The desert rises up and folds around us. The hills undulate and disappear. What is June thinking about, I wonder? And why am I carrying this brick, whose meaning I care little for and understand even less? But then I remember how thorny unanswerable questions are, how relatively thin these super-strength gloves.

Dusk tamps the desert down one grain at a time, and at last our luck turns: management reports that brick production at the kiln has reached an all-time high. Shit production from the camels is also at an all-time high. The Cowboy cheerleaders arrive at last, and morale soars. Cooperation abounds in the barracks and in the shadow of the uncomplicated tower. The tower is so tall we can barely see Mortensen in the boom lift, but we can hear him counting, brick by brick, our ambition, our desires, and the numbers are running very high. For the first time in weeks I feel a calm singularity in my blood, which moves clean and bright through my veins. I imagine this is what Mortensen, Dwayne, and all the others must be feeling—that giddy weightlessness brought on by too much oxygen, or maybe not enough. We are surrounded by an ocean of possibility. Endless sand, umber and orange and rust and all of it begging to be brick, shaped into the hard-edged sentences that stack up so nicely, one on top of the

other. I think of our unfailing delight in the possibility of possibilities and the architectures such dreams might assume. I think of what a magnificent accomplishment a tower like this is. "Upward, onward," I mutter my way toward sleep that night, that is, until June throws a misshapen brick through my tent. LOVE HURTS, she's spray-painted on it, and I have to admire her humor, since I think she may have broken my ankle.

I limp outside where darkness is pierced by long banks of klieg lights trained on the tower. The smell of camel piss and diesel fumes waft over the sand. June points to my swelling ankle, which even under the harsh light is turning a marvelous blue. "Sorry about that. I was aiming for your head." Another joke, I think.

Then June turns her gaze to the tower. "It's so exaggerated. Why don't they just stop now?"

I tip my head to the side and study the tower. Her words are mere scratches scuttling sideways over my eardrum. My heart is so full of admiration for what our hands have done, what our minds dreamed up, and yes, even for Mortensen's motivational bagpipe playing, that I can't help loving the magnificent tower, which I think loves me back just a little. "God, it's beautiful," I whisper.

June folds her arms over her orange sweatshirt. "You know, Leland, a desert is cruel but just. It levels all things equally in the end."

There's an arid quality to her voice I'm sure I don't know how to interpret. "Huh?"

"All I'm saying is things built out of sand and dung usually don't weather well in places like these."

It's all very un-aim-high-ish kind of talk, and I shake my head to will it away.

"Just think about it, Leland. How many towers have been built out here that are still standing?"

I shrug. As if the past has any bearing whatsoever on the future.

"If other people built grand monuments in the desert and then those monuments crumbled, and now you people are building a grand monument in the desert, then what do you think will happen next?" I study the grout lines of the tower as if the answer might be hidden there somewhere. The truth is, I've never been good at filling in the blanks or reading between the lines. It's why this whole build, I've been carrying declaratives.

"C'mon, Leland. It's a simple conditional if-then construction. Think." June's dark eyes are so solemn it puts a hitch in my breath.

"Is this, by any chance, something I could look up in the rules and regs?"

June is beyond exasperation. "Oh, Leland, you really are thick," she says, stuffing her hands in her pockets and brushing past me for the canteen.

Name calling is not, I repeat, *not,* in the heart of cooperation, and as I watch June take her station behind the counter, it occurs to me once again that June is a bit of a naysayer.

Inside the tent my ankle swells and my head swims. The greasy feeling that June may be onto something coats the lining of my stomach. I repeat each of her words quietly. *If-then, if-then.* There's a balance to her words, but the tower is so tall now, the pounding from the kiln so rhythmic: *If-then, if-then,* I fall asleep anyway, etherized by the even sounds of constant motion, which Dwayne has assured me more than once is a name for progress, the sound of people achieving their potential.

The next morning panic rocks our base camps. The tower has been vandalized. Mortensen is pale as alabaster as he reads and rereads through the bullhorn the graffiti spray-painted in day-glo tangerine:

LOOK ON MY WORKS, YE MIGHTY, AND DESPAIR.

What could it mean? It's a head-scratcher, all right, and the spraymanship leaves something to be desired. Thank heavens the scholars are on hand to tell us that we are gazing upon a literary reference. From a poem, no less. "Oh, that's swell," Mortensen splutters in outrage, as literary allusions we all know are highly HAZMAT due to their weighty overuse of fig-lang. And at this point all the scholars can assure us of is that whoever defaced our magnificent tower does not have a firm grasp of contextual boundaries, the proper use of irony, or MLA style documentation. "All in all, it's terribly juvenile," Mortensen pronounces, and for some reason all the scholars turn and look at me.

By evening the corporate head offices have faxed their response, and the hydraulics of Mortensen's lift whine as he positions himself

in the optimal air space. He waves the fax in one hand while in the other the bullhorn cracks and spits.

> *At high noon tomorrow the violators of the tower will be drawn and quartered, tarred and feathered, hung from the side of the tower and—purely for motivational purposes—shot. Sincerely, your friends at Omnicom, Bechtel, Inc., and Gazprom.*

Very dramatic. And the scholars are digging it, though I can tell by the way they roll their eyes that they think it's a bit clichéd.

"It's a reasonable use of the unreasonable," Dwayne elbows me in the ribs. "I myself never went in for twee half-measures."

I nod. Everyone knows you don't get in the way of men and their ambition.

"I'm sure whoever wrote that meant it in the best way possible. Like a joke. Ha!" June offers later by way of consolation. It's quiet in the canteen. Sugar rations are suspended until the culprit is identified, and I can tell by the way she's grinding that washcloth over the counter that she feels a little sorry for us.

I think of my ankle, June's oddly developed sense of humor. "A joke—well that spells a 63 percent chance of misinterpretation," I say at last.

"I know. I know," June says, "I'm sorry," and she slides a forbidden sugar cube into my hand.

Morning call to work is sweet and simple. At the kiln the brick I'm given is the biggest I've ever carried:

THE MEEK SHALL INHERIT THE EARTH, BUT NOT UNTIL THEY'VE FIRST STORMED HEAVEN'S GATES.

An unauthorized metaphor. And sloppy, too. All the way up the tower my load exudes the green reek of fig-lang and slides from shoulder to chest to hip to knees, and I know it's going to be a tough haul. Below me the camels kick and snort and balk at their feed. Above me the sky is the color of tarnished metal, and for once the over-bright sand is subdued. Beside me Dwayne is chatty. After the vandals are punished, Dwayne says, Omnicom, Bechtel, and Gazprom are going to battle it out in a flag-raising competition. We have to raise a flag, Dwayne says. But not a green one, as green is culturally insensitive.

And blue, he says, is far too pushy, too eager to be seen. And orange? Well, frankly we are all mighty sick of it.

By mid-morning the wind is up and gusty. The ribbons of Mortensen's bagpipe fly at a crisp 90 degrees. The tower is forty-three stories tall now and at this elevation the lungs labor. The bricks feel heavier. A low and ominous growling swells from beyond the dunes. "Put your backs into it, lads!" Mortensen shouts. But the wind whips up even harder. It pushes us back, pushes away all thought. Mortensen's bag squeals obscenities, and his face turns purple as the notes skirl through the air. And still that growling is getting louder. I'm thinking crane helicopters. I'm thinking Harrier jets. I'm thinking we are in deep shit here. Mortensen signals the cheerleaders back to their civilian transports, and just in time, too: his toupee lifts from his head and cartwheels through the air. There's the smell of ozone. Then from the clouds a bolt of lightening streaks sideways and unzips the x-axis from the y-axis. One second later thunder erupts with such concussive force that the camels are forced to their knees. The tower groans. Mortensen's bagpipe sails away without so much as a squeak. There's blood draining from Dwayne's ears and a thin trickle from his nose. "God damn," I think he says, but it's so hard to tell, the wind is howling and there's a strange liquid shift behind my ears. And then the unthinkable: the tower begins to crumble. "Retreat!" Mortensen shrieks. We are lucky to unharness in time, and we scurry down the switchback ramps as fast as our stocky little legs can carry us. Bricks fall to the sand. Story by story, sentence by sentence, the tower is stripped. Behind the orange veneer of our safety goggles, we watch our words topple and fall down, down, down.

In the grounded boom lift Mortensen sobs, his shoulders quaking. The scholars throw themselves into the roofless trench that used to be their kiln. They rend their clothes and gnash their teeth. The engineers unholster their cell phones, but there's no time for damage reports: the wind is driving the sand, lifting it from beneath our feet in thick swaths. The engineers, hoddies, and masons take refuge behind strategically positioned camels who have closed their nostril flaps, tucked their snouts between their colossal feet, and are sleeping. At the place that used to be the canteen is June, the girl of my dreams. She is crouched behind her counter, the top of which the wind has

peeled back like the lid of a sardine can. The wind is tearing at her, threatening to carry her off. "June!" I yell.

She peers from behind the counter. "What?" Another metallic flash lights the underpan of sky. Blood leaks from her ears and trails down her neck.

"Wait!" I cry.

"What?"

She can't hear me. I realize that nothing I ever say will reach her, not with this wind. I run toward her, and as I get to the counter her mouth, round in astonishment, makes the shape of my name. In this moment she is more beautiful to me than anything I have ever seen, and that I can know this is like the answer to every question I have ever wanted to ask. I strap my safety goggles over her eyes. With my left arm at her back, my right arm under her knees, she is up. And so light by comparison to any brick I have carried that I almost lose my balance. It's a haul in this wind, but we're in luck: a camel big as a boat sits snoring not two paces away. We tuck tight lee-side and June looks me over. "Your ears—they're bleeding." I'm reading her lips because the wind is just that loud.

"So are yours," I say, blotting her neck with my sleeve.

"Your eyes are bleeding a little, too," I think she says.

"Nobody's perfect," I say, pulling off my gloves, which I see are good for nothing now. June tosses them into the air and we watch the wind take them where it will. And for several minutes we sit, a snag in currents of sand. And in those minutes that become hours, her body fitting the hollows of mine, I am beyond the noise, beyond the confusion. What I don't know and don't understand, I see—even without my safety goggles—no longer matters. For when the wind wears itself out—in an hour? a day?—we will be standing on a sea of sand that never knew it had been brick. Suddenly the world becomes very simple. Because here's June, dabbing at the warm fluid draining from my ear. And I am never so happy to be here, beside June, in this complete state of disrepair, which I think may be necessary for a guy like me to lay hold of the hard and hurting wisdom I sorely lack.

June squeezes my arm. "I love you," she mouths. It's still a job hearing her over the ringing in my ears, this wind, and the penny whistles of our camel snoring. "What?" I say. Then, solemn as ever, June kisses me.

GREGORY ORR

How Beautiful the Beloved

Occult power of the alphabet—
How it combines
And recombines into words
That resurrect the beloved
Every time.
 Breaking open
The dry bones of each
Letter— seeking
The secret of life
That must be hidden inside.

§

Fate not just a pair of scissors
Waiting at the end to cut the thread,
But there at the beginning,
Spinning the same thread out:
That bright filament of song
Whitman said connects us all—

Spinning out that string of words
With which we wed the world,
With which we espouse the beloved.

Spinning out the poem of our vow.

§

Nazim Hikmet begins a poem
With the phrase: "Another thing
I didn't know I loved."
He writes in a tone of amazement.

He's a Turkish poet in exile.
He's on a train in winter,
Leaving Prague and headed
Toward an uncertain future.
The poem he's writing is a list
Of things he suddenly knows
Are precious.
 He doesn't know
Where he's going—old man
At the start of a long, cold ride.
The list he recites is also long.

As long as he keeps making that list,
He's traveling toward the beloved.

 §

Being being nothing
But breath

And the fog it makes
On the window pane,

Which is a page
In the Book

On which
You write your name.

 §

Steeling your heart,
Yet what's the use?

Already it's stolen.
Already the beloved
Has captured the castle.

How defend yourself
Against rapture?
How protect yourself
When the world
And all the words
In the Book
Conspire against you?

Better to surrender.
The beloved's beauty
Has pierced your heart,

And that's its purpose—
That's the point of it.

§

Snow on the mountain
This January morning,
Though the sky's blue.
Must have fallen
Last night.

More gray hairs
On my head
Every month.
My moustache
Almost completely
White now.

Too many funerals;
Not enough weddings.
Not enough birth
Announcements.

I hope the beloved
Isn't losing ground.

§

There's a mystery here:
The poet wrote her poem
To save her own life,
And now it's saving mine.

§

When the beloved died
You were silent.
Not for hours, but for years.

Did you think the world
Would speak for you?
Did you think
That if you sat quietly
The beloved would return?

O Book of the beloved—
Right there on the shelf!
Reach up. Read it aloud.
Don't die yourself.

§

If somewhere in us
Love lurks,
The beloved
Will find it.

If hope hides
In the smallest
Cranny,
The beloved
Will pry it out.

Demands it.
Won't take no
For an answer.

His poem
Luring it
To the surface.
Her song
Calling it forth.

§

So many to choose from
But only some can summon.
So many poems in the books,
But most are just words.

If only the beloved would tell us
How to find her, reveal
Where he's hidden himself.
Must I spend years searching?

Why not? Why not?
Easily found, easily forgot.

ERIC PANKEY

The Education of the Poet

Before the Tigris and the Euphrates, before the sedimentary, igneous, and metamorphic rocks were labeled and set on a shelf behind a panel of glass that slid creakily on ball bearings, before negative numbers, before fractions, before the earth, tilted on its axis, moved close to the sun and thus, illogically, it was winter, before the tornado drill, the fire drill, duck and cover, before the Venetian blinds were open and the dust of all summer lifted like dust into the light's slant, before the chairs were lifted one by one from the desks to the floor, before the protractor measured an acute angle on the board, before the compass, before the pocketknife flipped once and landed blade-first in a game of mumbletypeg in the dirt of the playground, before he pressed a button on the autoharp and with a pick stumbled up music, the boy spoke the words, *I pray the Lord my soul to take, Amen,* and his day ended. He said it sincerely, in the sincere voice of one whose prayer, once rote, was now a spell of sorts. A key. A lifted latch and trap door through which he entered sleep. How light he felt between the *now* and *then,* the disputed borders of dream, as if something *had* been taken from him, and he knew—the boy did not have the words for it yet—that *gravity* and *grace* would always be the variables, the integers and sum, the divisors and quotient, the end points of a single line, and to that end, the principle products of his brooding.

ANN PATCHETT

The Language of Faith [essay]

ONCE I LOVED a man who loved tennis. This was years ago. He had given up the game long before we met, but I took great pleasure in watching him follow matches on television. Wimbledon was a sacred time in his house. He knew the game better than he knew himself. He could spot a foot fault before the toe of the shoe crossed the line. He understood tennis because he had played it when he was a boy, an hour before school in the morning, three hours after school in the afternoon, all day on Saturday and Sunday. His parents drove him to matches in the distant corners of the state. He played in wind, scorching heat, bitter cold. He was good, he told me so. Maybe there was a flicker of hope that he would be a professional player, but then one year some other boy was better and he lost his ranking. It doesn't matter. He didn't become a tennis star. He became a novelist.

I know many young people who want to be novelists. There are flocks of them everywhere I go, and yet the young person I know now who I think would make the best novelist doesn't write at all. I met her last year when I was speaking at her high school. She was sixteen then and she sat in the front of the class. When I asked if there were any questions, her hand shot up with such urgency I thought she was going to tell me there was a man at the door with a gun. "What do you do when you know you're faking the emotion in your art?" she asked me. "What if you're really good and so nobody else can see it, but you know that instead of creating something genuine, you're creating the illusion of something genuine? Does it bother you? What happens when you don't know how to stop it?"

I stared at her. She was looking at me as if this was information she desperately needed. I should say here that I've been asked many questions about my work: Do you write in the morning? Do you use a computer? Are these characters based on people you really know? No one had ever asked me about the nature of faking emotion, and it is a

question that deserves to be asked. On the other side of the room, her teacher looked uncomfortable. "Eun-Mee is a violinist," the woman said by way of explanation.

Eun-Mee followed me from class to class, asking how I could write about things I had never experienced. How could I write about having children when I didn't even want children? And what should she do when she was instructed to play with passion when passion was a subject with which she had little experience? When my day at the school was over, she hugged me and asked for my address. I keep all of her letters. I have yet to hear her play, but if she puts half of the intensity into her music that she does into her sentences, I imagine she could make the concert hall draperies burst into flame. Even if she never becomes famous, these letters are a remarkable accountant of a rare and brilliant youth.

Eun-Mee plays the violin not unlike the way the man I loved played tennis. She plays in the morning and after school and in any other hour she can find. On the weekends her mother drives her the eight hours each way to and from Cincinnati so that she can study at a proper conservatory. She does her schoolwork for the week in the car. What other time is there for homework when a girl has everything to learn about the violin?

Of course, I have many friends who are writers who didn't start out with the grinding hours of tennis or violins or figure skating. Most of us wasted our childhoods in the normal ways—tormenting our sisters, walking our dogs, dreaming of being in love. But the ones who learned discipline by whatever vehicle they were given are the ones, I think, who are best groomed for writing. There is an art to repetition, to staying perfectly still and keeping your eye on the ball, to doing anything so long that some part of your body aches and begs you to stop. The same line of music played over and over again until you can't really hear it anymore begins to shape a person as slowly and completely as any rock was ever shaped by water. You can't see it, but it's happening. I had my own discipline in my youth, though it wasn't nearly so interesting—no contests, no trophies. The rewards for my sort of practice were much more abstract. If I was a rock, then my water was Catholicism. What I did through my childhood was pray.

I think all the girls with whom I spent twelve years in Catholic school were reconfigured by the experience of religion. If they weren't

praying as hard, they were certainly going through the motions, and this is a case where I think it's safe to say form and content will lead you to similar places. When I was very young, before the school made a few attempts to be modern and attract some Protestant girls who paid higher tuition rates, we marched up the narrow back stairs of the convent to the chapel every morning and said the rosary. This is where it begins, lined up in that hallway, the nuns keeping us silent and still simply by glancing in our general direction. We filed past the glass-topped relic table which contained sacred chips of bone and tiny scraps of sheeting that had touched a saint's dead body or had touched a piece of sheeting that had once touched a saint's dead body. The relics were labeled with names pinned to the felt that lined the case. Every morning, I looked in and every morning the sight of those minuscule bits of bone seemed spectacularly holy, as if Christ himself had been waiting beneath the glass. It was an honor; that's the only word that seems fitting. To file past the presence of real saints, the physical remnants of sacred lives, was something I never grew tired of. I loved it with pure passion. I loved the blue walls of the convent, the painted statue of Mary outside the sisters' living room on the second floor with her gold star crown, the plain sandstone Mary in the chapel that stood on the left-hand side of the altar near the communion rail. Her feet were bare and she crushed a snake beneath her toes. I memorized her feet, the sleeping lines of the snake, every fold and drape of her gown, her open palms, the kindness of her face. I was careful to divide my time evenly between her statue and the statue of Saint Joseph that stood to the right of the altar, but it was Mary I loved.

We said the rosary together, grades one through twelve, with the older girls saying the first half of the Hail Mary and the younger girls repeating the second half like a chorus. The young girls were each given a chunky plastic rosary every morning on our way up the stairs and we returned it before we went down to class. The thinking was that an average child was not to be trusted with a rosary of her own until First Communion. For me that was still two years away.

The problem with writing about one's self is that people are too in love with the details of their own lives. They go on and on about things that fascinate them when in fact those things are utterly boring to everyone else. I know this is true and yet still I want to go on, to recount the shape of every bead beneath my fingertips, the wording of

every prayer. You will think at first it is all a matter of simple repetition, but it's not. No two Hail Marys, no matter how many of them there are prayed, can mean exactly the same thing. Ask the young violinist who plays a Bach violin concerto for five hours at a stretch. Every time, it is a surprise. I could tell you about every pew, every red leather kneeler, because there was not one that hadn't bent to the shape of my knees. I could tell you about the designs on the floors and the stained glass windows, the thrilling, narrow walkway behind the altar, the sacristy where the priest, on those rare and lucky occasions a priest came to say a mass, hung his vestments. And if you were chosen to be the one who lit the candles, or better yet, the one to snuff them out after the mass had ended, then your heart soared for the rest of the day. There was no better prize for all the hours logged there on your knees.

The answer to Eun-Mee's question about faking the emotion is that some days you do. Some days you mouth your Hail Marys while your mind skims over the plots of sitcoms seen ten years before. Some days the mass is a meditation on what light does to dust in the air. But you keep showing up. You play the Bach again, you write another paragraph, you repeat the prayer. You hold on to the form through the stretches when the content has vanished. You observe the mass in all its glorious dullness. You practice. And then, in a storm in the middle of the night, all of the love comes rushing back to you. There is no reason why it left or why it should return, but it does. You play like a girl reaching into her chest to show her own heart. I write with so much assurance I feel like I am simply copying it down from some other source. And the prayers that you say—suddenly they are the rope that binds you to God.

After the school did away with the compulsory rosary in the morning, I went to school early to go to chapel and said my prayers alone. Alone, I could forsake the pews and go to the front, near the statues, where I thought my prayers had a better chance of being heard. What was I praying for? I cannot even begin to remember. It wasn't about a thing, something to have, a larger allowance or peace in the world; it was about prayer itself. It was about how straight I could hold my back. It was about repetition, the pleasure of the words I could not help but whisper.

Look at the girl who kneels at the front of the church on the cold marble floor, saying her rosary alone for Mary the Mother of God. That is me. I am learning to write.

I knew even then that I wanted to be a writer. I practiced. I wrote poems and stories. I read books. I prayed. How do we separate the things we learn? When they told us at the end of second grade that when we came back in the fall everything we wrote would be in cursive, they might as well have told me that everything I wrote would be in French. Those loops, those tails that grew down from letters, formed a language unto itself. But I learned to reconfigure my letters at the same time that I learned how to make the letters mean something by their combinations, and so those two acts stay locked together in my mind: the pencil moving back and forth between the lines becomes a creative act. I practice my letters. I practice writing poems. I pray.

I'm disappointed with myself for never having learned to speak a foreign language. I wish with all the hindsight of age that someone would have forced it on me in my youth. I wish that while they were teaching me to speak Spanish and Italian they had also taught me to downhill ski, another thing I feel I should have mastered before I understood how difficult it was. But I did learn the language of faith. I learned it the easiest way: by immersing myself in a world of native speakers. I spent my childhood in the specific and peculiar culture of nuns. There are two stories I could tell here and both would be equally true: one in which I suffer all kinds of injustice and lunacy at the hands of nuns, another in which I am shown enormous kindness and tenderness by these women. With a few startling exceptions, I loved the sisters and admired them. Nuns, at least the ones I knew, operated off of faith the way the rest of us operate off of air. Faith was the currency, the law, and the philosophy of their society. More than anything it was the language, the spoken or unspoken answer to any question. I have known nuns who left the church, but I have never known one who had forgotten her faith. In its first stages, faith is the ability to believe in something, to trust absolutely. When you are more fluent in the language, faith is the ability to believe and trust in something you will never see, to love absolutely something that is not there. In the final phase, when faith becomes second nature, the language in which you dream, faith is the ability to see all around you that which cannot be seen. To take this from the very comfortable

abstract to the less comfortable concrete, advanced faith is the ability to see God in all things. Advanced skills in the language of faith mean that when you don't see God in something, you roll up your sleeves and seek Him out, because you know, absolutely, that He is there.

Because my family lived in the country, far away from where my sister and I went to school, my mother would drop us off at the convent early in the morning, an hour or more before school started, so that she could get to work on time, and we would stay at the convent for hours after the other children had gone home, doing homework or being helpful. I remember sorting silverware in the big kitchen of the sisters' dining room where I didn't study faith but overheard it spoken casually.

Literature has a great tradition of brilliant, soulful atheists, but I think it has an even greater tradition of faith: Tolstoy and Dostoevsky, Eliot and Yeats, Graham Greene and Flannery O'Connor. What is writing, after all, but the ability to believe in that which you cannot see, to in the end believe in it so completely that you see it everywhere? Every day that I write it is in this secret language of faith. I cannot imagine how I will get to the end of any novel I begin. I do not know who the characters will become. I do not know how they will travel through their stories, how they will manage the fates I dole out to them. I have no idea if I will have the strength or courage to complete what I have started, but I am sure of my faith. It's a little like closing your eyes and stepping forward, one step and then another and another. It is trusting that I will be able to do this thing even when I don't understand exactly what it is I am doing.

Here's another way that faith prepared me to be a novelist: it introduced me to the ways of God. When I was a child, my greatest career goal was to be a saint, a human manifestation of God's love. I didn't mention it to anyone, but the nuns, possibly sensing my natural impertinence, said that it was a sin to think we could be like God. The delicate balance was to try to live by God's example while knowing with full humility that you would fail. But why did I have to fail? I liked the challenge of tireless goodness, I liked the expectations of perfection. I thought about the Amish and their quilts, the way they would tilt the last block that was sewn on to create a mistake so that their creation did not achieve perfection and presume to stand with God. But isn't that the greatest admission of the perfection of their

work? It was so flawless that a error had to be wittingly inserted into the pattern. Tilt the block back to its proper position and there is God in the art. Why not try?

As I got older and gave up my childhood dreams of matching God in terms of perfection, I became a novelist and decided to match Him in more ambitious ways. Like Him, my intention was to set out to create the world, maybe even in my own likeness. I would scoop people out of the air and shape them with my hands. The cities they lived in, the houses, the countries—those were my creation. The texture of their hair, the cereal they chose for breakfast and the way they chewed it, who they loved, the lies they told—every word of it was mine. I decided when they would have children and how those children would grow. I decided when their story would come to an end. People ask me, do your characters surprise you? Do you know everything that happens to them before you start to write, or do they take turns you had never imagined? It is not unlike predestination, one of the many religious questions I spent my youth trying to puzzle out. What I decided then was that God knew the future. We were not simple marionettes. He did not lift our hand and set it down again, but being the One who set us into motion, being the One who knows everything, He knows what we're going to do without having to control it. Yes, that was how I would write my books, as much as I believed God had written me. It is through my mimicking of the order of the universe that I offer God praise.

Children dream of complete access to candy stores, or they did when I was a child. Maybe now they dream they have keys to the entire mall. Adults often dream of the writer's life. Sometimes it's because they want to write and to this I say, yes, you are exactly right. It is something worth wanting. Most people have a story to tell. They've been putting sentences together all their lives and so would like the chance to do it on a professional basis. They would like to see a book with their name on it sitting in a store and again I say, yes, pursue that. It is indeed as fine a feeling as you imagine it to be. But that's not about writing. That's about having written. The other part of my life that people claim they want, I have to wonder about. Very few people are suited to live in a total absence of structure. What compels you to get out of bed when no one cares at all whether you do or you don't? I live alone with my dog, and walking her is as much of a routine as I manage. I don't

sell my novels until I finish them, so if one takes me six months or six years to complete, there aren't going to be any badgering phone calls reminding me of looming deadlines. I can play computer solitaire by the hour. I have spent days at a time on the sofa, reading novel after novel, and no one complains. I tell myself it is related to my work, that I am thinking, and even I'm not sure whether or not I'm telling the truth. But I never stray too far. I have something inside me that gets me up again, gets me back to my work. I have an almost unnatural ability to hold still, and this is the thing I think most people lack, the thing that separates the writers from the non-writers: the simple act of focusing. That came from faith as well.

Or not exactly from faith. That focus came from church, and church and faith are not the same thing. When I was very small, still capable of being formed, my parents were still married, and I still lived in Los Angeles. My mother did not participate in the ritual of Sunday mass, but for my father it was extremely important. I don't know if mass was important to him personally at that point in his life, but it was important to him that his daughters went to mass. Because my sister was three and a half years older, I never remember her being anything but the poster girl for good church behavior. I, on the other hand, wanted to flip through the hymnals. There was no greater pleasure than locking your toe beneath the kneeler, lifting it up a half an inch, dropping it. Stretching out on the pew was a great temptation, but I knew I would get caught long before I made myself comfortable. The trick was to recline right up to the limit of good taste and then recline a half an inch more, which usually involved touching a stranger with your shoe. At this point my father would yank me up and take me outside.

This was thirty years ago and more, a time when people spanked their children, hit their children, in order to correct misbehavior, and no one called it abuse. I do not call it abuse. I call it taking my place in a long family history. I certainly know my father had been yanked out of plenty of masses to get smacked by his father for crimes that far exceeded my own (I will only say they had to do with the contents of the collection plate). My grandfather, who lived to be a very lucid ninety-three years of age, told stories of getting knocked around with the best of them by his father. Several years ago my father took a parenting class as part of his work as a police officer. He was supposed

to counsel parents who were having problems with their children. He called me one evening when he got home from school.

"I wasn't supposed to hit you," he said. "I feel terrible about this."

"Don't be ridiculous," I said.

"No, really," he said. "It turns out you aren't supposed to hit children at all."

But as every police officer knows, there is a connection between fear and respect, and nowhere is that connection clearer than in the Catholic Church. Heaven and hell, God's love, God's wrath, Revelations and Micah all in one Bible. If love is the backbone, then fear is the muscle that wraps around it. Fear makes us work. Fear makes us eager to please. God grants us unconditional love and acceptance but only if we ask for it, only if we know enough to say how terribly sorry we are. Forget that part of the deal and you are out of the garden for good.

By instilling in me an element of fear to temper his love, my father taught me a wonderful trick that the children I see today don't know how to perform: he taught me to sit still and to listen. This is an important point. Sitting still was only half of what my father was after. He wanted me to pay attention. He seemed to have the ability to watch my mind wander off as clearly as he saw my leg kick the pew in front of me, and time and again he stilled the leg and called back my wandering thoughts. "Listen to the priest," he whispered, his voice making it very clear that this was a warning and the next time there would be action without words. I was a smart kid and I put it all together. I held still. I paid attention. I listened.

Try to become a prodigy on the violin without those qualities. Try to write a novel. I suppose there are a few very lucky people who are born into stillness and concentration. The rest of us need to be reminded.

It was my parents' divorce that sent me to Catholic school on the other side of the country. My father wanted my sister and me to have a religious education, the kind that he could have provided but now had to entrust to the Sisters of Mercy. They pursued my father's objectives of stillness and concentration without ever having met him, something I found an eerie coincidence until I realized that Catholic schools were all more or less cut from the same cloth—from the one my father attended in Los Angeles in the 1940s to the one I attended in Tennessee in the late 1960s and 1970s. The Sisters swatted and

spanked in the early years of my education but then were moved away from corporal punishment. Someone told them not to hit us and all at once they stopped. But there was still a lesson to be taught, and they were never deterred from their lessons. What I remember most about those early years was that crimes were punished collectively. When some girl had done something wrong, we were all made to leave our work and stand until the perpetrator confessed, and when she did confess she was sent to the chapel alone to pray while the rest of us were to pray for her, if we chose to do so, at our desks. In short, she was not sent to the principal for hiding the gym shoes of another girl in a foolish prank, she was sent to God. The nuns shook their heads grimly, unable to imagine how God would forgive such a thing.

When I was in seventh grade I entered the dreaded science class of Sister Lawrence Mary, the most feared nun in the convent. The rumors of how she had beaten her students in the days before that privilege was revoked were the stuff of legends. By the time I came to her she was old and terrifying, and I had no idea why she ever needed to hit anyone, as the respect she commanded was absolute. Still, it is her punishment that stays with me most clearly: nothing annoyed her more than a student who said "is when," as in, "Photosynthesis is when a plant...." We were to say, "Photosynthesis is the process by which a plant...." "The process by which"—a phrase I still use no matter how stilted it sounds. If one of us slipped up, forgot, Sister Lawrence Mary told us all to stand, stretch our arms straight out to the sides, and contemplate Christ's suffering on the cross. Christ had died for us, in all our stupidity, in all our unworthiness. He could remember every detail of our lives and we couldn't even remember to say, "The process by which." Somehow these two things were connected, and it was hinted that if we could only have remembered to speak properly, then perhaps Christ would not have been nailed to the cross. Even though it had happened two thousand years before our birth, He knew how we would fail Him and so He was forced to die.

It is a simple exercise. Try it sometime. Stand with your arms out to the side and contemplate anything, Christ's death, the poor quality of tomatoes in winter, anything. You won't last long unless Sister Lawrence Mary is there to scare you into compliance. You won't last until you learn how to last, to figure out exactly in what you are being instructed and take the lesson.

The girl in Introduction to Biology, standing with all the other girls who are dressed exactly alike, standing with her arms out to her sides, she is learning to be a writer.

When people tell stories of Catholic school they are either hysterically funny in some off-Broadway play or they are the bitter and furious explanation of why they will never darken the door of the Church of Rome again. My story is something in between. I believe there are many different ways to learn, and I was taught in a complex combination of styles. But learn I did. I know how to sit and think for hours alone in silence, to keep looking at something long after I'm ready to turn my face away. Maybe I would have come to that without the beautiful and painful lessons of my faith. I suppose I will never know.

I am a Catholic. That doesn't mean I follow all the teachings of the church or that many of those teachings don't make me want to hide my face in my hands. That doesn't mean I make it to mass every week. That doesn't mean that I believe anyone else needs to sign up for Catholicism or any religion at all as a way to have a relationship with God. I am simply stating a fact about myself. "I used to be a Catholic," people will say to me. Or, for those who prefer to express themselves through bumper stickers, there is the one that simply says, "Recovering Catholic." For years I said the same thing. I shopped for a religion the way other people looked for houses. Then a man named Robert Tannenbaum, a college professor and former rabbi, set me straight. "Stick with your tribe," he told me. "The religion isn't the point. They're all pretty much the same. Stay with the one that you know and use it to help you look for God." It was simple, logical, and completely accurate advice. I stopped being angry, I reconsidered the past, and I took up with my church again.

I have a theory that in life we are given a set of categories by which to define ourselves: our family, our country, our race, our religion, along with a whole host of other, smaller subsets of identification. Even when they are terrible, our families are very difficult to leave completely. Our race we are stuck with, even when we are persecuted because of it or feel shamed by it. Our country, well, most expatriates come home eventually. I haven't always felt good about being an American—certain wars, certain administrations, certain decisions about spending, have made my stomach turn, but I didn't pack up for France. How can you leave your country? How can you leave who you are? That leaves religion as

the thing we can most comfortably step out of. We can carry around a story of a philandering priest as the answer for our hasty departure. We can disconnect ourselves from our faith when we can't deny some poisonous uncle at a family reunion. I will only say it is a loss because it is important to have groups with whom to stand as a member. I have been to Catholic churches in cities where I didn't know a soul, and countries where I did not speak the language, but I could always follow along, and, by doing so, I could feel that there were some edges in my world. The church does not define my relationship with God, but it taught me how to believe. It taught me to be faithful to God, to be loyal. And I am. I only expanded the lesson, so that I am faithful to myself as well, to the people I love, and to my work. Without faith, I would never be able to find the end of the story.

DAVID PLANTE

Returning to Providence [essay]

OVER HALF MY LIFE had been lived in Europe, but I felt that, however far from my parish in Providence, Rhode Island, I got, I was still within hearing distance of its church bell. Sometimes, in a foreign city, it seemed to me I did hear that bell, especially as it sounded on a Saturday evening for vespers, and I would be filled with a sudden, deep grief. But grief for what, I had no idea.

On a visit to New York, where I stayed with a close friend, I thought, falling asleep one night, of a dream that I had had often when I lived in the house in my parish: that of being inside the house, terrified that the door was locked and I, pulling at the knob, couldn't get away from what was inside, and, simultaneously, that the door couldn't be locked and I, pressing my body against it, wasn't able to stop what was outside from coming in.

Now that I was in New York, my parish was just a few hours' ride along the southern New England coast.

I telephoned Mary Gordon, whom I wanted very much to see, and she told me to come to her right away, as if there were urgency in our seeing one another.

I no longer believed in God, but if I'd said to anyone, "I'm grieving because I do not believe in God," the expected retort would have been: "You are using that as an excuse for some deep, deep, deep, self-regarding, self-indulgent, even self-aggrandizing helplessness in yourself that you *must*, if you expect anyone to accept you as sincere, get out of. Your grief at the impossibility of being with God in eternity is, really, nothing but the longing to be helpless, and therefore blameless. You know that God, who alone could justify you in your longing to be blameless, does not exist and *cannot* justify any longing, least of all the longing to be with Him blamelessly in eternity. You *must* look into yourself for the real reason for such an impossible longing. Your 'spiritual' crisis is, and can only be, a 'neurotic' crisis, because it has

only to do with you." And my only consolation against such a retort would have been my own retort: "But all 'spiritual' crises are, for *everyone* who has had a spiritual crisis, nothing more than 'neurotic' crises." This would be a consolation because it would at least raise me out of myself enough to see myself among an accused number of people, and not alone.

Mary, however much I felt she above all had the right to because she knew me so well, would never reduce my "spiritual" crisis to a "neurotic" crisis. Mary believed in therapy, had had it herself and said it had helped her, and she even suggested it to me to help me, but Mary believed also that if a person *was* suffering "neurotically," which *was* to suffer, that person *could* be helped "spiritually" out of his or her suffering. Mary believed in impersonal, universal suffering beyond personal suffering which was, and had to be, spiritual suffering, and which *all* suffering could lead to, and which did not make you feel you were alone.

But when I went to see Mary in her apartment near Columbia University, I didn't want to talk about anything "spiritual." It seemed to be a banal subject, one we would give too much importance to by talking about it, an importance that embarrassed me. Sometimes Mary herself embarrassed me when she used, however matter-of-factly, words like "moral" and "immoral." She embarrassed me when she asked such questions as, "Do you think Henry James was a *good* man?" Also, I, who never felt I had the right to make judgements, was a little intimidated by Mary's, which she felt she had every right to make: some people were "good" and others were "evil."

We talked about writing.

I told Mary that all I had been writing was one image a page, all remembered from my parish, so I had over five hundred pages of one phrase images, such as:

A plastic statue of the Virgin Mother and a pot of plastic flowers on a refrigerator—

I tried to explain to Mary what I was hoping images would do if they were vivid enough—that is, create a world in themselves, beyond what *I* could intend them to create.

She said, "You believe in images."

After a moment of wondering, I said, "Yes, yes, I do."

I embraced and kissed Mary and left her.

On my way back to my friend's apartment, I asked myself, Did I believe in images? No, no, no, I answered myself.

But wasn't I at moments of writing images overwhelmed in such a way that I had no choice but to believe in them? Sometimes, yes, I felt overwhelmed, but I didn't know by what. And then it occurred to me, as though it were the strange realization of my deepest longing, that what the images, which seemed to come from some darkness all outside me, most overwhelmed me with was grief—grief in no way for myself, but for those images.

Why grief?

I wanted to see Mary again soon, and not only because I loved Mary. I did see her again soon. She asked me to her place for dinner with her family and close friends, those people who belonged to the moral city within the immoral. Among them was her close friend, the Jesuit priest Gary Seibert.

Gary, good looking and spirited, was wearing an open-collared shirt and a pullover. His church was Holy Cross on West Forty-second Street, and his congregation consisted in large part of theater people and the homeless. He would, the next day, which was Ash Wednesday, hold morning, afternoon, and evening services for those who wanted to receive ashes.

Mary said to me, "Why don't you come with me?"

If it were for communion, I said, I couldn't, because I'd be presuming on my immortality and committing a sacrilege. But I wouldn't feel that by receiving ashes and being reminded of my mortality I'd be committing a sacrilege.

"So you'll come?"

"Tell me once more where the church is," I said.

Before I left, Mary said, "Look, I don't want to force you to come, though I think I *should* force you. I'll be in the church at three o'clock, and if you come, fine, and if not, fine."

The next morning, out in the streets of the city going from one appointment to another—because, as I was in New York, I thought I must *try* to be professional as a writer—I often saw on the foreheads of people I passed along the crowded sidewalks the crude cross of black ash. People who, from the point of view of their native identities, were so different their differences implied separate worlds, were for this one day visibly marked as all belonging to the same world. I passed a small,

wrinkled Asian woman with a great black cross from the bridge of her nose to her hairline, from one side of her forehead to the other, and as I looked at her she glanced at me then quickly away. I knew something essential about her that she didn't know about me.

I returned to my friend's apartment. When the time came for me to go to Holy Cross church to meet Mary, I thought I wouldn't go, and yet I thought I would go. The contradictory feelings I had were just like the feelings roused in me by that recurring dream of simultaneously being in a house unable to open the door to get away from what threatened me inside and unable to lock the door against what threatened me from outside. In the apartment where I was staying, I delayed leaving without directly intending to, delayed until I'd be too late, but, at the same time, whatever I did to delay I did so quickly—telephone calls, lunch on my own from the refrigerator, notes in my diary. I found I had plenty of time.

I had enough time to walk across town to the West Side along Forty-second Street, past the shops that had been, when I'd last been in New York, porn shops, now all with corrugated metal sheets painted pink, green, and blue pulled down over their fronts and locked with shining steel locks, to the Port Authority Building, where out of state buses were entering and leaving and where the homeless gathered. Holy Cross church was just across Forty-second Street from the side entrance of the Port Authority.

I was, in fact, early. A few people were in the pews—each one of them, again, of a different identity, or so it seemed to me—but Mary wasn't among them. Without genuflecting or making the sign of the cross or kneeling first to pray, I sat in a pew half way down. I was among people who, kneeling or sitting, were deeply silent and still, so there was a great silence and stillness in the church, and I, in that silence and stillness, went into what I can only call a trance.

I was deep in that trance when Mary sat beside me. She didn't appear surprised to see me, though I was surprised to see her only because everything surprised me. And yet Mary's presence beside me was exactly as expected.

Gary and another priest, the actual pastor, came out from the vestry, both in green chasubles with yellow crosses, and while Gary sat, the pastor, a large man who looked as though he had at one time been a heavyweight boxer, talked to the congregation. He talked about why

people should come to church: if for nothing else, to be near one another bodily, to be aware of one another, and, during Mass, to wish one another peace. I listened with an attention I had never before in my life given to a sermon. What the pastor said sounded so reasonable to me, but, then, my trance made everything seem both reasonable and at the same time surprising—made, maybe, reason itself surprising. It was entirely reasonable, enlightened even, that people should gather together and wish one another peace, and yet it was an extraordinary idea that I seemed never to have heard expressed before.

The two priests stood side by side before the altar and people formed lines in the main aisle to receive ash on their foreheads. I followed Mary out of the pew and with her joined the line leading to Gary. As we advanced toward him, I felt both very far from and very near to everything happening, and the closer I got to Gary the further away I felt I became and also the nearer, so I was seeing the whole interior of the church from a vast distance, seeing the stitching of the hem of the chasuble Gary wore, seeing his hands, seeing the little silver boat of ashes in his hands. Mary received ashes before me and turned away, and Gary, smiling, embraced me before marking my forehead with the cross of black ash. I followed Mary down a side aisle and directly out of the church into the street.

I couldn't speak. I told myself that of course I could speak, of course, but what stopped me was that I had nothing to say. Mary didn't speak, but took my arm and we walked toward Eighth Avenue.

She asked me, "Why don't you give in?"

I must have had an answer for not giving in, but I couldn't think of it.

"Why don't you?"

My mouth open, I wasn't able to get my breath. Mary held my arm more tightly in hers. As we crossed Eighth Avenue, a car sped close by her, and Mary shouted at the driver, "Fucker," then, turning back to me, said, "It's just that Canuck stubbornness that won't let you give in."

On the other side of the Avenue, trying to catch my breath, all I could say was, "This only happens when I'm with you."

"Then what I'm saying means something to you that you insist on denying, but that won't be denied."

I stopped her, and, suddenly a little angry because she was pressing me and I had had enough of being pressed, I said in as assertive a voice

as I could manage, "Mary, I *do not* believe in God. All I believe is this: *There is no salvation for us, there is no life after death for us, there is no eternity for us. God does not exist.*"

Mary reacted to my anger with argumentative insistence. "This world exists," she said, "and we've got to have a reason for going on living in it all together without destroying it."

I didn't answer, but we resumed walking to Seventh Avenue, where we waited on the corner for the light to change.

I said, with my own argumentative insistence, "It's impossible to give in to something that doesn't exist."

But Mary insisted even more on her argument. "No," she said. "What you long for exists in the very longing for it. If you believe in images the way you do, you believe in God."

Mary could always stop me with her arguments.

I said, "I can't believe we're having this conversation here in New York City."

She said, "It's just because we are here in New York City that we're having this conversation."

We crossed and she left me to go down into the subway station, and I continued to walk across town, now marked with the cross of my religion, which, however, was not my religion, but which everyone passing would have assumed to be mine. When I passed someone marked as I was, our eyes very briefly met in recognition of one another, though what the passerby recognized on me had really nothing to do with me, because, though marked as a believer, I would have had to say, if approached by someone who spoke to me as one, that I wasn't.

I kept telling myself, the images I write have nothing to do with belief in God.

Maybe because so many people saw me as an introspective person, a person who was impelled to act much more in terms of feelings that made him look inwardly than that made him look outwardly, a person who was altogether more subjective than objective, I had assumed the same about myself. But, more than ever before, I realized that this wasn't at all true of me. I wasn't a person who would find faith, or even love, or even the inspiration to write, from a depth within my subjective self, which I wanted in fact to leave behind me by dying to myself, but was instead a person who needed confirmation of faith and love and the inspiration to write from outside me, from a depth

as objective as all the outer space that surrounds the world. No belief, ever, that came from within myself would convince me of the existence of God. To believe in God, I would have to be convinced by a force as positively outside me as a bright light flashing through the darkness of all that space. Mary didn't understand about me, and I only now really understood: I expected to be made to believe, not by giving in to my feelings, but by being taken out of my feelings into something entirely other than my feelings. That was my deepest longing. That was the longing that most made me the Catholic I was.

And I rejected, right away, any imputation that I was only committing the sin of pride in such an expectation, the sin of assuming I was worthy of such attention by an omnipotent force, that I would be taken out of myself and brought elsewhere by that force, the sin of assuming I counted.

It wasn't pride that made me think that if I were to be a believer, God, as I expected God to do, would have to come down and overwhelm me totally, so I would be knocked to the ground, unable to rise unless God helped me. It wasn't pride because I knew God would not do it. God had never, even in my youthful years of great devotion when I went to early Mass every morning before going to school, come down, and all I could honestly say I believed was that God would never come down.

Mary woke me the next morning by telephone to say she'd decided we were going to drive up to Providence to visit my parish. I may not have wanted to see it, but she did.

I said, "I'm sure my parish doesn't exist any more."

"Then you should see that," she answered.

I realized how much Mary tolerated in me, which I, when I was aware of it, found intolerant in myself: not that Canuck stubbornness, but, on the contrary, that Canuck will-lessness, that deepest Canuck longing to give in to what was beyond will. My mother had all her life tried, and failed, to save herself from that longing. What Mary was doing was to make me at least try to use my will, and she was right to do this, as right as my mother had been to try to use her will, even if she had failed.

I met Mary at her apartment early in the morning a few days later, and she drove us out of Manhattan along the West Side Highway, past great, craggy ledges of stone on the side of the highway from the cracks of which winter-bare trees grew. Those ledges gave me a disorienting

sense of suddenly being far from the city. There was little traffic; the highway seemed abandoned, littered with broken branches.

Mary drove along the Connecticut coast, from where the Atlantic Ocean was dark grey, and into southern Rhode Island and through low scrub woods, where a war between a native tribe and colonists had been fought, and which the colonists won. We crossed overpasses into the city of Providence.

I got lost guiding her out of downtown Providence onto Atwells Avenue that led up Federal Hill, where there was so large an Italian parish the traffic line down the middle of the avenue was red, white, and green. We rose up the hill through the Irish parish, through the Polish parish, all with brick churches with rosette windows, which I told Mary I used to visit during Holy Week when, on a certain day I couldn't remember, you received a plenary indulgence—meaning you were completely cleared of sin and any punishment in purgatory due to sin—if you said a certain prayer in seven different churches. Mary knew the day—Good Friday—and was able to recite the prayer. We drove up past bare maple trees along either side of the highway, clapboard tenement houses with snow drifts still unmelted in the yards between them, bars on corners with wide but blackened windows in which little neon signs flashed: BUD. And we came to the French parish, Notre Dame de Lourdes, brick with a rosette window, as opaque as if covered by a huge cataract.

Mary wanted to see, first, the house where I was born and brought up. Again, I lost my way, now among the narrow streets that were so familiar and so strange, and, impatient to go on and also frightened and wanting to pull back, I told her to turn at corners without knowing where they would lead. It was exactly as though I was dreaming, and in my dream I began to tremble. We rose over the crest of a hill and started down the other side, and I, still disoriented, saw the white clapboard bungalow on a corner. I shouted, "There it is." Mary parked the car in front of the house. I was trembling more with fear, and if it hadn't been for Mary I would not have gotten out of the car. If it hadn't been for Mary, I wouldn't have been there. I looked at the front porch, the glass storm door and the wooden door behind it, the porch lamp of a hanging lantern with yellow glass, the black numbers 128 over the door. I began to shake. Mary was the first to get out of the car. I got out.

The house looked dilapidated, as it had looked, I recalled, when it had been sold to a Franco couple after the deaths of my parents. The floorboards of the porch were rotting, the shingles of the roof were curling about the edges, and the maple trees that had spread their branches over it had been cut down to stumps.

Looking around at the other houses of the neighborhood, Mary said that she'd been brought up in a very similar place.

Suddenly, I felt that I no longer had anything to do with this house, I never had. I couldn't imagine living in it, couldn't imagine my parents living in it. It was not a haunted house.

As Mary and I left, I thought, I'll never come back here again.

We stopped at the church, which was locked. Mary suggested we come back in the morning for Mass, and I wanted to say, Never mind, it doesn't matter, but I said yes. And we went downtown again to book into a Holiday Inn—a hotel, Mary said, suitable to our class. We had dinner in an Italian restaurant on Federal Hill.

"For all my fantasies when I was growing up in Providence," I said, "never, never would I have fantasized about having dinner here with a fellow writer. My fantasies about being a writer were all based somewhere far, far outside Providence."

Before we went to our rooms for the night, Mary and I went to the pool, and there, alone, floating about each other in the illuminated lapping water, we talked quietly and intimately about our childhoods. And as we talked I became aware, in the closeness of Mary's full body, of a sadness I always felt with her. It was not, I thought, the sadness of our sexual incompatibility, but, instead, of our supra-sexual compatibility.

Mary woke me at six o'clock to go to my parish church for early Mass. She had found out about the hour. The parish seemed deserted, and we parked on a side street where there were no other cars. As we approached the church, I noticed a hole in a stained glass window at the side, made as if by a stone thrown through it. I expected the door to be still locked when Mary pulled at the handle, but it did open and we went into the foyer, where the linoleum tiles on the floor, brown and green, struck me with the force of years and years of fear. I was terrified of entering that church. There was the rounded marble holy water font and the glass in the double doors, each door with a

translucent purple cross, and, beyond the doors, the main aisle of brown and green tiles into the nave.

Mass had started. A priest I didn't recognize was at the altar, facing the congregation of about five people. Mary went right up to the first pew and I followed her in.

I remembered the long kneeler along the pew on which I knelt with Mary. She went to receive communion while I remained kneeling, my face in my hands. I went on kneeling, my face in my hands, when Mary returned, and I went on in that position until the end of the Mass.

I wanted to leave, but Mary said, "We're going into the vestry." I had never been into the vestry. As devout as I'd been, I'd never been an altar boy, and had never viewed Monsieur le Curé as a man I could have visited in the vestry after Mass. I had never spoken to him outside of confession. I would have been as incapable of opening the door to the vestry, as Mary did matter-of-factly, as I would have the tabernacle on the altar. Mary went in first. The priest, already unvested, was putting on a yellow baseball jacket over his black shirt and clerical collar. He seemed to have expected us, and said, "Come on in." Father was grey-haired and almost immediately said he was going to retire soon.

I didn't remember him, but when I gave him my name he said he'd buried my father and mother, and that was all he had to say about them.

Mary, who talked to him familiarly, asked him more about his retirement.

Then he said he had to go, a baseball team of kids he coached was expecting him. "Stay and look around the church," he said. And when Mary asked him where she could get a couple of candles, he said, pointing to a brown cardboard box on a counter, "Help yourself." He left.

I watched Mary take two large votive candles from the box. She said, "Let's go light these." We went, she carrying the candles, into the nave of the church again. Dim grey light was showing through the windows on the left side, and the church was chilly. We went up this side and up a little flight of circular wooden stairs into the organ loft where the organ was very dusty, then down and into the foyer and into the little space to the side of the foyer where the baptismal font was, and beside the font lay a pile of cardboard boxes as in a storeroom. Back in the nave, we went down the side aisle on the right side, the

side where there was a window with a hole in it, reading, below each window, the names of the French parishioners in black Gothic script who had donated money for them. The brown and green floor tiles were cracked and some unglued. Mary still carried the candles, looking for a place to light them.

Mary said, "This church looks like the butt end of something."

"Yes," I said.

In a niche was a life-sized statue of the Virgin Mother with large, sad eyes before which, I told Mary, I had as a boy coming into puberty fervently prayed for purity, and sometimes I'd been sure the Virgin Mother's eyes had filled with tears.

"We'll light our candles here," Mary said.

"No, no," I said, "not here."

"Why?" Mary asked.

"Because I'm not pure."

Mary held the candles out.

I looked round at both side altars and said, "In front of the crucified Christ."

Mary lit her candle from the only one burning in the stand, and I lit mine from hers. She knelt to pray and I stood behind her, looking at Christ's white body hanging on the black cross, blood running from his thorn-entangled head, from his nailed hands and feet, from the lance wound in his side, from his scourged flesh.

I looked away, and, staring into space as I had often seen my father stare into space, I thought that the God of my ancestors—ancestors who from generation to generation had lived through the stark facts that the doctor would not arrive in the snow storm in time to save the dying mother, that the crop would fail, the bank foreclose—this God was the God of the greatest grief, which was the greatest grief of His own helplessness toward us, the greatest grief of His not being able to help us. His greatest grief was His greatest desire to help us, but all He could do for us was to purify us in His grief. In His grief we were forgiven. In His grief was our tenderness, our gentleness. In His grief was our love for Him, and in our love for Him was our love for one another.

RICHARD RODRIGUEZ

Atheism Is Wasted [essay]
on the Nonbeliever

ATHEISM IS WASTED on the nonbeliever.
That thought occurred to me recently as I watched
Christopher Hitchens push his book, *God Is Not Great*, on a
cable television show hosted by Bill Maher. Mr. Hitchens proposed to
Mr. Maher that the human race would be better off trusting science
instead of religion. Mr. Maher agreed. Neither Mr. Hitchens nor Mr.
Maher mentioned Hiroshima—or that the problem with religion or
science might be the human race.

I remember, some years back, writing about Christopher Hitchens
on the occasion of his sleazy exposé of Mother Teresa, *The Missionary
Position*. Mr. Hitchens revealed that the woman popularly regarded
as a saint had extended her begging bowl under the noses of corrupt
men and women; she laundered money to serve the unwashed.

I had always assumed saints are tainted, as most of us are tainted.
Graham Greene taught me that holiness must dwell in a tarnished
temple. (There is no other kind.)

I do not, in any case, need this latest book by Mr. Hitchens, or any
of the books by the other best-selling "New Atheists," to persuade me
to disbelief. Atheism seems to me a deeply persuasive response to the
night. But then again, faith seems to me a deeply persuasive response
to the night.

A few days after Mr. Hitchens conferred with Mr. Maher, the
Democratic Party presidential front-runners took turns professing
religious belief. (Democrats are unwilling to cede heaven to the
Republicans and their politically active supporters in the Protestant
right.) The curtain of secular discretion that has made religion nobody's
business in America was cast aside for political advantage.

Listening to Hillary Clinton describe her faith in Jesus Christ from
a political dais was a disheartening experience. There was not a hint
of spontaneity in her confession. Doubtless, her every adjective had
been tested by handlers.

In American lore, the village atheist is an eccentric soul at odds with conventional propriety. But in truth, atheism has governed American intellectual life for most of the twentieth century. Atheism has long been the orthodoxy of the university faculty club, the New York journals, and most fiction. (For every Flannery O'Connor I can name ten Mary McCarthys.)

Now, thanks in no small part to the political ambitions of low-church Protestants and to the deceptively distant cry of the muezzin, religion looms, as never before, over American public life.

Americans who have never known religious war now routinely hear U.S. armed forces in Iraq and Afghanistan identified as "crusaders" by angry Muslims. And as Islam gathers force in Europe, American Protestants gather equal public confidence in Colorado Springs and Washington, DC.

It occurred last year to some faculty members at Harvard that the overwhelming importance of theism throughout the shrinking world might suggest that a religion course be required of their undergraduates. The atheists on the faculty quickly disapproved, and the proposal was tabled at a faculty senate meeting. In the name Veritas.

I am enough of an atheist to be horrified by examples of religious extremism on the evening news from the Middle East: honor killings, Shi'a murdering Sunni today in revenge for yesterday's Sunni murder of Shi'a, exploding mosques, Moqtada al Sadr addressing his piratical band at Friday prayers, and on and on.

Any Christian—Orthodox, Protestant, Catholic, especially Catholic—should be embarrassed, in the face of Islamic extremism, by the memory of the violence within our own history: the holy wars, the torture and murder of the heretic, the attack on the Jew, the Muslim, and the pagan—all in the name of a loving God.

What is that line of Anne Sexton's? *God is only mocked by believers.*

The great temptation for the believer, it seems to me, is not atheism; it is the arrogance of claiming to know God's will. It is therefore with some measure of irony and necessary caution that I say I believe in God.

I believe in Jesus Christ, the Christ who was a loser in human history—destroyed by this world—whose life reveals in its generosity and tragedy the most complete and challenging version of theism I

know. What the New Atheists do not comprehend is that the crucifix cannot be mocked. It is itself mockery.

As a Christian, I worship the same God as the Jew and the Muslim, a revealed God. I share with the atheist and the agnostic a sense of a God who is hidden. (I say hidden; an atheist would say never there in the first place.)

And more: I believe the monotheistic religions would be healthier, less inclined to extremism and violence, if those of us who profess belief in God were able also to admit our disbelief.

It seems to me not inappropriate that I take my inner atheist with me to church every Sunday. The atheist within me is as noisy as my stomach, even when I am standing in the communion line. But never is the atheist within me so quarrelsome as during the homily.

While I am blessed by belonging to a welcoming and consoling parish community, I have not heard from the pulpit what I desperately needed to hear in the aftermath of September 11, 2001—the implication for faith posed by terrorists who prayed to Allah even as they aimed Boeing jets into the World Trade Center.

The sound of the chanting within those planes has haunted my prayers, overwhelmed my own prayers like an engine's roar.

This is my prayer: *Dear God, I believe in you. Please strengthen my disbelief.*

PATTIANN ROGERS

Born, Again and Again [essay]

I GREW UP NEAR a small river in southwest Missouri, really a
large creek, an easily navigable waterway with a calm current, deep
in places, in others flowing with low white ruffles over rocky shoals.
I went to this river often, as if to a favorite relative, to see what was
happening, wading and swimming sometimes, watching the creatures
of the bank shallows and shore sedges, a buzzard or two slowly spiraling
the sky, finches and sparrows prattling in the mat of wild brambles.
The fragrances of spring blackberry and sassafras, the spicy scent of
summer grasses, the musty cold of damp, autumn leaves, hickories,
walnuts, oaks rooting in the river's domain—I found them all.

One summer afternoon I went to this river with my parents and
brother and another family. Together we were an ecclesia, as they
called it, a word from the fundamentalist religion my parents had
just joined. I went to the river this time for a baptism by immersion.
Mine. I was thirteen. Words would be said. Transformations would
take place, I was told. What would the river be then, I wondered, a
participant in a religious ritual? Every religious ritual I had ever known
had been performed inside a church sanctuary, out of the wind, away
from the sunlight and commotion always present under an open sky,
in a subdued church sanctuary enclosed by stained glass, lined with
heavy wooden pews, the soldier-like brass pipes of an imposing organ
standing at attention at one end, a choir in black robes, the minister
in velvet. Baptism in my former church had meant a red rose dipped
in water and held to an infant's head.

Beside the river on this day, they told me my sins would be washed
away. I would be cleansed of all the sins of my thirteen years alive
in Missouri and be born anew. I didn't doubt it, whatever my sins
were. I already knew the river's chants and spells. I knew, without
knowing I knew, that the river had something elemental to do with
beat and blood, their risings and ceasings, everything to do with the
transformations that happen when earth and sun and water come
together, what emerges from that union breathing, grasping, seeking

and scrambling, suckling and nesting, what cacophony of webs, tones, carols, and spans sustain themselves within that union.

Inside the aura of ceremony, I walked into the river, meeting it as always, feeling the cool shore water on my feet, scattering a swirl of river-colored minnows, passing the black beads of a tadpole pod in the reeds, the circling of two water striders, down into the river's moving presence, its flow stronger, colder, unrelenting, knocking a stick against my knee, wrapping a broken weed at my ankle. A knot of fishing line snagged on a small branch drifted by. I don't remember the words said as I balanced against the current, but I went down over my head into the river's swath and taste, its muffled silence, through the dim, broken light of underwater sun, feeling the muddy leaves and slippery stones of its base, a living fish bumping my shoulder, the river sliding against my face, through my hair, far beneath birds winging above faster than the current, down into the force and time of the river's body.

And when I came up again and gasped the rash blaze and explosion of summer, I believed wholeheartedly in river belief. The river was here, tangible, soothing and biting, cresting and waning, not a gift but an ongoing giving and re-giving. The river, with all the being it spawned, was acting. *River* was a verb, not a noun. *Bank swallow, blue butterfly, bumblebee, bittersweet* were not things but soaring and alighting, bearing and consuming. *Wild grape* meant twining and persisting, *dogwood* reaching, blossoming, seeding, withdrawing, *perch* and *carp* and *catfish* pulsing, holding, enduring. The river was being—swift, assertive, foresworn—moment by moment by moment. And I knew I was joined in that same being and supreme in the being of believing, moment by moment by moment.

Later that afternoon we ate beside the river. We made a small fire on the gravel bar, just large enough to recall again the frenetic art of fiery vigor and brilliance, the art of woodsmoke climb and fragrance. The river and our place beside it took on the colors of evening. And the crickets with their glass castanets, the frogs hidden near the water with their long bass strums and trilling trebles, struck up their defiant sounds of declaration, once the low melodic call of an owl. The dim fire-points of the stars and the blinking fire-points of the lightning bugs in the heavy bank bushes transfigured the shore, the sky, the night. As the river grew darker, I could hear more distinctly the slow lap and

easy slap of its moving waters. We gathered up then and started back, walking single file with flashlights along the narrow path.

I never regarded the river as a god. I would never have tangled it up in the vagaries of that word. Today, I remember, and I want to define *God* as unfolding, engendering, keeping, yielding. I want to imagine God, not static as the river is not static, as mountains are not static, as the stars are not static, as life is not static, but God as mighty, empowering, urging, infusing, coming, and continually pressing against oblivion.

All the earth is engaged in this being. Every living entity—from the eelpout on the bottom of the Arctic Ocean to the bar-headed goose flying over Mount Everest to the golden, orb weaving spider of the mangroves to the giant forest hog of the Congo to the bent and twisted bristlecone pine in the ice of the Rockies to the beds of fluffgrass on the barren Mojave—every living entity is testifying to this and agreeing with me.

NICHOLAS SAMARAS

Alone Together in Church

This must be in the present
tense, because it's the blue
moment I live in forever.

This must be in the present
tense, because our theology
says we go on changed utterly

but still ourselves, the one thing
I hold onto because we are atoms
of each other, because we are defined

by each other eternally and nothing
has happened to change that.
This solitude together is merely

after all have gone from the wake.
After the fickle friends and the genuine
strangers have gone, after the priest

has left, letting me lock up later,
I alone remain with you, attentive
in vigil—ever by your side.

How solitude magnifies.
I look around the stillness for us,
the empty nave in which I hold

your still-warm folded hands.
The altar's flickering votive candle
casts its garnet prism over your sleeping face,

the magnificence of your patriarchal beard.
Father, because you are transfigured,
I am transfigured against my will.

Because it is so quiet, I hold you
in focused belief. Flesh and spirit.
Because we are father and son before God,

and this is our present forever,
I continue us in light and shadow. I lean
into you and kiss the communion of your lips.

VALERIE SAYERS

A Freak of Nature [fiction]

THE FIFTIES. I don't remember much—I was a small child—but I do know that fear was always buzzing in the background, like static from a transistor radio: a jangly, jazzy fear, not altogether unhappy.

The day I discover I'm a freak of nature, the thrill runs from my bellybutton to my throat. We've come to see Dr. Freitag about the mysteries in my mouth, and he's found two whole sets of teeth up there in my top gums waiting to claim the space when my baby teeth fall out. TWO ROWS OF TEETH. The current jolts me, sitting there in his big red leather chair, a princess on my throne. Not everybody gets a spare set of teeth.

But my mother squints and blinks at the x-ray film, and when she finally makes out all my extra teeth, she moans, "Oh my God," the way she did when she heard that Sister Alma's boils were cancer of the face. That's when I understand that I'm a monster. That's when I see how I'll have to curl my lip, how the prissy girls on the playground will lift up their pink chiffon skirts and shriek at me.

Dr. Freitag says we must go to Charleston. For special shoes and my father's assistant principal suit we go to Savannah. For special doctors, like when my mother almost lost the baby again, we go to Charleston.

"It couldn't be polio-related, could it, Herb?"

Dr. Freitag rubs his big belly and cackles. Out in the colored waiting room, his parrot Lucinda lets out a cackle, too. "Doris, you take the cake, and I mean the twelve-layer cake. Sweetheart, you just nervous about this baby, all the trouble you've had. Fanny, don't pay her any mind."

"Don't you tell Fanny not to pay me any mind."

"Y'all excuse me. I've got to go turn the x-rays off."

When he's halfway out the door my mother rubs her own belly. "The way he forgets that machine we'll all be dead of radiation time

we're forty anyways." She's raised her voice and I'm already dead, from the shame of having a mother who says what she thinks. *Don't say Jewish, don't say Jewish, don't let her say Jewish,* I pray, though I'm not exactly sure what Jewish means. My mother wouldn't even know it if she broke Dr. Freitag's heart.

Those times were a lot like these times: the way paranoia travels the airwaves, the way we're all so afraid. I can see clear as that bright summer day in 1958 the way I flee Herb Freitag's office and run for my life through the alley and down to the docks. Every few feet I peer over my shoulder to see how much ground my mother, in hot pursuit, is losing. Our feet pound out a desperate rhythm on the old rotting boards, the bay sloshing beneath us, and every time we come to a knothole we miss a beat. She could trip and lose the hat she holds to her head, or even the baby. I take pity on her and let her catch me, though my father says I run like the devil and if I wanted to I could be over the bridge and onto the islands by now. My mother leans over, precarious, and the fake ostrich feather quivers atop her head as she stretches to deliver that hard slap to my thigh (at home she uses the hairbrush, and not on my thigh). To spite her, I don't even flinch.

But then she's the one who takes pity. She tells me I won't go through life with two sets of teeth. They'll give me an operation, or operations, and it'll be scary—no, she's not going to deny that, because so many children catch pneumonia after the anesthesia. But we'll all say a rosary before I go under, and that should make it come out right. We'll be brave no matter what happens. "Oh Fanny, it's good training, sugar, because I mean to tell you it's scary going under the gas when you have babies, too. I'll be there behind you, little pixie. Little changeling girl. We can't have you with two rows of teeth and those cowlicks, too!"

Do you suppose you can possibly remember something as clean and as whole as I think I remember screeching to a halt on the docks that day? I couldn't stand it when she called me *changeling.* I used to chant *I hate you, I hate you, I hate you,* though it never occurred to my sisters to say such a thing. She pulled down our panties and used the back of the brush, only she was never going to do that to

me again. I incited my brothers to riot. I was her match, and we
both knew it.

"It couldn't be polio-related, could it?" I ask my father. I'm still
such a freak I'm allowed to sit up front between my parents the whole
way to Charleston. My mother likes it when I rest my hand on her big
belly, and I like that too, better than anything except maybe resting
my head there to hear the swoops and the gurgles, which might be
gas and might be the next one, a boy or a girl I cannot say. In the
middle seat AgnesAnn and Teresa have Caroline between them. Willie
and Martin are all the way back, covered with filth already, and every
five minutes one of them says, "I'm suffocating, I'm dying, help me,
I can't bweathe."

"Girls! You cannot keep the windows rolled tight when it's ninety-
two degrees outside. You cannot."

"My hair," AgnesAnn shrieks.

"You have to compromise," my father says, "and roll them down
halfway."

Will moans that he's going to throw up.

"Stop melodramatizing," my father calls to the back of the station
wagon, and we all count the syllables. My father speaks that way all the
time, even on the baseball field, where he's apt to bark out, *Maintain
your equilibrium, men.* To me he says: "No, Fan, it's nothing to do
with polio. It's a genetic anomaly."

Anomaly sounds like a dread disease, a sickness of the blood. My
frantic mother often calms me down, but my calm father makes me
think I'm dying after all.

"It's no big deal, is what that means. Where do you want to go after
we see the specialist? You're the patient. Pick three spots."

"Only one of them has to be Harvey's," my mother says. Harvey's
is the restaurant where my parents can get a martini, which my father
says is illegal like everything else in the godforsaken state of South
Carolina. I could go to jail and never get rid of my freakish teeth, but
my father reads my mind and says, "Don't worry, the mayor drinks
there, too. And the sheriff."

"Okay, Harvey's. And the slave market. And the Battery." I pat my
father's thigh under the steering wheel. He hands me his smoldering

cigarette to rub out, which is almost as good as listening to my mother's belly.

When I raise my head from the ashtray, the sun blazes off the yellowing marsh, the air prickles with road dust, the whole world waits to explode. Up ahead we'll pass between two rows of live oaks, the moss swishing down, a canopy of shade. *Hurry, hurry.* Soon we'll drive over the bridge with the little stone chambers where the fairies hide till nighttime, and then we'll be in Charleston. *Hurry, hurry.* My father reads my mind again and speeds up till we're under black cloud-cover. The world darkens. AgnesAnn and Teresa roll down their windows a little way, and hot wind comes rushing in.

The surgeon doesn't have nearly so much time to talk as Dr. Freitag, and there's no parrot in his waiting room, just Martin and Will raising holy hell. He makes a face at the sounds coming from his outer office and says I'll have *surgeries,* not *surgery,* a childhood of waiting for the monster teeth to ease down low enough to pluck, then a new battle plan after we see how the survivors drop in.

My mother says it will be like childbirth: I won't remember what it's like. If you did remember, you wouldn't show up the next time and then the poor babies would never get born. Already I think of my extra teeth as babies that are going to get dropped into the incinerator the way my mother's last baby did, their bloody roots sizzling in the flames, next to little charred baby fists.

But that first day I get no gas and no flames, just my parents white-faced in the bright sun when, after the surgeon's, they take us to the Battery so Martin and Will can clamber onto the cannons and fire on Fort Sumter. I'm supposed to be clambering too, only I hang behind with Teresa and AgnesAnn, shamed, and we overhear my mother moaning:

"We'll never get out from under now."

"Don't worry, Fanny," Teresa says. "You can't go through life with two sets of teeth! We'll find the money somehow." Teresa is the sacrificial one who always says she doesn't need any new clothes or shoes or second helpings. I look at her mournful, encouraging face and take off, darting between park benches till my father, this time, catches me.

"Where do you think you're going?"

I won't look at him. I won't, I won't.

He has to bend to take my hand. I'm so short and so skinny that they're always saying I could blow away—and I did once, during a little tornado nobody saw but my mother, a *baby funnel cloud,* a whirligig that swirled me up in our backyard till my mother at the clothesline pulled me back down to earth. Now my father hangs onto me.

The whole family has to go without clothes and shoes and second helpings just so I'll be normal, but I'm never going to grow anyway so why don't I just join the sideshow the next time the fair comes, when the greasy man with no teeth at all stands outside the sagging tent, beckoning? My father says you call them carnies, and don't get too close. Don't peek inside. It would break your heart.

I drop my father's hand and dash off to climb aboard a big cannon. The clouds over the bay gather in my honor, sulky and mean. A storm brews over Fort Sumter: the wind swoops, the palmettos rustle, the hairs on my arms rise up, defiant. I spread my legs wide so I can blast away.

At the slave market my mother takes wet diapers wrapped in waxed paper out from her giant pocketbook and scrubs Will's and Martin's faces and hands till they holler. Then she makes AgnesAnn do their knees. She can't bend anymore. My father lines us up, scrubbed, for the slave lecture.

"Remember, these were human beings, wrenched from family and forced to do whatever the plantation owners wanted them to."

"But Pat, don't forget, lots of times the owners tried their best to keep the families together—"

"They were ruled by the whip."

"In fact, the whip was very rare in South Carolina, very rare. Slaves were like *family,* and the climate was just like Africa."

My father glowers. "The idea that you could own another human being." He shakes his head, and we six shake our heads and hang them down, ashamed, ashamed, deliciously ashamed and so relieved we were not born colored because if we were colored we would think about whips and shackles day and night.

Now we are allowed to walk through. It's an open air market, with a roof above: I'm trying to get it right. Was the roof tin? I see straw but that, I think, is from some fairytale. Brick pillars, or wood? Wood, surely. These days it's a tourist trap, with gewgaw stalls for the Yankee tourists, but then it was mostly empty, only an old lady

or two selling tomatoes or cucumbers or woven baskets. A ghost hall, light stippling down.

We tiptoe, our tongues dry. We don't make eye contact with the fat old colored lady: we don't want her to know that our eyes are already glistening. A crate's upended, and we see a big young man forced to stand atop it, stripped naked for all to see, a whip curled in the auctioneer's hand. We are all six chilled up the spine. We are our father's children.

In Harvey's all the waiters are dignified old colored gents with crinkled white hair to match their white jackets. They only see my father once a year, but they always say, "Doctor! How you been down there in Due East?" I don't know why they think my father's a doctor. My mother says they call him Doc because he looks so distinguished in his assistant principal suit and because he can pronounce the French names on the menu. My mother looks pretty distinguished herself, with her pink straw boater pushed back over her curls. Lots of women don't wear hats anymore, but my mother says in her day you could tell a lady by her hat.

She tells us *don't look now* but there's the weatherman in the corner, and we all count to three before we turn. He looks *exactly* like he does on the television. We've only had it a little while, and we still gather around it every night. My father says the way we watch it is as much of a prayer as the rosary we say after. The weatherman's drinking a martini, too. When they bring my parents' martinis in those very same royal glasses, it occurs to me that maybe we aren't so poor after all, not for all my mother threatens to sell Tupperware and Teresa makes a big show of washing her panties in the sink so we don't have to buy her so many pairs.

After a few sips of martini my father says we should get anything we want on the menu, anything. Teresa runs her finger down the prices—she'll get a plate of hush puppies with not so much as a glass of tea to wash it down—and Martin and Will cry, "Meat! Meat!"

"Shush now." My mother laughs at them, balancing her hat as she leans her head back. "You'd think we starve you poor orphans."

Only on the word *orphans* her voice drops down low, as if she's seen an apparition. Here she goes again. Lately she's been crying over anything we do and sobbing out that she just hopes she doesn't

die in childbirth because we would feel such sorrow and ache then. Women don't die in childbirth anymore! It doesn't happen! My father says so.

"Stop now," my father says. "Stop." But she juts her head out, like a turtle, to stare. Then she turns as white as she did out in the blazing sun. All four of us girls, sitting across from her, turn around to look.

It's a giant taking his seat. Really, it's a giant, and we all see him this time, not just my mother. He's twelve times my father's size, but he's wearing a suit just as normal as an assistant principal's suit, a blue seersucker suit same as all the Charleston men wear in the summer, only twelve times bigger. His hair's combed over to the side like my father's, too, but the giant's hair is sparse and oily like the carny's. *Don't get too close.* His face looks smushed: his nose is a flattened, streaked tomato, as if somebody stepped on him. Who would step on a giant? Maybe he has cancer of the face like Sister Alma. He sits down all alone to eat his supper at Harvey's, and we all hold our breath to see if he breaks the chair. If he orders a martini, they'll have to bring it in a bucket. Caroline waves at him, only he doesn't see. My mother gasps.

"Just calm down," my father says, or at least I think that's what he says. He's whispering, and so is everybody else in Harvey's.

"Here's what we do," my mother hisses. "I'll grab up Caroline, and Willie and Martin can hang onto my skirt. One of the girls can distract him—you, AgnesAnn."

"What?"

"Spill a glass of water or something. I'll get them out on the sidewalk, Pat, while you slip the waiter enough for the martinis."

My father groans, and AgnesAnn groans with him. My mother does this all the time now. The giant looks perfectly charming—see, the waiter greets him like an old friend, and then turns toward our table. My mother whispers: *Tell him. Tell him.*

The waiter leans in above my father. "Some tall gentleman, heh?"

"Uhm-hum," my father says, stiff and sad.

"Must be very nearly eight feet tall. You see him before?"

"Nun-unh," my father says.

"You hear about him, though."

"No, I can't say I have."

"Most famous man in Charleston. Come in here about once a month," the waiter says, not even troubling to lower his voice. "Got a law practice specialize in colored people problem."

"Oh, yes?"

"Fair man. Very fair man."

"You see, Doris."

That is too much for my mother, who jumps from her chair but forgets the part about grabbing up Caroline and Will and Martin. She pushes through the restaurant, which is not so easy with her belly that big, and the giant half rises in his chair as if to give her a hand. She escapes him, though, and wends her way through table after table till she passes through the doorway to the illegal bar.

"Think she gone find the washroom all right?"

"She just needs a breath of fresh air. She's...expecting," my father says.

The waiter chuckles. "We know how ladies *get*."

And then we all order our food, as if my mother has not fled the restaurant, as if she isn't part of this family anymore. My father leads us in conversation about the miracle of television and what it must be like to be the TV weatherman, and when we have exhausted that, we move on to Captain Kangaroo, a saintly man, kind as my father. The food comes in waves, like the tide, and we don't mention my missing mother, though every now and again I remember how she lost the last baby. We all thought she was just carrying on, till the blood pooled all over the front seat of the car and ran out the passenger door. I wonder if she's sitting on the sidewalk in a pool of blood.

When Teresa's hush puppies land, I seize the moment to peek at the giant again. He's stooped over his own plate—shrimp! a mountain of it, a giant-sized portion—and not just because his head is so high above the table. His bones are bent, his back stooped. His neck hangs down from shame, the way ours were hanging down in the slave market: only ours was the shame of being white and his is the shame of being a freak of nature. I want to go sit in his lap. I want to show my mother there's nothing to be afraid of. I wouldn't actually *tell* him about the two rows of teeth, but if I opened my mouth wide enough he would see, and I wouldn't mention that they were going to fix me.

The giant reads my mind the way my father does, and smiles, his own teeth huge and crooked and a soft yellow, like roses. He has four or five sets in there. Nobody sees but me.

"That suit custom-made," our waiter says when he brings dessert—vanilla ice cream with sparklers, six cut-glass bowls he removes from the tray with great caution, as if they're alive. We all sit in awe as the sparklers sputter and pop, red and blue, the ice cream itself singing out a cheerful message.

When we come outside, blinking in the bright, cloudy haze, my mother is sound asleep in the hot car, all the windows rolled down but the door locks depressed and the plastic seat covers hot to the touch, as if they're melting. Her hat's tumbled down and my father makes us all stand back while he plucks it off the seat and rests it on her head. When he sets the paper bag of food down next to her, she starts awake at the rustle, then stares as if she doesn't have the least idea who he might be.

"Did the giant take the babies?"

We all laugh. She's joking!

"Everybody in." My father brings Martin and Willie round to the back and opens the tailgate. Then he comes back for me, to go in through the driver's side.

"Aren't you hungry?" I ask my mother. She won't answer, but squeezes my hand, and when I look up I see the tears streaming down. I squeeze back, furious, and let my nails dig in.

My father lights a cigarette before he pulls out. He has to guide us through the narrow Charleston streets and then the gloomy Charleston highway, where the wrecks pile up in the summer: drunken marines and blown-out tires and people with bad luck who don't see they're running off the shoulder, into the muck. "Got to make tracks, chickpeas. Got to beat out this storm."

By then the sky's blistered with black cloud puffs, and the streets of Charleston are still. The birds have all found their shelter, and if we don't make it over the fairy bridge fast, we'll be trapped. "I hate Charleston," I say.

My father says: "I think it's the specialist you hate."

"Don't tell her who she hates," my mother whispers.

My father drives on, over the bricked streets and past the walled gardens. Everybody in Charleston lives in a mansion, unless they're poor and live in an old shack.

"If I die in childbirth," my mother says, "I suppose you'll marry her."

"Doris, stop melodramatizing. Women do not die in childbirth anymore."

"I would rather you did. I would rather the children had that mother than no mother at all."

"Doris, I will not have you scaring them."

"I want to go to the cathedral," she whispers. "I want to make my confession."

"Marry who?" Martin calls, all the way from the back.

"Nobody." My father speaks in a calm, clear voice that roars through the station wagon. "We're not going to the cathedral, and we're not going to scare the children." He drives on, his cigarette burning close to his finger.

"I'll put it out." I'm whispering. He doesn't hear me.

My mother sobs. "I want to go to the cathedral. Please. Take me to the cathedral."

"Let her go." Maybe I'm still whispering. He drives on. "Let her go to confession." My mother squeezes my hand. I never take her side.

"Fanny's the only one, the only one who sees what it's like for me."

I'm her match. I can run like the devil and I will never let her spank me again. My heart is murderous, monstrous. "She's scared." I cannot stop myself, pleading for her.

My father drives on. We're almost up to the fairy bridge, almost, but here comes a yellow light. My father slows, but before the car rolls to a stop, my mother opens her door, and so he must slam on the brakes. She's out before the light turns red, before the tires stop turning. She runs on those little bird-legs, her hand to her hat and the rain just starting to spit. Martin starts to cry, and then Caroline, and then Will. AgnesAnn says: "There is no woman, sillies! Daddy wouldn't do that. There is no woman."

When the light turns green, my father slides the station wagon forward and we all sit stunned as we realize he means to take us home, over the fairy bridge, down the narrow highway in the darkening

night, through the woods and over the marshes, while our mother wanders the streets of Charleston with a giant abroad. And she hasn't even had her supper.

A great clamor arises, even from Teresa, even from AgnesAnn. We're all shrieking her name, our mama, our mama, a cacophony of miniature Doris-voices. In our terror, we've become our mother. I hear myself hiccup: "She just wants to go to confession. She just wants to go...."

When my father turns the car around and goes back for her, she's waiting, dignified, at the curb, though the rain lashes down and the water slides in streams from her boater. Or am I making up that part, melodramatizing, hurling down lightning bolts to show how dazzling my mother was? Maybe she was only waiting in the wilting heat. Maybe she was trudging away from us, still heading for the cathedral.

She climbs into her seat and smiles down sweetly at me. Don't let her squeeze my hand again, don't, don't. She takes from my lap the brown bag of food my father's brought her from Harvey's, a doggy bag that any other time would make her cringe with shame. But this dark night she opens it eagerly and removes a single shrimp, from which she takes a dainty bite. The thunder crashes around us as we cross over the fairy bridge into the night. Or maybe it doesn't. Maybe I don't need a storm to find sitting next to my mother thrilling. We never did go back to the cathedral for confession that night, but still all our troubles were forgotten, washed clean.

By the time she was done, my mother delivered nine babies who survived, and even I, the hippie flower child, had four—but I'm not holding my breath waiting for grandchildren. My daughter told me she wasn't so sure she wanted to raise a child in Brooklyn, waiting for the F train to blow or the bombs to start going off in cafés, and I thought: oh no, it's the fifties all over again. I should have told her that it's not just the terrifying world, it's your own selfish heart you question over and over when you bring children into the world. Over the years I asked again and again about that woman my mother invoked, but begrudgingly my sisters AgnesAnn and Teresa would explain that there never was another woman. How could there have been? Wasn't my father always around? Even when the baseball team had an away game he was home by midnight, and on Sunday mornings he stood at the back of the church, an usher

resplendent in his assistant principal suit—then, hooray, his principal suit. I never entirely believed them. Sometimes I wished my father loved another woman. Sometimes I prayed for it. *You're a mean old shriveled witch,* I hissed at her. And later: *You're a racist, an anti-Semite.*

And then, when I gave birth myself, I thought I understood her whole: the loneliness of living with small children, of never being heard, the way I thought I'd been banished from the world, hushed up and locked away, a princess in a tower with no one coming to rescue me. I even thought I understood her paranoia—I was a little paranoid myself, when my children were babies.

Now, all these years later, she haunts me. That time haunts me. Sometimes as I'm drifting off to sleep, I feel my mouth crowded with another set of teeth and I can't open my jaw, can't get a word of warning out. Sometimes I wake with my head sliding across the pillow, listening for swoops and gurgles, sounds of life. Sometimes I remember that one and only time I took her side, imagined her despair, and feel again that the years themselves are transmitting messages. The air is electric. The world waits to explode.

SANDRA SCOFIELD

Anger [essay]

Be angry but do not sin; do not let the sun set on
your anger, and do not leave room for the devil.

—Ephesians 4:26-27

I WAS IN TROUBLE out in California, and I ran away with my boyfriend to escape it, because I was pregnant and I was young, and it was easier to run than face the music. My grandmother, Frieda, who lived in Texas, must have been frightened for me, and I'm sure she didn't understand what we had done or why it couldn't be put right, but she didn't say. She would have done anything to help. I asked her for a few hundred dollars to make her know I needed her. I had sold my car, the last money left after our run with lawyers. We took a bus to British Columbia. Before we left I wrote her: *Please don't be mad at me.*

I had seen my grandmother's anger all my life but I had never been afraid of it, because I knew it was about the world and not about me. It was manifested in pursed lips and swollen silence; it infested the family and made us suspicious and wary of outsiders. She knew things, but she didn't speak of them, and we were always trying to guess what had happened, what had been done. After she died, my aunt and I tried to talk about her anger for years, but we missed her and we couldn't remember or didn't like to remember too much. It seemed disloyal to remember her anger because, really, we remembered it as a fault and we wanted better memories of her. We wanted her to have had a better life.

I had observed, in my childish way, that Frieda resented rich people—she was a union steward for a flour mill—and most men. Widowed young, she hated fate that had cheated her of happiness. Her oldest child, my mother, died at thirty-three after long suffering. Frieda lived a life full of pain and grief and unfairness, and she minded mightily, but she had never run away or called attention to

herself. She banked her anger, drawing on it, I sometimes think, to fire her strength: for working overtime, for bailing out her children from ill health and fiscal woes, for the husbands that came and went like bad weather, for nursing her mother in her last days, and her stepfather, too, whom she did not love, in his. She was never angry with us grandchildren. I did not know the concept of unconditional love, of course, until I was a schooled adult, but I basked in it all my childhood.

In Canada my boyfriend and I found a rough shed on a hillside where the owner was clearing land for an RV park, and we lived there and my boyfriend worked for him while I spent my days worrying about the baby and walking up and down the road in the cold rain. I heard from some hippies about a phone that you could use to call the U.S. and it returned your coins. It was true! It was weeks before the phone company sent someone all the way out to our tiny outpost to fix it. I called my grandmother to tell her I was pregnant and then three or four more times to say I was okay, trying not to cry. She mailed me a warm coat. She said I should see a doctor for the baby soon.

In a while I got large with the baby and we got back on the bus. The baby was born in July and died twelve days later. I settled things with California the next fall and spent October to Christmas in a county jail. The other women were hard on me. I was very thin, white, jumpy. I cried because my lips were chapped. The women stole my candy bars and came to my bunk after lights-out to punch me. The jail was new and clean.

When the women heard what had happened to my baby, they let up, though they sat away from me on the bolted steel stools where we watched TV in the late afternoons. A woman in the community heard about me, and she brought a huge sack of yarn and crochet needles. You wouldn't have thought they would let the needles in, but she was the wife of someone important, and it was almost Christmas by then. Besides, none of us were violent offenders. One of the prisoners, a Latina in her mid-twenties, a shoplifter and a new mother herself, knew how to make crocheted squares and was a willing teacher. In the afternoons, four or five of us sat up on a big stainless steel ledge in the day room crocheting while the matron watched us, drinking coffee and chatting in a friendly way. Something about the crocheting made everyone relax and tell stories, and at night I repeated the stories

to myself until I fell asleep, wanting to remember them because I had never heard anything like them and because it helped if I thought of the women as characters in their interesting lives and not as people who had hurt me. The black woman who had hit me the hardest said she had always wanted to know how to make something with her hands.

I made a small afghan for my grandmother out of ugly orange and yellow and brown yarns. I mailed it to her as soon as I was released. After she died in 1983, it came to me in her things, wrapped around a statue of the Blessed Virgin that had been my mother's. A few years ago I threw it away because it was ugly, but I still think of the time I visited my grandmother in her house and saw it folded neatly on her closet shelf. It prompted me to tell her how sorry I was about "all that." By then I had my daughter and I was in many ways like a person in recovery, shuffling through my history, making amends.

She never asked for any of the details, and I didn't give them. I said it had been a trivial matter but a big misunderstanding at a time when people were scared of youth and hair and color and anyone's opinions not like their own. My boyfriend and I had made a mistake, living in a conservative little town where we never should have been, and people had mixed us up with other people we would never be.

That was when she told me that two FBI men had come to her house looking for me. I don't know what shocked me more, that anyone could have thought I was a person of consequence, or that she could have kept their visit to herself. I was flooded with embarrassment and indignation. My experience with the legal system had fed my resentment of authority. At the same time, I realized instantly that Frieda hadn't fully understood or cared that I had been responsible for what had happened to me: that I had broken the law, in however minor a way, and that however exaggerated the reactions, I had brought my misfortunes on myself. Indeed, I had not yet absorbed or admitted this; I had not examined the experience, only lived it, then scrambled to begin my life again, struggling to shed my fears, trying to sort out a way to start fresh like the adult I needed to be in order to raise my child. At least I had a good job, the kind that gave you time off to take your new baby home to Texas. I had married my boyfriend. I wanted to tell Frieda that things would get better soon, that I would be more and more like other people, but she spoke first.

She said, "They asked to come into my house, and I said, Do I have to do that? Is there a law that says I have to let you in without a warrant? And you know there is not. I stood in the doorway. They were uncomfortable on my concrete step. They had come out here and they must have known there was nothing for them, they must have known we were no threat."

I heard that "we," as if she were complicit in my misdemeanors.

She glowed with anger. I was in awe of her audacity. All along I had seethed with indignation: Why couldn't they see my innocence? (Or at least my innocuousness?) But I had whimpered and held my tongue, while she had stood up to the FBI, whom she saw as invaders and false accusers of her family. Her outrage was fresh as she remembered the men at her door.

It was the first time I realized that her anger, always present, visible as a night-light, could be called up and focused, that it held within it the potential for havoc. She felt justified in her wrath because the men had it so wrong; and she had learned the Psalms as a child: ...*thou hast broken the teeth of the ungodly.* Maybe those men had not pushed her far enough, but someone could. Even as I was glad to have her love me, I was repulsed by her zeal.

I hadn't learned the beautiful power of anger when it is rooted in God's love. I had not associated it with Jesus in the temple, casting out the moneychangers. I had never seen it on the faces of strong people standing up to injustice and suffering because I had never looked, although there had been civil rights marches in the South while I was finding dubious adventures and wondering if anything in life would ever have meaning.

Something stirred: a sorrow for the many times I had hurt her with my absences and my waste of opportunities and her steady love. I ached for her to care about something better, steadier and more deserving than me, something worthy of her defiance. Something holy.

And even more I wanted the sweetness I knew in her to be reflected in what she saw around her. Oh, I would be that sweetness! I thought, I with my child. I would never again give her reason to worry about me. I would give her reason to shed her anger and love the world.

I wouldn't have believed it if someone had told me that in a few short years she would suddenly grow old and look inward where I could see nothing, where I had no place and from where she barely

bothered to hold me in her weary vision. I wish I had known: I wish I had thought to look to that common ground we must have shared in our different faiths and to step into it with her right then, to seek joy and the surcease of bitterness outside ourselves and our histories. I like to think this is what she was doing in the last months of her life when she was so much alone with her photographs, her Bible, her cache of clipped poems from half-century-old newspapers, but she never gave us a hint. We knew her anger all our lives, but when she let it go in her dying, she told us nothing of what filled her in its place. She made it clear it was none of our business.

The hard lines of her face did soften a little that day, and I thought that I had breached the space between us and closed the sorry narrative of my bad behavior, but no, there was one more thing she had to say.

"They stepped down lightly and didn't look the least surprised. They didn't even seem to mind. I said to the one who was closest to me, Young man, I don't know what else you have to worry about, but there must be more important things than my granddaughter. She's a good girl and she's never hurt anyone but herself.

"And then you called me that very night on your peculiar free phone and I said, Don't you worry, sugar, you'll be all right in spite of everything."

And I am.

MARTHA SERPAS

As If There Were Only One

In the morning God pulled me onto the porch,
a rain-washed gray and brilliant shore.

I sat in my orange pajamas and waited.
God said, "Look at the tree." And I did.

Its leaves were newly yellow and green,
slick and bright, and so alive it hurt

to take the colors in. My pupils grew
hungry and wide against my will.

God said, "Listen to the tree."
And I did. It said, "Live."

And it opened itself wider, not with desire,
but the way I imagine a surgeon spreads

the ribs of a patient in distress and rubs
her paralyzed heart, only this tree parted

its own limbs toward the sky—I was the light in that sky.
I reached in to the thick, sweet core

and I lifted it to my mouth and held it there
for a long time until I tasted the word

tree (because I had forgotten its name).
Then I said my own name twice softly.

Augustine said, *God loves each of us as if
there were only one of us,* but I hadn't believed him.

And God put me down on the steps with my coffee
and my cigarettes. And, although I still

could not eat nor sleep, that evening
and that morning were my first day back.

LUCI SHAW

Making a Path: Tuolumne Meadows

Take the first step towards where
you want to go, then keep going, brushing
through the manzanitas, crushing the sweet grass
of the valley floor so its pungency
seasons the air, flowing lively as the trout stream
at your right hand, all color and gleam.
On meadow grass you are sketching a new course
that will echo the current, will skip and dodge in

and out of willow shadows on the bank
of its ancient water-path for fish. You
are no fly fisherman, but after you
the quiet carriers of rod and creel
will follow, several in a month,
and, almost without thinking, obey your
rabbit track, verifying the subtle hollow
being carved between tufts of brittle sedge,

a coarse growth, bleached as the hair
of your children's heads in August, years ago.
Your walking has woven, unhurried
as a Kashmiri rug, a narrow runner of turf
with threads of tan, greens fading,
burnt ambers, straw. Will the winter snow
bleach out the subtleties, and iron
the field fabric flat? Does all this have to

start over every spring? How many footfalls
go to make a meadow path? Buechner said beat
a trail to God long enough, he will come to you
on the trail you have beaten, bringing you the gift

of himself. Abruptly, evening shadows the meadow,
but you keep pacing along and along
your own slow track. In whose fisherman boots
will you meet him, coming the other way?

ROBERT SIEGEL

Carrying the Father

Pater.... Ipse subibo umeris, nec me labor iste gravabit.

—Aeneas to Anchises, *The Aeneid*

1

From here I carry him upon my back.
He is no longer heavy, though sometimes I
stumble over grief. In fact, he is

thin as the wing on an October fly,
seen through as if not there at all, but in
a certain light suddenly ablaze,

a transparent map of all my life.
He's here, and his voice runs through
my bones and through the roots of my hair.

2

We are at Gettysburg on the observation tower
of Little Round Top. He in his summer khakis
tells how the gray soldiers came on.

I am five; the trees are green moving ranks.
Later, in the museum he shows me
the yellowing jawbone of a drummer

and hands me in their green patina
musket balls dug up, a pyramid
still my paperweight. Like him,

these words are more than I can carry,
yet in a draft from the window float
from my desk to the floor.

3

We push open the door to the cabin,
met by a sweet and musty cold, the tick
of mice in the rafters. The electric lantern

shines on the black, shuttered windows,
the furniture sleeping under white sheets.
You crouch: a blue spurt, a flame

crawls up birch bark in the fireplace,
yellow, orange, a hand's width
of warmth reaching out. A stirring, crackling,

and the whole hearth is ablaze and roars,
the log walls leap and shake with light.
Outside, you open the first cream shutter

which I unhook from inside. Blue sky
drops in foursquare, the sun blinding,
the thin birch leaves a transparent

green melting in the May light. Now,
all windows open, a warm wind of pine,
cedar, and smoke flows through the room.

You hand me the cold icehouse keys and say,
Open it, take the boat out, anchor, oars.
Tonight when the moon goes in, the walleyes
will hit and hit hard, hungry from the winter.

4

Those sweltering days you came home early,
jacket over your shoulder, white sleeves rolled,
we walked to the air-conditioned theater,

through colored shadows entered the same dream.
Or, better yet, while the sun retreated
behind smoke-blue elms, we walked over

to the park where, far off, we heard
faint shouts and smelled the chlorine from the pool.
Down in that damp dressing room my trunks,

still wet from afternoon, coiled cold
around my shivering thighs. The fur on your chest
kept you warm, you said, as we showered

and waded the footbath to the flashing water
not yet streaked with overhead lights, pink
in the fading humid afterglow.

You heaved into the pool, rising like a walrus,
water streaming silver down your red face,
and yelled as you swam to dunk me—

letting me dunk you back, push the weight
of your body under water, light as I was.
You lay there, pretending the dead man's float,

then rose up with a roar and a laugh
while I fled, climbing the ladder
to the high dive, calling for you to watch me

where, reckless, bouncing on the edge
of that heavy board shuddering like a tongue
about to speak its first clumsy word,

I plunged headfirst into the summer air.

5

Mother in her white dress with yellow flowers
crossing the green in Washington during the war,
my sister and I running alongside to keep up—

always at the end of the eight-millimeter film
before the white spots erase the space
and time runs out over and over.

White dress with flowers that I remember,
carrying the summer with her, the sweet smell,
the soft touch, the words, the laughter.

In that white summer evening by the Potomac
she is the whiter center
of the picnic, the soft clink of silver glasses,

while I, running breathless over the lawn
on which I've fallen, stains on both knees,
smell the green mystery. She moves like a cloud

with flowers out of the sky reaching to me,
lifting me, the earth rising up, the grass,
with the shouts of children: *Oley oley ocean free...*

Every Christmas you showed this to us, Father,
together with the scene where you wave good-bye
from the Chevy window, the peak of your cap

cutting a shadow across your eyes. At the white
spots we'd cry, "Stop. Run it backwards."
And you did. Quickly, jerkily,

time and space knit together
until the picture was frozen on the sheet
hanging crooked, a wrinkle running through it,

while we sat there, wanting
somehow to hold the trees, flowers, faces
down to that very day, reaching out

in the darkness for what was always slipping
by, even as we pressed it to us
forever: earth too heavy, too light.

6

It is dark and cold, the high night sky
black as a hat.
Stars like fish swim as you lean

on the rake, now and then stir the coals
of the last few leaves, their heavy ghosts
filling my head, shaking a star or two as they rise.

A small flame leaps: a yellow maple
leaf curls like a fist down to its glowing bones.
In its brief flare your face is

orange, your hatbrim lights from underneath
and your red-checked shirt glows and goes out.
In the dark your shadow beside me says,

"Do you see the Great Bear, the Little Bear?"—
pointing with the handle of your rake, its shadow
arcing across the heavens—

"Those three stars are the belt of Orion, the Hunter.
There's his bow, there his feet where he climbs
up the sky, silently crossing it all winter."

7

In Florida, which you never liked, you fell again,
missing a step on the patio, breaking your hip,
while dizzy with Parkinson's, planting the *impatiens*.

Disgusted with yourself, you lay an hour,
until mother returned; then you calmly gave orders
to the doctor and medics as they carried you out;

over the next four years fell again and again
trying to walk, until it was a joke with you—
how hard your head, how soft the furniture.

After the massive heart attack, they found
no pulse for five minutes, but you came back,
disappointed (you said later) they revived you.

Grown used to your miraculous escapes, we weren't
ready when my sister called and said
you had died quietly, riding in the car

with Mother. The medics worked an hour
while you, no doubt, hovered over them, kibitzing,
floating in the too-white Florida sky,

telling them to leave well enough alone, ready
after years trapped in that wheelchair,
like Orion to take the sky in one long stride.

8

Father, I have just begun to carry you
toward the strange country of the rest of my life
with the household gods and the whole past,

away from the ashes and the smoking walls
across an ocean whose waves rise steep and blue
to the continent of the future, where I shall set you down

flat and weightless, except when you rise like this
from a small gesture, tine of a rake, or ghost
of a burning leaf to your full height and voice

and speak to me even as the light shows through
your flesh, and every scar on your leather jacket
stands out sharp and clear and your voice builds

as you say, *Do not forget the dark*
dear past from which all the shapes come, the rich
drift and sleep of leaves over and over,

this soil ever crumbling
in which you lay the still invisible garden.

for F.W.S.

M. RAE THON

The Liberating Visions (and Futile Flight) of Melanie Little Crow

[fiction]

VIRGIN MARY VISITS RESERVATION

ON APRIL 11, 1998, the Virgin Mary was seen and photographed on the Flathead Indian Reservation in Montana. A forty-year-old woman, Melanie Little Crow, who is a native Montanan but not a Native American—and who has taken the name "Little Crow" falsely and with permission of no one—claims she spotted Sweet Mary Mother of God sometime before eleven that morning. She had witnessed other signs earlier that day: snow, rain, and hail—black clouds so low they touched the treetops. As she drove south, the clouds began to break, and soon the sky turned almost clear and miraculously blue as Mary's garment. Little Crow was able to snap one photograph before the Virgin vanished. The snow also vanished, but more slowly. Little Crow reports that the encounter left her with "a feeling of absolute peace and enveloping protection." After the sighting, Little Crow (who also claims to be a virgin), continued on her merry way to Wild Horse Hot Springs, where (for five dollars, probably stolen) she immersed herself in the healing waters of the mineral baths for a full hour. Against advisement, she also swallowed a fair amount of the water, but claims the Virgin spared her any serious side effects. Little Crow said, "I experienced an inner cleansing, which I suppose I badly needed."

LITTLE CROW ARRESTED

MELANIE LITTLE CROW—who claims to have seen a vision of the Virgin Mary last April and who now insists she met Jesus Christ her Personal Savior on the banks of the Flathead River—has been arrested by Flathead County Sheriff's Deputies for vagrancy and trespassing. Little Crow was found sleeping in an overturned dumpster near the gravel pit just over the bridge off Highway 35. No Trespassing signs are clearly posted, and Little Crow says, Yes, thank you very much, she can read, but that she had received permission of a higher order. "Jesus said his house is my house," Little Crow reportedly told Deputies Weylin Van Hoose and Sheldon Cross as they took her into custody. "And remember what Our Father says about trespassers," she added. She said she knew it was really Jesus "because he wore a red robe and a crown of thorns. He was very clean, but I noticed his head was bleeding."

Little Crow herself—whose true name, if she even has one, is still unknown—wore a yellow parka and huddled inside a blue sleeping bag. "Both were filthy," Van Hoose told this reporter, "but we are investigating the possibility that these items were once new and lovely and may have been stolen from a mobile home parked at the River Rest Trailer Park for three weeks last February."

Little Crow told authorities she did not feel obligated to obey any white man's law "unless his name is Jesus." She originally claimed Sans Arc, Absarokee, and Nez Perce ancestry, but later admitted, "Okay, maybe I'm just a Kalispel Indian like the rest of you." The matron at Flathead County Jail who prefers to remain anonymous but who is well known to most of you anyway, who sprayed Little Crow down and saw her "I swear, naked as a baby," maintains now and forever and to her dying day that Little Crow is "white, bright white, fishbelly white, and a damn liar."

Little Crow is being held on $500 bond at the county jail. The Unnamed Matron is free to go when her shift ends at eleven tonight, "But," she says, "I'll probably stay on. Most people sleep through the night shift, which is fine by me and I wouldn't be one to complain or even mention it under ordinary circumstances, but I don't trust a woman that twitchy who says she's seen both Jesus and his holy

mother. Somebody's got to stay awake and watch her. Might as well be me—nobody's home waiting, and I'm not that tired anyway."

LITTLE CROW CONFESSES

MELANIE LITTLE CROW, who still refuses to take her father's name, either in vain or for legal purposes, now claims she is responsible for over a hundred crimes in the Flathead Valley—some dating back as far as the early seventies.

She told the matron on duty, "my keeper, my captor, my sister," that she gutted a cabin one winter, burned it flat "during the month of the snowblind, when the drifts were so deep they covered the windows. I was cold," she said. "It was an accident." She liberated three llamas "one warm day in the month of the melting moon, after the winter when the grizzly woke too early." She said the llamas just wanted to go home. "That's what they told me. Then they headed south, toward their own country."

She thinks she may have borrowed a car and camera the day she saw the Virgin Mary. "Maybe a man took a nap on his porch. Maybe his keys fell out of his pocket."

The blue sleeping bag and yellow parka Little Crow had in her possession when she was apprehended were indeed stolen from the River Rest Trailer Park in February, but Little Crow believes these items were gifts gladly given. "I needed them. The nice woman who left them on the bed in the trailer in plain sight must have wanted me to have them. I saw them through the window, and breaking the glass with a rock she'd left underneath the steps was easy."

Lois Hopper, who once owned the sleeping bag and parka, but who no longer wants them, said, "I got home late that night—okay, early that morning—but it was still dark as dirt and let me tell you I was terrified when I saw the busted window. Glass all over the floor, and that smell—well, maybe your deputies can describe it."

Little Crow prefers to sleep in boats and has done this every summer as long as she can remember: "Bitterroot, Swan, Flathead, Whitefish—even Lake Koocanusa, which is the greenest of all and still my favorite. But most times I'm not choosy. Boat is just another word for cradle," she said, "and the cradle's the grave when it stops

rocking. I sleep wherever I can, but it's nice to have a place on the water in July and August."

District Judge Wanda Harp cautioned reporters not to take Little Crow's confessions too seriously. "Some people get dangerously comfortable in jail. Dry beds, regular meals. They'd stay forever if we let them. We want her to take responsibility for the crimes she did commit, but we don't encourage any of our prisoners to take credit for ones they didn't."

Little Crow, 5' 4" tall and 92 pounds, confirmed that she is often hungry. "Wet too," she said, "especially in March and April." She learned to love fasting while living with the nuns at Our Lady of Perpetual Mercy in Walla Walla, Washington. "But," she said, "now that I'm forty, I'm less enamored of my suffering. Even Jesus stopped at thirty-three, which was always my intention. I slept in the snow. I lay on the train tracks. I fell out of trees. I jumped off of bridges. Funny thing is, the more I lose of my body, the more I love it. I'm a walking miracle," she said, "proof of something."

She also confided that "a hair shirt grows smooth as silk if you wear it as long as I have." This was a lie, of course. She was wearing a man's flannel shirt, green plaid, when deputies hauled her out of the dumpster. "Another gift from a kind stranger—I cross my heart by your candles. The man who owned it before me was dead when I met him. We made a trade: he offered me his shirt and jeans, and in exchange, I washed him."

After her confessions to the matron, Little Crow asked to see a priest and lay on the floor of her cell until Father Ray McKinnick—despite badly swollen feet and too many nips of holy wine—graciously agreed to visit. This confession was private, of course, so one can only imagine. "There are sins of commission and sins of omission," Father Ray reminds us. "The former are easily named and numbered. The latter too often denied, or too long forgotten."

Our matron, who is full of revelations but who still wishes more than anything and for all time to remain anonymous, whispered, "off the record," that she overheard some of Little Crow's words. "And since I did, I consider them mine to tell you."

The prisoner neglected to visit her mother. "I knew she was sick, but never expected a woman that mean to go so quickly." She deserted her brother. "He crashed into a tree, and I flew into the high grass,

but he was trapped there." She told Father Ray, "I was three, he was twenty. But that's no excuse. I already knew what Jesus expected. I should have gone back to the car and prayed with my Willie until the gas tank exploded."

Little Crow abandoned her babies. "Even before they were born, they wouldn't stop crying. Every time I moved into a house I heard them caught in the walls like birds and squirrels. I heard them like rats living under the floorboards. That's why I like to live outside. That's why I became a virgin."

The matron said Little Crow talked in her sleep. "No words, just mumbo, like those people who go to church in tents, who all claim they're talking to God in some secret language. She was going on like that, and I had to slap her, but she just turned the other cheek as if my smack hardly touched her. Later on, she cried and sweated. She threw herself against the walls, which is how she got those bruises. I had to put her in restraints for her own protection; and once I got her down, I figured it made good sense just to sedate her."

The matron, unnamed but known well, dark as an Indian herself, squat and solid, with a wide, flat face and a heart like an awl, is now on her third shift, going on twenty-four hours and still, she insists, not a bit tired. She doesn't want to go home. "How could I sleep," she said, "after all that talk about rats and squirrels?"

LITTLE CROW MOVES CAMP

MELANIE MOVES CAMP, who first identified herself as Melanie Little Crow, apparently moved camp, debunked, disappeared, departed from her cell at the Flathead County Jail sometime before dawn this Sunday.

Sheriff Ripley Jessup says that to the best of his knowledge Moves Camp is neither armed nor dangerous, but he advised citizens to keep their distance and call his office if they encountered any dirty strangers, little dogs, or oddly shaped shadows. "You never know with these people." When asked what he meant by "these people," Jessup feigned momentary loss of hearing, so we'll never know if these people are vagrants, Indians, twitchy women without husbands, or just unwashed people in general. He did say that the name Moves Camp implies that

Little Crow might be Lakota, "maybe Sans Arc like she said, maybe Brulé, but most likely Oglala and therefore crazy as a wild horse, and most certainly not to be trusted."

Althea D'Arcy, the matron on duty when Little Crow moved camp, who wished to keep her identity secret, but who has lost all rights to privacy due to her negligence, said, "To my way of thinking you can't trust a Sioux of any feather." When she said, "Sioux," she drew a line across her throat then wriggled her arm like a snake. She whispered, "Custer's the one they killed, but they were everybody's enemies."

Sheriff Jessup declined to comment on the rumor that Matron D'Arcy may have assisted the prisoner in her escape while the good citizens of Kalispell, other residents of the jail, and yes, even the damn crows were sleeping. He did admit, "Well, we've got a bit of a mystery, don't we?" When he took this reporter on a tour of the eight by eight cell, he locked the door to make his point about security. "Moves Camp may be narrow in the shoulders," Jessup said, "but she's a full grown woman." He pointed to the window near the ceiling. "She's got a head, doesn't she? Human head won't fit between those bars. Ask Althea, she'll show you."

Strange Twist in Little Crow Disappearance

SHERIFF RIPLEY JESSUP has confirmed that Althea D'Arcy, former matron at the Flathead County Jail, is now wanted for questioning as a possible accomplice in Melanie Little Crow's escape last Sunday. "Unfortunately," he said, "Ms. D'Arcy is also missing."

Deputies talked to D'Arcy two days ago, Jessup reported. "Nothing official, you understand, just trying to get straight on details." The matron, suspended without pay, was home at last but still not sleeping. When asked if she'd had any hint of Little Crow's intentions, D'Arcy said, "Not a breath. She liked her cell. She was perfectly happy."

When pressed to reveal her last conversation with Little Crow—which took place late Saturday night just hours before the prisoner moved camp—D'Arcy confessed, "All right, in retrospect, I can see maybe she dropped a clue, but I swear, nothing definite. First of all, she forgave me, which I didn't particularly appreciate. Nothing worse than being

forgiven when you're not guilty of any wrongdoing. But she didn't act all high and mighty about it. She was kind of humble—you might even say she seemed ashamed of what she was doing—and I thought, Well, somewhere along the line I must have done something bad and missed out on a pardon. So I figured I might as well take her forgiveness now; and I have to say that when I did, I felt a whole lot better.

"Later on I heard her whimpering, and I asked why, and she said she loved me. I said, 'That's okay,' and she said, 'No it isn't,' and I said, 'Why not,' and she said, 'Because I have to leave you.'

"Well, I didn't take it serious. I mean, everybody leaves jail sooner or later. Ladies get out, or get shipped to Billings. When she was gone, I figured her love for me wouldn't be a burden to either one of us.

"Maybe it was three o'clock when she asked me if I was still awake, and I said, 'Who can sleep with you jabbering?' Then we both had a good laugh because really she'd been pretty quiet all night, and completely silent for the past hour.

"'Jesus is outside,' she said. 'He wants me to go with him. I told him I'd rather stay with you, that I was warm at last, and almost happy. He said it wasn't really my decision, though I know he was trying to be nice about it. He promised the wilderness is not that far and not that dark, and if I get cold, I can wear his red robe, and he'll go naked.'

"I didn't much like that," D'Arcy said. "In fact, we argued. I told Little Crow I didn't want to hear any more of her nasty talk about the good Lord going naked. She turned mean then—well, maybe not mean, exactly, but sarcastic. Suggested that next time I was in church I should take a look at Jesus on the cross and think about what he was wearing.

"So you can understand," D'Arcy said, "why we stopped talking. And no, I didn't sleep, even then, but maybe I covered my ears with my sweatshirt, maybe I turned out the light, maybe I rested my head on the table—but I swear not long enough for her to trick me."

Now Sheriff Jessup suspects he and his deputies are the ones who have been duped. "No way out of that cell except to unlock it," he said. "Maybe it was mostly an accident, and maybe it was kind of on purpose. Maybe D'Arcy put her keys on the table just where Little Crow could reach them. I honestly can't think of any other human

explanation. We'd like to question her again, but unfortunately for us, D'Arcy, like Little Crow, has vanished."

Belle and Svee Okken, who have lived next door to Althea D'Arcy for twenty-two years, who are not husband and wife, but sister and brother, and who keep to themselves mostly for the obvious reason, couldn't help noticing the former matron packing her car late Monday night. "Heading north," Svee said, "that's my guess. Took a lot of food, took a lot of blankets."

Jessup is cautious but admits he has his suspicions. "Could be Little Crow and D'Arcy are in cahoots," he said. "I've seen it happen. Guards start to identify with the ones they're keeping. It's dangerous, of course, and goes against all our training." He professes he never had reason to suspect that our matron, now named, might be susceptible to this or any other weakness. "She was a professional," he said. "I admired her. Until last week, I'd never seen Althea D'Arcy display even the faintest glimmer of compassion."

FUGITIVE RECAPTURED

MELANIE LITTLE CROW, trespasser, thief, liar, fomenter, arsonist, liberator, imposter, and possible seductress of a matron thought to be absolutely and forever invulnerable to any tender emotion, was captured last night just south of the Port of Del Bonita on the Blackfeet Reservation. The fugitive has been in flight nine days and asks us to believe she walked from Kalispell to Browning, ninety-nine miles, before a good Samaritan offered a ride and brought her here to Del Bonita, where she camped within sight of the Canadian border.

Several Indian women tried to shield her from the authorities, insisting she was on tribal land and therefore under Blackfeet jurisdiction. Sheriff's Deputies Weylin Van Hoose and Sheldon Cross told the women to please observe that they were not wearing uniforms and not driving a cruiser, and that they acted, truth be told, as private citizens, bounty hunters, and were therefore under no obligation whatsoever to abide by the laws of this or any other nation. "Crow, Blackfeet, Cheyenne, Flathead, United States of America—makes no

difference," Van Hoose said. "Tuesday morning we'll be back at work, wearing the man's outfits. Till then, nobody can touch us."

Apparently, Mr. Van Hoose is quite correct in his assertion about the rights of private citizens, especially in Montana. Sheriff Rip Jessup contends that although he does not approve of his deputies' escapade, he's pleased with the outcome. He denied rumors that his officers used anything more than justifiable force. "They cuffed her right away, as they should have, but didn't cinch the ropes hog-style until she bit poor Sheldon. Yes, her face is swollen, but we have no proof—save the testimony of five squaws—that either of my boys whacked, punched, or even slapped her."

As the private citizens sped away with their bounty, the Blackfeet women chanted, "We have hunters of our own. They come like owls. You'll never hear them."

Van Hoose swears he's not a man afraid of dancing women, either at home or on the reservation. "Only completely desperate people resort to magical thinking. My wife, Violet, makes the same kind of crazy threats every time she loses an argument."

Sheldon Cross is just grateful that the bite on his hand is not infected. "Only thing that troubles me is the fact that any one of those women could have been Althea D'Arcy in disguise. Looking back at them, I thought I saw Althea D'Arcy multiplied."

Little Crow alleges she is genuinely astonished by the suggestion that she might have been making camp with Althea. "They were Blackfeet. I wasn't one of them," she said, "and they knew it. Our great-great-grandfathers all tried to scalp each other at one time or another. But we were women with many enemies, some much closer than our ancestors. The women were very kind to me and let me make my own camp at the edge of their village."

When asked why she hadn't crossed the border and escaped into Canada like so many before her, Little Crow said, "I was weary; I was waiting."

Sheriff Jessup was convinced that she who loves to confess finally meant to reveal exactly when she thought D'Arcy might be coming. The prisoner vowed she had no expectations. "If she's on her way, she's lost," Little Crow said. "But it's nice to think that after all these years, my sister, dear Althea, might try at last to save me."

Letter from the Women's Correctional Facility
Billings, Montana

Dear Althea,

Sister or no sister, they say you have saved yourself from humiliation or possible indictment as my accomplice. You are in flight forever.

Trust me.

I told them seven times you did nothing.

Once, after walking in the Absaroka Mountains four days and three nights without food or water, I saw Jesus drowned in a glacial pool. Then he said my name, my real name, and I saw he was alive in the air above me. The Jesus deep in the lake rose to the surface, a reflection only.

Things are not as they appear, he said. *Have mercy.*

The night I escaped I was like him, thin as water. Althea, you are not to blame. In the dark, you did not see me trickle past you.

They have given me thirty years because I would not stop confessing. Thirty years, imagine. Does this mean I will live to be seventy? A miracle. I take it gladly.

I am waiting.

They say you face no charges. They say nobody wants you.

Althea, I want you.

Come back. When you return, I will be your prisoner. You will be my keeper. We will trade places. We will be drowned. And saved. And reflected.

<div style="text-align: right">

Your sister,
in blood and water,
Melanie

</div>

JOHN TERPSTRA

Our Loves Quit the Places We Bury Them, and Ascend

Yellow green, the willows are emerging first again
out from our color-free past, whisper
how brown it's been, is yet.
 Across the street
the magnolia bush, wild candelabrum, has set
pink white tapers at its fingertips, waiting
for the day to ignite.
 Everyone waits
to see what will happen next, asks why
the leavetaker lingers.

 As the long dying weeks
of this latest winter slowly stripped us
we ate less and less, slept through the mornings.
Pinned to these weeks as we are, and knowing
the seasons, we accept the drawn-out ending;
but natural history, nor past attendance, nor
scriptured almanac prepare us for the always abrupt
brutality, the late storm screaming ice and snow,
or that quieter violence which intersects earth
and spearing lily head.

 All color is contained in white.
Why shouldn't we prefer to pull that cover tighter
that the late storm drops, and the third day
liquefies, revealing the ground, its sample resurrection
of crocuses, like brightened memories,
 purple yellow wakings
from a death we should be glad of?

We live on the simple surface of things, have felt
the earth's floor not deflect, stamping our feet

to shed snow, no deep reverberation to trouble
our limbs, the core; till now—the ground cracks open
wider than a crocus head and, granted spring
the earth has always had, our loves have quit
the places we had buried them. We see them walking,
and feel the earth that bears us reverberate
each step: the landscape's an event
more sea than not, that we
must learn to walk again
and trust
　　　　　　what happens next.

　　　　　　　　　　Reach your hand.
This past half-season has taken us
like water, beyond reason and belief. We live
where water empties itself, rolls stone, or rises
as a hill; and the air breathes in.
　　　　　　　　　　Should it
surprise us you take leave, and rise
again, intangible as vapor, caught up
as the cloud we're staring after, then witness
what we see: a hand, a rose, a fraying sleeve.
All color is contained in shapes the wind will free,
that linger our delight and desolation—
　　　　　　　　　　and ours
are now your only eyes, this
your hand that's reached, let go, and these
your only feet, returning toward our lives.

DANIEL TOBIN

The Afterlife

What's worse, nearly, than the nothing you hope it's not
Is the thought of your many dead still nearby
Watching you from behind your life's one-way mirror.

They seem as they hover behind the living screen,
So close you almost sense them in the play of movement
Glazing off your own form in a shop-front window,

Like the revenants of dogged film noir private eyes
Who shadow their suspect's every move, who ghost
Their oblivious quarry by blending into the crowd.

Over time, they come to regard your every intimacy
Until you're naked as a newborn before the afterlife,
The more so since you still believe you are alone,

That your solitude, even in your happiest moments
Spent with your wife or your remaining friends,
Can be unfurled, the banner of your inmost self,

Even if it's blazoned with the pretentious seal
Of your delusion. Is it their own failures toward you
Summoning them back to the unresolving world?

Or what Agency do they report to with your foibles,
Mutterings, the wild outbursts of dread and dismay
You thought no one would hear, the unguarded rituals

Performed behind the closed doors they walk through
As if now were the moment they would make your arrest?
Though maybe they're only present like the part of you

That trails your life like a moon on a clear evening,
A new moon burning its absent reflection in a pond,
The light of its full face turned wholly to the other side.

G.C. WALDREP

Invisibility

*True humility is neither thinking too highly of one's self, nor thinking
too little of one's self, but rather not thinking of one's self at all.*

—Amish proverb

I've spent this week pretending no one could see me,
not some childish comic-book kind of invisibility
but rather self-effacement so effective, so total,
that one blends into whatever moment or circumstance
happens to be passing. It's all in the mind.
Context is everything. Say you're visiting
a distant city, on business perhaps, walking
along a busy thoroughfare and suddenly someone
thrusts two heavy beams into your arms, you see
the insignia, the blade's edge, you hear the command
in that foreign accent and find yourself marching
up a steep hill, carrying someone else's punishment
which of course makes it your own, the shouts
and taunts and spittle aimed both at you
and at the death you carry, equivalent stand-ins
for the good mood you'd been celebrating since lunch
(heavy bread, cup of good wine by the east gate).
Did I mention your chronic agoraphobia?
The only way: pretend it's not you
who carries the burden, in fact you're not there
at all, body perplexed, misplaced, submitting
to the minute as each moves into the next
with a dreamer's wide-eyed wariness. Mnemonics help:
repeat words or phrases or the Latin names
for Judean shrubs and wildlife. Count,
then count again in base six. Back home your wife
would be busy about now with the mid-morning chores.

She's humming a tune, sweeping out the clay oven.
She's hanging the wash to dry in the salt air.
Probably she's not thinking of you at all:
see, it's working, it would work beautifully
except for the short man in the stained tunic—
he's somehow got your name and number—and that other,
up ahead, and the weight in your arms that just
will not grow less heavy or less there.

JEANNE MURRAY WALKER

Saving Images [essay]

I COME FROM two cultures that despise each other. I am an artist and I am a Christian, the child of fundamentalists. In fundamentalist churches as well as in arts magazines and organizations, the unquestioned assumption is that these two groups are mutually exclusive, that fundamentalists never make art and that artists are never fundamentalists. For years I have felt that my existence creates an embarrassment for both. I want to admit here that both are my parents and that I love both equally. It is the only way I can think of to make both sides look up from their long and bloody—at times, literally—war, to realize that some of the values they share are of far greater consequence than the points over which they differ.

When I was a child, I was a devout Baptist, like the rest of my family. I walked around believing that Jesus might return any minute. I had a very clear image of what that return would be like. I would be outside playing or maybe riding in a car. I would hear a great trumpet. I would look up. There would be a few scattered clouds in the sky, and Jesus's actual tanned feet would be slicing through those clouds like the prow of a ship through water. The light of the whole sky would point like arrows and rivet on Jesus's dazzling white robe.

I remember quite vividly the first time it dawned on me that Jesus might not be coming back in exactly those terms. I was sixteen, lying in bed at night, listening to the radio. I lunged out of bed, flung the door open, and ran into the Nebraska night. I padded around our dark neighborhood for several hours. The disintegration of that image of Jesus descending through the clouds was more shocking than my first understanding of what was going on behind my parents' closed bedroom door. Subsequently, I worked very hard to get the image back, and it did return, but there was something around and under it that hadn't been there before—namely, the catastrophe of losing it.

Until a couple of years ago, I had forgotten this. No wonder. I used to be afraid to talk about it. If I did, on the one hand, I would

seem puerile to my friends who are artists and university professors. On the other, I would reek of unbelief to my family, themselves still fundamentalists, and to other fundamentalist Christians. Lately it has occurred to me that I have always lived my life betwixt and between. How does anyone get into this impossible position—torn between the arts and Christian fundamentalism?

In memory I climb the steps to Temple Baptist Church on a quiet corner in Lincoln, Nebraska, and walk past the planter of English ivy, through the modern glass doors. I stand at the back, where I sat for my father's funeral when I was thirteen, and look toward the altar. But there *is* no altar—not of the kind I now expect after years of worshiping in an Episcopal church. There is a square blond communion table, utterly without ornament. Above the table, on the platform, stands a severe blond pulpit with a practical looking pulpit light. The doors to the baptistery, behind the pulpit, are closed.

There is nowhere in this church to put my eyes. I have been told why. Our eyes are supposed to stay fixed on Jesus, and Jesus is God. He cannot be trapped in an image. This truism is frustratingly obvious, like a knot I can't pick apart. I am fifteen and I want to ask questions, but every question I can formulate sounds dumb or flippant. How can my eyes be fixed on something that isn't there? My Sunday school teacher tells me that our *inner* eyes are supposed to be fixed on the *idea* of Jesus. Why not a picture or a statue, I ask. Easy, he answers, and I imagine him now, whipping a Superman cape around himself. We are commanded not to worship images. And, of course, I know that. I have memorized the Ten Commandments, including the one against graven images.

Now it is a Sunday noon, just after communion. Water is rushing into the baptistery. My mother is a new deaconess, and while she washes communion cups we kids discover this secret, that the water in the baptistery is not magic, that the baptistery has to be filled with water from a common tap that looks like an outdoor faucet, that the water has to stand all afternoon so it isn't bone-chilling cold for the evening baptism. This discovery makes me wonder about other things.

As I gather communion cups for washing, I ask another deaconess, "Why do we have that picture in the baptistery?" She is tall and big-boned and she is wearing a flowery dress with a wide patent leather belt and a big bow under her chin. She pauses, her big arms hugging

three racks of cups to her ample chest, and stares at the baptistery as if to locate the answer. "I don't know, Honey," she says. "That's the Jordan River. I think we have that there so the candidate can be dunked in the river where Jesus was baptized."

Oh, I say stupidly. What I mean: So it's about history. It's about actually getting *back* there? The idea appeals to me. It's quaint. *Quaint! Your immortal soul is at stake:* my mind turns on me, firing truths I have known all my life.

And yet, although I know these truths by memory, I am still exploding with questions. The trouble is, I know I don't have the language to ask them. They are gathered into a lump in my throat. If I could think of the words, I would ask whether the painter ever saw the Jordan River, whether our painting is photographically correct. How accurate does the painting have to be to work? What happens if you get baptized without a picture of the Jordan River? Why doesn't this picture, apparently, count as an image?

Or if it does, why is *this* image permitted? If the Jordan River is so important, why don't we have to go there and stand in the actual river? I am desperate to know what's going on. But I am also worried about seeming too serious. That Sunday night, during the evening service, I sit in the back of the church with my boyfriend's arm around me, relieved to be released for a little while from thinking.

But I have started down this path, and soon I see images everywhere. The individual communion cups perched in the seamless, unifying, round stainless steel tray. The upright, hard, unadorned pews. I wonder what is an image, exuding charisma and danger, and what is just itself, harmless, contained within its own boundaries?

The next day in class I ask my English teacher a lot of questions about *Macbeth* because I am suddenly aware of images in Shakespeare. I see the connection between the Bible and a play. I am frantic for language to articulate what is—without warning—bursting into view all over. Everything is an image. Nothing is just itself. But what does that mean? If I squint and look sideways at the world, suddenly everything appears fake. Maybe it is all meaningless.

It is shortly after that that I lose my image of Jesus's second coming.

When I recently related this loss to a friend of mine, the editor of an eminent literary journal, he told me that something similar had

happened to him. He claims it happened to many of the artists whose biographies he had read. Could this sort of thing be common? Is it like going back to your old neighborhood to discover that the jungle where you hunted for panthers is only a square, average-sized back yard? Only what hangs in the balance here is not the accuracy of your memory about your childhood, but the eternal salvation of your immortal soul. Maybe my experience is more like the story my friend told me of her thrilling run-up to her first communion—the ceremonial buying of the white dress, the early rising on Sunday, taking the ritualized bath, walking to the rail, being handed the body of Christ, only to gasp with the horrified realization that the wafer looked like a scab. The demystification of an image. The fall into skepticism.

I don't remember fundamentalists ever talking about such demystifications. I think they tried to guard against them by poohpoohing any absolute identification between a physical object and God. One of the great, central debates within the Christian faith, as I began to realize later, is how, if at all, the bread and wine actually *become* the body and the blood. Or *are they merely a metaphor for,* or do they simply *remind us* of Jesus's body and blood. Many thousands of people have lost their lives over this question.

My Baptist church made a big point at every service of the fact that the bread and wine are merely reminders and are not transformed into the thing itself, as, for example, held in Roman Catholic doctrine. (My confusion was complicated by the fact that we had a stand-in for wine, namely grape juice.) When you stop to think about it, why would my people want to equate an object—the bread or the wine—with God? Worldly things—like food and music and language and dance—have a hypnotic power to lure the faithful *from* God, as they used to point out regularly. The fundamentalists I know are keenly aware of the danger of fixing their eyes on an enticing earthly image and thereby losing their interest in the world of unseen presences.

Ironically, while they tried to banish images, they cared passionately about them and about having the proper view of them. I suspect it was their awareness of the awful damage images can wreak that made them want to live in a truly image-free zone. But, of course, that isn't possible. Images, like the one of the second coming, whether in words or music or pictures, are essential to thought. And so the outlawed image, which is bound to sneak up the back staircase, became even

more terrifying. I think it was this complex vision of imagery and its power that set my feet—and those of others—on the path to becoming an artist. I doubt that that is what the people in my church intended. And yet, although they could never explain it to me, I believe that they probably understood better than anyone except my artist friends the power of images to transform lives.

What I am not so sure they appreciate is the difference between losing an image and losing faith in the thing behind it. When I lost that image of Jesus's second coming, I did not permanently lose my faith. I lost an image. There is a monumental difference between losing a *representation* and losing the *thing itself.* Images are what artists make. Probably I got my image of Jesus's descent from a Bible story book. Or maybe Pastor Garland painted it with words during one of his sermons. It seems to me now that it wasn't much to lose, that clichéd picture. But it felt like everything then. I did think that I was losing my faith. Probably fundamentalists knew of people who had mistaken an image for the thing itself and then, rejecting the image, had thrown over their faith. That must be part of why they were wary about the place of images in worship. But that wariness left me confused about the difference between losing an image and losing faith in the thing behind it.

It is important to explain what I mean by losing an image. When I was in my high school chemistry class, I could close my eyes and imagine my bedroom. I knew absolutely that it was my bedroom. I knew that when I went home from school, I could lie on the bed and do my homework. It never occurred to me, for example, that my parents might be moving during the day, that when I walked home from school some other girl would be listening to the radio in my bedroom. I believed with such utter certainty that the picture I had in my mind of my bedroom was really my bedroom, that it never occurred to me to doubt it. In the same way, I knew we drove a blue Chevy. I knew what the maple tree by my friend's house looked like. In my head there was a whole inventory of images I knew portrayed my life accurately. If you had asked me, I'd have said the images *were* my life.

Of course at some level, I must have known better. Imagining my bedroom, for example, I surely knew that I was in school and not *in* my bedroom. If someone had questioned me closely, I'd have agreed that

there was a difference between imagining the thing and the thing itself.
I might have even been irritated by the obviousness of the point. But
I hadn't really thought about what that distinction meant, and I had
no language for it. It seemed trivial because I had no awareness of its
implications or why it mattered. My lack of experience at manipulating
images was related to my preference for "realism." I didn't care for
iconic representations or allegorical images. I favored representations
that I could "believe." Maybe I was so powerfully in the grip of the
emotion they evoked that I forgot they were representations.

Anyway, on the day I had my realization, I saw that my old image
of Jesus's second coming was only a picture. When I saw that, it lost
its meaning. Or, to put it another way, I experienced the wrenching
apart of the image and the reality it represented. If I couldn't believe
the one, I lost faith in the other. Of course, I couldn't have explained
it that way at the time. Then, I was just terrified. To me it meant there
would *be* no Second Coming. If it wasn't going to happen the way I
had conceived it, it wouldn't happen at all, because I certainly couldn't
conceive of it happening any *other* way. I was devout. I believed what
I had been taught, that God holds human time in his hand and that
Jesus's impending return is what gives history prior to that return
tension and significance. Suddenly my whole understanding of the
meaning of human history crashed around me.

It would have been helpful if someone had explained to me that I was
just losing my faith in an *image*. But who? Should I blame my distracted
mother, who had been shunted out into the world to support the family
after my father died? Could frail old Mrs. Duacheck, the refugee from
Russia, bundled in her black seal coat, have turned to me as we were
waiting to shake hands with the minister and explained the nature of
imagery? Or, for that matter, was it the minister's job? It's not that I
had made my strange, difficult questions clear. I was utterly inarticulate.
And none of them were aestheticians. No. That particular loneliness and
confusion was nobody's fault. Furthermore, in an odd way, I am grateful
for it. I am still running on the energy with which it fueled me.

I want to be clear. I don't mean that when I lost an image I could
never see it again. I could turn to it in my mind, as if it were a page
in a book. I just couldn't have it any more without being aware that
it was *an image*. That extra level of knowledge—knowing that I was
thinking of an image which might be true and might be false—created

in me a vast, world-weary, adolescent irony. *Sure there'll be a second coming! Like snow on the Fourth of July!* I would mutter that sort of thing, never aloud, since I thought it might kill my mother. When I got to college, I found friends who had developed the tossed-off mock. I didn't need to learn how myself; I lived through them.

Maybe I was awash in such irony because, since I could see the strings behind the puppet-image, I assumed that the image must be fake. I didn't want to know that images are created by writers and painters. Lying on a couch, reading about Holden Caulfield, I began to abhor all forms of fraud. But of course all those J.D. Salinger characters who hate the fraudulent images adults concoct, are images themselves. I didn't understand until later that Salinger's diatribe against deceit is, ironically, part of the American literary tradition. Wasn't Hawthorne railing against hypocrisy in *The Scarlet Letter*? Wasn't Thoreau urging us to strip down to discover a new authenticity? Isn't it routinely American to think of images as fake and to want to disrobe down to "the honest truth"? A noble impulse. Nature, and all that. But isn't Nature itself an image? Americans have gone *that* route, too. Think of the novelist, James Fenimore Cooper, the photographer, Ansel Adams, the Nature Company and all its knock-offs. In the end, undress as we might, we can't think without images. They are the building blocks of consciousness, and they are inevitably contrived.

So irony became, for me, the monument that marked the loss of my innocence, the loss of straightforward belief in whatever appears natural or real, my loss of belief in the surface. I suspect my story is in many ways typical. Most children are fairly credulous. As they gain experience in the world, they realize how the surfaces of the world are illusory, and they fall into irony. One of our culture's most central stories is about how in the Garden of Eden, Adam and Eve sinned and their eyes were opened. They saw things a different way. After Eden, everybody has had to deal with the duplicitous nature of reality. The exile from Eden, particularly the version in Milton's *Paradise Lost,* is one of the saddest stories I have ever read. But irony has entered the world, and there's no point in pretending otherwise.

Irony is not a valued mode within Christianity, of course, because Christianity is a religion of hope. And yet Frederick Buechner has made the point that belief does not come easily for anyone in the contemporary

world. "Not the least of my problems," Buechner says, "is that I can hardly even imagine what kind of an experience a genuine, self-authenticating religious experience would be. Without somehow destroying me in the process, how could God reveal himself in a way that would leave no room for doubt? If there were no room for doubt, there would be no room for me." Buechner's question is profoundly ironic.

Although irony is at least as old as Plato's dialogues, we tend to identify it with contemporary culture. Northrop Frye talked about contemporary literature as existing in the ironic mode. Listen to the mocking tone of many novels and poems. Criminals like Bonnie and Clyde and Butch Cassidy flaunt heroic status. And, of course, irony is essential to the accurate reading of images around us. We are barraged with advertising and political hard sells—claims that we wish were true but know are not. Even as we page through catalogues and dream of our next purchase, at some level we know it will not *satisfy* us for long. We might be materialists, but irony prevents us from being fools.

When I started working on my Ph.D. dissertation—which, not surprisingly, turned out to be about images—my advisor told me about the rabbit/duck sketch in Ernst Gombrich's book, *Art and Illusion*. If you look at it one way, it's a rabbit. If you blink and look at it another way, it's a duck. By showing it to my friends, I discovered there are people who can't see the rabbit, who only see the duck, and *vice versa*. But the triumph of that sketch is that most people can see both. It is two things in one. The rabbit both *is* and *is not*. The duck both *is* and *is not*.

During some of those lonely mornings at home when I was supposed to be scribbling my dissertation on a legal pad, I stared at Gombrich's rabbit/duck until I got pretty good at making myself see whichever one I chose. No one can see both at the same time. So the sketch forces the process of going back and forth. And that changing perspective is what was important to Gombrich and to me—not the rabbit or the duck itself.

By practicing the switch, I gained control over it. Having lost its power to shock me, and when there was nothing at stake, it began to make me happy. It functioned like a game. Who really cares whether the thing is a rabbit or a duck? But most of the time when I lose an image, I don't feel that kind of detachment. If I have a stake in some

image and then discover I have been fooled, the shift can feel like a rip-off—even though I am on the lookout for it now.

I would like to say that the rabbit/duck picture helps me remember that images are never true or false, that they can only *represent* more or less adequately. But, in fact, I often forget. The minute I fail to see that an image *is* an image, for my purposes it *becomes* the thing itself. That is a sort of literalism. Idolatry. And for me it almost always turns out to be painful. Everyone knows the commandment that sets up idolatry as one of the greatest sins. Israel was to make no graven image of God, presumably because it is so easy to mistake an image for God himself.

Indeed.

I am a sucker for words and music and dance and painting. I keep falling in love with them and mistaking them for the truth, and then, like Snoopy, I experience a rude awakening. That is, I lose the image and I am hurt. I re-learn painfully that no image is the thing itself, that there is a built-in ambiguity to images. Ultimately, around the time I had my first child, the year I finished my dissertation, I said to myself: Well, this ambiguity is not lack of meaning. If I can move between two meanings, I am not without either. The rabbit/duck sketch doesn't mean *Nothing*, it means *Both*—the rabbit *and* the duck. Surely there is no reason to get so bitter over the instability of an image. A shifting perspective is not the same as meaninglessness.

What followed was a new stage of belief. Or, I should say, a new *kind* of belief. Shortly after I stopped seeing images as literal, I began to understand metaphor. In the process, I started writing poetry and then fiction, and finally, I started writing for the theater. Talk about metaphor! On the stage Dustin Hoffman walks around pretending he is Willy Loman, saying all the things a salesman might say in his actual living room. But he is in a theater, not a living room, and Willy Loman is a made-up name. So a production of *Death of a Salesman* is either metaphor or it's madness. *Group* madness. But of course, by the very act of going to a play, we are agreeing that an actor is both himself and another person, whom we are watching, through a fourth wall, live out his life. That is, by buying a ticket to the theater, we have agreed to participate in a metaphor.

Metaphor states a mystery. It collapses the membrane between the thing itself and the image of it. The formulation is that of an equation, $X=Y$. But unlike mathematical equations, metaphor participates in

absurdity, because X is also utterly different from Y. Say the moon is a thumbtack in the sky. At the risk of belaboring the obvious, the moon is not like a thumbtack in most senses. It does not have a point and it cannot be held in your hand, for example. But for a fleeting moment you see the two terms of the metaphor as married and you understand the truth, which is a third thing, which is transcendent, beyond either of the two terms. I believe now that metaphor, which cannot be taken literally because it has paradox at its heart, must be our most accurate way of stating the transcendent.

I love metaphor. I am endlessly grateful for it. I do not believe for a second that anyone, while thinking up a metaphor, can be hopeless or without vision. Whatever the initiating spirit is called, writing involves a renewed faith which seems to come unbidden. Call it the play of grace—whatever rushes in with a new image to replace the old one. It begins as the itch to live and to create. What I think of—the new image—is often wacky or childlike or unorthodox. It is sometimes misshapen. It is frequently astonishing and uncooperative. But above all, it is born out of hope. It is new and palpable. Maybe it is provisional. It might not work. But it is not skeptical. It is a possibility.

As a writer, I do not live in a state of loss. I *replace* lost images with something else. People have connected this process of creating new images to God for a long time. The Greeks talked about the nine Muses, who lived on Mount Olympus and poured their glory on chosen poets and sculptors. Milton called his inspiration the Holy Light. English Renaissance iconography connected the three Graces with the grace of artistic creation. Writers still marvel over the way their novels or poems steer them into mysterious places they could never have discovered by themselves.

If I could write an open letter to my fundamentalist people, I would say: All right. Images are dangerous. One keeps losing them, precisely because they are not the thing itself. The thing itself stays intact. So who cares if any *particular* image of the Jordan River or the second coming survives? The loss of those images doesn't need to wreck anyone's faith. If you want proof, just look at what happened to me. When I lost the image of Jesus's second coming, I entered a new stage of belief. What I mean is that the loss led me beyond literalism to an understanding of metaphor.

All that is well and good. But my people might ask, what about the truth? All these new images are weird and scary. Yes, they are. Even to the artists who create them. Any artist worthy of the name worries a lot, moreover, that his new image may be false. No wonder artists fiddle and revise endlessly. The new image never quite portrays the same truth as the old one. That's a fear-inspiring fact. And even if the new image becomes well known, it might not be as brilliant as what came before. While a new love poem might convey the edgy speed of street slang, it may not make a reader feel the pang caused by Shakespeare's "bare ruined choirs where late the sweet birds sang." Certainly the two will not *mean* the same thing.

But the record shows that the truth can take care of itself. I think the succession of images in the history of art is in some ways similar to the succession of translations of the Bible. As Andrew Walls has pointed out, the Christian faith has been processed through dozens of translations as it passed from Aramaic to Greek to Latin to Celtic to Romance languages and African languages and Asian languages. One of the glories of Christianity is its ability not only to survive but to flourish in these transformations. And in the same way, as Christianity has touched each new culture, it has excited glorious and ever-changing songs and pictures and stories. But no one of these captures the whole truth. Each is a different approximation. Each is not the Thing itself, but an image.

Images are dangerous. They are powerful. If they affect you, the arts can be frightening because they use images while, at the same time, exposing them for what they are—ambiguous and shifting and replaceable by other images. In fact, my life as a writer involves continual loss and a certain kind of irony. But on the heels of this irony comes new understanding and renewed faith. I write to assure fundamentalists: *Not all artists are hostile to your faith.* I write to comfort artists: *Not all fundamentalist Christians need be lost to your work.* I write to urge both groups to stop hating each other, to regard one another with kindness. I write to tell them that they may not be so different from one another as they imagine. Both celebrate and are moved by the transformative power of images. I say, let images transform the world, let new words and new music and new choreography point out new ways to the truth.

WIM WENDERS

Interrogation [essay]

A S SOON AS I KNOW in the back of my head that I am going to be answering this question for *Image* (as soon as I am free to sit down at my computer and ponder it) I find myself trying to respond to it under all sorts of circumstances.

I get up in the morning and brush my teeth. "Why do you believe in God?" I ask the face in the mirror.

I ride through the city on my bicycle and stop at a red light. "Hey, why do you believe in God?"

Filming at the G8 summit, I find myself sitting on the asphalt among the protesters in a roadblock. I stare into the sky: "Why do I believe in God?"

Right now, for instance, I'm in an airport waiting for my connecting flight. I eat a sandwich and try to avoid looking at the TV screen above me. (Is it a disease or a bad habit that I always have to watch whenever something presents itself, no matter what it is?) I take out my notebook: *Why do I believe in God?*

The answer is never the same. Depending on where I am and how I feel, on who I imagine I'm answering to, the response changes. Is that a good sign or a bad sign? Shouldn't my answer always be the same?

And doesn't the question somehow intrinsically imply that I am asking it of myself? But why would I? Would such a self-interrogation ever cross my mind?

Not now, but some time ago, it might have.

I have been away from God for a large part of my life, so I remember his absence. No, that's the wrong way to say it. He wasn't absent, I was. I had gone into exile of my own free will. I meandered through

all sorts of philosophies, surrogate enlightenments, adventures of the mind, socialism, existentialism, psychoanalysis (another ersatz religion). Some of these I won't deny or badmouth. I'm happy to have been there—and back.

I remember how tentatively I started to pray again. I remember how that slowly changed me. I remember how I wept when I realized I had finally come home, when I felt that I was found again.

And how that feeling slowly transformed into a certainty.

Yes, a certainty.

But can I now answer: I believe in God because I remember how lost I was when I didn't care? Or: I believe in God because I couldn't take his absence anymore? Or: I believe in God because I cannot imagine any alternative? Or could I even conclude: I believe in God because in my life God has become such a reality that the very question is like asking myself why I breathe?

Asking myself is obviously not the right approach. Any reason is necessarily redundant. It will not get you, the reader, anywhere. I have to imagine somebody with that burning question on his mind, somebody to whom I can respond.

I'll think of somebody who does not believe in God.

"How are you?" I'll ask him. (Somehow I imagine a man. I meet far fewer women who do not believe in God.)

"Fine," he'll say.

"Let's cut to the chase," I'll say. "You seem like an intelligent, caring, decent person. It is difficult for me to grasp how you live your life without knowing God is watching you."

He smiles at me. "Same to you. How can you even know he's watching? I mean *know*, not just vaguely *sense*."

"If God could be taken for granted, so that we could all be certain of him, there'd be no more sense in believing—"

He interrupts me. "Obviously. But 'believing' leaves me with a choice. I took the other option. God didn't seem to want to present himself too obviously to me."

"Did you try to listen?"

"Very much so. I just didn't hear a thing."

We fall into a silence.

"That was the wrong approach, then," I finally say. "Tell me another thing: How come we're here, even *thinking* about God."

"We could be thinking about any other concept."

"Only God's existence is beyond any concept."

"I'm not sure I'm following you," he says.

"For me, God is the creator of all, and therefore of any concept," I say.

"I hear you. But for me it's all biochemical reactions and cell activity and evolution. No need for a creator."

"So you assume that the very existence of life, the very existence of love can be explained by that."

"Yes, my friend."

Another silence. And I realize that in the long run there is no convincing argument between a believer and a nonbeliever. We can't really dispute the existence of God.

If I can't persuade (let alone convert) an atheist, and if, when I put it to myself, the question is redundant, how do I answer it? *I believe, therefore I am?*

I go for a walk. By now I'm in the countryside in Italy, no longer in a big city. Funny how that changes perspectives. Sometimes, surrounded by technology and man-made objects, people have difficulty experiencing faith. They feel so self-sufficient that God can only be a secondhand experience for them. (That's common enough these days. It's stunning how people have gotten used to living practically without self-acquired knowledge, without any apparent need for a firsthand life.)

So once more, sitting in a field and letting the sun shine on me, I ask myself: "Why do I believe in God, Wim?"

"He called me by my name."

He did. That's all I can say in the end.

I am thankful for that every day.

Grace.

JOY WILLIAMS

Ack [fiction]

W E WERE visiting with friends of mine on Nantucket.
Over the years they've become more solitary. They're
quite a bit older than we: lean, even wolfish in appearance,
intelligent and carelessly stylish. They drink too much. And I drink
too much when I visit them. Sometimes we'd just eat cereal for supper;
other times we'd be subjected to an entire stuffed fish and afterwards
a tray of Grape-nut pudding. Their house is old and uncomfortable,
with a small yard dark with hydrangeas in August. This was August.
I told my wife not to expect dinner from my erratic friends, Betty
and Bruce. We would have a few drinks and then return to the inn
where we were staying which offered a late supper. There was only
one other guest expected on this evening, a local woman who had
ten daughters.

"What an awful lot," my wife said.

"I'm sure we'll hear about them," I said.

"I suppose so," Bruce said, struggling to open an institutional-size
jar of mayonnaise which had been placed on a weathered picnic table
in the yard.

"She's unlikely to talk about much else with that many," my wife
said. "Are any of them strange?"

"One's dead, I believe," my host said, still struggling with the jar.
"Whatsoever thy hand findeth to do, do it with all thy might," he said,
addressing his own exertions.

"Let me give that a try," I said, but Bruce had found the proper
grip and broken the plastic seal.

"I meant intellectually or emotionally or physically challenged," my
wife said, determinedly returning to the subject of the daughters. She
had already decided to dislike this poor mother.

Bruce dipped a slice of wilted carrot into the jar. "I really like
mayonnaise. Do you, Paula? I can't remember."

"Bruce, you know very well it's Pauline," Betty said.

"I'm addicted to mayonnaise practically," Bruce said.

My wife smiled and shook her head. If she had resolved to become relaxed in that moment it would have been a great relief to me, for Bruce had been kind to me and there was no need for tension between them. Pauline prefers to be in control of our life and our friendships. She's a handsome woman, canny and direct, never unreasonable. I suppose some might find her cold but I am in thrall to her because before her I was almost crushed by life. I had some rough years before Pauline, years I only just managed to live through. I might as well have been stumbling about in one of those great whiteouts that occur in the far north where it is impossible to distinguish between a small object nearby and a large object a long way off. In whiteouts there is no certainty and every instinct is betrayed—even the birds fly into the ground believing it is the air, and perish. I strained to see and could not, and torn by strange sorrows and shames I twice attempted suicide. And then a calm suddenly overtook me, as though my mind had taken pity on me and called off the hopeless search I had undertaken. I was thirty-two then. I met Pauline the following year, and she accepted me, broken and wearied as I was, with a conviction that further strengthened me. We have a lovely home outside of Washington. She wants a child, which I am resisting.

We were all smiling at the mayonnaise jar as though it were one of the sweet night treasures when a bell on a rusted chain wrapped around the garden gate jangled. We had entered by the same gate and likewise engaged the bell an hour before. A woman appeared, thinner than I expected, almost gaunt and shabbily dressed. She seemed a typically well-born island eccentric. She looked at us boldly and disinterestedly. This was not lost on Pauline. It was difficult to determine her age and so impossible to guess the ages of her many daughters. My first impression was that none of them had accompanied her.

"Starky, have a drink, my girl!" Bruce said, greeting her.

She embraced him, resting her cheek for a moment in his hair which was long and reached the collar of his checkered shirt. She breathed in the smell of his hair much as I had and found it, I imagine, sour but strangely satisfying. She then turned to Betty and kissed, as I had done, her soft warm cheek.

She had brought a gift of candles which Betty found holders for. The candles were lit and Pauline admired the pleasant effect, for with

night, the hydrangeas had cast an almost debilitating gloom upon the little garden. It did not trouble me that we had brought nothing. We had considered a pie, but the prices had offended us. It was foolish to spend so much money on pie.

"Guinevere," Bruce called. "We're so glad you came!"

A figure moved awkwardly toward us and sat down heavily. It was a young woman with a round flat face. Everything about her seemed round. Her mouth at rest was small and round.

"Look at all that mayonnaise," Starky said. "Bruce remembered it is a favorite of yours."

"I like maraschino cherries now," the girl said.

"Yes, she's gone on to them," her mother said.

"I have jars of them awaiting fall's Manhattans," Bruce assured her. "Retrieve them from the pantry, dear. They're in the cabinet by the waffle iron."

"Guinevere is a pretty name," my wife said.

"She was instrumental in saving the whales last week," her mother said, "the first time, not when they beached themselves again. The photographer was there from the paper, but he always excludes Guinevere. She doesn't photograph well."

"So many pitching in to no avail," Betty said sadly. "And those beautiful animals!"

They continued to speak of the yearly summertime tragedy of schools of whales grounding on the shore. It's their fidelity to one another that dooms them, as well as their memories of earlier safe passage. They return to a once navigable inlet and find it a deadly maze of unfamiliar shoal. The sound of their voices—the clicks and cries quite audible to their would-be rescuers—is heartbreaking apparently.

Pauline pointed out that those sounds would only seem that way to sympathetic ears. It was simply a matter of our changing attitudes toward them, she argued. Nantucket's wealth was built on the harpooning of the great whales. Had they not cried out then with the same anguished song?

Starky murmured liltingly:

Je t'aimerai toujours
bien que je ne t'ai jamais aimé

It was impossible to tell if she possessed an engaging voice or not, the song, rather the song's fragment, was so brief. It was quite irrelevant, in my opinion to the topic of the whales.

Pauline frowned. "I will always love you though I never loved you.... Is that it? Certainly isn't much, is it?"

"One of Starky's daughters has a wonderful voice," Betty said. She looked about, almost in confusion.

Pauline nudged me as if to say, here it's beginning and we'll have to hear about all of them, even the dead one. She then continued resolutely, "...as a statement of devotion. But perhaps it was taken out of context?"

"Everything's context," Bruce said, "or is as I grow older."

Guinevere returned with a bottle of cherries and munched them one by one, dipping her fingers with increasing difficulty into the narrow jar.

"Those aren't good for you," Pauline said.

The girl tipped the liquid from the jar onto the flagstones and retrieved the last of the cherries.

"They're very bad for you," Pauline counseled. "They're not good for anyone."

The girl ignored her.

"Did you work at the library today?" Betty asked. "Guinevere has a job. She puts all the books back in their proper places, don't you, Guinevere?"

"Someone has to do the lovely things," Bruce said.

"And someone does the ugly things too," Guinevere said without humor. "In Amarillo, Texas, more cattle have been slaughtered than any other place in the world. They make nuclear bombs in Amarillo as well."

"You must read the books then," Pauline asked, "as you put them back on the shelves?" Her efforts at engagement with this unfortunate child were making me uncomfortable. She wanted a child but of course a lovely one. She had no doubt it would be a lovely one. Would even a bird build its nest if it did not have the instinct for confidence in the world?

"I have a joke," Guinevere said. "It's for him." She pointed at me. "They name roads for people like you."

"I think I've heard this one, but I can never remember it," Betty said.

"One Way," the girl said, and she smiled a round smile. She was much older than I had initially thought.

"You're such a chatterbox tonight," her mother said. "You must let others speak." Guinevere immediately fell silent, but for a moment we were all silent too.

"I'm going to get more ice," Pauline announced.

"Thank you," Bruce said. "And more ingredients for the rickeys all around, if you please."

Starky rose to accompany her into the house, which I knew would vex Pauline who only wanted to remove herself from this group for a while, a group I'm sure she found most unpromising.

"You look good, my boy," Bruce said.

"Thank you. It's Pauline's doing." Betty's look was skeptical. "I've found there's a trick to knowing where you are," I said. "It's knowing where you were five minutes ago."

"Why, you were here!" Betty said.

"I know where you were long before five minutes ago," Bruce said.

"Yes, you do," I agreed. "And if that man, that man you knew, came into the garden right now and sat down with us, I wouldn't recognize him."

"You wouldn't know what to say to him?" Bruce asked.

"I could be of no help to him."

"Those were dark times for you."

I shrugged. I had once wanted to kill myself and now I did not. The thoughts I harbored then lack all reality for me.

Bruce said nothing more. Quiet voices from the street drifted toward us. The tourists were "laning" which is a refined way of saying they were peering into the lamp-lit and formal rooms of other people's houses, which did seem on display, and commenting on the satisfactoriness of the furnishings, the paintings, the flower arrangements and so on.

My thoughts returned to the whales and their deaths. They were small pilot whales, not the massive sperm whales which Pauline had made reference to, the taking of which had made this island renowned. The pilot whales hadn't wished to kill themselves, of course. But one was

in distress, the one who was first to realize the gravity of the situation, the dangerous imminence of an unendurable stranding, and the others were caught up in the same incomprehension. In the end they had no choice but to go where the dying one was going.

Or that's one way of putting it. Marine biologists would know far better than I.

Pauline returned, carrying a tray with an assortment of bottles and a mixing bowl of melting ice. "Starky is on the phone," she announced.

"It's probably her real estate agent," Bruce said. "She told me he might be contacting her tonight. She's selling her home, the one where she raised all her girls."

"I'm sure she'll get whatever she's asking," Pauline said. "People are mad for this place, aren't they? They'll pay any price to say they have a home here."

The night was growing colder. Bruce had brought out several old sweaters earlier and I pulled one over my head. It fit well enough—a murrey cashmere riddled with holes.

Betty placed her tanned and deeply wrinkled hand on mine. The veins were so close to the surface I wondered if they didn't alarm her whenever they caught her eye. She had to look at them sometimes.

"We are all of us unique, aren't we? And misunderstood," she said.

"No," I replied, not unkindly, for I was devoted to Betty, though I was beginning to wonder if she wasn't becoming a bit foolish with age. The world does not distinguish one grief from another. It is the temptation to believe otherwise that keeps us in chains. "We are not as dissimilar from one another as we prefer to think," I said.

The rickeys were not as refreshing as they had been earlier. It was perhaps because of the ice.

Starky reappeared, gaunt and unexceptional as before and giving no explanation for what had become a prolonged absence.

"Oh, do begin now," Betty said.

"Begin what?" Pauline asked.

"Without further preamble?" Starky said.

"Or delay," Bruce said.

"What must this place be like in the winter!" Pauline cried.

We all laughed, none more forgivingly than Starky, who then began, as I had suspected, to describe her children.

"My first daughter is neither bold nor innovative but feels a tenderness toward all things. When she was young she was understandably avaricious out of puzzlement and boredom but experience has made her meek and devoted. She is loyal to my needs and outwardly appears to be the most praiseworthy of my children. She ensures that my lucky dress is always freshly cleaned and pressed and waiting for me on its cloth-covered hanger. Despite such conscientiousness, I feel most distanced from this child and might neglect her utterly were she not the first.

"My second daughter is the traveler of the family even though she seldom rises from her bed. One need only show her the shell of a queen conch or a paperweight with its glass enclosing a welsh thistle and she is swimming in the Bahamas or tramping the British Isles, though this only in her mind, for she is far too excitable and shy to make the actual journey. She prepares for her adventures by anticipating the worst and when this does not occur she delights in her good fortune. Some who know her find her pitiful but I believe she has saved herself by her ingenuity. The bruises she shows me on her thin arms and legs, even on her dear face, incurred in the course of these travels, evoke my every sympathy."

"This is preposterous," Pauline whispered to me.

"My third daughter," Starky continued, sipping her drink, "is plain and compliant, with great physical stamina. In fact it is by her strength that she attempts to atone for everything. She is sentimental and nostalgic which is understandable for given her nature her future will be little different from her past. She is not lazy. On the contrary she labors hard and conscientiously, but her work is taken for granted. She is hopeful and trusts everyone, leaving herself open to betrayal. She pores over my trinkets, believing that they have special import for her. She often cries out for me in the night. Though she never calls it by name, she fears death more than I, more, perhaps, than any of us here."

"Bless her heart, Betty said.

"Does she?" Pauline asked. "But there's no way of judging that is there? I mean how can you even presume..."

"I wish you'd continue," Betty said to Starky.

"Yes," Bruce said. "Mustn't get stalled on that one."

"My fourth daughter is a singer, an exquisite mezzo-soprano. Her voice was a great gift. She hasn't had a single lesson. Even when it became clear that she was extraordinary, we decided against formal training which would only have perverted her voice's singularity and freshness. Sing, I urge her always. Sing! For your voice will desert you one day without warning."

"Mommy," Guinevere said, startling me, for I had forgotten her completely.

"Do sing for us, Guinevere," Betty said. "We so love it when you sing."

"Yes, go ahead," her mother said.

The girl's round mouth grew rounder and after a moment in which, I suppose, she composed herself, she sang in the most thrilling voice:

> *If there had anywhere appeared in space*
> *Another place of refuge, where to flee*
> *Our hearts had taken refuge in that place*
> *And not with thee*
>
> *And only when we found in earth and air,*
> *In heaven or hell, that such might nowhere be*
> *That we could not flee from thee anywhere,*
> *We fled to thee.*

There was silence.

"My God," I said.

"How sweet," Pauline allowed.

"Is that Trench?" Bruce asked. "I'm not as keen as I used to be in identifying those old English hymnists."

Guinevere rose and said something urgently to Betty.

"Go behind the bushes, dear," Betty said. "It's quite all right."

"Behind the bushes!" Pauline exclaimed. "She's a grown woman!"

"Guinevere doesn't like our bathroom," Betty said. "It frightens her."

"Perhaps there are ghosts," Pauline said. She giggled and whispered in my ear, "Don't tell me the Vineyard wouldn't be better than this."

"I don't know about ghosts," Betty said, "but in any old house you can be sure things happened, cruel and desperate things."

When Guinevere had disappeared behind the large lavender globes of the hydrangeas, her mother said quietly, "Her voice is in decline."

"I find that difficult to believe," I said, though of course I am no expert. "Her voice is splendid."

Starky said calmly, "She is like a great tree in winter whose roots are cut, only mimicking what the other trees can promise—the life to come."

Guinevere returned and took her place. She could not be convinced to sing again. We were all sitting on old metal chairs, rusted from years of the island's heavy almost unremitting fog, but not so badly that they marked one's clothes. I believe Bruce and Betty stored them in the cellar during the winter.

"My fifth daughter," Starky resumed to my dismay, "is the one I personally taught about time. I did her no service for she is my most melancholy child. She is unable to give value to things and never surrenders herself to comforting distractions. Alternatives are meaningless to her. She is a hounded girl, desolate, captive, seeking in silence some language that would serve her. Faith would allow her some relief, but she resists the slavishness of spirit that faith would entail. No, for her faith is out of the question."

Bruce gestured for me to make more drinks for all. I wanted further drink badly. Indeed I had almost taken Pauline's glass and drained it as my own. Something was stirring in me and with it a chilling sense of the immediacy of something that is inconceivable. I made the drinks quickly, without the niceties of sugar or lime and with the last of the ice.

"My sixth daughter is dead," Starky said. "She ran the brief race prescribed to her and now her race is done."

"She has a lovely stone," Betty said.

"She wanted a stone," Starky said. "I had to assure her over and over that there would be a stone."

"Well it's lovely," Betty said.

"She found the peace which the world cannot give," Starky said, quite unnecessarily, I thought.

Pauline stared at her, then turned to me and said, "What could she possibly mean? How could she know what the poor thing found?"

I wanted to calm her though I knew she was more angry than anxious. Only hours before this mad evening had begun we were sitting quite happily alone on the moors, or what they refer to as the moors on this island for they are not technically moors. We had wasted the morning we'd agreed then, but not the afternoon. We could not see the sea though we were aware of it because of course it was all around us. Love's bright mother from the ocean sprung, the Greeks believed.

"I can't bear this another moment actually," Pauline said, rising to her feet. "Why do you expect to be so indulged? Why did you have so many? Where is the father? Who is the father? The children are freakish the way you present them. Why do you put them on such cruel display? Why are their efforts so feeble and familiar? Why are you not more concerned? This is not the way friends spend a sociable evening. Why didn't you tell a real story, not even once? How could you believe we would even be interested? No, I can't endure this any longer."

And with this she hurried out, unerringly I must say, through the dark garden, across the uneven flagstones. It took me several minutes to say my apologies and goodbyes but even I left so hastily that it was not until I was well down the street that I realized I was still wearing Bruce's old sweater. I would mail it to him in the morning before we boarded the ferry. I wondered if Betty and Bruce would store the old chairs when the days grew bitter and if they did would the effort be made to bring them out again in the spring.

It must have been quite late, for the streets were deserted. I hoped that a walk, at my own pace in the light chill fog, would clear my head. Starky had seemed amused by Pauline's outburst and Betty and Bruce unperturbed, while Guinevere had not raised her head, either then, or at my own departure. Indeed, she appeared to be practically in a stupor. Her mother might have been correct. The effort she was making could not be sustained much longer.

I walked slowly down the cobblestoned main street, turning left at the museum where earlier in the day Pauline and I had spent some time, less than an hour, for it was a dispiriting place, cheerfully staffed by volunteer docents but displaying the most grotesque weapons and tools of eighteenth-century whaling—knives and spades and chisels, harpoons and lances and fluke chains. Antique drawings and prints accompanied by descriptive commentary filled the walls. One phrase

concerning the end of the flensing process which took place alongside the ships remains with me:

Finally the body was cast off and allowed to float away.

Most disturbingly put, I felt, the word *allowed* being particularly horrible.

Pauline had been quite right about the whales. Had they not cried out in the days of their destruction with anguished song? And their pursuers, with a purpose unfathomable to them, had not heard them. Indeed, man had only reveled in the fine red mist which fell as though from heaven, which signaled the collapse of those great hearts and heralded the deaths of the harried and bewildered creatures.

The inn where we had taken lodging was now in sight. I thought once again of the debt I owe Pauline. I owe her everything I am. I would even prefer that she would leave this life, in time, before me, but I do not feel strongly about this. It is proof of her success with me that I could entertain such a thought. One of us will be the first, in any case, and until then, we have each other.

CHRISTIAN WIMAN

God's Truth Is Life [essay]

WHEN I WAS TWENTY years old I spent an afternoon with Howard Nemerov. He was the first "famous" poet I had ever met, though I would later learn that he was deeply embittered by what he perceived to be a lack of respect from critics and other poets. (I once heard Thom Gunn call him a "zombie.") My chief memories are of his great eagerness to nail down the time and place for his mid-day martini, him reciting "Animula" when I told him I loved Eliot, and asking me at one point—with what I now realize was great patience and kindness—what I was going to do when I graduated later that year. I had no plans, no ambitions clear enough to recognize as such, no interest in any of the things that my classmates were hurtling toward. Poetry was what I spent more and more of my time working on, though I found that vaguely embarrassing, even when revealing it to a real poet, as I did. Equivocations spilled out of me then, how poetry was all right as long as one didn't take it too seriously, as long as one didn't throw one's whole life into it. He set down his martini and looked at me for a long moment—I feel the gaze now—then looked away.

§

The irony is that for the next fifteen years I would be so consumed with poetry that I would damn near forget the world. One must have devotion to be an artist, and there's no way of minimizing its cost. But still, just as in religious contexts, there is a kind of devotion that is, at its heart, escape. These days I am impatient with poetry that is not steeped in, marred and transfigured by, the world. By that I don't mean poetry that has "social concern" or is meticulous with its descriptions, but a poetry in which you can feel that the imagination of the poet has been both charged and chastened by a full encounter with the world and other lives. A poet like Robert Lowell, who had such a tremendous imagination for language but none at all for other people, means less and less to me as the years pass.

§

I once believed in some notion of a pure ambition, which I defined as an ambition for the work rather than for oneself, but I'm not sure I believe in that anymore. If a poet's ambition were truly for the work and nothing else, he would write under a pseudonym, which would not only preserve that pure space of making but free him from the distractions of trying to forge a name for himself in the world. No, all ambition has the reek of disease about it, the relentless smell of the self—except for that terrible, blissful feeling at the heart of creation itself, when all thought of your name is obliterated and all you want is the poem, to be the means wherein something of reality, perhaps even something of eternity, realizes itself. That is noble ambition. But all that comes after—the need for approval, publication, self-promotion: isn't this what usually goes under the name of "ambition"? The effort is to make ourselves more real to ourselves, to feel that we *have* selves, though the deepest moments of creation tell us that, in some fundamental way, we don't. (What could be more desperate, more anxiously vain, than the ever-increasing tendency to Google oneself?) So long as your ambition is to stamp your existence upon existence, your nature on nature, then your ambition is corrupt and you are pursuing a ghost.

§

Still, there is *something* that any artist is in pursuit of, and is answerable to, some nexus of one's being, one's material, and Being itself. The work that emerges from this crisis of consciousness may be judged a failure or a success by the world, and that judgment will still sting or flatter your vanity. But it cannot speak to this crisis in which, for which, and of which the work was made. For any artist alert to his own soul, this crisis is the only call that matters. I know no name for it besides God, but people have other names, or no names.

§

This is why, ultimately, only the person who has made the work can judge it, which is liberating in one sense, because it frees an artist from the obsessive need for the world's approval. In another sense, though, this truth places the artist under the most severe pressure, because if that original call, that crisis of consciousness, either has not been truly

heard, or has not been answered with everything that is in you, then even the loudest clamors of acclaim will be tainted, and the wounds of rejection salted with your implacable self-knowledge. An artist who loses this internal arbiter is an artist who can no longer hear the call that first came to him. Better to be silent then. Better to go into the world and do good work, rather than to lick and cosset a canker of resentment or bask your vanity in hollow acclaim.

§

Dietrich Bonhoeffer, after being in prison for a year, still another hard year away from his execution, forging long letters to his friend Eberhard Brege out of his strong faith, his anxiety, his longing for his fiancée, and terror over the nightly bombings: "There are things more important than self-knowledge." Yes. An artist who believes this is an artist of faith, even if the faith contains no god.

§

Reading Bonhoeffer makes me realize again how small our points of contact with life can be, perhaps even necessarily *are*, when our truest self finds its emotional and intellectual expression. With all that is going on around Bonhoeffer, and with all of the people in his life (he wrote letters to many other people and had close relationships with other prisoners), it is only in the letters to Brege that his thought really sparks and finds focus. Life is *always* a question of intensity, and intensity is always a matter of focus. Contemporary despair is to feel the multiplicity of existence with no possibility for expression or release of one's particular being. I fear sometimes that we are evolving in such a way that the possibilities for these small but intense points of intimacy and expression are not simply vanishing but are becoming no longer felt as necessary pressures. Poetry—its existence within and effect on the culture—is one casualty of this "evolution."

§

The two living novelists whose work means most to me are Cormac McCarthy, particularly in *Blood Meridian,* and Marilynne Robinson. Both of these writers seem to me to have not only the linguistic and metaphorical capacities of great poets, but also genuine visionary feeling. My own predispositions have everything to do with my

preference, of course: I *believe* in visionary feeling and experience, and in the capacity of art to realize those things. I also believe that this is a higher achievement than art that merely concerns itself with the world that is right in front of us. Thus I don't respond as deeply to a poet like William Carlos Williams as I do to T.S. Eliot, and I much prefer Wallace Stevens (the earlier work) to, say, Elizabeth Bishop. (To read his "Sunday Morning" as it apparently asks to be read, to take its statements about reality and transcendence at face value, is to misread—to *under*-read—that poem. Its massive organ music and formal grandeur are not simply aiming at transcendence, they are claiming it.) Successful visionary art is a rare thing, and a steady diet of it will leave one not simply blunted to its effects but also craving art that's deeply attached to this world and nothing else. This latter category includes most of the art in existence (even much art that seems to be religious), and it is from this latter category that most of our aesthetic experience will inevitably come.

§

The question of exactly which art is seeking God, and seeking to be in the service of God, is more complicated than it seems. There is clearly something in all original art that will not be made subject to God, if we mean by being made "subject to God" a kind of voluntary censorship or willed refusal of the mind's spontaneous and sometimes dangerous intrusions into, and extensions of, reality. But that is not how that phrase ought to be understood. In fact we come closer to the truth of the artist's relation to divinity if we think not of being made subject to God but of being *subjected* to God—our individual subjectivity being lost and rediscovered within the reality of God. Human imagination is not simply our means of reaching out to God but God's means of manifesting himself to us. It follows that any notion of God that is static is not simply sterile but, since it asserts singular knowledge of God and seeks to limit his being to that knowledge, blasphemous. "God's truth is life," as Patrick Kavanagh says, "even the grotesque shapes of its foulest fire."

§

What is the difference between a cry of pain that is also a cry of praise and a cry of pain that is merely an articulation of despair? Faith?

The cry of a believer, even if it is a cry against God, moves toward God, has its meaning in God, as in the cries of Job. The cry of an unbeliever is the cry of the damned, like Dante's souls locked in trees that must bleed to speak, their release from pain only further pain. How much of twentieth-century poetry, how much of my own poetry, is the cry of the damned? (By "damned" I mean simply utterly separated from God, and not condemned to a literal hell.) But this is oversimplified. It doesn't account for a poet like A.R. Ammons, who had no religious faith at all but whose work has some sort of undeniable lyric transcendence. Perhaps this: a cry that seems to at once contain and release some energy that is not merely the self, that does not end at despair but ramifies, however darkly, beyond it, is a metaphysical cry. And to make such a cry is, even in the absence of definitions, a definition, for it establishes us in relation to something that is infinite. Ammons:

> ...if you can
> send no word silently healing, I
>
> mean if it is not proper or realistic
> to send word, actual lips saying
>
> these broken sounds, why, may we be
> allowed to suppose that we can work
>
> this stuff out the best we can and
> having felt out our sins to their
>
> deepest definitions, may we walk with
> you as along a line of trees, every
> now and then your clarity and warmth
> shattering across our shadowed way:

§

Reading the Scottish poet Norman MacCaig and thinking again of how some poets—surprisingly few—have a very particular gift for making a thing at once shine forth in its "thingness" and ramify beyond its own dimensions: "Straws like tame lightnings lie about the grass / And hang zigzag on hedges"; or: "The black cow is two native carriers / Bringing its belly home, slung from a pole." What happens

here is not "the extraordinary discovered within the ordinary," a cliché of poetic perception. What happens is some mysterious resonance between thing and language, mind and matter, that reveals—and it does feel like revelation—a reality beyond the one we ordinarily see. Contemporary physicists talk about something called "quantum weirdness," which refers to the fact that an observed particle behaves very differently from one that is unobserved. An observed particle passed through a screen will always go through one hole. A particle that is unobserved but mechanically monitored will pass through multiple holes at the same time. What this suggests, of course, is that what we call reality is utterly conditioned by the limitations of our senses, and that there is some other reality much larger and more complex than we are able to perceive. The effect I get from MacCaig's metaphorical explosiveness, or from that of poets such as Heaney, Plath, Hughes, is not of some mystical world, but of multiple dimensions within a single perception. They are not discovering the extraordinary within the ordinary. They are, for the briefest of instants, perceiving something of reality as it truly is.

§

Encroaching environmental disaster and the relentless wars around the world have had a paralyzing, sterilizing effect on much American poetry. It is less the magnitude of the crises than our apparent immunity to them, this death on which we all thrive, that is spinning our best energies into esoteric language games, or complacent retreats into nostalgias of form or subject matter, or shrill denunciations of a culture whose privileges we are not ready to renounce—or, more accurately, do not even know how to renounce. There is some fury of clarity, some galvanizing combination of hope and lament, that is much needed now, but aside from some notable exceptions of older poets (Adrienne Rich, Eleanor Wilner) it sometimes seems that we—and I use the plural seriously, I don't exempt myself—are anxiously waiting for the devastation to reach our very streets, as it one day will, it most certainly will.

§

"The intellect of man is forced to choose / Perfection of the life, or of the work, / And if it take the second must refuse / A heavenly

mansion, raging in the dark." Lord, how much time—how much *life*—have I wasted on the rack of Yeats's utterly false distinction. It is not that imperfections in the life somehow taint or invalidate perfections of the work. It is, rather, that these things—art and life, or thought and life—are utterly, fatally, and sometimes savingly entwined, and we can know no man's work until we know how, whom, and to what end he did or did not love.

LARRY WOIWODE

Dylan to CNN [essay]

S ERIOUS NEWS arrives in a calamitous context, already upon us, or an artistic one, with its newsworthiness intact. A thousand years before the birth of Jesus, Homer was reciting in verse the lessons and warnings of war and, in contrast, extolling domestic life on home ground.

The troubadour poets of southern France and northern Spain and Italy were nobles who held political strongholds from the twelfth to the fourteenth centuries, and were newsbringers. Richard I of England was one. Troubadours employed servants, called jongleurs, to set their words to music, so it arrived in a form we might call "artistic news."

In England troubadours were named minstrels, from the Latin *minister*, meaning servant. Since the poems of troubadours are preserved in the canon of Anglo-Saxon and Provençal poetry, you may wonder whether calling them newsbringers, the anchors of their day, is accurate. Not all their work survived, and the fate of their more pointed compositions is clear from the way the troubadours met their end on the continent: "The great cause of the decadence and ruin of the troubadours," says a trustworthy version of the Britannica, the fourteenth edition (of 1929), "was the struggle between Rome and the heretics." That is, their unofficial capacity was viewed as heretical.

The minstrels of England didn't fare much better. They sank to the level of forming a guild in London, a kind of union that all were supposed to join, but didn't, of course, being writers. Finally the minstrels faced the troubadours' fate: the Church denounced them, and "The state also viewed them with disfavor as men who wasted their own time and that of their listeners. For these masterless men carried the news from place to place, sang biting lampoons against unpopular ministers, or voiced the wrongs of the poor.... Local riots seem to have owed much to their activity." They were put in stocks, whipped, imprisoned.

Why "a trustworthy version" of the Britannica? Because in our time facts have been fiddled with and details left out, as most realize. Our

descent into "newspeak," as George Orwell called it, or "spin," as we say now, has picked up such speed that what we take for facts, even those of history, are often forgeries. Big Brother was in operation long before 1984, giving his version of events, but we have been too busy with TV, that mind-numbing nurse and anesthetist of his, to notice.

I'm beginning to feel I'm:

> Knock, knock, knockin' on heaven's door,
> Knock, knock, knockin' on heaven's door.

One brief book holds most of the information gathered over the centuries on Shakespeare, while it would probably take a library to hold all the words and ephemera poured out on the phenomenon known as Bob Dylan. I heard his first album in 1963. He was my age, twenty-one, just a kid (though at the time I thought I was getting on in age), and I was drawn so far in that I've never quite found a way out. He delivered to my generation not only political and cultural news but, with each album, was clearly charting an individual spiritual odyssey—his own.

He came from the north country, the other side of my native state, where the wind hits heavy on the borderline—Hibbing, Minnesota, at the edge of the Mesabi Range. Outside Hibbing, excavations for iron ore have opened up a pit leagues deep and miles wide. The first sound of his voice entered me like electricity. I didn't think of him as a great poet, as academics have, but a troubadour, a newsbringer in touch with his and the world's makeup and not about to falsify his report for any favored political group or audience.

When I think of the first album I heard, *The Freewheelin' Bob Dylan*, I'm astonished at how the songs—"Masters of War," "Blowin' in the Wind," "A Hard Rain's A-Gonna Fall," and the rest—seem to be the raw nerve of my generation written down. The effect was a rage of recognition. We were displaced and restless and knew something was amiss, but didn't have words for it then.

Our condition is usually blamed on the repressive Eisenhower years, but I won't repeat that rhetoric. That decade was partly a comfort in the placid way it passed, under aging Ike. America has never again had quite the same confidence. That time had a tenderness, too, expressed

in the closeness of families, which may have risen from the knowledge that all that you cherished could disappear in a flash. A literal one.

Every week we heard more from schoolteachers or radio prophets or newsreels about a new twist on the atomic bomb: the *hydrogen* bomb. Once a month in my grade school we had a drill in which we practiced diving under our desks or standing against a wall, away from windows, to avoid the blast of the flash that could crisp us like the bodies in the film footage from Hiroshima and Nagasaki. These films were shown to teach us what to expect and how to react. I sometimes think we were inarticulate out of numbed shock.

And then there was Dylan. Here were the words we had been searching for, an outpouring from this quirky writer and musician who took his name from the last Romantic Poet, Dylan Thomas (no matter what he may have said later), though his adopted father was Woody Guthrie. Dylan was a radical populist from the northern hotbox of LaFollette and the Non-Partisan League, and he delighted in all he did, laughing and making mistakes on tracks and leaving this on his records, happy to take his act anywhere he was asked.

"The Times They are A-Changin," he told us, and we were "Only a Pawn in Their Game," those "Masters of War," but he promised we would see a day "When the Ship Comes In":

> Oh the foes will rise
> With the sleep still in their eyes....
> Then they'll raise their hands,
> Sayin' we'll meet all your demands,
> But we'll shout from the bow your days are numbered.
> And like Pharaoh's tribe,
> They'll be drownded in the tide,
> And like Goliath, they'll be conquered.

This is the original version of what contemporary Christians call a ministry of music. Before this we had gospel singers and country singers who added gospel to their repertoires, but none was reaching the broader, young audience with religious imagery and content as Dylan did. Killjoys said of him, "Aw, he can't sing," or "He can't play," as if that dismissed him.

He set the agenda for a generation, and neither it nor the world has recovered. He galvanized our view on civil rights: integration, Selma, and Oxford. His songs sent thousands to picket lines. He wrote such an articulate series of anti-war songs that he can ultimately be seen, with his voice and lyrics, as the one who ended the war in Vietnam. His words drew protesters by the ten thousands.

Dylan didn't write the slogan for the generation—Don't trust anybody over thirty—but his songs inspired it. They were pitiless in describing the generation gap, as it came to be called:

> Because something is happening here
> And you don't know what it is
> Do you, Mr. Jones?

He made drugs appear a tool and prohibition of elderly folk ("Everybody must get stoned!") and exuded a casual attitude toward sex ("Don't think twice, it's all right"), yet sang with a heart-stopping tenderness about women, beginning with the "Girl From the North Country" to "Oh, Sister," and beyond. He added another theme—Make love, not war—to the agenda of those now called hippies, who before had been socialists or utopians or commies or beatniks.

Whether we agree with him or take exception at every point, there's no denying his impact in those days before the Beatles or Stones or all their current imitators. This is the news of real history. Within a matter of years, as if overnight, the repressive view of the body and its sexuality present in the Christian (and most every contemporary) community swung to the other side: sexual license. This may have been in reaction against the Eisenhowerish sense of community, under which many in my generation, as they grew up, heard from their parents not so much about a moral or ethical standard as fearful considerations of what the neighbors might think.

In 1965 at the Newport Festival, a host of followers booed Dylan off the stage because he introduced into his act the instruments we associate with rock, even "Christian" rock. Before, he had accompanied himself on his acoustic guitar and harmonica. His admirers and adherents believed he had deserted them and the cause.

He wasn't a chameleon; he was maturing, the enduring quality of a newsbringer. He didn't see himself as a celebrity or an artiste (he

sang about these with irony or scorn), or as the tool of any cause, but a performer who was out to do as much of the best as one can. Christians still seem confused on the use of popular music: according to the contemporary idiom, singing is a ministry, but it is more properly a vocation, chosen because of one's obvious gifts.

The glory of Dylan is the record of his spiritual journey. That journey became apparent in the album *John Wesley Harding*, continued to emerge in *New Morning*, and was made manifest in *Slow Train Coming*, *Shot of Love*, and the album with a title so specific it's hard to miss, *Saved*:

> I was blinded by the devil
> Born already ruined,
> Stone-cold dead
> As I stepped out of the womb.
> By His grace I have been touched,
> By His word I have been healed,
> By His hand I've been delivered,
> By His spirit I've been sealed.
> I've been saved
> By the blood of the lamb.

You can hardly get more explicit. Here is the genesis of Christian rock and all its groups. As Dylan was the musical father of Bruce Springsteen and dozens like him, so he was of Rich Mullens and his wave. He brought raucous art to gospel music and created the cymbal-clashing kind of psalm. When he stopped singing openly about salvation and its work, a new set of followers abandoned him, claiming he was no longer "Christian."

I'm not his apologist (think, though, of the sin and backsliding we tolerate in ourselves), but I suspect he found the liberty of serving his Savior in his art rather than through churchy confession. His change may be a loss to those who found faith through him, but his end is the celebration of God through the discipline of song and the good news true art brings.

His first identity, as a folk singer, defines his work. He wrote for the folk, as Shakespeare did (and here I do not equate the quality of their

art but their outlook). During Shakespeare's lifetime, most people at his plays were poor. Called groundlings, they stood or sat on the ground. The stage of Shakespeare's day, developed from the open courts of inns, was for them. In 1599 Shakespeare, now prosperous, built his own playhouse across the Thames, in Southwark, and named it the Globe. Its shape was a thatched, wooden O with a stage extending into its interior, open to the sky. The O structure held two raised decks that surrounded the stage. Lords and the ladies and some Puritans who didn't wish to be seen at a play were cloistered here, somewhat like spectators in a very small baseball stadium: the entire Globe was only eighty feet in diameter.

Groundlings gathered like groupies at a rock festival; if you've seen a concert in a stadium, you get the picture. They were in intimate proximity to the actors; the performance was a flesh-and-blood presence, the antithesis of the shadowy never-never land of movies and TV we absorb today. Those media, because of the frame they use, tend to open a window to the peeping tom in us. Their assumption is, Hey, you voyeur! They entice us to buy into the distancing destructiveness of another medium: pornography.

Dylan was never accused of obscenity onstage. Sometimes he rambled, or seemed to have had too much of something, and you never knew how the songs you had by memory might come out, but he always went from beginning to end, a professional dramatist. His acts were artful, from the simple, early ones—onstage alone with a stool and guitar and his harmonica in its holder at his mouth—to the arranged, titled tours like "The Rolling Thunder Review."

Dylan writes of fools and clowns but doesn't assume he's Shakespeare, though Shakespeare too wrote songs. Shakespeare was as popular in his day as Dylan in his. We should be able to see in both a relevant truth: to reach great numbers, a performer doesn't have to ratchet the level of art down to the lowest common denominator. Dylan and Shakespeare seemed always to have between their ears the best advice I've heard: you have to assume your reader is at least as bright as you.

Dylan's songs do not discriminate, as the best writing does not. Sometimes he may seem to be delivering messages from another planet; in fact, a favorite album of mine is *Planet Waves*. It's about love for a wife and children, and we come to understand that the planet that

animates him is no other than Earth. He is celebrating domestic life on home ground. He has sung with eloquence about so many issues at times when the news about them was needed, and has so often hit the target dead center, I often wonder if he isn't hot-wired to a manifestation of the Holy Spirit.

The premise of television news is that we're dumb and dumber, as a movie put it. The obscenity in this is its disdain for humankind. This is epitomized in the bland and repetitive disclosures and outright deception of CNN, which some have called Chicken Noodle Network, for its hodgepodge of slippery stuff. CNN was caught in a legal deception a year ago over a Peter Arnett story, but the deception goes on daily in their selection of "news," not to mention the commentary. There is art in this, or anyway artfulness, as in the engulfing Gulf War, which had the appearance on CNN of a mini-series from Hollywood. The deception here was supreme. Thousands were being killed, women and children, more than in Bosnia, but our viewpoint was CNN's: aerial glitz, bombs homing in on windows of buildings, not burning babies.

Ted Turner, the guru of CNN, sums up his opinion of a certain class of people in a word: stupid. He means Christians. CBS and NBC and ABC aren't quite as forthcoming, but their view is the same, judging from content. Christians are a convenient target for the networks' contempt of the audience in general, and perhaps this is deserved, since people keep watching.

And not only keep watching, but click to programs with scenes and words more provocative than any novel's. Faced with the hard copy of art, those Christians agitate to have it banned, then sink into the hypnotizing fuzz of TV. There they watch people of faith—or with any ethical standard—detonated by the likes of Oprah and Geraldo. The religious are the only slice of society it's safe to slam. They are fair game even on the worst shows, the ones shot through with canned laugher to cover their emptiness. No wonder books on self-esteem sell to Christians at such a clip.

People of faith, especially those who confess to take Jesus seriously, have to start looking away from TV for the news and stop imbibing as fact what they take in from Dan Rather or the latest anchor on CNN, material they receive as if from a prophet of the Bible, and sometimes seem to believe as if it's scripture. The sad news is that *they* is us. And

if we don't look away soon, we face the prospect of being clicked off ourselves, shut away from the artists and artisans and jongleurs and minstrels who are delivering the good news within the grace and health of a flesh-and-blood relationship, a living, breathing presence of the kind groundlings felt at the Globe, and we will be no better off than specks of light going dim and then snapping away into the black hole of our universe inside the tube.

TONY WOODLIEF

Name
<div align="right">[fiction]</div>

I AM LYING on cracked, checkered tile, watching a cricket. He is hiding behind Samphy's scuffed sandals, beside a broken pencil nub. The pencil is thick and brown, the kind we used here when this was a school. Samphy would recognize it, though he would deny this. He would also remember that crickets have always been drawn to this place. Sometimes two crickets would speak to each other from opposite corners of our school room, whispering cricket secrets in their soft, clicking voices. The other teachers lectured over them, but Samphy would stop teaching, angrily search out the crickets, and crush them with his sandal. Perhaps this cricket also remembers Samphy, and so he lies still and quiet on this tile, as I do.

Samphy's glasses have disappeared, but he didn't recognize me even when he wore them. The thin gold rims gleamed in the sun. I remember rushing into that gleam with my mind, the day they hung me from the old gymnastics frame in the courtyard. I imagined that the gleam was an angel's light, and that I was being lifted to heaven. Sometimes, to extract confessions, they hang people. They hang us by our arms and leave us for days, with mounded rice husks smoldering beneath our feet. Sometimes we die.

I thought I would die that day. The heat built like the hiss of cicadas until it was everything—everything except the gleam of Samphy's glasses. The fire scorched the hair on my legs and blistered my feet, but in my mind I followed that light to heaven. My father and mother were there, and Sister Jeannette, and Linh. I wept when the guards cut me down, and they mistook the reason for my tears.

They call this place Tuol Sleng—*hill of the poison tree*. Chantrea whispered this to me one night as we lay side by side, chained with fifty others to an iron bar running the length of a classroom. Chantrea smells of urine and fear, and she should not speak, but sometimes she whispers to keep from weeping, which is a worse offense. She tells me

the workers next door had another name for Tuol Sleng—*the place where people go in but never come out.*

Chantrea is watchful. Even here she watches, her eyes wide and white, like little moons. The factory boss accused her of spying, and so now she sees for herself what happens here. Perhaps once she spoke to him disrespectfully, or maybe production had fallen and he wanted back into the good graces of the Party. Perhaps he really did think Chantrea was a spy. Eventually everyone will prove a spy. The last Khmer will have to slit his own throat for whispering secrets to himself. Then the death throes of my country will be stilled, and we will be but a corpse, stretched out from the salty stretches of the sea, across the rainy plateaus, to the mountains in the north. The cries of the dead will be like a mist over the earth, but there will be no one left to mourn us.

Samphy kicks me again, and blood warms my face. At first I was afraid to bleed, but I remembered the blood poured out by the Christ. To bleed is to be alive.

It is important not to let them know one's fears. This, and the ability to go with one's mind into the smallest thing—the breath of a cricket, or the gleam of eyeglasses—are the secrets to endurance. There is no surviving; there is only the enduring, until one is poured out. *Endure for yet a little while, and he who is coming will come and will not tarry.* This is what I learned from Sister Jeannette when I was a child at the orphanage, before she sent me here for a time, to learn things that now I can't remember. All I remember today are the people I have loved, and the words Sister Jeannette taught me, and the two names Samphy believes he must learn, but which I will not teach him.

Before he was Samphy *hardworking,* because he wants to be a good comrade—I learned from him in these classrooms. Now, he is the pupil, and I am the one with hidden knowledge. He knows that I deny him, even after the electrical shocks and the hanging, the suffocation and beatings, after they pulled out my fingernails. He knows it even though I have already confessed many terrible untrue things about myself and the nuns and poor old Bora the mute, who in the next room finally discovered something close to a voice, for they taught him how to scream. I'm sure he betrayed me in his newfound language, just as I betrayed him. We will be forgiven, for we have done one another no

real harm; we were already condemned. In Khmer, *prisoner* means *guilty one*. We are all guilty ones.

Samphy steps back after kicking me, and absently, because death comes so easily here, he almost crushes the cricket. If not for the slightest motion, I would think the cricket is already dead. It has nerves of steel, this cricket. I will be like him today. Though I dwell in the shadow of death, I will fear no evil. The guard puts the flat of his sandal against my shoulder and rolls me to my back. My hands go to my testicles.

"Tell me Sokhem Rithy, where is your hope today?" Samphy chuckles. My father was named Sokhem—*hope*. His family name was Sotha—*pure*—but my mother died bringing me into the world, making me a bad-luck child. My father gave me his own name to be my family name. Khmer fathers only do this when they want to show great love for a child. Father wanted our village to know that I was not a bad-luck child to him. He was a hopeful man, but he was wrong.

The guard, Heng, does not laugh at Samphy's joke. To Heng, I am just Rithy—*great strength*—because I have endured longer than the others. Nobody endures long here, unless they want you to, but I have been here the longest. The older guards, like Heng, whisper sometimes as they walk me from my cell to an interrogation room: *Good morning, Rithy. Is the iron still in your veins?* They whisper, but with cruelty still in their voices, in order not to be accused.

The young ones whisper nothing, for fierceness and hate bubble in them like fish stew in a pot. Their parents are dead, their aunts and uncles and grandparents are dead, and they have been taught that this is good. They have abandoned the names of their families, and they wear like badges the names of revolutionary leaders. They screech at me that my gaze is insolent, and beat me if I look at them. The worst of these is Mao, because though he is only twelve, he is strong. He screams that I am spying, as if I will whisper to the cricket the secrets of their electric cables and wire snips.

Samphy kicks me again, on my jaw. A tooth breaks free and, without thinking, I swallow it. My body no longer knows what is food. It is like Cambodia, feeding on itself. I wonder through what crack the cricket got here, and if I could follow him back out. Lead me home, cricket. Lead me to my Linh.

"Sokhem Rithy, we have lost patience with you."

In the first days, Samphy was an "I." Now he says "we." I can tell

by the clothes and faces that another cleansing has begun. They are dragged into our stinking cell, well-fed and wearing fresh black shirts and pants. Some mumble that there has been a mistake, others snarl at us for accidentally touching them, as if they are not *guilty ones* too. Some beg to confess, even before they have been interrogated. In these times everyone is more careful, because each watches the other to see who does not belong. So Samphy says "we" and he squints, because his eyeglasses made him look like a westerner.

"Rithy, why do you make poor Linh suffer?"

I close my eyes, and this is a mistake, because it tells him what is in my heart. It is best to kill everything you cared for, but I cannot.

"She wants to see you," he says, "and she does not understand why you are being so stubborn. I know there is still something you keep from us, because there is resistance in your face. Spies and counterrevolutionaries who reveal all of their crimes have no resistance left in them. They are empty cups, ready to be refilled with loyalty to Democratic Kampuchea. But your cup, Rithy, it is not empty. Tell me what you hide in the dregs. Tell me what is so important that you would let Linh suffer."

Linh came to the orphanage with several others. The nuns took them in, though we were full, as they did until the very end. I was chopping wood by the kitchen, but I stopped when I saw her. She was taller, and her skin far lighter than a Khmer's. She was also beautiful, even before Sister Jeannette gave her soap. When she saw me watching her, she smiled, though it was more like a wink of her mouth than a smile. I returned a smile. The sisters had chided me to do this more, because my scowls frightened the littlest ones. The sisters always chided me for scowling, even when I was only a boy myself, sent here by my aunt after my father and uncles drowned. They were fishermen, and the sea had appeared calm the day they took father's old boat out past the foamy waves. Fishermen know that terrible strength lies beneath the cool glass of the sea, but sometimes they are deceived. The people in my village whispered that I had been the last to see them alive. They remembered that I was a bad-luck child.

The sisters ushered Linh and the others to water troughs, and I saw no more of her until dinner. She sat with the quiet children, away from the rambunctious ones who attracted the sisters' attention. When she

saw me filling my bowl from the big steaming pot, her mouth again twitched upwards. Her slender oval face was like cream, and her eyes were a rich brown, like good earth. They were sad, her eyes. The rags she had arrived in were gone, replaced by stiff pants and a blue cotton shirt made by Sister Jeannette, the shriveled French nun with hard bright eyes. By this I knew Linh was not only beautiful to me, for the cloth had come from Sister Jeannette's curtains, one of her few European luxuries. The shirt was deep blue like fishing waters, with curls and lines of stitches that traced about it in aimless joy, like the wake of a fishing boat.

Linh passed close after finishing her meal, and I could smell the sudden freshness of juniper. I have never seen juniper, but I know its name because it is the smell of Sister Jeannette's soap, and she told me. Sister Jeannette was not always a nun. "Old mother," I asked her once, letting a smile bubble up to my face, "why should a virgin married to the Christ make herself so lovely and sweet smelling?" She did not look up from where her nimble old fingers pinched at the herbs sprouting from the earth around her knees, but a smile came to her face. She shook her head and made a disapproving noise. "The Savior could come at any time," she said, "perhaps even to catch his bride being harassed by an impertinent young heathen in her own garden." This was how we always spoke, Sister Jeannette and I, even after Father Paul baptized me in the cold stream.

I realized that Linh reminded Sister Jeannette of someone. I knew this not so much by the way she looked at Linh, or from the crisp blue shirt or the juniper soap, but, of all things, by the way she sometimes would not look at Linh. As I said, Sister Jeannette was not always a nun. She told me once that some are called gently to the fold, but others must first be broken. All we Khmers who belong to the Christ are like Sister Jeannette, in need of breaking. And she is like us, a Khmer, even though she is a Frenchwoman with an herb garden and juniper soap.

Linh soon became a tutor in the orphanage, once the sisters discovered that she already knew most of what they could teach. She was fourteen, though she looked younger, and it was only when she spoke that one realized her maturity. Her parents had been shop owners, and Viets. They were murdered by a mob of hill people—dark and angry, like the guards of Tuol Sleng. Linh's father used to sing in the evening

from his seat on their porch. Her mother used to grow orchids in a small garden behind their kitchen. This is all Linh ever spoke about her parents.

Heng is lifting me to my feet, and for a moment I think it is morning. I have been unconscious. I lean against Heng and my tongue skates along my teeth to see if others are missing, while my hands flit across themselves to see if there are still eight fingers. Samphy glowers at me. "You will speak to us soon, Rithy. Comrade Duch knows of your resistance."

I nod respectfully, because I am grateful to Samphy for not killing me today. In these moments, when it has ended, I love Samphy the way the Christ intended. *Love thine enemies.* I will protect his name from himself.

Heng leads me from the room. In the wide hallway we pass closed doors. Behind some there is groaning or low talking, and occasionally a scream punctuates the warm, dense air. "You are foolish to waste the time of Comrade Duch," whispers Heng. I am filled with affection for him, and I lean closer into his body. His muscles recoil and he forces me to stand upright. "Fool."

What the European priests and nuns did not understand is that in our country it is good to marry young. For this reason they watched Linh and me nervously. For our part, we demonstrated the lightest affection, and whispered, whenever we were briefly alone, about how we might convince the Father to marry us. There was no leaving, for work and food were scarce. The church had rice. We believed in the Godhead of the Christ, and in the sacrament of holy marriage. We needed the church's rice, and we wanted its blessing.

So we waited, and I endured the ache that men feel. Old Bora would make fun of me, when it was just the two of us tilling the big garden, or fishing at the river. He would straighten his battered frame to be sure no one was watching, then grab his crotch. He would groan with mock pain, and then snort while pointing a thick finger at me. He meant no harm.

A few weeks before the Khmer Rouge came, I found Sister Jeannette sitting on a stump behind the kitchen. She often went there after dinner, to smoke a thin cigarette and watch the sunset. Her legs were

deeply crossed, her sharp elbow planted in the top thigh, working like a hinge to deliver the cigarette to her lips. She gave me a lazy glance before returning her eyes to the orange and purple spread out above the swaying trees. "Sister," I said, "does God know who we will marry?"

She rolled her eyes, then surveyed me. Her hinge of an elbow delivered another drag. Through the smoke she asked, "Why do you want to marry her?" Her eyes wandered down to my crotch, in a way that nuns are not supposed to look at a man, before returning to my face. "Is it because you want to lie with her?" Sister Jeannette was not always a nun. She sucked deeply from the cigarette.

"No."

She chuckled, and the dregs of smoke tumbled from her lungs. "Then you would be the first man." She looked back to the sky. "So it is love, is it?"

"Yes, Sister."

"Will you stay with us? Will you build a house near our land, and stay with us?"

"Yes, old mother."

She nodded. "I will speak to Linh. Then perhaps I will speak to Father Paul."

For the rest of the day I didn't scowl once. But as a second day stretched into a sleepless night and then into another endless day, I began to worry that Linh did not love me. Perhaps I had imagined everything. I am ten years older. Maybe she was only kind to me because I reminded her of her father, or of a favorite uncle.

I thought about the proofs that she loved me. The way we called each other *my sweet,* when no others could hear. How, when she stood at the large black pot to ladle rice into our bowls, she would steady my bowl by placing her warm hand beneath my own. She only did this with the small children. I thought about the times we had whispered of marriage, and wondered if I had confused myself. Perhaps Linh had simply been sharing dreams of marriage with me, her big brother friend.

By the third day, I was sure Linh did not love me. As I hacked at dirt clods in a new patch of garden, I could see Sister Jeannette in the shade of the kitchen, shelling beans, watching me. I was certain, in that moment, that Linh had confessed no love for me. I could feel

the pity and dislike in old mother's gaze. It was the same face of the mourning women in our village, on the day they made me leave.

With my angry chopping at the dirt, I did not feel Linh approach. She stood at my elbow, holding a small bucket of water. A wooden cup floated inside. "The sun is hot today," she said, in her quiet voice.

I squinted, searching her face for pity. But there was only the cream skin, the gentle curves of her smooth cheeks, her rich brown eyes, and then, the slight turning up of her mouth. "Soon, sweet," she said. She said this as a woman, knowing all the things *soon* meant to a man. As she took back the cup, her hand squeezed my own. I watched her pick her way across the clotted dirt, and into the kitchen. I have always been so faithless. In the Bible there is a man who says to the Christ, *I believe, Lord, help my unbelief.* This is who I am.

Comrade Duch is shorter than Samphy, and very thin, with high, hard cheekbones. His hair is cut short with a razor, and his shirt and pants are blacker than black. His sleeves are rolled up, in the way of the worker. He enters the room slowly, his eyes on me from the moment he appears. He is like a tiger. He looks hungry, as if he has never eaten, and for a moment I am afraid that he will eat me, that Samphy and Heng will hold me down while Comrade Duch devours everything I have ever been.

Then he smiles, as if we are being introduced at a party. "Good morning, Sokhem Rithy," he says. "My name is Comrade Duch." I am kneeling on the concrete, and I lower my head almost to the floor.

"Comrade Samphy tells me that you are not yet empty."

Now I touch my head to the concrete. I am swallowing the names. I do not know the names. I am Rithy. Behind Comrade Duch is Samphy. These are the only names we have. If my friend the cricket were here, I would whisper the other names to him. He could spirit them away, before I am eaten.

Comrade Duch stoops and grips my wrist. He is holding a hatchet. It is best not to watch, so I look at his face. He is very thin. He is studious about his work, and this reminds me of my father. Comrade Duch looks the way my father did, when he would squat to the deck of his boat to bait a hook. As he takes my finger, all of his muscles tighten in unison, like a man being electrified.

Someone is screaming in my cell. All the pain that is in the world

has found its way to the place where my hand has lost part of itself. I look up at Comrade Duch, who now stands over me. His sandal is on the stump. His eyes are like the eyes of a fish, but to him, it is me who is the fish. *Hasten thee to help me, O my God.* Sister Jeannette, when she used to teach me Bible verses, liked to joke that she was a bad Catholic not to teach them in Latin. Plant them in your heart, she used to say, and in your hour of need they will spring to life unbidden. *Thine, O Lord, is the greatness and the power and the glory and the victory and the majesty, for all that is in the heavens and the earth is thine.*

Comrade Duch puts weight on his sandal. "I will take them all, Sokhem Rithy." He leans forward and stares at me. "You are protecting someone." The names are flopping about in my mind like fish, trying to burst from the net. They want to be free. They want to betray themselves. *Thine, O Lord, is the kingdom, and thou art exalted above all.*

Samphy chuckles. He is holding a folder full of papers. Everything we whisper or scream is inked to a page. They drain us onto paper, until there is nothing left except the pages, to mark where we used to be. "Would you like to know what we are doing to Linh?" He is lying. He is lying because he is afraid, because Comrade Duch has to do his work. He is afraid, and so I try to love him with the love of Christ. "She satisfies all of us," Samphy says.

Set a guard, O Lord, over my mouth. Keep watch over the door of my lips.

"It is good work for her. She enjoys it." Comrade Duch nods, and grinds the stump of my finger. Someone is screaming in this cell.

Samphy makes a vulgar motion with his hips. "And we enjoy her." *Let the wicked fall into their own nets, O my God.*

I utter the name, "Sambath." Comrade Duch grabs my throat. "What?" His fish eyes shine.

I stare at Samphy. "Sambath." It means *great wealth*. It is a name a merchant might give to his son. It is the name of a teacher who once taught history within these rooms. To be either a teacher or the son of a wealthy merchant is to be emptied onto a page by the Party. Samphy looks like I have struck him.

"Who is this Sambath?" Comrade Duch tosses his hatchet aside and takes a cane from the corner. "Was he your collaborator at the counterrevolutionary training camp? Where is he now?"

Samphy looks small and childish cowering behind Comrade Duch,

and now I am sorry that I have vomited up the name. I try to love him with the love of Christ. Nobody deserves to be a *guilty one* here. His eyes are wild and crazed, darting between me and Comrade Duch, who continues to ask me questions in his high-pitched voice. At the end of every question, he strikes me with the cane. The blows are to my thighs, the bottoms of my feet, the back of my neck. I see now why Comrade Duch commands us. His skill at causing pain is far superior to that of a history teacher.

My throat strains to betray Samphy. It is ready to betray even my own name, the name I received the day Father Paul baptized me in a rushing stream. This is my secret self. If I give it to them, there will be nothing left of me for Linh. They will destroy it as they destroy everything, and I will have no soul to fly to heaven. But I think to be nothing would be better than this pain. What does it matter, when there is no one to mourn us?

And now Samphy saves me, because he has pushed past Comrade Duch to stomp my face. As he withdraws his foot to stomp me again, I see that tiny nub of pencil, lodged in his sole.

We knew the Khmer Rouge were coming hours before they arrived, because of the children and women streaming up the soggy road. We recognized some of the women, though their faces were streaked with mud; they were teachers from a school in the valley. The Khmer Rouge had called it a CIA training center. Some of the nuns led the refugees to the dining hall, while others shepherded our own children back to the school building. Bora sidled up to me, and motioned that I should go. I shook my head. It was safest here. Father Paul and the nuns are westerners, and of the church. The Khmer Rouge would not harm us here.

The first of them to appear was a boy. He wore ragged black pajamas, and sandals cut from thick pieces of tire, bound with wire. His fingers continuously spread and tightened over his rifle. Soon others appeared on the path behind him. They shouted at us in high, piercing voices to assemble in the commons. One of them went into the dining hall. The screams of the children were loud and piercing as they streamed outside.

We gathered around Father Paul, who shook, his eyes wide and watery. The Khmer Rouge captain shouted at him in Khmer. Father

Paul tried to keep up, but he was quickly befuddled. Linh was beside me now, her hand clamping mine. One of the nuns, a Viet, stepped forward to translate for Father Paul. "He says this a CIA camp. That we all CIA."

"That's ridiculous. Tell him we are of the church. Tell him I am a priest. Tell him I am from Belgium."

The Khmer Rouge screeched louder, and his men and boys began to shift their weight from sole to sole. His fingers darted on and off the rifle balanced in his palms, as if it were a musical instrument. "It no use, Father. He says we go with some his men, but leave Chinese and Viets here."

Father Paul looked very old and ill. "What does he intend, Sister Maria?"

Sister Maria stared into the shining eyes of the Khmer Rouge captain. What she saw there made her face look like water under clouded sky. "They bring death, Father."

"No," he said meekly, and I knew then that he had already surrendered in his heart.

"Father, if I tell him you say no, his men kill us all now. Go with him. You and whites go. Maybe they let you live."

"No."

The captain screeched, and then pointed his rifle at Father Paul's face. A second later I could smell his urine, strong and pungent from afternoon coffee. "Sisters," he whispered, "those of you who are white should go with them now." The handful of white nuns, except for Sister Jeannette, formed a tight cluster and followed some of the Khmer Rouge. Father Paul glanced at Sister Maria. "I am sorry, child."

One of the white sisters took Father Paul's arm. He let her lead him, stepping over the mud created by his urine. He did not look at any of us.

The Khmer Rouge began to separate the children. Some of the children squealed, but most were now quiet, shivering like rabbits, like Father Paul. The soldiers separated the darker Khmer children from the light-skinned Chinese and Viets. Linh was pulled away from me, to the second crowd. I moved to be with her, and felt a sharp blow to my back. I was on my knees, and a Khmer Rouge shouted in my ear to follow him. Linh was shivering, like the other rabbits.

"Go with them, son," said Sister Jeannette. She joined the light-skinned children. "I will watch over these little ones."

A Khmer Rouge yelled at her, but she only looked at him, almost with curiosity. He pointed his rifle at her face. Sister Jeannette stared down its barrel, into his eyes. She placed a hand on her crucifix, and with the other she stroked the hair of a child quaking at her hip. The Khmer Rouge captain said something to the soldier. The soldier chuckled and nodded, lowering the barrel. He motioned for Sister Jeannette to stay.

They made us march, myself and old Bora, Father Paul and the white nuns, with the dark Khmer children following behind. Soon the Khmer Rouge relaxed. They smoked and spat and bantered. It was almost as if we were strolling. A couple of them even put Khmer children on their shoulders. Far behind, I could see the blue of Linh's shirt amidst the small bunch of light-skinned children. Sister Jeannette and Sister Maria stood on both sides of the little bunch, their short arms outstretched, as if to hold all of the children at once. We rounded a curve in the long rutted road, and I could not see Linh any more.

I am lying on cold tile. Light streams through the slats over the windows and tries to warm me. There is pain like a blade, running from the top of my head to my scrotum. It is my new name, this pain. It has forced out everything that I was. I am afraid that I betrayed my secret name. There is whispering. It is Chantrea. I am back in the cell, though I cannot smell the others.

"I thought you were dead, Rithy." I try to speak but there is only moaning in my throat, and it feels as if the blade inside me is twisting. "Your mouth is broken." She weeps quietly as she whispers. "You are hurt very badly. Soon you will join your Linh. I pray that in your new life you will be together, far from Cambodia." I feel her turn away from me, toward the door, and then she draws closer. "They have arrested Samphy. I was led past his cell and I saw him, chained to a bed."

My eyes try to weep, but the pain is too great. I have condemned another man. Perhaps, before Samphy stomped me unconscious, I betrayed my secret name as well. I am nothing but emptiness and pain, and I will wait for death. Chantrea places her head gently against my own. "I shall miss you Rithy. I hope we are brother and sister in the next life."

Perhaps an hour into our stroll, the Khmer Rouge who had stayed behind at the orphanage began to appear. One of the Khmer Rouge boys wore Linh's blue shirt, with the curled stitching. Another held a crucifix. He darted among the older soldiers, showing off his prize. I had been praying, and listening for the crack of rifles, which I know was double-minded. The book of James was Sister Jeannette's favorite. *Do not be double-minded,* she would say. I was sure there had been no shots, even though my prayer had been a double-minded prayer. I did not understand then what I have learned since, which is that efficiency is very important to the Party. It does not waste bullets.

I strained to turn back, but old Bora pulled me into him, his arm like a tree trunk. We walked that way, and he assured me that he had not heard rifles, either. We told each other that the Khmer Rouge had simply robbed everyone, and left them there. We whispered plans to escape and return to the orphanage. We walked and walked.

We are walking. Hands grip my arms, the tops of my feet drag over tile. I can barely lift my head, but I see that Heng is to my left. He stares straight ahead, his jaw clenched so tight that he looks to be chewing a ball. I haven't the strength to look to my right. Perhaps it is Mao. I am sorry that he will see more death, and that he will enjoy it. Now my feet are drag-thumping down whitewashed concrete steps, and we are outside. The sun is warm, and I pray that it will melt this sharp blade where my spine used to be. We are in a part of the grounds I have not seen before.

Beside me someone is talking. It is Samphy. I force my head to look up, and fireworks ignite behind my eyes. When they focus, I see that he has been beaten. We are on our knees, in a line with other prisoners. I am propped against someone's leg. Heng, I think.

Samphy is reciting the kingdoms of Britain. His face is peaceful, beneath shiny purple and red bruises. He turns to me as if I have spoken to him, though my mouth will not work. "It is better this way," he says, smiling, "because in my heart I was a traitor. I treasured in my mind the things I learned in the reactionary university. I believed myself superior to my comrades. My mind is hopelessly polluted. It is better. I will return as a loyal Khmer."

I hear the guards conferring in a small group behind our line of kneeling forms. Heng does not join them, because if he leaves me I

will fall into the freshly turned dirt. Samphy frowns at me. "You were wrong not to reveal who I was, Rithy. Were I your family, even your precious Linh, it is still better to reveal the counterrevolutionaries among us. It is the wheel of history. I see this now, though I silenced you in the cell. Comrade Duch has made all of this clear to me." Samphy looks down at the dirt and nods, as if recalling a childhood song. "Yes, this is better."

The guards have finished their conversation, and I hear the scratch of their sandals as they pad over pebbles and soil. Heng squeezes my shoulder and I know that he is wishing me a speedy voyage to my ancestors. I pray that he will come to know the Savior before it is he who kneels in this dirt, awaiting an iron bar to the skull.

Samphy curses me now, his voice thick. "I know you hid more than my name, Rithy. I tried to help Comrade Duch see this, but he says you are an empty husk. I know, Sokhem Rithy. Tell me what other names you are hiding."

They take their positions behind us. Someone tells Heng to hold me at arm length, so the killing blow can be administered. Some of the kneeling ones are weeping. Samphy screams: "Rithy! I must know! Comrade Duch! He is not yet empty! Comrade—"

The sound is like a gourd being sliced open. The other guards congratulate Samphy's executioner for shutting him up. I am whispering a prayer, and trying to look at the sky, that I might see the angels coming for me. Heng understands, because he gently tilts my head upward. For a moment I think I have already been struck, the pain is so sharp. But now I can see thick sheets of cloud, and the waiting blue sky. "Nahh," my executioner barks at Heng. "You make it harder to hit the base of his skull."

"He is nearly dead already. Are you a woman? Just swing hard. Swing like a man."

I am praying thanks to God, that his name for me was never uttered here. My treasure is in heaven. There they will call me by my secret name, Gabriel—*God is my strength*. In heaven I will not remember the hill of the poison tree.

God has appointed my death for a beautiful day. I thank him for the silent blue sky, looking down at what we have become. They kill everything here, but they cannot kill the sky. It will be our witness, and it will mourn us.

FRANZ WRIGHT

Language as Sacrament in the New Testament

[essay]

A version of this essay was delivered at Boston University on November 1, 2007, at a lecture sponsored by the Luce Program in Scripture and Literary Arts in memory and honor of Amos Niven Wilder.

THE LANGUAGE of the New Testament has been with me since childhood. The words of Jesus, specifically, are so familiar that I am constantly in danger of becoming insensitive to their power. As an antidote to that I have been trying once again to think about Jesus's words, the so-called authentic sayings of the historical Jesus, as well as those attributed to him by the earliest believing communities in the decades after his death, the words found in the mysterious fourth Gospel, for example, words which I think might more accurately be attributed to the risen Christ. I have been trying to read them again, and to think about them again from both a literary and a theological perspective, and then simply to experience them, and not for any mystical purposes (I personally have had just about enough mystical experience, and it's become a life-or-death matter that I contemplate these things and even try to put them into practice in a rather orthodox and practical way). I wanted to experience these words again naïvely, personally, literally, as if I had never heard them before. I wanted to find myself in the company of the other spiritually needy, blind, crippled, and lost individuals to whom they were first addressed by this adorable, radiant, and somewhat scary person who is like no one anyone has ever met.

I'm well aware of how all this appears to many of the people I know or associate with, of its quaint absurdity in the eyes of so many I encounter in the literary world, in everyday life, even among the religiously observant sometimes; and I am afraid their attitude can be contagious, or at least so profoundly discouraging that I have at times found myself giving in and adopting it. This sense of estrangement from

normal reality and common sense, or rather this implicit accusation coming at me from outside or even from within myself that (as one prominent American poet once told me) I either believe in a fairy tale or am the victim of delusion and hallucination, calls for a powerful antidote. And this is where I find it: in contemplation of this human being as isolated and powerless as anyone else, who wished to show others how much God loved the world.

After they'd tortured him for a while, and forced him in agony and humiliation, in public and in broad daylight, to carry the monstrously heavy instrument of his own execution to a lonely bone-strewn spot outside the city of Jerusalem (population about twenty-five thousand at the time), a few gawking onlookers jeering him or turning away out of fear of being associated with him, and after they'd hammered big, crude handmade iron nails through the palms of his hands, maybe stabbing him a couple times with their spears or, as was common practice, breaking his legs to hasten death, and after he was lifted up a few feet from the earth, his response was to gaze out across everyone alive and everyone who had ever lived, with all their stupid ugly little failures and meaningless crimes, and love them. After a lifetime of intellectual and aesthetic interest in the scriptures, this is what I suddenly *saw* and *knew*, one day at about one thirty in the afternoon in the middle of September back in 1999. Then he looked out over the faces of every person who would ever exist in the future world, right down to the last one, and loved them. And this is what people think they understand when they knowingly roll their eyes at the mention of his name. Or if they happen to read or hear spoken aloud the words, "I am going to the Father"; or "unless a grain of wheat falls into the ground and dies, it remains nothing but a grain of wheat, but if it dies, it brings forth food enough for all"; or "when I am lifted up, I will draw all men to me."

I have come to see language as sacrament in the New Testament—or rather, the words of Jesus as sacrament. I suppose that sounds general or vague, so I should say something about the term itself. A sacrament both represents, in a graphic and dramatic way, the state of grace it conveys and also creates an event-situation that predisposes the person receiving the sacrament to experience grace. So it's unusual, maybe, to think of certain words representing, conveying, and creating the setting for an interior and wordless experience, a condition of interior

and inexpressible understanding and peace, but that is what I am saying. The sacrament of baptism, for example, is the visible form or enactment of burial and resurrection, and the shock and fear of being under the water has some emotional resonance with self-loss and dying, followed by the renewal or salvation of drawing breath again. So the sacrament actually effects what it stands for. (Though when I say "stands for" I think we need to take seriously Flannery O'Connor's famous observation, "Well, if it's a symbol, to hell with it.") The sacrament of marriage is said to be related to the union of Christ with his followers, to whom he says, "The Father and I are one." The sacrament of the anointing of the gravely ill might, as I understand it, bring to mind and allow one entrance into Jesus's miraculous acts of healing when confronted with the crippled, the insane, the blind, even the dead, and I think that just about accounts for all of us. And I think this is as good a time as any to tackle that troublesome term *miracle*. I could simply be done with it by quoting Whitman—"Who speaks of miracles? I know of nothing but miracles." But specifically I'd want to add that I understand the miracles to be Jesus's exceptional and usually extremely reluctant acts of personal friendship or sheer pity. Underlying, behind, and surrounding them there is always implicit a fierce warning against reliance on the supernatural, and an insistence on the primacy, for his followers, of the hardest and most improbable miracle of all—a consistent and perpetual attitude of compassion and love for *all* others. I think my favorite miracle is the restoring, with a touch, of the arresting soldier's ear when Peter cuts it off in the Garden of Olives.

As a corollary of all this, a word on the after-death appearances of Jesus to his friends, and to me the most moving of them, the one that involves their encounter with him on the road to Emmaus several days after his execution. I think it is enough to suggest that their initial failure to recognize him reflects the period of time that had to pass before the meaning of the cross, that apparent utter catastrophe, began to dawn on the scattered and disappointed disciples; before they could grasp the significance of that Passover meal during which Jesus had weirdly offered them his own body and blood to eat and drink; before they could grasp that their Messiah, instead of being crowned in Jerusalem, had done something far stranger and more astounding than anything they could have imagined, that in a Passover time, Jerusalem reeking

with the blood of thousands of slaughtered lambs, Jesus had become the Lamb of God.

As Jesus spoke in images, is it so strange that his followers, or their followers, might have recourse to images when it came time to write about him? The real disaster here is the temptation of fundamentalism, the bizarre and disturbing abuses of absolute literalism, the insistence on remaining at the most primitive level of comprehension.

The Eucharist, the sacrament involving the poignant necessity of sitting down at a table to eat every day, involves the taking into our mortal bodies the transfigured and immortal body of Jesus as Christ, and a being reminded of and comforted by a most physical and literal sense of his companionship.

To these and other sacraments I would like to add the sacrament of words. I would like to talk about my experience of Jesus's words in the same way I have spoken about the ingestion of his body—those unprecedented words which astonish and silence the hearer, words first and for a long time orally passed down, along with remembrance of their event-settings, at some point written down in stark lists of his individual sayings, before finally being given the familiar narrative structure of the numerous Gospels, many of them modeled on the early Gospel of Mark with its marvelous clarity and simplicity. I believe that when we take these words in with full attention, ingest them with our eyes and ears, we are taking in not the body but the mind of Christ and the creative will of God, as Christ is called the Word through which the universe was uttered into being; we are taking in the very thinking of Christ, its meaning and presence which never goes away though we may choose to turn away from it; and we are taking in the ultimate mystery—that Christ came not to abolish suffering (clearly!) but to take part in it.

I think the taking in of Jesus's words changes us, and what we are newly enabled then to do is twofold. One, we receive the power to perceive that reality is the opposite of appearances or the evidence of our senses, or our previous experience of what it means to survive and succeed in the world: "Blessed are the poor, for theirs is the kingdom of heaven; blessed are those who mourn, because they will be comforted"—"Let the dead bury the dead, and come and follow me"—"Give to Caesar what belongs to him," the coin with his image stamped on it, "and give to God what is his," your own lives made in his image. The other

thing that happens is we begin to be prepared to experience the end of the world. I'm not especially interested in the argument over whether Jesus intended to found a religion—though I'm inclined to believe his intention involved preparing us to experience the end of religion along with everything else. Even the literary and theological aspects of the New Testament itself, gradually composed in the after-light of Christ's earthly manifestation, still resonate with this state of perception and this ultimate imperative. Eschatology was not an abstract concept but something being lived out, incidentally, in the decades following the execution of Jesus. I have read that hundreds if not thousands of crucified bodies encircled the besieged Jerusalem before it was finally brought down and its residents largely exterminated some forty years after his crucifixion. Christ's words enable us to see that the truth is the opposite of appearances and that we have to change our lives, because whether it takes the form of the general and imminent conflagration we may all be facing, or of each person's solitary mortality, the hour of our death alone in some ghastly hospital room, say, the end of the world is truly at hand.

But quite apart from the teaching itself, what made the words with which Jesus conveyed it so radically memorable, enough to be orally transmitted to others for years and decades by often completely illiterate people before they could be collected for the first time in writing? What made these sayings so unforgettable in their intent that it would hardly matter whether they were reproduced verbatim, or in a range of variations when at last they were finally incorporated into the numerous Gospel narratives? What gives them their unique power?

Let me quote, from one of Paul Valery's essays, a few lines that have helped me understand the meaning and power of poetry since I first came across them as a student:

> The poet consecrates himself to and consumes himself in the task of defining and constructing a language within the language; and this operation, which is long, difficult, and delicate, which demands a diversity of mental qualities and is never finished, tends to constitute the speech of a being purer, more powerful and profound in his thoughts, more intense in his life, more elegant and felicitous in his speech, than any real person....

I doubt if this can be improved on as a way of describing the heightened states of consciousness recorded in great poetry. I frankly also think it contains an excellent description of Jesus as a person, the man of heaven, as Paul wrote, among the men of dust. Jesus did speak this way, in poetry—and here is something truly weird: according to the great German Protestant theologian Joachim Jeremias, when Jesus's sayings are translated back into Aramaic, it's clear that he favored a certain four-beat rhythm, and that he was especially fond of alliteration and assonance as well as rhyme!

Now I'm going to remind you that poetic forms (rhyme is the most obvious example) are mnemonics. And they served, in this case, the necessity of transmitting intact information of a subversive and disturbing nature in a culture almost entirely made up of illiterate and impoverished workers as well as slaves. Jesus employed Homerically extended parables, unprecedented in Judaic teaching, and he made vivid use of symbols from common experience (bread, water, light, life, shepherd, door) as well as contrasting images from the thought-world of the time or of any time (light/darkness, truth/lies, love/hatred) to make his meaning gripping and clear. What has been referred to as antithetic parallelism is one of the most noticeable habits of Jesus's manner of talking, and one has only to call to mind the incantatory phrases of the Sermon on the Mount as example. This is one of the moments in which Jesus's words most clearly reveal truth to be the opposite of appearances and our usual sense of what makes for a successful life.

Our poor friend Friedrich Nietzsche got so many things wrong when it came to religious experience, but in spite of himself he made somewhere the very funny but oddly prescient statement, "It was subtle of God to learn Greek when he wished to become an author—and not to learn it better!" I think I know what he meant, whether he completely did or not. If one thing distinguishes the Gospels from any other comparable works, or any works conveyed by language, it is their eerily childlike diction, their utter clarity and translucence. And this extreme simplicity, apart from facilitating multiple superimposed levels of interpretation, must also surely have served as a mnemonic aid as well as allowing Jesus's particular audience to identify with what he had to say. This style must have helped people to recall his meaning and message, which is so deep and clear and unforgettable that its rephrasings in the hands of different authors could not alter it.

I want to go off on a kind of tangent, an entertaining and relevant one I hope, involving a poet sometimes influenced by this style, one of such human power and significance that his most successful works also transcend everything associated with literary artifice. Rainer Maria Rilke wrote in a letter somewhere that when he was traveling, as I suppose he almost always was, the only indispensable book he carried and read from each morning before beginning his own work was a little New Testament, and I think this must have had something to do with the lucidity and devastating simplicity that came into his own writing. In 1913, in a hotel in Spain, he composed his own version of the great Lazarus narrative found in the eleventh chapter of the fourth Gospel—it never appeared in any of his collections and remained unpublished in his lifetime, and I came across it in an obscure collection his daughter Ruth helped edit from his scattered notebook fragments; and as a junior at Oberlin in 1976 I spent one of the happiest long winter days of my life trying to translate it.

The Raising of Lazarus

Evidently, this was needed. Because people need
to be screamed at with proof.
Still, he imagined Martha and Mary
standing beside him. They would
believe he could do it. But no one believed,
every one of them said: Lord,
you come too late.
And he went with them to do what is not done
to nature, in its sleep.
In anger. His eyes half closed,
he asked them the way to the grave. He wept.
A few thought they noticed his tears,
and out of sheer curiosity hurried behind.
Even to walk the road there seemed monstrous
to him, an enactment, a test!
A high fever erupted inside him, contempt
for their insistence on what they called
their Death, their Being Alive.
And loathing flooded his body
when he hoarsely cried: Move the stone.
By now he must stink, someone suggested

(he'd already lain there four days)—but he
stood it, erect, filled with that gesture
which rose through him, ponderously
raising his hand (a hand never lifted
itself so slowly, or more)
to its full height, shining
an instant in air...then clenching
in on itself, abruptly, like a claw, aghast
at the thought *all* the dead might return
from that tomb, where the enormous cocoon of
the corpse was beginning to stir.
But finally, only the one decrepit figure appeared
at the entrance—and they saw
how their vague and inaccurate
life made room for him once more.

I want to conclude by saying some more about the fourth Gospel.

When I was young, I was excited by the scholarship concerned with highlighting those words of Jesus which can be shown to be historically authentic, most of them occurring in the first three so-called synoptic Gospels, Mark, Matthew, and Luke (though some can be found in sources outside the canon, and if you are interested in pursuing this, the greatest work I know on the matter is Joachim Jeremias's *Unknown Sayings of Jesus*). Such issues are of much less consequence to me now. In some ways I have come to love best the Gospel of John.

The fourth Gospel is furthest removed in time from the historical person of Jesus, appearing maybe around 90 or 100 AD, in other words, sixty or seventy years after the crucifixion. It's possible the author was a follower of the disciple named John and was recording and giving order to John's memories and preaching, the way the author of the book of Mark is thought to have recorded Peter's. In a way the author of the fourth Gospel is not only the most theologically minded but the most literary, opening with the parallel or echo of Genesis's "In the beginning" and at the same time displaying an obvious familiarity with the transcendently poetic pre-Socratic Greek philosophers by borrowing one of Heraclitus's central terms, the mysterious multidimensional word *logos,* which means, of course, "word" but so much more as well. "The logos is common to all," says Heraclitus—in other words, there is just one—"yet men behave as if they each had one of their own!"

It's clear from this fragment that *logos* more hugely signifies sentience itself. Which makes sense, since thought can hardly be said to exist in the absence of language, the absence of words. And this realization presents a departure point for all sorts of interesting digressions. For example, a few years ago I was introduced to the fact that the first known deliberate human burial sites, caves much like the one in which Jesus's corpse was placed, were discovered (where else?) in the vicinity of the Dead Sea, and are thought to be around sixty thousand years old; these sites provide concrete evidence of a capacity for symbolic thought, and from that can be inferred the existence of spoken language. When you have symbolic thought, you have indirect evidence of language; when you have language, you have *poesis,* making, creation. In the beginning was the Sentience, as well as, in the beginning was the Word by which God uttered the world into being.

But what I cannot get over, and it haunts me more and more in this Gospel, is the mood, incomparably expressed, of valedictory tenderness and concern for his followers as Jesus prepares for his death. He seems already to be speaking from beyond and looking back on both his preexistence with the Father and then on his Incarnation in the human world. What is felt so vividly is his infinitely sad concern for those who will have to remain here without him. When he says, "Now I am no more in the world, but they are in the world," I feel I am being personally referred to. I ask myself in discouragement and real terror sometimes, why will I always remain this side of the kingdom of heaven? Why can't I do it, follow the one very simple commandment to love, every moment, without qualification? What is wrong with me, that I always, relentlessly, fail? I feel that if I could do it, I could do anything, go through anything. And Christ's response in the fourth Gospel is always the same: *But I have done it, and I have done it for you.* Here in this world I know for a fact that I am not going to become like Christ. I know that the best I can do is to become the lowlife crucified next to him—not the reviler, but the one who suddenly understands and says, "Jesus, remember me when you come into your kingdom."

> I have said these things to you in images; the hour is coming when I shall no longer speak to you in images but tell you plainly of the Father. For the Father himself loves you, because you have me and believe that I came from the Father. Now I am leaving

the world and going to the Father. The hour is coming, indeed it has come, when you will be scattered, every man to his home, and will leave me alone; yet I am not alone, for the Father is with me. I have said this to you, that in me you may have peace. In the world you have affliction; but be of good cheer, *I have overcome the world.*

I am the true vine, and my Father is the vine-grower. Every branch in me that bears fruit, he cares for, that it may bring forth even more. Abide in me, and I in you. I am the vine, you are the branches. If a man does not abide in me, he is cast forth as a branch and withers. If you abide in me, and my words abide in you, ask whatever you will, and it shall be done for you. As the Father has loved me, so I have loved you; abide in my love. This is my commandment, that you love one another as I have loved you.

You are my friends.

To me this is even more staggering than the words "God is love" in John's epistle. All reality is the manifestation of God, and as Christ has returned to God, unbound by space or time, what we are now presented with is a universe in which we are not alone, but one which says, "You are my friends." Think of it.

Christ's followers learned to use his very way of speaking—and this is what we have in the fourth Gospel—but they could not make themselves into Christ any more than we can. Yet this message remains: *For you I have overcome the world. I am love, and you are my friends.*

Christ turned water to wine, blindness to sight, death to life and—the most improbable of all his acts—hatred to love, and the desire for revenge to forgiveness. The older I get the more staggering this becomes to me. I've been around the block a few times, and have an idea of what men are capable of. I've been capable myself. And I would echo and amplify Dostoyevsky's declaration: If it could be proved that Christ is not the truth, the resurrection, and life, then I would rather have Christ.

Dick Allen's seventh poetry collection is *Present Vanishing*. It follows *The Day Before: New Poems* and *Ode to the Cold War: Poems New and Selected*. He's received a Pushcart Prize and inclusion in various editions of *The Best American Poetry* and *The Year's Best American Spiritual Writing*.

Dan Bellm has published three books of poetry, most recently *Practice*. His work has appeared in *Poetry, Ploughshares, Threepenny Review, Best American Spiritual Writing*, and *Word of Mouth: An Anthology of Gay American Poetry*. He lives in San Francisco, and is also a translator of poetry and fiction from Spanish and French.

Ben Birnbaum is a senior administrator at Boston College, editor of *Boston College Magazine*, and an essayist whose work has been collected in *Best American Essays, Best Spiritual Writing*, and *Best Catholic Writing*. He is also the editor of *Take Heart: Catholic Writers on Hope in Our Time*.

Scott Cairns is professor of English and director of creative writing at the University of Missouri. His recent books include: *Compass of Affection: Poems New & Selected, Short Trip to the Edge: Where Earth Meets Heaven—A Pilgrimage*, and *Love's Immensity: Mystics on the Endless Life*.

Richard Chess is the author of three books of poetry, *Tekiah, Chair in the Desert*, and *Third Temple*. He directs the Center for Jewish Studies at University of North Carolina Asheville.

Michael Chitwood's most recent books are *From Whence* and *Spill*. His work has appeared in *The New Republic, Poetry, The Threepenny Review, Field, TriQuarterly* and numerous other journals.

David Citino (1947-2005) authored thirteen volumes of poetry, most recently *The News and Other Poems* and *A History of Hands*. For thirty-one years, Citino taught at Ohio State University, where he was named Poet Laureate.

Robert Clark is the author of four books of nonfiction and four novels, most recently the novel *Lives of the Artists* and *Dark River*, an account of the 1966 flood of Florence.

Robert Cording teaches English and creative writing at College of the Holy Cross where he is the Barrett Professor of Creative Writing. He has published five collections of poems, the most recent of which is *Common Life*, 2006.

Deborah Joy Corey has published stories in *Ploughshares*, *Agni*, *Carolina Review*, *Story*, *New Letters*, *The Crescent Review*, *Image*, and many others. Her novel *Losing Eddie* won the Books in Canada First Novel Award and was voted one of the best hundred novels of the nineties. Her short story collection, *You Are What You Drive*, is forthcoming, and she has just completed a new novel, *The Almost Island*.

Alfred Corn is the author of nine books of poetry, the most recent titled *Contradictions*. He has published a novel, *Part of His Story*, and two collections of literary essays, the second titled *Atlas: Selected Essays, 1989-2007*. He has received a Guggenheim, the NEA fellowship, an award in literature from the Academy of Arts and Letters, and a fellowship from the Academy of American Poets. He has taught at Yale, UCLA, and Columbia.

Kate Daniels is the author of four volumes of poetry, including *Four Testimonies*, *The White Wave*, and the forthcoming *A Walk in Victoria's Secret*. She teaches at Vanderbilt University.

Madeline DeFrees, author of eight poetry collections and two memoirs of convent life, lives and writes in Seattle. Her most recent honor is the Maxine Cushing Gray award from the University of Washington. "The Eye" appeared in *Spectral Waves* (Copper Canyon, 2006).

Rubén Degollado's stories have appeared in *Beloit Fiction Journal*, *Bilingual Review*, *Gulf Coast*, *Hayden's Ferry Review*, *Relief*, and *Fantasmas*. Recently, one of his stories was a *Glimmer Train* "Family Matters" top twenty-five finalist. He is a middle school principal in Oregon and has been an educator for thirteen years.

Annie Dillard received a Pulitzer Prize for *Pilgrim at Tinker Creek*. Her other books of poetry and prose include *Holy the Firm*, *For the Time Being*, *Mornings like This*, and most recently a novel, *The Maytrees*. "How to Live" is copyright © 2002 by Annie Dillard.

Clyde Edgerton is the author of nine novels. He has been a Guggenheim Fellow and five of his novels have been *New York Times* notable books. He is a member of the Fellowship of Southern Writers. Edgerton teaches creative writing at the University of North Carolina Wilmington, where he lives with his wife, Kristina, and their children.

B.H. Fairchild's fourth book of poems, *Early Occult Memory Systems of the Lower Midwest*, received the 2002 National Book Critics Circle Award and the Bobbitt Prize from the Library of Congress. His poem, *Frieda Pushnik*, appeared in *Trilogy*, with illustrations by Barry Moser and in *Usher*.

Makoto Fujimura is a New York-based visual artist whose works combine traditional Japanese Nihonga painting with the metaphysical language of abstract expressionism. His books include *River Grace* and the forthcoming essay collection *Refractions: A Journey of Faith, Art, and Culture.*

Margaret Gibson is the author of nine books of poems, most recently *One Body*, winner of the 2008 Connecticut Book Award. A memoir, *The Prodigal Daughter*, appeared in 2008. She is Professor Emerita, University of Connecticut, and lives in Preston, Connecticut. In summer 2008, she taught a poetry workshop at the Image Glen Workshop in Santa Fe.

Diane Glancy's newest books are *The Reason for Crows*, a novel about Kateri Tekakwitha, and *Pushing the Bear*, after the Trail of Tears. Her latest collection of poems, *Asylum in the Grasslands*, won the 2008 William Rockhill Nelson award from the Writer's Place and the *Kansas City Star.*

Patricia Hampl's most recent book is *The Florist's Daughter*, winner of numerous awards, including the *New York Times* One Hundred Notable Books of the Year and the 2008 Minnesota Book Award. She has received fellowships from the Guggenheim Foundation, NEA, Ingram Merrill Foundation, Djerassi Foundation, and MacArthur Foundation.

Ron Hansen's most recent novel is *Exiles*, about the shipwreck of the *Deutschland* and the Jesuit poet Gerard Manley Hopkins. This selection is taken from his collection *A Stay against Confusion: Essays on Faith and Fiction.* He teaches literature, film, and creative writing at Santa Clara University.

Jeanine Hathaway teaches writing and literature at Wichita State University and is on the poetry faculty for Seattle Pacific University's MFA Program. Her books include the autobiographical novel *Motherhouse* and a collection of poems, *The Self as Constellation,* which won the Vassar Miller Prize.

Mark Heard (1951-1992) was a record producer and singer-songwriter. Originally from Macon, Georgia, he released sixteen albums during his lifetime, including *Dry Bones Dance, Second Hand,* and *Satellite Sky.* He influenced countless musicians of his generation, including Pierce Pettis, Buddy and Julie Miller, Bruce Cockburn, Emmylou Harris, Michael Been, Fergus Marsh, and Sam Phillips.

Ingrid Hill grew up in New Orleans and lives now in Iowa City, Iowa. Her first novel, *Ursula, Under,* won the Great Lakes Book Award for fiction and was named a Washington Post Best Book of the Year. She is at work on her second novel, *Widows and Orphans.*

Edward Hirsch has published seven books of poems, including *Wild Gratitude*, which won the National Book Critics Circle Award, and *Special Orders*. He has also published four prose books, among them *How to Read a Poem and Fall in Love with Poetry*, a national bestseller, and *Poet's Choice*. He is president of the John Simon Guggenheim Memorial Foundation.

Linda Hogan is a Chickasaw novelist, poet, and nonfiction writer. Her most recent books are a novel, *People of the Whale*, and a book of poems, *Rounding the Human Corners*. Her honors include NEA and Guggenheim fellowships, a Lannan Foundation award, and Lifetime Achievement Award from the Native Writers Circle of the Americas.

John Holman is the author of *Squabble and Other Stories* and the novel *Luminous Mysteries*. His stories also have appeared the *New Yorker, Mississippi Review, Oxford American*, and elsewhere. He directs the creative writing program at Georgia State University in Atlanta.

Andrew Hudgins is a professor of English at the Ohio State University. His most recent books are the poetry collections *Ecstatic in the Poison* and *Shut Up, You're Fine: Poems for Very, Very Bad Children*. Other collections include *Babylon in a Jar* and *The Glass Hammer*.

Mark Jarman's collections of poetry include *Unholy Sonnets, Questions for Ecclesiastes* (winner of the Lenore Marshall Poetry Prize and finalist for the National Book Critics Circle Award), and, most recently, *Epistles*. He is Centennial Professor of English at Vanderbilt University.

Richard Jones is the author of seven books of poems, including *Apropos of Nothing, The Blessing*, and *The Correct Spelling & Exact Meaning*. Editor of the literary journal *Poetry East*, he is a professor of English at DePaul University in Chicago.

Rodger Kamenetz is a well-known poet of the Jewish experience. His five books of poetry include *The Missing Jew: New and Selected Poems* and *The Lowercase Jew* (Northwestern, 2003), in which "My Holocaust" appeared. He is the founding director of Louisiana State University's MFA program and its Jewish studies program. His latest book is *The History of Last Night's Dream*.

Julia Spicher Kasdorf's poem "Across from Jay's Book Stall in Pittsburgh" is from her new manuscript, *Poetry in America*. She has published two previous collections, *Eve's Striptease* and *Sleeping Preacher*, and her poems have won a Pushcart Prize and NEA fellowship. She directs the MFA program at Penn State and serves as poetry editor for *Christianity and Literature*.

Sydney Lea is author of a novel, two books of naturalist nonfiction, and eight collections of poetry, most recently *Ghost Pain*. His *Pursuit of a Wound* was a Pulitzer finalist in 2001. He founded and for thirteen years edited *New England Review*, and is now the longtime moderator of the First Congregational Church of Newbury, Vermont, where he lives.

Denise Levertov (1923-1997) wrote over twenty books of poetry, including *Evening Train, The Sands of the Well*, and the posthumous *This Great Unknowing: Last Poems*. She taught for ten years at Stanford University and spent the last decade of her life in Seattle, Washington.

Philip Levine's fiction has appeared in the *Missouri Review, Hopkins Review, American Literary Review, Cincinnati Review, StoryQuarterly*, and elsewhere; his nonfiction has appeared in the *New York Times*. A graduate of the MFA program at Johns Hopkins University, he's held residencies at Yaddo and the Virginia Center for Creative Arts. He lives in Washington, DC.

Paul Mariani is one of America's leading literary biographers and poets. His books include the poetry collections *Salvage Operations* and *The Great Wheel*, a work of nonfiction, *God & the Imagination: On Poets, Poetry, & the Ineffable*, and biographies of Hart Crane, Gerard Manley Hopkins, and others, including three *New York Times* notable books.

Erin McGraw is the author of five books of fiction, most recently *The Seamstress of Hollywood Boulevard*. Her stories and essays have appeared in *Atlantic Monthly, Story, Good Housekeeping, Southern Review, Allure*, and elsewhere. She teaches at the Ohio State University. Her collection *Lies of the Saints* includes a version of the story reprinted here by permission of Brandt & Hochman Literary Agents, Inc. Copyright © 1994 by Erin McGraw.

Mary Kenagy Mitchell has been the managing editor of *Image* since 2000. Her fiction has appeared in *Image, Georgia Review, Beloit Fiction Journal*, and in the anthologies *Peculiar Pilgrims* and *Not Safe but Good*.

A.G. Mojtabai has recently published *All That Road Going*, her ninth book. Her previous books include the novels *Mundome, A Stopping Place, Autumn*, and *Ordinary Time*, the short story collection *Soon: Tales from Hospice*, and the nonfictional study *Blessed Assurance: At Home with the Bomb in Amarillo,Texas*.

Les Murray is an Australian poet and recovering depressive who lives on a farm in New South Wales. In North America his books are published by Farrar Straus & Giroux. The most recent is *The Biplane Houses*.

Marilyn Nelson's honors include a Guggenheim fellowship, three National Book Award Finalist medals, the Poets' Prize, the Boston Globe/Hornbook Award, the Lion and Unicorn Award, and the American Scandinavian Foundation Translation Award. Nelson is the former Poet Laureate of Connecticut, and founder/director of Soul Mountain Retreat.

Kathleen Norris is the author of the *New York Times* bestsellers *Dakota, The Cloister Walk, Amazing Grace,* and *The Virgin of Bennington.* Her seven volumes of poetry include *Little Girls in Church.* She has been an oblate of Assumption Abbey in North Dakota for nearly twenty years.

Gina Ochsner lives and works in Keizer, Oregon, with her family. Her story collections include *The Necessary Grace to Fall* and *People I Wanted to Be.* Her novel, *Russian Dreambook of Color and Flight,* is forthcoming.

Gregory Orr teaches poetry at the University of Virginia. These poems are from a book-length lyric sequence entitled *How Beautiful the Beloved,* which follows the trajectory begun in his ninth collection, *Concerning the Book that Is the Body of the Beloved.* Both are from Copper Canyon Press.

Eric Pankey is the author of eight collections of poetry, including *The Pear as One Example: New and Selected Poems 1984-2008.* He is Professor of English and the Heritage Chair in Writing at George Mason University.

Ann Patchett is the author of five novels, including *Bel Canto,* winner of the PEN/Faulkner Award and the Orange Prize and a finalist for the National Book Critics Circle Award. Her most recent book is *Truth & Beauty,* a memoir of her friendship with the writer Lucy Grealy.

David Plante's most recent books are the novel *ABC* and the memoir *The Pure Lover.* His trilogy of novels, *The Family, The Woods, and The Country,* is centered in the French Catholic parish in Providence, Rhode Island, where he was born. *The Family* was nominated for a National Book Award. His work has appeared in the *New Yorker, New York Times, Esquire,* and *Vogue.* He lives in London and New York and teaches at Columbia University.

Richard Rodriguez's most recent book, *Brown,* completed an autobiographical trilogy concerned respectively with class, ethnicity, and race in America. He has lately been working in the Middle East on a book of essays concerned with the ecology of monotheism—the influence of the desert on the religious experience of Jews, Christians, and Muslims.

Pattiann Rogers has published thirteen books, most recently *Wayfare*. Her awards include a Lannan Foundation Award and five Pushcart Prizes. Her papers are archived in the Sowell Collection at Texas Tech University. She has two sons and three grandsons and lives with her husband in Colorado.

Nicholas Samaras won the Yale Series of Younger Poets Award with his first book. He is now completing a new manuscript of poetry, a memoir, and a book of poems rewriting the Psalms from an Orthodox Christian perspective. He lives in West Nyack, New York, with his family.

Valerie Sayers, professor of English at Notre Dame, is the author of five novels including *Who Do You Love* and *Brain Fever*. Her fiction has won a fellowship from the NEA and a Pushcart Prize and has been translated into several languages. Her stories, essays, and reviews appear widely.

Sandra Scofield is the author of seven novels, a memoir, and a craft book for writers. She has been a finalist for the National Book Award, and a winner of a book award from the Texas Institute of Letters. After two decades devoted to writing, she has been teaching and editing for several years; and lately, she has been learning to paint.

Martha Serpas has published two poetry collections, *The Dirty Side of the Storm* and *Côte Blanche* (New Issues), in which "As If There Were Only One" appeared. Her work has appeared in *The New Yorker, The Nation,* and in the anthology *American Religious Poems*. A part-time trauma chaplain, she teaches at the University of Tampa.

Luci Shaw is a poet, essayist, and teacher who is currently a writer in residence at Regent College in Vancouver, Canada. Her most recent books are the poetry collection *What the Light Was Like* and *Breath for the Bones: Art, Imagination & Spirit*. For further information, visit www.LuciShaw.com.

Robert Siegel's most recent books are *A Pentecost of Finches: New and Selected Poems* and *The Waters Under the Earth*. He has received awards from *Poetry,* the Ingram Merrill Foundation, and the NEA.

Melanie Rae Thon's most recent books are the novel *Sweet Hearts* and the story collection *First, Body*. Her work has been included twice in *Best American Short Stories,* three times in the *Pushcart Prize* anthology and once in *O. Henry Prize Stories*. Originally from Montana, she now teaches at the University of Utah in Salt Lake City.

John Terpstra's most recent collection is *Two or Three Guitars* (Gaspereau, 2006), in which "Our Loves..." appeared. An earlier work, *Disarmament*, was short-listed for Canada's Governor General's Award. His newest nonfiction work is *Skin Boat: Confessions of an Unrepentant Church-goer.*

Daniel Tobin's books include: *Where the World Is Made, Double Life,* and *Second Things.* He has received the Robert Penn Warren Award, Greensboro Review Prize, and an NEA fellowship.

G.C. Waldrep is the author of *Goldbeater's Skin, Disclamor,* and most recently *Archicembalo,* which won the 2008 Dorset Prize from Tupelo Press. He lives in Lewisburg, Pennsylvania, and teaches at Bucknell University.

Jeanne Murray Walker is the author of six poetry collections, including *Coming into History, Gaining Time,* and *A Deed to the Light.* Her poems have appeared in *Poetry, American Poetry Review,* and the *Atlantic Monthly.* She is a professor of English at the University of Delaware.

Wim Wenders' many films include *Buena Vista Social Club, Wings of Desire, The Million Dollar Hotel, Don't Come Knocking, Willie Nelson at the Teatro,* and most recently *Palermo Shooting.*

Joy Williams has written four novels, the most recent, *The Quick and the Dead,* being a finalist for the Pulitzer Prize; three collections of stories, and a book of essays, *Ill Nature.* She is a member of the American Academy of Arts and Letters.

Christian Wiman is the author of three books: the poetry collections *Hard Night* and *The Long Home,* and most recently a work of nonfiction, *Ambition and Survival: Becoming a Poet.* He is the editor of *Poetry.*

Larry Woiwode's work has appeared in a variety of publications, including the *Atlantic, Harpers,* and *The New Yorker.* He is a Guggenheim and Lannan Fellow, the Poet Laureate of North Dakota, and Writer in Residence at Jamestown College.

Tony Woodlief lives in Kansas with his wife and four sons, where he is earning an MFA from Wichita State University. This is his second published story. His essays have appeared in various national publications, and his memoir, *Somewhere More Holy,* will be published in 2010.

Franz Wright's most recent collection of poems is *Wheeling Motel.* He received the Pulitzer Prize in 2004 for *Walking to Martha's Vineyard.* Other recent collections include *God's Silence, Earlier Poems,* and *The Beforelife.*

Frederick Brown has painted over three hundred larger-than-life portraits of jazz and blues greats, including Billie Holiday and Louis Armstrong. He taught at the Central College of Fine Arts and Crafts in Beijing, China, and was the first American to have an exhibit at the Museum of the Chinese Revolution at Tiananmen Square. In the summer of 2002, the Kemper Museum of Contemporary Art in Kansas City, Missouri, had an exhibit of thirty of his jazz and blues portraits. He is based in New York City.

John Cobb is a portrait artist based in Beaumont, Texas. He studied painting at Lamar University and has worked as a courtroom sketch artist. He had solo exhibitions at the Beaumont Art Museum and the Art Studio Incorporated. His website is www.JohnCobb.net.

William Congdon's (1912-1998) was born in Providence, Rhode Island, and gained notoriety as an artist in New York City in the 1940s. For almost ten years, he kept a studio in Venice, while traveling constantly. After his conversion to Catholicism in 1959, he withdrew form the art market and he spent most of his life in Italy. His works are housed in many public and private collections, including the Metropolitan Museum of Art, the Museum of Modern Art, the Whitney Museum of American Art, and the Peggy Guggenheim Collection in Venice. After his death his literary and artistic heritage has been entrusted to the William G. Congdon Foundation of Milan (www.Congdon.it).

Eleanor Dickinson's works have appeared at museum exhibitions across the country, including the Peninsula Museum of Art and the Museum of Contemporary Religious Art in Saint Louis, and are in several public collections, including the National Museum of American Art, the Stanford Art Museum, the San Francisco Museum of Modern Art, and the Library of Congress. A native of Knoxville, Tennessee, she is professor emerita of California College of the Arts and resides in San Francisco. Her website is EleanorDickinson.wordpress.com.

Roger Feldman's installations have been shown nationally and internationally, and his work is included in *Who's Who in American Art* as well as *Who's Who in America*. He chairs the art department at Seattle Pacific University. His website is www.RogerFeldman.com.

Wayne Forte was born in Manila, Philippines, in 1950. He did undergraduate work at the University of California at Santa Barbara and his MFA at University of California at Irvine. Presently he lives with his wife and four kids in Laguna

Niguel. He was a participant in the Florence Portfolio Project and has been a CIVA member for many years. He has also taught at Biola Universtiy and Gordon College, Orvieto Campus. His website is www.WayneForte.com.

Ginger Geyer is a sculptor based in Austin, Texas, who creates trompe l'oeil glazed porcelain objects. Her work has been exhibited at the Center for Arts and Religion in Washington, DC, Cidnee Patrick Gallery in Dallas, and will be the subject of an upcoming show at McKinney Avenue Contemporary in Dallas. She worked for many years at the Kimbell Art Museum and Dallas Museum of Art, and now consults on art for Laity Lodge in the Texas hill country. Her website is www.GingerGeyer.com.

Erica Grimm-Vance is an assistant professor of art at Trinity Western University. Working in encaustic and steel with themes of embodiment and liminality, she has had over twenty-five solo exhibitions and is in numerous private and public collections, including the Vatican, Canada Council Art Bank and the Richmond Art Gallery. She has studied at the University of Regina, Banff School of Fine Arts, and Academie der Bildenden Kunste in Munich, and is now pursuing a PhD in arts education. Her website is www. EGrimmVance.com.

Steve Hawley's paintings are included in the collections of the Metropolitan Museum of Art, the Brooklyn Museum, the Smithsonian Museum of American Art, the DeCordova Museum and Sculpture Park, and in many other public and private collections. His work has been featured in the *New York Times, American Art Now,* and in the books *American Realism* and *Art Today.* He has taught at the School of the Museum of Fine Arts in Boston and at Tufts University. His website is www.SteveHawley.com.

Bruce Herman is a painter and professor of art at Gordon College, near Boston, where he is currently Lothlórien Distinguished Chair in the Fine Arts. His work is housed in many private and public collections including the Vatican Museums in Rome and Grunwald Center/Armand Hammer Collection at LA County Museum. His website is www.BruceHerman.com.

David Herwaldt studied photography at the Massachusetts Institute of Technology and has taught and the New England School of Photography and Harvard University, where he won an Excellence in Teaching Award. He works on long-term, self-assigned projects, photographing a diverse range of subjects—such as blues musicians, construction workers, the highest and lowest points of the fifty United States, pilgrimage, and city trees. His pictures have been published in *Doubletake* and exhibited at Messiah College, Gordon College, Wellesley College, the University of Iowa, and the Danforth Museum.

Edward Knippers received his MFA in painting from the University of Tennessee and works out of a studio in Manassas Park, Virginia. He is nationally recognized as a figurative painter of biblical subjects, and has had over one hundred solo and invitational exhibitions, including at the Los Angeles County Museum, the Museum of Biblical Art in New York, the Catholic University of America, and a recent one-man exhibition at the Corpus Christi Festival in Orvieto, Italy. His work is found in numerous public and private collections including the Vatican Museum, Armand Hammer Museum, and the Cincinnati Art Museum. His website is www.EdKnippers.com.

Barry Krammes is an assemblage artist whose work has been featured in both solo and group exhibitions, regionally and nationally. His pieces are in private collections throughout the United States and Canada. Since 1983 he has taught in the art department at Biola University, where he has served as department chair as well as administrator of the art gallery. He is currently the editor of *Seen*, the journal of Christians in the Visual Arts.

Laura Lasworth received her BFA from the School of the Art Institute of Chicago and her MFA from California Institute of the Arts in Valencia, California. She is represented by the Lora Schlesinger Gallery in Santa Monica. Her website is myhome.spu.edu/Lasworth.

Zhi Lin trained at the China National Academy of Fine Arts in Hangzhou and the Slade School of Fine Arts in London. His work has been exhibited internationally and is in collections including the Princeton University Art Museum, the Frye Art Museum in Seattle, the National Fine Art Museum in Beijing, and the Great Britain-China Centre in London. He is an associate professor of art at the University of Washington.

Tim Grubbs Lowly was born in Hendersonville, North Carolina, in 1958. After growing up in South Korea as the son of medical missionaries, he attended Calvin College. He and his wife, the Reverend Sherrie Lowly, reside with their daughter Temma in Chicago where Tim is affiliated with North Park University as gallery director, professor, and artist-in-residence. His art is housed in many public collections, including the Metropolitan Museum of Art. He is represented by Koplin Del Rio Gallery, Los Angeles.

Jim Morphesis lives and works in Los Angeles, California. For more than thirty-five years, he has been exhibiting his paintings both nationally and internationally. His works have been shown in thirty-nine solo exhibitions and in well over one hundred invitational group exhibitions, and are in the permanent collections of more than twenty-five museums including the Los Angeles County Museum of Art, the San Francisco Museum of Modern Art, and the Whitney Museum in New York.

Barry Moser is one of the most respected and acclaimed wood engravers in the world. His work can be found in museums and permanent exhibitions globally—from the National Gallery of Art in Washington to the Vatican Library, and at www.Moser-Pennyroyal.com.

Catherine Prescott taught painting at Messiah College for twenty years and continues to teach with Gordon College's Orvieto Program and Andreeva Portrait Academy. She was awarded a 2008 Individual Artist's Fellowship from the Pennsylvania Council on the Arts. Her work can be seen at www. PrescottPaintings.com.

Theodore L. Prescott is a Distinguished Professor of Art at Messiah College in Grantham, Pennsylvania. He is a sculptor who often writes about art. The Phillips Museum of Franklin and Marshall College will have an exhibition of his work in 2010, and he is working on research for an exhibition he will curate about imagery mediated by substances, tentatively scheduled for 2012. His website is www.TedPrescottSculpture.com.

Tim Rollins is the founder of K.O.S. (Kids of Survival), a South Bronx collective of young artists that creates collaborative visual responses to music and literature. Their work is in the permanent collections of the Museum of Modern Art in New York City, the Tate Modern in London, and others.

Melissa Weinman is a painter and professor of art the University of Puget Sound in Tacoma. She received her AB from Bowdoin College and her MFA from the University of Southern California. Her work is housed in several public collections, including the Tacoma Art Museum and Seattle University, and she has exhibited nationally and internationally. Her website is www. MelissaWeinman.com.

Jerome Witkin is a professor of art at Syracuse University. His paintings have been shown in over one hundred exhibitions since 1966, and are found in many permanent collections worldwide, including the Metropolitan Museum of Art, the Hirshhorn Museum, and the Uffizi Gallery in Florence. He is represented by ACA Galleries in New York and Jack Rutberg Fine Arts in Los Angeles.

[acknowledgments]

I DON'T KNOW about you, but I generally read the acknowledgment sections of books, as I also watch the credits scrolling up the screen when the movie is over. It's a matter of both respect and gratitude.

Founding and sustaining a literary quarterly—which has grown into a nonprofit arts organization with half a dozen programs from a summer workshop to a daily blog—has been an endeavor requiring the love and labor of many individuals over the past two decades. As the Grateful Dead used to sing: "What a long strange trip it's been."

In the beginning was Suzanne, my kick-ass wife. We had the good fortune of meeting and falling in love when we were quite young, and so you could almost say that we grew up together; ours has been a partnership on so many levels. Suzanne's influence—on me and on the shape that *Image* would take—is beyond measure or description. She has not only proofread every word we've ever printed and been a constant advisor and critic, but she has made innumerable personal sacrifices so that *Image* could continue to exist. Our four children—Magdalen, Helena, Charles, and Benedict—may not have chosen the sacrifices they were asked to make, but they ratified them many times over in their hearts.

The earliest conversations about launching an effort in the realm of religion and the arts took place with Maclin and Karen Horton. Then Harold Fickett joined the dialogue, spending countless hours on the phone with me as we worked up the courage and resources to launch the journal. Without his connections, his passion for good writing, and his encouragement, *Image* would never have been founded. Harold served as coeditor during our start-up phase and has continued as a contributor to our pages.

Luci Shaw, poet and spiritual writer, had the generosity and trust to make the printing of our pilot issue possible. She has remained by our side ever since, serving on our board of directors throughout. I call her *Image*'s fairy godmother.

Kathy Lay-Burrows, who was serving as art director for InterVarsity Christian Press at the time, donated her services in creating the layout and typography for the journal—a design that has remained consistent—and been consistently acclaimed—for twenty years.

Image has been well served by three managing editors. Richard Wilkinson and William Coleman joined the enterprise when it was a rather uncertain, fragile thing. They not only worked diligently and cheerfully throughout this wobbly phase but added their own distinctive imprints as the journal became a more professional and wide-ranging project.

Mary Kenagy Mitchell, who has been managing editor since 2000, took over where these gentlemen left off. Her impact on every aspect of the journal and our other programs has been incalculable. Not only is she an enormously talented writer of fiction and a sensitive editor, but she has blossomed into a graphic designer, business manager, and much, much more. Mary helped with the selection of the contents of *Bearing the Mystery,* designed its typography and layout, and wrangled the whole thing into shape. Her counsel over the years has been invaluable.

The *Image* staff has been blessed with a number of hard-working and creative folk in the last few years. I sometimes compare the team at the office with the Miles Davis Quintet at its height: we can jam together but everyone can also solo magnificently. Sarah Steinke became *Image*'s first events and development program director. Julie Mullins took the baton from Sarah and has lapped the field several times; she has been unflappable and unflagging and extraordinarily patient and giving. My assistants—first Sara Arrigoni and now Anna Johnson—have reveled in the challenges placed before them and effortlessly overcome them. Sara graciously proofread this book.

Beth Bevis has been an enormous help as program coordinator of the Seattle Pacific University MFA in creative writing program and able editor of our e-newsletter, *Image* Update.

From the beginning a legion of volunteer interns have enabled us to cope with the workload. I will name just one to stand in for all the rest—thanks to Hayley Poole, who has helped us compile and lay out this volume.

No nonprofit organization is likely to last long without a loyal, creative board of directors, and *Image* is no exception to this rule. Carol Windham, who served briefly as board chair, has been a tremendous support over the years; this book is co-dedicated to her. To our current chair, Mark Wiggs, our deepest gratitude, and to our other board members: Michael Capps, J. Steve Davis, Laurel Gasque, Jane Owen,

Greg Pennoyer, Robert Royal, Luci Shaw, Dick Staub, and Richard Vaughan.

Our distinguished editorial advisory board has consistently offered us wise counsel and timely aid. Thanks to Ronald Austin, Doris Betts, Scott Cairns, Robert Coles, Annie Dillard, Denis Donoghue, Gordon Fuglie, Patricia Hampl, Ron Hansen, Mark Helprin, Andrew Hudgins, Thomas Lynch, Paul Mariani, Mary McCleary, Barry Moser, Kathleen Norris, Theodore Prescott, Richard Rodriguez, Dan Wakefield, Jeanne Murray Walker, Wim Wenders, and Larry Woiwode

Our friends at Wm. B. Eerdmans Publishing Company have been patient and supportive throughout the process of publishing this book. I'd like to thank Bill Eerdmans, Sandy de Groot, Willem Mineur, and Klaas Wolterstorff.

Seattle Pacific University, our academic host, has provided us with a nurturing environment in which to work. I am grateful to the president of SPU, Phil Eaton; vice president for academic affairs Les Steele; and dean of the college of arts and sciences Bruce Congdon. Our former English department chair, Mark Walhout, was instrumental in bringing *Image* to SPU, and its current chair, Chris Chaney, is a staunch champion. Two of my faculty colleagues, Roger Feldman and Jennifer Maier, have made valuable contributions as associate editors of the journal.

Thanks, too, to my agent, Carol Mann.

To my companions in the Seattle community of Communion and Liberation: thank you for being witnesses to the Mystery for me— especially to Alex Edezhath, Tia Corrales, Laura Lewis, and Ismael Garcia Fuentes.

Finally, a great shout of appreciation for all of the subscribers and donors who have kept *Image* alive and well through two decades. I pray that this volume is a welcome addition to your library and a confirmation of your belief in the journal.

 Gregory Wolfe